GLORIES OF THE PAST

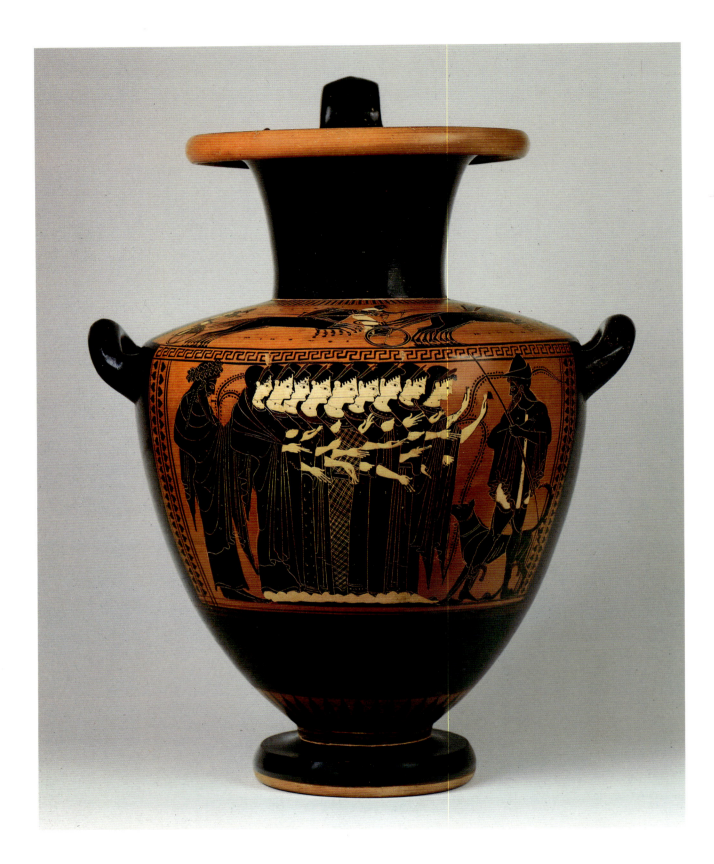

GLORIES OF THE PAST

ANCIENT ART FROM THE SHELBY WHITE AND LEON LEVY COLLECTION

EDITED BY DIETRICH VON BOTHMER

The Metropolitan Museum of Art, New York

DISTRIBUTED BY HARRY N. ABRAMS, INC., NEW YORK

This volume has been published in conjunction with the exhibition "Glories of the Past: Ancient Art from the Shelby White and Leon Levy Collection," held at The Metropolitan Museum of Art, New York, September 14, 1990–January 27, 1991

Published by The Metropolitan Museum of Art, New York

John P. O'Neill, Editor in Chief
Ellen Shultz, Editor
Steffie Kaplan, Designer
Gwen Roginsky and Susan Chun, Production

Library of Congress Cataloging-in-Publication Data
Glories of the past: ancient art from the Shelby White and
 Leon Levy collection/edited by Dietrich von Bothmer.
 p. cm.
 Includes index.
 ISBN 0-87099-593-6. — ISBN 0-87099-594-4 (pbk.).
 — ISBN 0-8109-6400-7 (Abrams)
 1. Art, Ancient—Exhibitions. 2. White, Shelby—
Art collections—Exhibitions. 3. Levy, Leon—Art
collections—Exhibitions. 4. Art—Private collections—
United States—Exhibitions. I. Von Bothmer, Dietrich,
1918– . II. Metropolitan Museum of Art (New York, N.Y.)
N5337.W47G57 1990 90-6373
709'.01—dc20 CIP

All the photographs of objects from the Shelby White and Leon Levy collection were especially commissioned from Sheldan Comfert Collins, with the exception of the photograph of catalogue number 141 *e*, which is by Jerry Fetzer; catalogue number 164, which is by Otto Nelson; Figure 1, page 98; and catalogue number 174, page 241

JACKET/COVER: Roman bust of a young man. See catalogue number 154

ENDPAPERS: Detail of a hydria attributed to the Darius Painter. See catalogue number 126

FRONTISPIECE: Hydria attributed to the Priam Painter. See catalogue number 109

Printed and bound by Arnoldo Mondadori Editore S.p.A., Verona, Italy

Contents

Foreword

The creation of the great museums of the world—the Metropolitan Museum is no exception—and their continued existence and well-being owe much to a special breed of individual: the collector. No matter where or when they plied their trade, these individuals are linked by a common thread—the ardent desire to own works of art.

Large public institutions such as The Metropolitan Museum of Art, by their very nature are repositories of objects that for the most part are made to fall neatly into historical and chronological categories. Objects thus acquired are subject to the constraints of committees, to financial restrictions, and to the relative academicism of many of their curatorial guardians. However, in the assembling of private collections every whim can be exercised at will, and the preferences of the collectors tirelessly pursued and indulged: the result is fresh and often surprising because it reflects the collectors' personal taste and a sense of risk and adventure.

Shelby White and Leon Levy are true and passionate collectors, but theirs is far from an innocent eye; on the contrary, they have gained a broad knowledge of their field, both through experience and study. The collection of ancient art that they have brought together in a remarkably short time is enormously rich and diversified. Its superior quality and sustained level of interest reveal both the Levys' exceptional intellectual curiosity and boldness and also their willingness to strike out in relatively unsung areas to acquire mere whispers of an era in a small carved gem, or its resonant echoes in an over-life-size bronze figure. The interrelationships of cultures from continent to continent intrigue them, and are manifest in an especially engaging way in the profusion of varied animal images and sculptures in their collection. One is struck by how extensive a cross-section of the ancient world the collection affords, and it almost stretches our credibility to acknowledge that these are not the holdings of a large museum but, in fact, a panoply of treasures assembled with relentless perseverance, according to a very personal vision.

In this exhibition, the visitor is confronted with a spectacular constellation of objects ranging from several rare Neolithic marble sculptures and breathtaking early Cycladic figures, to Attic black- and red-figured vases, to superb Roman marble portrait busts and bronze statues, to striking examples of Greek and Roman metalwork and jewelry. However, as the spectators in the galleries and the readers of this volume marvel at the considerable scope of the treasures before them, they should bear in mind that these are but a selection from a much larger collection. Also, while the exhibition and the accompanying catalogue celebrate the acumen of Shelby White and Leon Levy, it should be noted

that the final page on their collection is decidedly not yet turned—indeed, several purchases were too recent to be included in this show, as our friends continue to give free rein to their love of collecting through their concupiscent attachment to the art of the ancient world. It is for the privilege of allowing the Metropolitan Museum and its visitors to share in the enjoyment of these treasures that we express our deep gratitude to these two collectors on this noteworthy occasion.

The catalogue and exhibition have involved the tireless participation and the expertise of many members of the staff at the Metropolitan Museum and of several other individuals to whom we owe our gratitude. First and foremost, I would like to thank Dietrich von Bothmer, Distinguished Research Curator of Greek and Roman Art, for his wise and informed selection of objects; for his enlightening entries; for the entries he commissioned from other experts; and above all for his care and unwavering concern in shepherding the texts along the way to becoming a finished catalogue.

Mahrukh Tarapor, Assistant Director, was the guiding hand in bringing the exhibition to fruition. Carlos Picón, Curator in Charge, Department of Greek and Roman Art, devised the installation and oversaw its presentation with the help of Jeff Daly, Chief Designer. The efforts of Emily K. Rafferty, Vice President for Development, were also vital to the realization of the exhibition.

The catalogue was prepared and took shape under the watchful guidance of John P. O'Neill, Editor in Chief. The contributions of over twenty authors were carefully edited by Ellen Shultz, designed by Steffie Kaplan, and the volume has been beautifully produced by Gwen Roginsky. We are also grateful to Sheldan Comfert Collins for capturing the essence of the objects in the handsome color and black-and-white photographs that fill these pages.

PHILIPPE DE MONTEBELLO
Director
The Metropolitan Museum of Art

Introduction

Two decades ago, we raised our hands at an auction and became the owners of a Roman Head of a Philosopher. We had bought an ancient sculpture but scarcely realized then that it would mark the beginning of a collection.

The excitement of collecting has been not only the joy of possessing a beautiful object but the fascination of discovering the links between that object and its place in history. We owe this view of collecting to our greatest teacher—our friend the late Harry Bober. He accompanied us through the museums of Europe, visited auction galleries, and trooped along from dealer to dealer all the while opening our eyes to the wonders of ancient art. Harry, although a medievalist, looked at art from an artist's viewpoint. He taught us to recognize the connections between the arts of different periods and cultures and, beginning with the marvelous cave paintings at Altamira, made us aware of the vast continuum of art history.

We began by purchasing classical art. Our curiosity then led us to wonder about the civilizations and the antiquities that came before and followed that of ancient Greece. We broadened the scope of our collection, reaching back to obtain objects from the Neolithic period and forward for those produced by nomadic tribes—the Franks, Goths, Visigoths, and Merovingians. Geographically, the works we have collected originated in territories from almost as far east as China—the Ordos plaques—to as far west as the lands inhabited by the Celts.

Naturally, we have favorites in the collection. The marble portrait bust of Octavian fascinates us because it was carved soon after he sent Cleopatra and Mark Antony back to Egypt but before he became the first Roman emperor. The vase by the Bucci Painter depicting a farmer plowing his field gives us a glimpse of everyday life in ancient Athens. The Brygos cup shows an exquisitely rendered scene from the Trojan War—that touching moment when Priam begs Achilles to return the body of his son Hector. We admire the grace of our painted Cycladic Idol, and we take special delight in our Roman portraits, some of which resemble people we know.

Some objects, such as our hammered-bronze Griffin Protome from the seventh century B.C., intrigue us by their rarity. We once visited the museum on the island of Samos that houses one of the outstanding protome collections and were captivated by these fierce dragon-like creatures—made by Greeks but obviously displaying Eastern influences. When the protome became available, we knew we had to own it.

We had to stop somewhere, however, so that our collection does not include any Egyptian art or works from across the Indian border, despite the obvious

appeal of Gandharan art, with its Hellenistic influences. Of course, we are still collecting, so who can tell what may come our way?

The oldest works in our collection were created more than five thousand years ago. Some bear ancient repairs, signs that they were cherished by others throughout their long history. We know our objects have had many caretakers— for when you are a collector a caretaker is what you become. We know, too, that we are just links in a very long chain and that our treasures will someday have new homes in other places.

We have been fortunate, as collectors, to have become friends with the dealers who first showed us these wonderful objects, the curators and scholars who helped us learn about them, and the conservators who willingly shared their knowledge when we called. The experts at The Metropolitan Museum of Art have always made us feel welcome. Many people have assisted us through the years, and the exhibition and the catalogue reflect their combined efforts.

Dietrich von Bothmer's fine eye and extraordinary scholarship have shaped this exhibition and the catalogue, and his wit and anecdotes enhanced the pleasure of his weekly visits to study the collection. Philippe de Montebello's involvement in all aspects of the exhibition and his empathy were essential. We also welcome Carlos Picón's thoughtful and intelligent contribution. Finally, we thank our dear friends, Barbara and Larry Fleischman, for it was their suggestion and encouragement that led to this exhibition.

SHELBY WHITE AND LEON LEVY

Early Aegean

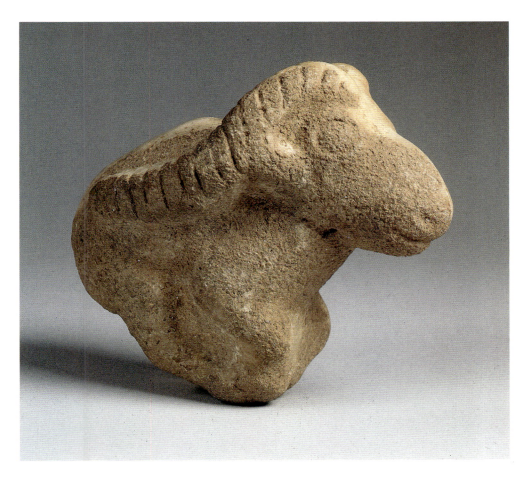

1. *Wild goat*

Height, 11.2 cm.; length, 15.7 cm.
Marble
Aegean, Neolithic, about the fifth to the fourth
 millennium B.C.

The animal represented is difficult to identify. On the basis of geographical distribution in antiquity and the shape of the horns, the subject is more likely to be a species of wild goat, such as the *agrimi,* than a wild sheep, or mouflon (B. Grzimek, *Animal Life Encyclopedia* 13, New York, 1972, pp. 486–90; see also pp. 496–502). The little goat is shown with its four hooves drawn together under the body in a way that emphasizes the volumes of its form. The structure of the head gives prominence to the nose and to the area of the eyes. The mouth is indicated with a slight furrow, the nostrils with two shallow depressions. The large, wide-open eyes are modeled with particular attention to the lids and to the convexity of the eyeball. The care in articulating the animal's head is further reinforced by the handling of the ears and of the horns, which grow from the front of the forehead and sweep back almost to the tail. This detail is not realistic for what appears to be quite a young animal, but it is the symbol of the species. The balling up of the body causes the back and spine to arch above the level of the horns. While unusual, this position made it unnecessary for the sculptor to address the problem of the space that exists, in reality, between the animal's back and its horns. The latter are articulated into segments that roughly correspond from one horn to the other. The ears appear as though they were appendages of the horns, without articulation but with considerable artistic effect, in terms of the depiction of the whole animal. From the back, a short tail and the testicles are visible.

Most distinctive in the rendering of the wild goat is the

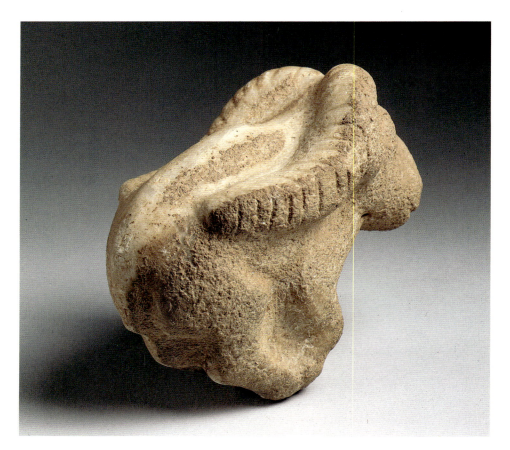

emphasis on the head, virtually at the expense of the legs and body. Moreover, the very palpable volumes and the sense of alertness in the eyes convey remarkable energy and vitality.

It is useful to observe not only the detail of the piece but also the overall impression, for, according to reliable reports, it was found with a counterpart now in the collection of Mr. and Mrs. Michael Steinhardt, New York. The Steinhardt example (see figs. 1, 2) may well depict a different variety of wild goat, such as an ibex; again, the horns provide the best indication of the species (B. Grzimek, op. cit., pp. 480–84). Its greatest height is 16 centimeters, its greatest length 23.7 centimeters. This animal appears to be either standing or lying on its side. As a result, the legs, chest, and anatomical detail are articulated more fully. At the same time, one has a far stronger sense that the animal remains embedded in its matrix of marble. A membrane of stone fills the spaces between the legs, inhibiting the limbs that, here, are so much more forcefully modeled; note especially the forelegs, the rump, and the chest with the clearly marked ribs. Because of the difference in species as well as position, the ibex's horns arch a bit rigidly from the top of the head to the back; seen from above, a long furrow was hollowed out and then individual ridges were cut—or abraded—transversely. The ear is a distinct but not separate element. The head is somewhat more summarily formed, although the mouth is rendered with the tongue clearly visible between the lips.

The sibling relationship between the two sculptures is indicated not only by their appearance but also by the quality of the marble, the color and crustiness of the surface accretion, and the fact that they were cleaned in modern times in a comparable manner on one side only.

The precise function of the sculptures eludes us. The conventional hypothesis that they served as dedications or offerings is probably applicable. Evidence exists that sheep, goats, pigs, and cattle are among the species of animals that were domesticated in Greece by the latter part of the seventh millennium B.C. While certain varieties may have been indigenous, animal husbandry was introduced from the Near East (S. Bökönyi, "Stock Breeding," in *Neolithic Greece,* D. Theocharis, ed., Athens, 1973, pp. 165–78).

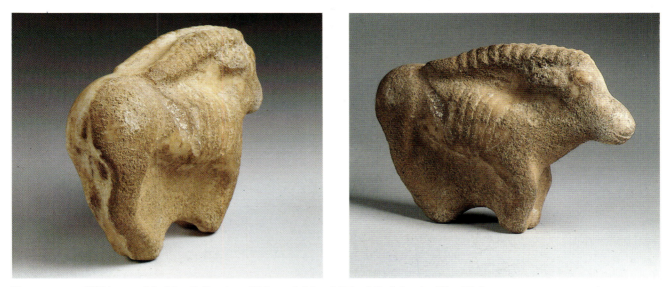

Figures 1, 2. Wild goat. Marble. Collection of Mr. and Mrs. Michael Steinhardt, New York

This innovation may well have brought with it the concept, or practice, of animal sculpture for purposes of propitiation, invocation, and thanksgiving. Most eloquent and beautiful representations of animals from Israel have been dated as far back as the tenth millennium B.C. (U. Avida, *Treasures from the Holy Land,* New York, 1986, pp. 31–40). It is pertinent to note that these pre-Neolithic—as well as later Neolithic—depictions from the East may present a single animal or a herd. As a single instance of the former one may cite the statuesque alabaster mouflons of the mid-fourth millennium from Tepe Yayhia (M. J. Mellink and J. Filip, *Frühe Stufen der Kunst,* Berlin, 1974, pl. 68). A most impressive depiction of herds occurs on a carved ivory handle of the later fourth millennium from Egypt (The Brooklyn Museum, 09.889.118; W. Needler, *Predynastic and Archaic Egypt in The Brooklyn Museum,* Brooklyn, 1984, pp. 152–68, 268–71).

Animal sculptures in marble from the Greek world that can usefully be compared with the works in the Levy and Steinhardt collections come from the Cyclades. These range from several small quadrupeds dating to the fourth millennium (J. Thimme, *The Art and Culture of the Cyclades,* Chicago, 1977, no. 429, pp. 579–80) to such accomplished creations as the bird in the Ortiz collection (J. Thimme, op. cit., no. 433) or the vase in the shape of a pig in the Goulandris Collection (J. Thimme, op. cit., p. 99).

No concrete evidence exists for either the provenance or the date of the wild goat sculptures in the Levy and Steinhardt collections. I would attribute them, at least provisionally, to the extended Aegean ambient encompassing the Peloponnesus, Attica, Crete, and the wider periphery of the Cyclades that has yielded Neolithic representations of human figures (S. S. Weinberg, "Neolithic Figures and Aegean Interrelations," *AJA* 55, 1951, pp. 121–33). Chronologically, they may be among the earliest animal sculptures in marble from this region, datable, perhaps, to the fifth or the fourth millennium B.C.

One final feature of the Levy wild goat deserves mention. The placement of the legs strongly suggests that the animal was bound. Without drawing any particular inferences or conclusions, one cannot fail to be reminded of the repeated occurrences of the motif in Archaic Greek art. The recent monograph of Angeliki Lebessi on the bronze plaques of the seventh to the fifth century B.C. from Kato Syme corroborates and supplements existing evidence for the particular prevalence of the motif on Crete; the animal of choice here is the ibex (A. Lebessi, *To Iero tou Erme kai tes Aphrodites ste Syme Viannou: 1. Chalkina Kretika Toreumata,* Athens, 1985, English summary, pp. 221–40; see *eadem,* "Der Berliner Widderträger," in *Festschrift für Nikolaus Himmelmann,* Mainz, 1989, pp. 59–64). While representations of the bound animal alone are exceptional, there are over forty plaques on which a man is subduing, tying, or bearing an ibex. In considering the Levy sculpture we must at least pose the question as to whether it preserves for us an early antecedent of practices—possibly also ideas—that underlie the Cretan reliefs and that receive definitive expression, for instance, in the Moschophoros from the Athenian Acropolis.

J. R. M.

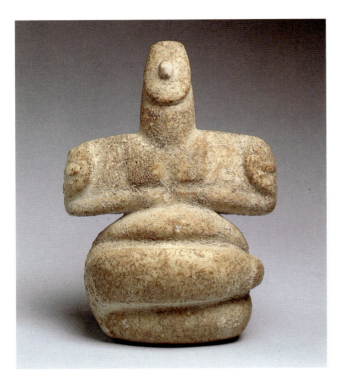 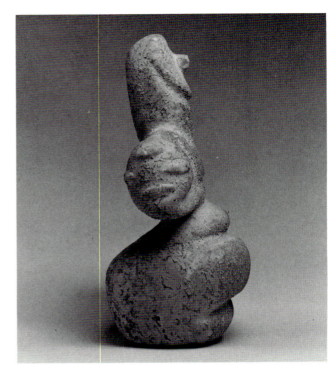

2. *Marble sitting female figure*

Height, 20.5 cm.
Aegean Neolithic, about 5000–3500 B.C.

A robust figure with a commanding presence, this work is an excellent example of a rare Neolithic type. Displaying a harmony of blocky forms and subtle curves, the image sits, stable on its flat bottom, leaning slightly backward. Its typically Aegean features include the head and neck treated as a single form, from which the face is set off in relief; the prominent, slightly upturned nose, which is the only facial feature; a broad upper body that is flat and slender in profile, in distinct contrast to the amplitude and rounded contours of the lower torso; elbows that stand out from the body, with the arms arranged symmetrically and the hands meeting in the middle; a small waist; and legs arranged in a folded position, obscuring the lower abdomen and the pubis (compare cat. no. 3).

The present work shares all of the above characteristics and more with another, much smaller and quite delicate example of these scarce images of the great goddess of the prehistoric Aegean, also in the Levy collection (see cat. no. 8 a), but remains the largest member of the group. It differs from the others in that its upper arms show massive bulges

on each of which four almond-shaped—or perhaps fish- or even vulva-like—"tattoos" are indicated in relief.

This type of sculpture represents the full-fledged version of the Neolithic violin-shaped figure (*ACC*, nos. 27, 28, fig. 33). With its standing variant (*ACC*, nos. 1, 3), it was the prototype for the earliest Bronze Age images made in the Cyclades (*ACC*, nos. 31–48, 65–73). This particular work most probably was carved on the Greek mainland or in the Cyclades.

For further discussion and parallels, see S. S. Weinberg, "Anthropomorphic Stone Figurines from Neolithic Greece," in *ACC*, pp. 53–58, and the publications listed below.

The figure was formerly in the collection of James Johnson Sweeney.

P.G.-P.

BIBLIOGRAPHY
C. Alexander, "Early Statuettes from Greece," MMA *Bulletin*, June 1945, p. 238; S. S. Weinberg, "Neolithic Figurines and Aegean Interrelations," in *AJA* 55, 1951, pl. 2 A; G. M. A. Hanfmann, *Ancient Art in American Private Collections*, Cambridge, Massachusetts, Fogg Art Museum, 1954, no. 126; *Cat. Sotheby's (New York) November 24, 1986*, no. 92; S. S. Weinberg, "A Neolithic Greek Goddess," in *Sotheby's Art at Auction 1986–87*, London, 1988, pp. 388–90.

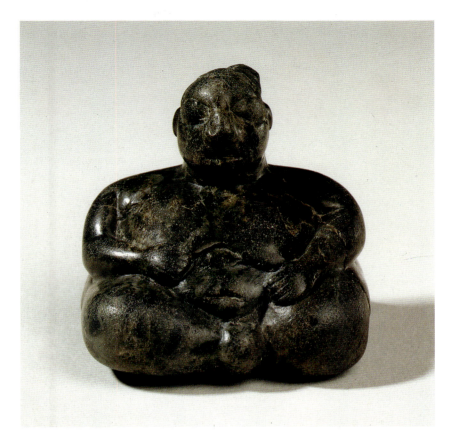

3. *Steatite sitting female figure*

Height, 3.4 cm.
Anatolian Neolithic, about 6000–5000 B.C., or later

Diminutive in size, this Buddha-like image, with its relatively massive proportions, full complement of delicately rendered details, and polished surface, has considerable presence and the power to attract attention. Made of soft, dark green steatite, with lighter green mottling, the figure is as wide as it is high and nearly as wide when viewed in profile as frontally. Designed to be seen from the front, the rear is somewhat compressed, but the flat underside, which enables the work to sit without wobbling, is carefully finished, with the outlines of the legs indicated. The image, with its lustrous surface, has considerable tactile appeal, and was evidently made to be handled.

Small, amply endowed female figures, both standing and sitting on the ground, executed in clay and in stone, were widespread over the greater Mediterranean area and beyond in the Neolithic Age as well as later. Nowhere, however, are they especially plentiful—and even less so in stone—and only rarely have they been recovered in systematic excavations. Some scholars believe that the type originated in Asia Minor, where this example almost certainly was found.

Such figures (see also cat. no. 7) differ from the better-known Aegean ones (see cat. nos. 2, 8 *a*) in that the heads are generally set on short rather than elongated necks and are distinct shapes independent of the necks instead of merely extensions of them. In addition, the upper body can be quite fulsome, as is the case with this miniature, whereas on Greek examples the upper torso is often thin in profile, in marked contrast to the exaggerated forms of the lower torso and legs. Among stone figures from Asia Minor, moreover, there seems to be greater variety in the positions of the arms and legs. Finally, large almond-shaped eyes are also characteristic chiefly of Near Eastern works, as are topknots. See, for example, J. Mellaart, *The Neolithic of the Near East*, London, 1975, figs. 54, 56, 65; *ACC*, nos. 553, 554.

P.G.-P.

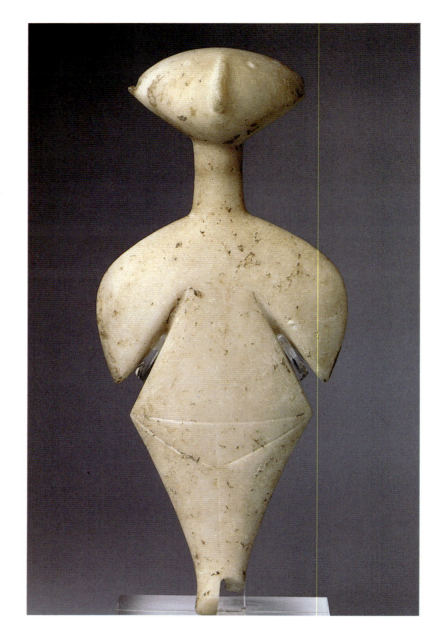

4. *Marble standing female figure*

Height, 17.4 cm.

Anatolian Chalcolithic, about 3300–2500 B.C. (said to
have been part of a group found at Kirşehir in central
Anatolia)

This figure is an excellent example of a distinctive type
localized in Anatolia. The workmanship of the sculpture is
unusually fine, and its proportions are especially well bal-
anced, suggesting that it was carefully planned prior to its
execution.

Highly stylized into a fusion of geometric forms, Kilia
(or, popularly, "stargazer") figures are characterized by rela-
tively massive heads carved in the round atop long, delicate
necks. The rest of the image is, by contrast, thin and flat
and essentially two dimensional. On this figure the unnatu-
ralistic breadth of the head (without the elfin ears, one of

which is missing) is about the same as that of the hips; on some examples the head is even proportionately wider. Characteristic, too, are the broad shoulders that slope in graceful curves ending abruptly at the elbows. The arms are set off from the torso by oblique cuts, with the forearms on this and most other figures to be read as sharply bent at the elbows and pointing upward, parallel to the cuts, as if supporting the breasts, which are, however, never specifically represented. The oblique orientation of the cuts gives the Kilia figures small Empire waists. Although the left foot of the present figure is missing, it is clear that, originally, the feet, too, were separated by a slender cleft. On some examples the feet are indicated by a single form no wider than the neck and are differentiated merely by a superficial incision. Incised details—the broad pubic triangle, the leg division, and the horizontal buttock line—tend to be finely drawn, and the eyes are often indicated by raised dots.

About thirty examples of this figure type—named for a site near Gallipoli where a figure now in the American School of Classical Studies, Athens, was reputedly found—are currently known. Of these, only about a third are complete or nearly so, and some remain unpublished. In size the stone ones vary from about six centimeters (the estimated original height of the figure sold at Sotheby's, London, November 12, 1989, no. 185) to 22.5 centimeters (the example in the Guennol collection on loan to The Metropolitan Museum of Art, L66.11).

Few of these images have been recovered during systematic excavation, making it difficult to determine their function or to form a clear idea of their distribution and dating. The type is thought to be western Anatolian in origin, with examples known from the Troad and from Mysia, Caria, and Lycia. (One image mentioned in the literature as having originated in the Thracian Chersonese—not in Thessaly, as reported in M. S. Joukowsky [*Prehistoric Aphrodisias . . .* , vol. 1, Providence and Louvain, 1986]—is most probably the name-piece of the type; another, now in Mytilene, may be from Asia Minor, as well.)

The Levy sculpture reputedly belongs to a group of several said to have been found near Kırşehir, in central Anatolia. The others include a small marble figure and a diminutive electrum one in the Schindler collection, New York; a small figure in the Schimmel collection, New York; one similar in size to the Levy example, formerly in the Nelson A. Rockefeller collection (*Masterpieces of Cycladic Art*, Edward H. Merrin Gallery, New York, 1990, no. 7); and the Guennol figure, the largest known example of the type (O. W. Muscarella, ed., *Ancient Art: The Norbert Schimmel Collection*, Mainz, 1974, no. 8). (See also M. S. Jou-

kowsky, op. cit., p. 208, n. 122, for other figures possibly from the Kırşehir area.)

To date, two fragmentary Kilia images have been found at Aphrodisias, in Late Chalcolithic contexts—from about 4360 to 4100 B.C. A small shell pendant in the form of the middle portion of a Kilia figure was found in perhaps a still earlier context (about 4600–4000 B.C.) at Can Hasan in south central Anatolia (*Anatolian Studies* 13, 1963, pl. 2 d opp. p. 37). Not only is this pendant very likely the earliest example of the type, albeit a schematic one, but it also has the easternmost provenance of any object whose findspot is definitely known—nearly as far east as Kırşehir, in fact. Curiously, the part of the figure shown on the pendant is the same as that on the two fragments from Aphrodisias and on one, from an early context, excavated at Beşik-Sivritepe in western Anatolia, among others.

Apparently, the Kilia type was made for at least as long as two millennia. No example has been found in a context later than Troy II, which ended about 2300–2200 B.C. The association of the Levy figure with the electrum one, if correct, would suggest that it and the other stone members of the Kırşehir group—whether or not the provenance is correct—are datable to the second half of the type's incredibly long duration.

Quite unlike the Cycladic folded-arm figures (see cat. nos. 9, 10, 12), to which the Kilia figures have been compared, the latter show very little stylistic variation—seemingly too little for the type to have been produced for so long (some four times as long as the Cycladic). Moreover, what variation does exist cannot be ascribed to developments over time, since sculptures presumably found together—and, therefore, probably coeval—display most of the differences found within the type as a whole.

The closest published parallels to the Levy figure are the Guennol figure, whose forearms are, however, rendered in relief, and those from the Schuster and Rockefeller collections, which have this feature as well as feet treated as a single form.

(On the Kilia type, see M. S. Joukowsky, op. cit., pp. 202–8, 217–21. References to the figures mentioned above without any bibliography are cited in M. S. Joukowsky, op. cit., p. 220, n. 126. Other unpublished examples are a head in the Louvre; a figure in the J. Paul Getty Museum, Malibu; and two fragmentary figures—on the art market—said to have been found with the one in Malibu; see also *Antiquities from the Schuster Collection, Cat. Sotheby's [London] 7 October 1989*, no. 66, with references to two other fragmentary works in the Bomford collection.)

P.G.-P

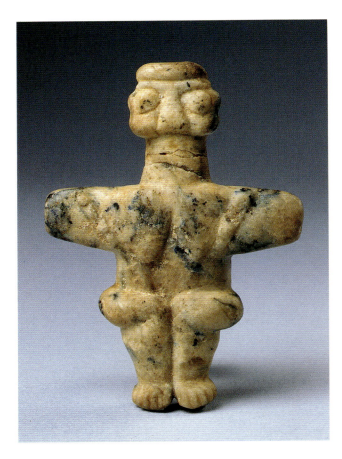

5. *Quartzite squatting female figure*
Height, 6.6 cm.
Cypriot Chalcolithic, about 3000–2500 B.C.

This small figure is an example of a type of image common during the Chalcolithic period in southwestern Cyprus. Usually such sculptures are carved in green, blue, gray, or brown picrolite, an attractive stone that was fairly easy to work and to polish; one especially large example, in the J. Paul Getty Museum, Malibu, is of limestone. This figure is unique in that it is made of quartzite mottled with azurite, an ore of copper. (The stone was identified, at the suggestion of Dr. Stuart Swiny, by the Department of Objects Conservation at The Metropolitan Museum of Art. Dr. Swiny informs me that this type of stone is common on Cyprus, especially in areas with deposits of copper ore.) Most likely the raw material in this case was an eye-catching pebble found by chance by the sculptor or someone who delighted in its unusual appearance. The material looks rather like Roquefort or Gorgonzola cheese, but, in fact, is much harder than the stones normally worked by Cypriot carvers.

The figure belongs to the cruciform type, in which the arms are outstretched in what appears to be an expansive, welcoming gesture, but which may, instead, be a gesture of balancing or seeking support during the act of giving birth in the squatting posture. Cruciform images are strongly frontal and two dimensional. Thus, the hips and feet project outward in an exaggerated fashion, just as the stylized rendering of the arms out to the sides may be a similarly flattened reduction of the more complex three-dimensional gesture of bending the arms at the elbows (see E. J. Peltenburg, in *Antike Welt* 19, no. 3, 1988, cover ill., fig. 18, p. 12).

Such figures have been found in graves (including those of children) and in buildings. Whether protective images of a life-giving, nurturing divinity or simple fertility charms, they were no doubt personal possessions made to be handled and worn as amulets. Some are perforated for suspension, while others, such as this one, would have been fastened at the throat by a cord or band, as seen on a large figure bearing, in relief, a likeness of itself on a band attached to its neck (see D. Morris, *The Art of Ancient Cyprus*, Oxford, England, 1985, fig. 150; see also E. J. Peltenburg, op. cit., fig. 1, p. 2, fig. 17, p. 11, which shows a pottery child-birth figure with a painted amulet and a band at the throat). The extended arms of the cross motif would have effectively prevented suspended images from turning, and those fastened around the throat by a band from slipping.

Many of the more detailed cruciform figures have a hatched or checkered pattern on the arms (D. Morris, op. cit., figs. 153–164). The present work is no exception, but here the simplified raised bands are nearly obscured by the strong mottling in the stone. Also noteworthy is the treatment of the face—especially the large bulging eyes, and the absence of a mouth or, indeed, of any space for one below the prominent nose. Similar features characterize certain picrolite figures, all conceivably carved by the same sculptor. See D. Morris, op. cit., figs. 132, 163; *Idols: The Beginning of Abstract Form*, New York, Ariadne Galleries, 1989, no. 54.

On the interpretation of the cruciform figures of Cyprus, see D. Morris, op. cit., pp. 122–23.

P. G.-P.

BIBLIOGRAPHY
P. Getz-Preziosi, "An Early Cypriote Sculpture," in *J. Paul Getty Museum Journal* 12, 1984, p. 28, fig. 2, p. 24 (the stone is incorrectly identified as marble).

6. *Terracotta female figure*

Height, 27.1 cm.
Cypriot, Early Bronze Age, about 2000–1900 B.C.

This is a fine (albeit somewhat restored) example of the gingerbread-like figures made on Cyprus after stone images (see cat. no. 5) went out of fashion. Its primarily incised and punctate details were probably filled with a white substance to contrast with the rich color of the slip. Characteristically, the head and neck are rendered as a small rectangle set atop a large rectangle representing the torso, with neither legs nor body contours indicated. The patterns on the body might suggest a woven garment, overlaid with jewelry in front, which obviated any need to show primary sexual characteristics. This makes it difficult to identify the sex intended, although, presumably, Cypriots of the period would have had no such problem. Because some of these red polished-ware Plank figures are shown holding an infant, it seems likely that they represent females.

Here, as on a few other examples, breasts with nipples in the form of holes are present in relief, but they are not especially feminine in appearance. More common than breasts was the addition of lug-like ears—the right one on this figure is damaged—pierced as if to accommodate earrings, although no actual earrings have survived on such works. Other characteristic features are the nose rendered in relief, holes for eyes on either side of it, and groups of short lines on the face, perhaps indicative of tattooing or cosmetic painting. The long, parallel, vertical lines ending in a motif of three dots on either side of the front of the figure appear to represent arms and hands. The same motif, treated in various ways, occurs on other examples; in rare cases it is present on figures with an arm, or arms, clearly defined in relief, suggesting that the motif was not anatomical at all but, rather, part of the figure's adornment, which might have included dangling strips of woven cloth or ropes of twisted wool ending in tassels or beads.

The Plank figures with known provenances come from graves, but the meaning and function of such images are as yet unclear. While they form an easily identified, homogeneous group, with similar outlines and proportions, no two examples are quite alike. Few show a full complement of distinctive features and, although the repertory of decorative motifs is not large, the variety of combinations and permutations in their rendering seems almost endless.

For further examples and a detailed discussion, see D. Morris, *The Art of Ancient Cyprus*, Oxford, England, 1985, pp. 135–62, especially pp. 137–38, 144–48, 161–62; P. Flourenzos, "Notes on the Red Polished III Plank-shaped

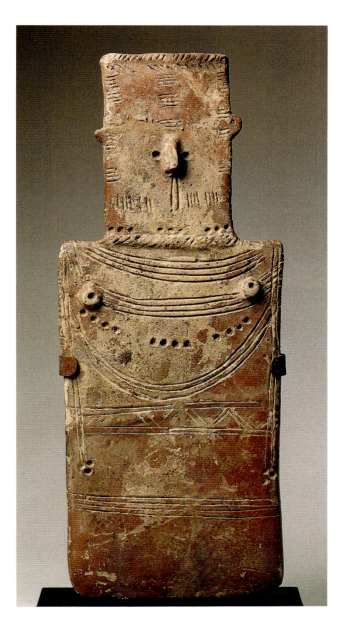

Idols from Cyprus," in *Report of the Department of Antiquities*, Cyprus, 1975, pp. 29–35; see also *ACC*, no. 574.

The figure was formerly in the collection of Nelson A. Rockefeller.

P.G.-P.

BIBLIOGRAPHY
Cat. Sotheby Parke-Bernet (New York) May 16, 1980, no. 146.

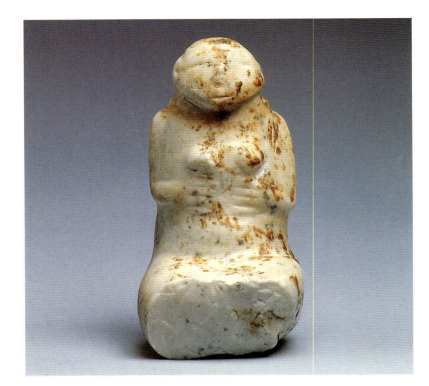

7. *Marble sitting or squatting female figure with a child on her back*

Height as preserved, 12 cm.
Near Eastern Neolithic, about 6000–3000 B.C. (said to
 be from north Syria)

Of the Neolithic stone sculptures now known of a child or
children clinging to the back of a crouching or sitting
woman, this is the last of three to have entered the Levy
collection (see also cat. no. 8 *b*, *c*). Like the other figures
bearing children, this one also appears matronly, sober, and
even stern, as if the responsibility for the human burden
were a weighty matter. Yet, despite this and other sim-
ilarities in the iconography of the three works—most im-
portantly, the postures of the clinging children—the re-
semblance of this work to the Aegean ones (especially to cat.
no. 8 *c*) is probably fortuitous, given the present sculpture's
Near Eastern provenance. What it has in common with the
related works is the depiction of a universally popular
method of carrying a child and a prehistoric penchant for
sitting or squatting on the ground. More surprising, per-
haps, than the similarities among the many early fertility or
"mother goddess" images is that so few are shown carrying
children in this or any other way. Without associated objects
or a known context, this sculpture is impossible to date with

accuracy, and may or may not be earlier than the Aegean
versions of the same subject.

Prominent breasts are the only indication that the pri-
mary figure represents a female. It is unclear whether the
missing lower legs were folded (as are those of the figures in
cat. nos. 2, 8 *a*) or tucked up in a frontal position (see cat.
no. 8 *b*, *c*). Curiously, the child is carved in a very different
style from that of the blocky, rather stiff-looking mother
figure. By contrast, it is lithe, sinewy, and graphic, its arms
clasping its mother's collarbone and its feet braced on her
hips. The child's head, in profile, is strangely snake- or even
cat-like, and the markings on it are difficult to read, which
may be due to the sculptor's inexperience carving this
particular theme, rather than to any deliberate attempt to
give the child an ophidian or feline appearance (compare the
seated clay figure of a goddess holding a leopard cub, from
Hacilar VI, in J. Mellaart, *Excavations at Hacilar*, vol. 2,
Edinburgh, 1970, fig. 65, p. 115).

The closest parallel—again, most probably fortuitous—
for the stone images of a child clinging to the back of a
female figure is a representation in clay from Hacilar VI (see
J. Mellaart, op. cit., fig. 220, p. 497).

P. G.-P.

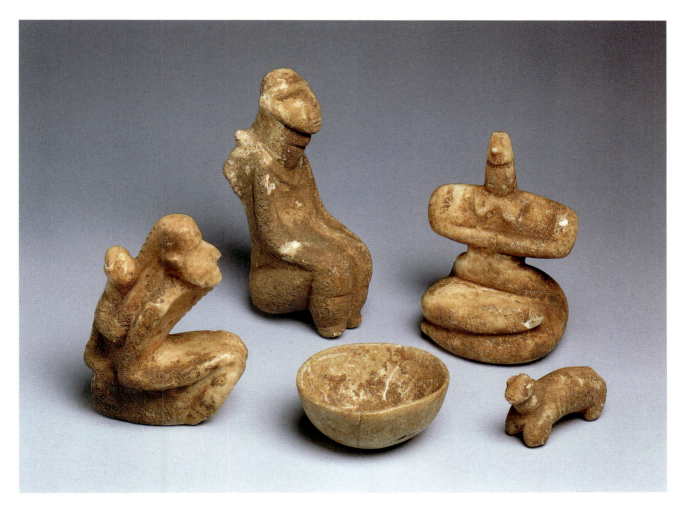

8. *Marble group*

Early Aegean Neolithic, about 5000–3500 B.C. (said to be from Euboea, or the east coast of Attica opposite, near Porto Raphti, perhaps from an islet attached to the mainland in prehistoric times)

a. Sitting female figure
 Height, 13.3 cm.
b. Squatting female figure with two children on her back
 Height, 15.5 cm.
c. Squatting female figure with one child on her back
 Height as preserved (feet missing), 12.1 cm.
d. Animal
 Height, 4.25 cm.; length as preserved (tail missing), 7.25 cm.

e. Oval bowl
 Height, 3.65 cm.; length at mouth, 7.9 cm.; width at mouth, 6.7 cm.

This remarkable collection of Neolithic objects is unparalleled in the prehistoric art of the Aegean, and, except for the sitting figure (*a*), the individual sculptures in the group are unique. That they were found together is very likely, in view of their similar rust-colored surfaces. Neolithic marble figures have been recovered—albeit almost never in the course of systematic excavation—in various parts of the Greek mainland, as well as on Crete, the Cyclades, and Euboea. While a Euboean or an Attic provenance is quite possible for this marble group, these are not the only places with rusty—that is, iron-rich—soil. Indeed, iron ores very

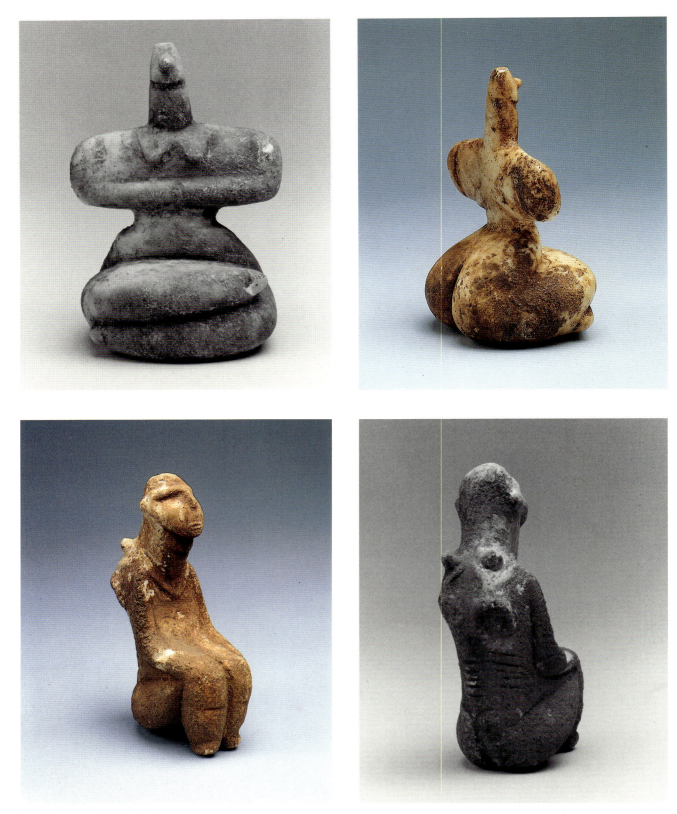

8 *a* (above) and 8 *b* (below)

often occur in close association with marble beds, which is certainly true in the Cyclades.

It is clear that the Levy group represents the work of more than one artist—possibly even of sculptors of different origins. The sitting figure with folded legs (*a*) is the sole sculpture among the five that belongs to a well-established, if rare, Aegean type, and the only one likely to have been made in the Cyclades (see cat. no. 2). If the sculptor of this work had wanted to carve a female figure with a child or children clinging to her back, one assumes that he would have made a sculpture that, on the whole, looked much like this one. He would not have adopted an entirely new style. The two females in the group carrying children (*b*, *c*) show no resemblance whatsoever to the canonical sitting figure, although figure *b* has lower legs rather like those of its standing counterpart (see *NAC*, no. 1). Indeed, it is chiefly their association with the sitting image that allows one to place these works in a chronological and geographical context at all.

While the two strange figures bearing children noticeably differ in several respects, they are probably the work of a single sculptor, who was also responsible for the statuette of a male animal (*d*)—a dog perhaps—with small pricked ears. The animal's head is quite similar to that of the single child (see figure *c*) as well as to the head of the figure with two infants (*b*), the latter also providing close parallels for the animal's thick neck, articulated ribs, and stubby feet. Typologically, the oval bowl (*e*) is too different from the four figurative works, and too simple, to identify it with the hand of one sculptor or another. However, one might suppose that it was made by the same artist who fashioned the figures bearing children and the little quadruped, although it is perhaps only a coincidence that the last carving fits very nicely inside the bowl, with only its head hanging over the rim, as if the vessel were designed to serve as its pen.

The greatest curiosities of the group are the two seem-ingly dour, even pained, figures with children carved in relief on their backs. They look as if they were meant to represent matronly if not old women, whether divine or mortal. Only one of them (*c*) shows any marking of her sex. Crouching or squatting on their haunches, supporting themselves with hands on knees, they seem to stare into the distance. The figure carrying a single, large child (*c*) looks more encumbered by her burden than the one with twin infants (*b*); her child seems to cling to her quite securely, whereas the twins appear to have all they can do to keep from falling.

Among the indications that the two works were carved by one person are their similarly thick, powerful necks inclined forward, their corresponding aquiline noses, and their flat-topped heads. Moreover, both have horizontal grooves on their backs: figure *b*, below the infants; figure *c*, down the length of her head, above the child who occupies her entire back, allowing no room for grooves there. I would suggest that the figure with twins (*b*) was the first of the two to be fashioned and that the sculptor may not have previously attempted such a work. The figure with a single child (*c*) is much more boldly executed and is also the more detailed of the two. Their differences are probably due to the absence of a canonical type, which left the sculptor free to experiment with his chosen subject with markedly expressive results.

For a coincidentally close treatment of the theme and further discussion, see catalogue number 7.

The group was formerly in the collection of Charles Gillet and Marion Schuster.

P.G.-P.

BIBLIOGRAPHY

[*a–e* treated as a group]: J. Thimme, "A Late Neolithic Grave Group 'from Attica,'" appendix 1, *ACC*, p. 579, fig. 190, p. 580; *a*: *ACC*, no. 4, *ECS*, figs. 8, 13a, *NAC*, no. 2; *b*: *ACC*, no. 24; *c*: *ACC*, no. 25; *d*: *ACC*, no. 429; *e*: *ACC*, no. 283.

9. *Two joined standing female figures of marble*

Height, 46.6 cm.
Early Bronze Age, about 2800–2600 B.C.

The boldly conceived and precisely executed composition consists of two figures that are virtually identical, except that the larger one is twice the size of the smaller, and is shown pregnant. The treatment of such details as the fingers and toes is nearly the same in both images, although those of the larger figure are neater because the sculptor had more space in which to work. It is tempting to see in this sculpture a potent symbolic (parthenogenic ?) representation of life and regeneration: a mother with one child—a daughter—and a new baby on the way.

The nearly horizontal position of the mother's feet suggests that a standing posture was intended. Although the work is not self supporting, it could have been propped up against a wall, perhaps in a niche. Whether or not it served its doubtless female owner during her lifetime, it is likely that the sculpture was found in her grave, where it would in all probability have been in a prone position, serving as a fertility charm either for the rebirth of its owner or to assure her reproductive powers in the afterlife.

This is one of very few well-preserved examples of a rarely attempted but clearly established type within the Cycladic sculptor's repertory, and is probably the earliest of these surviving works. For additional related sculptures, for which Ios, Paros, Tenos, and the coast of Caria are among the reputed findspots, see *ACC*, no. 257; Goulandris, 1983, no. 167.

On the basis of its standing posture, naturalistic arms and hands, and the profiles of the legs, the sculpture has been identified as precanonical; in earlier publications it is dated to the period of transition from Early Cycladic I to Early Cycladic II, or to about 2800–2700 B.C. However, it also shows well-developed features of Early Spedos type A figures (see *NAC*, nos. 32, 33) of the Early Cycladic II phase—about 2600–2500 B.C.—especially in the contours of the front and rear, the shape of the head, and the absence of sculpturally indicated facial features other than the nose. This combination of elements from two stylistic approaches presumed to have been chronologically distinct remains difficult to explain. Perhaps the work should be viewed as "archaistic" and dated a century or more later than first supposed. Alternatively, one might speculate that in some places in the Cyclades the precanonical approach was succeeded not by the Kapsala variety (see cat. no. 10), usually considered the first full-fledged folded-arm type (about 2700–2600 B.C.), but by the Early Spedos, which thus dates the two-figure composition back to about 2700 B.C. (J. Thimme, in a review of *NAC*, in *Gnomon* 61, 1989, p. 338, agrees that the sculpture is the earliest of its type, but regards it as a work of the Early Spedos variety.) Only further systematic excavation of various undisturbed sites in the archipelago will clarify such points as this and allow for refinements to be made in the typology of Early Cycladic sculpture.

P.G.-P.

BIBLIOGRAPHY
ECS, pl. III; *Sculptors*, pl. 1 A; *NAC*, no. 18.

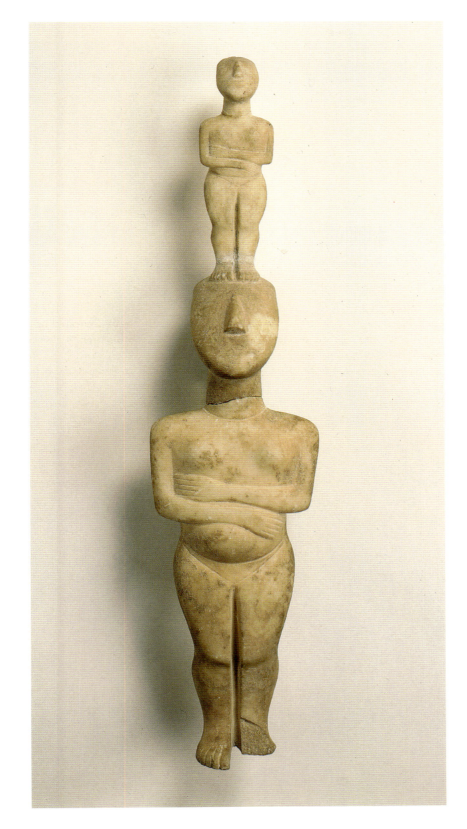

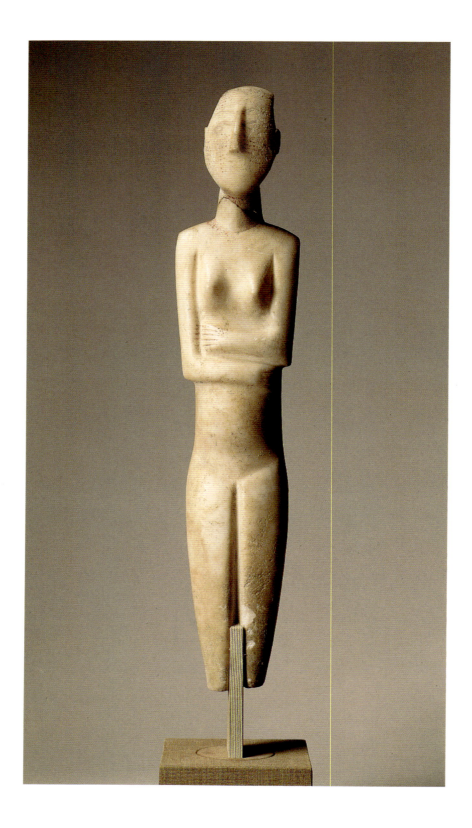

10. *Marble reclining female figure*

Length as preserved, 69.4 cm.
Early Bronze Age, about 2700–2600 B.C.
Possibly the work of the Kontoleon Master

This figure is at once a masterwork of marble carving and one of the most important Cycladic sculptures, because of the wealth of painted detail that survives—more than on any other known well-preserved work. The largest example by far of the Kapsala variety, this slender, attenuated image was at least eighty-five and perhaps as much as ninety centimeters long when complete. Clearly, it is a fully mature and—in terms of scale—an unusually ambitious work by an enormously talented, sensitive sculptor. (On the possibility that the figure represents the crowning achievement of the Kontoleon Master, see *Sculptors*, p. 86; *NAC*, p. 157.)

Much of the surface of the sculpture is in superb condition. Some areas even retain their original luster, allowing us to fully appreciate the tightly controlled, sinuous contours, boldly sensuous relief modeling, subtle changes of plane, and sharp definition of the grooved details.

The figure has its arms securely folded in the canonical right-below-left position. Bracelets and, perhaps uniquely, finger grooves are painted red. Below the abdomen, shown (not atypically) moderately swollen in pregnancy, the pubic area was painted blue, which was probably the rule on early folded-arm figures. However, the greatest concentration of painted detail was reserved for the head and the throat. Blue (now discolored to black) eyes and hair, the latter in the form of a band across the forehead and a solid mass on the reverse, and rows of red dots (partly weathered to purple) are common enough on such images, but the red fringes and the necklace are, so far, without parallel. Calcium carbonate deposits, especially on the right side of the head, obscure some of the painted detail. Moreover, the blue pigment used by Cycladic artists was much more fugitive than the red, causing blue-painted areas to be less easily readable. For example, the right almond-shaped eye appears to be dark except for the pupil, while the left eye seems to be indicated by a dark outline and to have a dark pupil. Here, I believe, it is easy to confuse areas of weathering with faint traces of color. Both eyes almost certainly were originally indicated with blue outlines surrounding dotted pupils, as were the eyes of the vast majority of folded-arm figures.

The painting of red patterns on the faces of Cycladic sculptures probably reflects a custom practiced by the Cycladians on themselves, at least as part of the preparations for burial but quite likely at other times as well. Such figures were no doubt placed in the graves of men and of women to provide protection and to secure the rebirth of the dead beyond the tomb. The Kapsala variety, which developed from the experimental precanonical figures (cat. no. 9), is considered the earliest in a series of stylistic variations on the theme of the reclining female figure, presumed to be the image of a life-giving, life-sustaining, life-taking, and life-renewing divinity. While the style of the images changed over time (see cat. no. 12), the iconography remained unaltered for half a millennium.

The figure was formerly in the collection of Charles Gillet and Marion Schuster.

P.G.-P.

BIBLIOGRAPHY
P. Getz-Preziosi and S. S. Weinberg, "Evidence for Painted Details in Early Cycladic Sculpture," in *Antike Kunst* 13, 1970, plates 2:2, 3; *ACC*, fig. 40; *ECS*, pl. VI a, b, figs. 41, 42; *Sculptors*, pl. VI A, fig. 29; *NAC*, no. 24, pl. I.

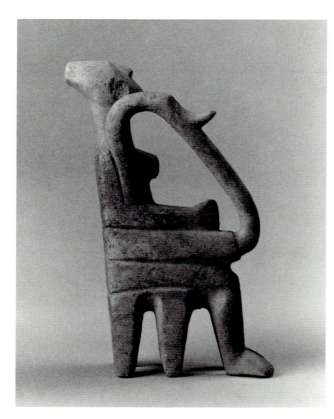

II *a*

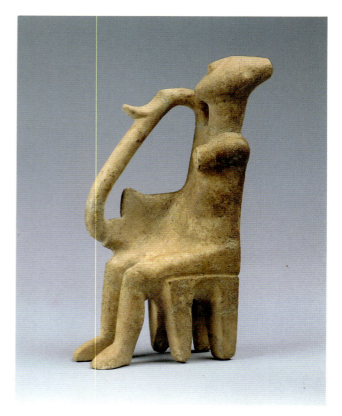

II *a*

11. *Marble group*

Early Bronze Age, about 2700–2600 B.C. (said to have
 been found on Amorgos)

a. Seated harpist
 Height, 19.8 cm.
b. Seated harpist
 Height, 17.2 cm.
c. Footed and spouted bowl on stool
 Height: overall, 7.4 cm., of vessel alone, 4.2 cm.

There can be little doubt that these three objects were
found together. They are similarly preserved and clearly
were carved by one person, who intended them to form a
unified group in the same modest scale. Although each is a
fine example of Cycladic marble carving, important for its
rarity, and, in the case of the stone still life, for its apparent
uniqueness, they are especially appealing and impressive as
a group.

There are at present ten indisputably genuine Early
Cycladic marble harpists. Of these, eight are well pre-
served. (One of the two very fragmentary examples is un-
published; an eleventh harpist, found on the coast of Caria a
century ago, is not traceable and no illustration of it sur-
vives.) While in all ten the instrument is carved on the
musician's right side, the figures display a variety of arm
and hand positions. The right arm of each of the Levy
harpists rests on top of the sound box, but there is an
important difference in the positioning of the left arm and
hand. The missing left hand of figure *a* apparently was
shown plucking the imaginary strings, while that of the
only slightly smaller figure (*b*) originally must have grasped
the front of the frame where a missing section, which broke
off together with the hand, has been restored in plaster. A
correct restoration would show the hand as well.

Of particular interest is the fact that when the top of the
instrument is preserved, as it is on eight of the ten works, it
bears an ornament in the form of a swan's head. Especially
well defined on these two examples, this motif was to
survive on stringed instruments in Greek and Etruscan art
until at least the early fifth century B.C.

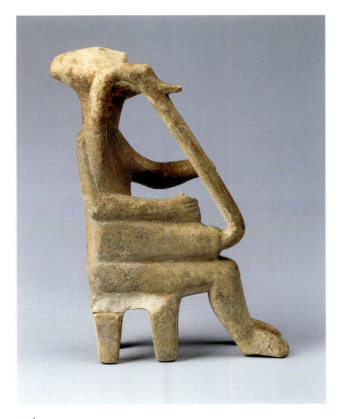

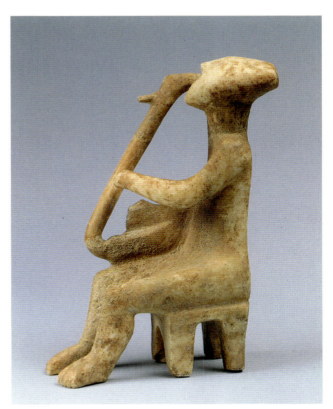

11 *b*

11 *b*

The musicians sit erect on their simple stools, their heads tossed back. We can imagine them transported by song, but the position of the head also may have been affected by the sculptor's extremely difficult task of freeing such small, delicate forms from a block of raw material (see *ECS*, fig. 47). Carved in the style of the Kapsala female folded-arm figures (about 2700–2600 B.C.; see cat. no. 10), the Levy harpists are among the earliest examples of a marble type dating from about 2800–2700 B.C. (the figure in the Metropolitan Museum, 47.100.1) to about 2600–2500 B.C. (examples in the National Archaeological Museum, Athens, and the J. Paul Getty Museum, Malibu, among others).

The larger figure (*a*) has a somewhat stiff and awkward appearance in comparison to figure *b*, suggesting that it was the first one carved. The smaller sculpture is much more accomplished. With head inclined toward his instrument, his left arm supple, and his right arm correctly differentiated from the harp—as are his thighs, from the well-proportioned stool—this harpist has a thoroughly relaxed

look about him that is virtually unmatched among the other harp players. The sculptor, in the absence of practice materials—like modeling clay, plaster, sketch pads—necessarily learned from the experience of his earlier carvings. Such complex, fragile works were only infrequently attempted by marble sculptors, who normally fashioned folded-arm figures and vessels, although, conceivably, sculptures of harpists were more commonly of wood. It is likely that the small still life was created last: The table or stool on which the vase sits most closely resembles the smaller harpist's stool, and of the three pieces of furniture it has, perhaps, the cleanest lines.

Only one Cycladic harpist has been found in a controlled excavation (in a grave on Naxos); another is reported to have been recovered from a grave on Keros, and a pair now in the Badisches Landesmuseum, Karlsruhe, is from a grave on Thera. Presumably such sculptures were made specifically for sepulchral use.

The miniature still life, with its typical if diminutive spouted bowl with lug, mounted on a broad-based pedestal,

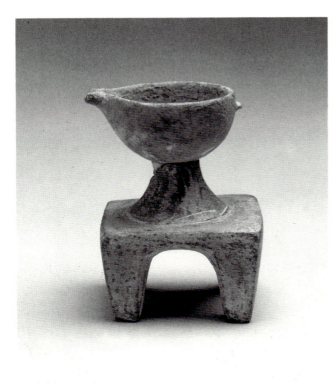

11 *c*

was made to serve the harpists either as a symbolic oil lamp—in which case the spout would have supported the wick (see cat. no. 14)—or as a container for symbolic refreshments (water or wine) such as one might find set before musicians on a small table at a festival or other celebration in Greece today.

On harp-player figures and their interpretation, see *NAC*, pp. 261–62, with references.

The group was formerly in the collection of Charles Gillet and Marion Schuster.

P. G.-P.

BIBLIOGRAPHY

[*a*–*c* treated as a group]: *ACC*, fig. 77, *Sculptors*, pl. VIII A, P. Getz-Preziosi, "Early Cycladic Marble Art," in *Archaeology* 40, September–October 1987, ill. p. 67; *a* and *b* as a pair: Safani, no. 1, *ECS*, fig. 23; *a* only: PGP, 1980, no. 12, pp. 15–19, figs. 25–28, 31, *ECS*, fig. 47 a, *Sculptors*, p. 66, plates 7–8[1], *NAC*, no. 90; *b* only: PGP, 1980, no. 11, pp. 15–19, figs. 21–24, 30, *ECS*, fig. 47 b, *Sculptors*, p. 66, plates 7–8[2], *NAC*, no. 89; *c* only: PGP, 1980, fig. 29, *NAC*, no. 145.

12. *Marble reclining female figure*

Length, 56.8 cm.
Early Bronze Age, about 2600–2500 B.C.
Attributed to the Copenhagen Master

With its unusually straight and narrow profile, flat front and rear surfaces, graceful contours, and attenuated thighs, this large figure epitomizes a particular, rather understated, approach to the female form taken by certain sculptors near the beginning of the Early Cycladic II period, probably on only one or two islands. (On the Early Spedos type B style, see *NAC*, p. 161.)

Instead of the usual bright white marble for which the Cyclades—especially Paros and Naxos—are famous, the sculptor chose a buff and light-gray banded stone for this figure similar to that used for an oval bowl also in the Levy collection (see cat. no. 13). The banding is visible along the profile of the sculpture.

The work can be attributed to an accomplished master named for a partially preserved figure in the Nationalmuseet, Copenhagen. Repeated features of this sculptor's style include a pear-shaped head with a high, flattened nose and a shallow chin, low breasts, and a horizontal incision between the raised upper thighs, defining the top of the pubis. (On the Copenhagen Master, see *Sculptors*, pp. 89–90.)

P. G.-P.

BIBLIOGRAPHY

P. Getz-Preziosi, "Risk and Repair in Early Cycladic Sculpture," in *MMJ* 16, 1981, figs. 54–55; P. Getz-Preziosi, "Five Sculptors in the Goulandris Collection," in J. L. Fitton, ed., *Cycladica: Studies in Memory of N. P. Goulandris* (Proceedings of the Seventh British Museum Classical Colloquium, June 1983), London, 1984, figs. 5–7 (a); Safani, no. 5 (photo in reverse); *ECS*, fig. 55; *Sculptors*, plates 24–25 [1]; *NAC*, no. 37.

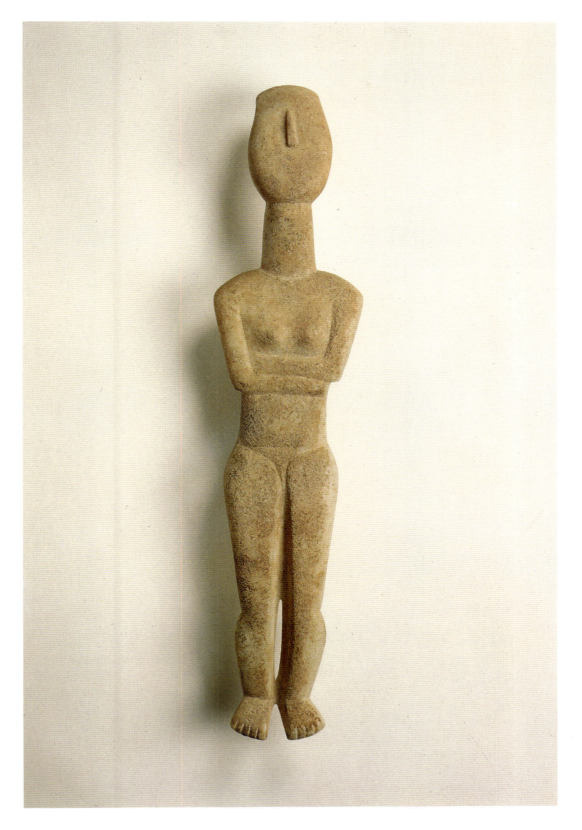

13. *Marble oval bowl*

Height, 6.2 cm.; maximum width, 17.7 cm.; length, 27 cm.

Early Bronze Age, about 2700–2500 B.C.

This large and unusual vessel combines elements of two common Early Cycladic II types: the deep hemispherical bowl (cat. no. 15), sometimes, as here, equipped with a single horizontal ledge-like lug for use as a finger rest, and the squat, rectangular palette with convex ends and a flat, raised rim or border. Whereas usual round bowls customarily have a circular indentation on the underside to provide a modicum of stability, this vessel has a sizable rectangular depression.

The bowl is carved in a buff and light-gray banded marble. This type of stone was used on occasion both for

vessels and for figurative sculpture (see cat. no. 12), perhaps exclusively in the first half or so of the Early Cycladic II period—about 2700–2500 B.C.—and probably in a limited number of places.

For similar vessels, see *ACC*, no. 330 (an example with one lug on each long side), and J. L. Fitton, *Cycladic Art*, London, British Museum, 1989, fig. 70, p. 55 (a much smaller vessel shown with two flat palettes, one with a raised border).

P.G.-P.

BIBLIOGRAPHY
Safani, no. 23; *NAC*, no. 130; P. Getz-Preziosi, *Early Cycladic Art in North American Collections*, Virginia Museum of Fine Arts, Richmond, 1987, p. 30, no. 130.

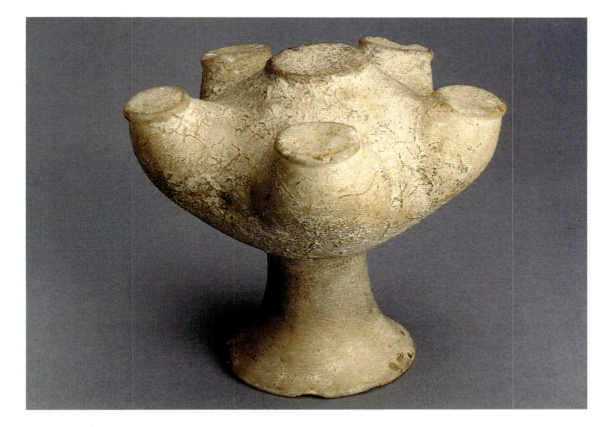

14. *Marble model of a lamp*

Height, 12.6 cm.
Early Bronze Age, about 2600–2400 B.C.

This solid, nonfunctional object is composed of five small "vessels" arranged at intervals around, and projecting from, a larger "vessel," the whole mounted on a tall, bell-shaped pedestal. All seven of its elements are slightly indented so as to provide them with rims. The object should be viewed as the model of a lamp, its nozzles (wick supports) grouped around a central well that served as a container for olive oil. However, if it were not for the existence of one other completely preserved lamp model whose nozzles do not resemble miniature "vessels," one might view this work as the model of a kernos, which is composed of multiple offering containers joined together.

The other marble lamp model comes from a richly furnished grave on Naxos that also held, among other objects, two Spedos variety figures carved between about 2600 and 2400 B.C. The lamp models should be similarly dated.

Models such as these, along with miniature objects (see cat. no. 11 c) and extremely fragile ones, must have had purely symbolic functions. In a sepulchral context especially, the idea of an object, conveyed by its basic shape or image, was what was important—not that it actually be serviceable in the realm of the living (see also cat. no. 15).

For a discussion of the form, and references, see *NAC*, no. 147.

The lamp was formerly in the collection of Henri Smeets.

P.G.-P.

BIBLIOGRAPHY
Ancient Art, London, Robin Symes, 1971, no. 8; J. H. Crouwel, "Early Cycladic Marble Figurines and Vessels in Holland," in *Bulletin Antieke Beschaving* 50, 1975, pp. 146–47, no. B 12, figs. 42–43; E. Godet et al., *A Private Collection: A Catalogue of the Henri Smeets Collection*, Weert, 1975, no. 122; *ACC*, no. 325; *The Smeets Collection of Antiquities, Cat. Sotheby's (London) 11 July 1977*, no. 98; Safani, no. 21; *NAC*, no. 147.

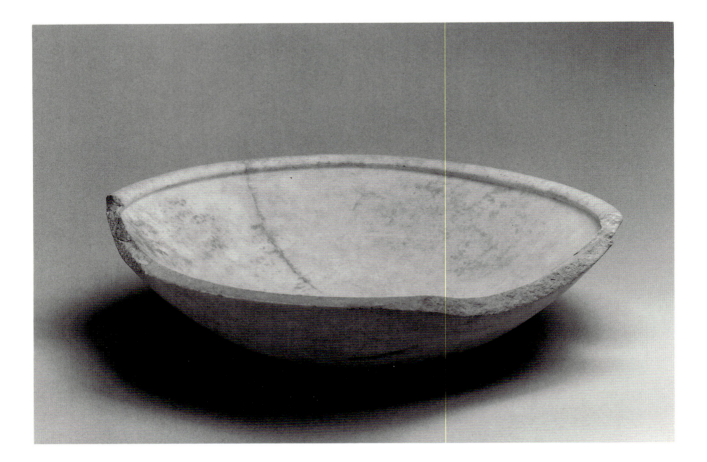

15. *Marble bowl*

Maximum height, 13.8 cm.; diameter, 47.5 cm.
Early Bronze Age, about 2700–2400 B.C.

This handsome bowl is an unusually large and relatively deep example of the type of object, figurative or receptive, most frequently made by marble sculptors in the Early Cycladic II period. Because of its size it should probably be dated in the first half of that stylistic phase.

Carefully crafted, with the natural banding in the white stone effectively used to enhance the simple circular form, the rim of the bowl is characteristically thickened on the inside. In contour, the vessel describes a continuous curve interrupted only by the circular indentation on the bottom, endowing the bowl with a measure of stability.

Traces of the pinkish-red pigment (most likely cinnabar) that was ground and/or mixed with oil or water in the vessel can still be seen. This pigment is quite commonly found on Cycladic marble bowls. It was evidently used to paint the face and perhaps the body of the dead in preparation for burial; additional pigment and painting utensils were placed in the grave for use in the afterlife. Some marble bowls appear to have deliberately painted interiors, perhaps to give the illusion of a container full of paint ready for use. The same blood-red color, symbolic of life, is also found on contemporaneous marble figures (cat. no. 10).

On Early Cycladic II bowls, see *NAC*, p. 299, nos. 122–127.

P.G.-P.

Ancient Near East
and Central Asia

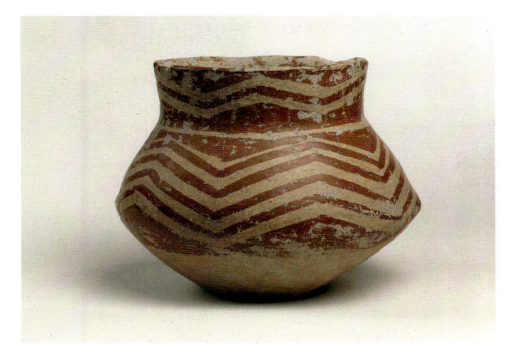

16. *Ceramic jar*

Height, 13.7 cm.; diameter, 17.2 cm.
South central Anatolia, Hacilar region, sixth
 millennium B.C.

This hand-built jar has a flat bottom, a biconical body, and a relatively tall neck with a smooth, plain rim. Although the base of the vessel and the neck are circular in section, the body has been slightly modified into an oval at its widest point by two small protrusions. This modification, however, does not affect the interior volume of the vessel. The reason for this subtle alteration is unclear, as the protrusions do not extend far enough to serve as handles, nor are they pierced for suspension. At best, they allow the vessel to fit more snugly in the hands. The coarse, pale ceramic fabric of the vessel is decorated on the upper half of the body with a wide band of dark red, slightly lustrous paint (in fact, a burnished slip) featuring four continuous chevrons against a reserve ground. The neck is ornamented with a single painted zigzag line, while the rim and the interior edge are painted red.

Vessels of identical form, with the same burnished red and cream-colored decoration, have been excavated at Hacilar in (modern) southwest Turkey, where the strata in which they occur, Levels I to II, have been dated to the sixth millennium B.C. (J. Mellaart, *Excavations at Hacilar*, 2 vols., Edinburgh, 1970: vol. 1, pp. 62, 66, 72; vol. 2, pp. 125, 133, 137, 367, 413, 416–21). A painted jar from Level II.5 (58/180) (J. Mellaart, op. cit., vol. 2, pp. CVI:2, 413) is extremely close to the Levy jar, and a wider, shallower version, with the same decorative pattern, is in the collection of the Lands of the Bible Archaeology Foundation, Tel Aviv (O. W. Muscarella, ed., *Ladders to Heaven*, Toronto, 1981, p. 154, no. 115).

The Hacilar pots are among the earliest ceramics produced as fine art rather than as merely utilitarian objects. They represent the culmination of a long process that resulted in glossy vessels painted with a variety of forms, including large-scale anthropomorphic examples. The style of the painted ornament is uniformly angular and geometric, at times suggesting basketry patterns. The figural pots have strongly striped bodies and, sometimes, inlaid obsidian eyes.

The emergence of pottery as an art coincides with the rise of cities and the domestication of plants and animals. These developments are characteristic of the Neolithic revolution, a major cultural shift that changed the entire Near East. Thus, the colorful Hacilar pots mark a major stage in the history of ancient art.

T.S.K.

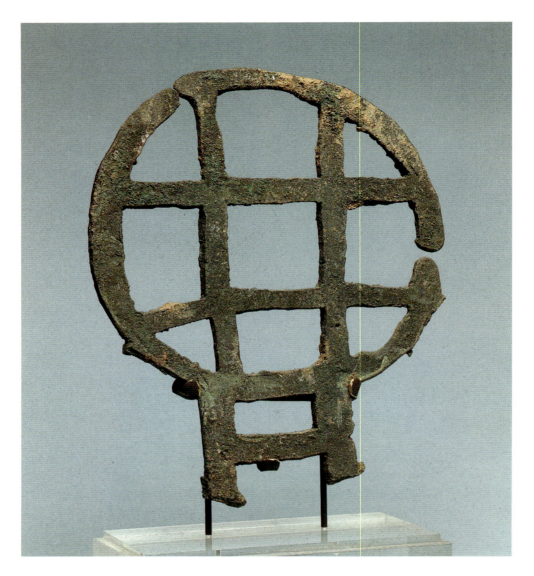

17. *Copper or bronze circular standard*
Height, 13 cm.
Central Anatolia, late third millennium B.C.

This curious device appears to be a simpler, perhaps provincial version of the elaborate sun-disk standards excavated at Alaca Hüyük in central Anatolia. Found in richly furnished tombs from the twenty-second to the twentieth century B.C., these copper or bronze standards feature elaborate interlaces within a circular configuration, and sometimes also include small bulls, felines, and floral forms (E. Akurgal, *The Art of the Hittites*, New York, 1962, pp. 20–25, plates 7–9, 11). The works are some of the most intriguing to date from third-millennium-B.C. Anatolia, when it was a wealthy metal-working culture and links to Mesopotamia and Syria first arose. Because no writing has survived from this period, we do not know the ethnic identity of the people or their religious beliefs. It is often assumed that these standards refer in some way to the cult of the sun goddess who was worshiped at Alaca Hüyük in the second millennium B.C., as other aspects of religious ritual and iconography suggest a continuity between the two eras.

T.S.K.

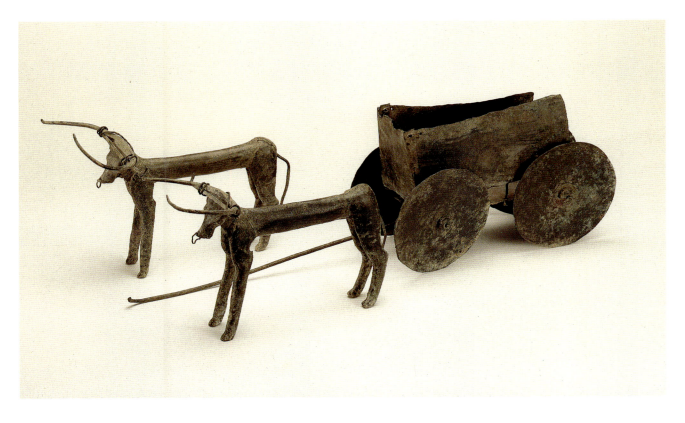

18. *Bronze wagon model with oxen*

Height of wagon as assembled, 18.1 cm.; width of axle,
 12.7 cm.; length of ox, 12.5 cm.
Anatolia or northern Syria, early second millennium B.C.

The model features an internal frame of cut strips, the
vertical elements of which project through the wagon bed
and the upper edge of the frame to hold the parts together.
The ends of these vertical elements curve around at either
end to secure the frame. The front of the wagon frame is
taller than the sides and has a double curved outline that
mimics actual ancient construction (M. A. Littauer and
J. H. Crouwel, *Wheeled Vehicles and Ridden Animals in the
Ancient Near East*, Leiden, 1979, pp. 14, 15, 37, 38, 48,
49). A vertical bar near each corner also curves around the
axle, which is situated beneath the wagon bed. The front
and side walls of the wagon are wired to the frame. It is not
clear if the pair of leggy, rather angular oxen that are hitched
to the wagon at present were associated with it in antiquity.
They themselves are ancient, but the wire with which they
are attached to the yoke does not appear to be. Nonetheless,
on the basis of other known examples, these oxen certainly

are very close to the team that was with the wagon
originally.

The wagon and its team are part of a body of related
models that came to light through unsupervised digging
and are thought to have originated in Anatolia or northern
Syria (M. A. Littauer and J. H. Crouwel, "Early Metal
Models of Wagons from the Levant," *Levant* V, 1973, pp.
102–6, plates XXXII–XLIV; W. Nagel, "Zwei Kupfer-
modelle eines Kultwagens . . . ," in *Acta Prähistorica et
Archaeologica* 16/17, 1984/85, pp. 143–51). Specific details
of wagon construction, as well as the separately added wire
tails of the bovines, find numerous parallels in the works
studied by Littauer and Crouwel.

Because the wagon models lack an archaeological con-
text, the exact date, origin, and function of these objects are
uncertain. General stylistic parallels together with certain
details of wagon construction place them in the early second
millennium B.C. At present, we have no idea if they come
from funerary, domestic, or perhaps religious settings.

T. S. K.

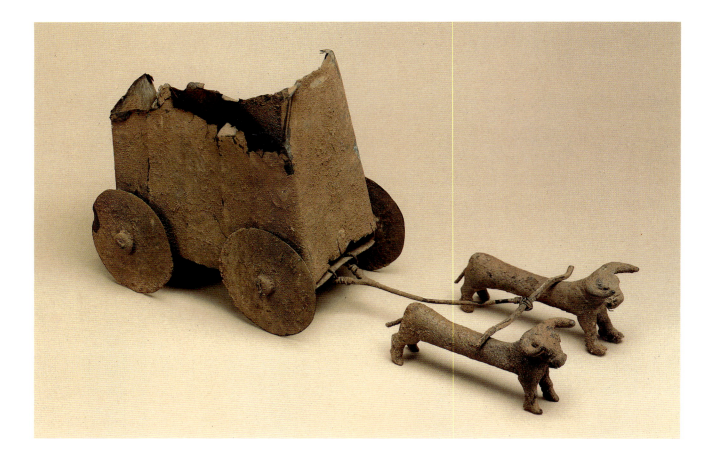

19. *Bronze wagon model with oxen*

Height of wagon as assembled, 17.7 cm.; length
 of wagon as assembled, 20 cm.
Anatolia or northern Syria, early second
 millennium B.C. (?)

In contrast to the other wagon model in the Levy collection
(cat. no. 18), this one features a number of unusual elements
that find few parallels in the related published models.
Unlike nearly all of those, this wagon does not have an
internal frame to which the various pieces of sheet metal are
attached. Instead, the wagon box has a flat sheet-metal bed
with turned-up sides. The walls of the wagon are formed
from a single sheet of metal, bent into a rectangle, with the
ends overlapping at the back. The walls are held to the
wagon bed by the axles situated above the bed and extend-
ing through its walls and upturned edges.

This method of construction is highly atypical. The only
parallel to this wagon—a model in the collection of the
Lands of the Bible Archaeology Foundation, Tel Aviv
(O. W. Muscarella, ed., *Ladders to Heaven*, Toronto, 1981,
p. 159, no. 125)—is apparently a pastiche. The wheels of
the Levy model, along with the yoke pole and the little
oxen, give every appearance of having been produced in
antiquity. Although examination of the Levy model by
Deborah Schorsch of the Department of Objects Conserva-
tion at the Metropolitan Museum suggests that the metal of
the body of the wagon is also ancient, it is difficult to
reconcile the model's construction with that of the other
known examples. Perhaps parts of the wagon model and
other ancient metal pieces were combined in recent times to
create this completed model.

T.S.K.

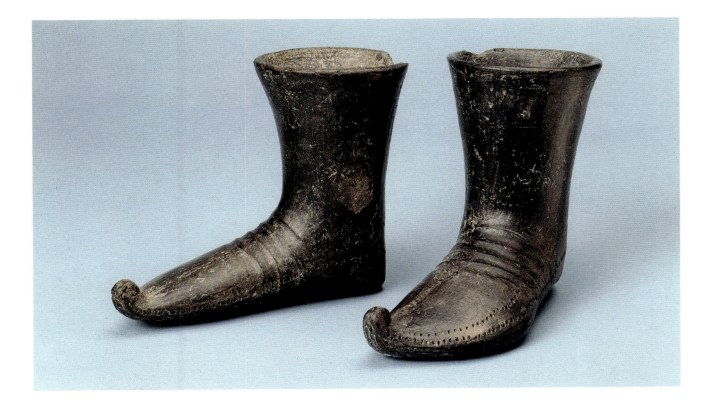

20. *Pair of ceramic boot-shaped rhyta*

Height: left boot, 10.5 cm., right boot, 10.7 cm.;
 length: left boot, 12 cm., right boot, 12.1 cm.
Northwestern Iran or northeastern Anatolia, Urartian
 culture, ninth–eighth century B.C.

The dark gray boots are of a moderately coarse ceramic fabric with a sandy temper and a well-burnished surface. A line of small dots, punched into the once-malleable clay with a square pin, extends around the side of the foot part of each boot, indicating the seam between the sole and the upper portion. A second dotted line continues along the outside of the foot part, from the upturned toe to the ridged band over the instep. A third line of dots bisects the top of the foot part, extending from the toe to the ridged band, where it ends in a small dotted circle.

These distinctive drinking boots, the distant ancestor of the modern German glass boot, originated in the early second millennium B.C. in Anatolia, where similar vessels with turned-up toes and painted decoration were produced

(for instance, The Metropolitan Museum of Art, 67.182.2). Approximately one thousand years later, the unusual form found favor with the Urartians, the inhabitants of northwestern Iran and, earlier, of Turkey, who were rivals of the Assyrians. Excavated examples from Hasanlu in Iran (R. H. Dyson, "Hasanlu and the Solduz and Ushnic Valleys: Twelve Years of Exploration," in *Archaeologia Viva* 1, 1968, p. 94, pl. 111) and Karmir Blur in Turkey (M. van Loon, *Urartian Art*, Istanbul, 1966, p. 36) vary widely in size, shape, and style. The naturalistic modeling of the Levy boots distinguishes them from the more formalized shape and wide, flaring rim of the black Karmir Blur boot, whose "seams" are delineated with lines of tiny punched triangles (G. Azarpay, "Two Urartian Boot-shaped Vessels," in *Artibus Asiae* 27, 1965, fig. 2 opp. p. 64). The careful detailing of straps and seams, and the lustrous dark burnished surface are characteristic of Urartian ceramics, as is the witty treatment of the shapes.

T.S.K.

21. *Limestone statuette of a standing worshiper*

Height, 16.4 cm.
Mesopotamia or Syria, about 2400 B.C.

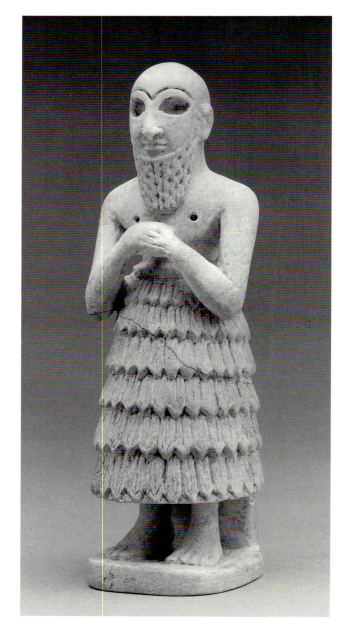

The bearded male stands with hands clasped in front of his chest, his lower body and legs covered with a thick, tufted skirt. Large eyes and arching eyebrows, both once inlaid, dominate the smooth bald head, distracting attention from the delicately modeled nose and small mouth. The lower half of the face is framed by a long beard of carefully carved, rippling ringlets. In contrast to the hieratic quality of the face, the sides and the back of the head are naturalistically modeled; the ears, the curves of the cranium, and even the fleshy folds at the base of the skull are shown. The body is schematically rendered, with angular shoulders and elbows and a triangular torso having sharply angled sides. The cone-like form of the tufted skirt, with its ridge-like layers, completely obscures the lower portion of the figure. Only his thick ankles and broad feet protrude at the base.

Limestone statues such as this are a major category of Mesopotamian art of the mid-third millennium B.C. (the Early Dynastic period). These sculptures, dedicated in temples, were surrogates for the donors, often bearing their names along with a prayer or exhortation to the statue to pray for them.

The Levy statuette compares favorably with a group of elegant statues from the site of Mari, a major Early Dynastic city on the northwestern borders of Mesopotamia (E. Strommenger, *Five Thousand Years of the Art of Mesopotamia*, New York, 1964, plates 88–89, 96–99; A. Moortgat, *The Art of Ancient Mesopotamia*, London and New York, 1969, plates 64, 66, 78, 79). The Mari statues, although somewhat larger, show the same naturalistic modeling; inlaid eyes, eyebrows, and nipples; bald head; clean-shaven upper lip; and delicate rendering of the beard in long, undulating ringlets with lightly curled ends. It is possible that the Levy statuette came from the region around Mari or from a major Mesopotamian city.

T.S.K.

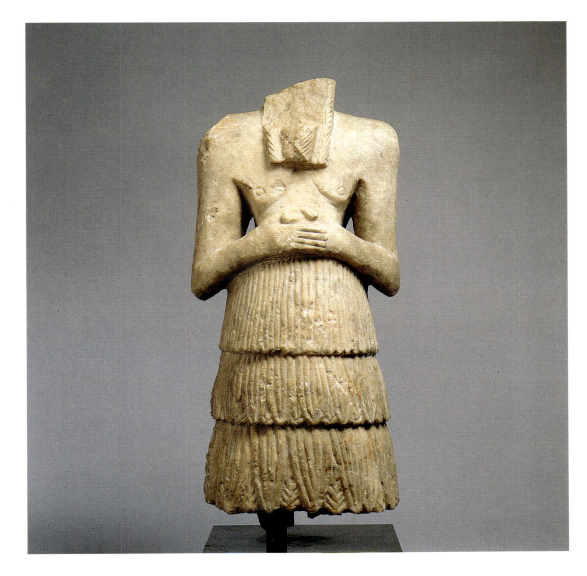

22. *Limestone statuette of a standing worshiper*

Height, 75.7 cm.
Northern Mesopotamia or Syria, about 2400 B.C.

The fragmentary figure stands in the traditional Mesopotamian posture of worship, with his hands clasped in front at waist level. As is customary with male worshipers, he wears only a heavy tufted skirt. The end of a thick beard with a square tip is framed by two long, straight locks of hair that remain in front; bluntly cut long hair falls down the figure's back. The heavy skirt has only three tiers: The topmost layer is patterned with straight vertical lines, while the other two layers have the more common tufted patterns.

The angularity of the anatomy and the crudeness of the modeling argue for a provincial workshop rather than one in a major urban center. The style of the work finds its closest parallels in statues excavated at Tell Chuera, a Syrian site under Mesopotamian influence (A. Moortgat, *The Art of Ancient Mesopotamia*, London and New York, 1969, p. 36, plates 72–75).

T.S.K.

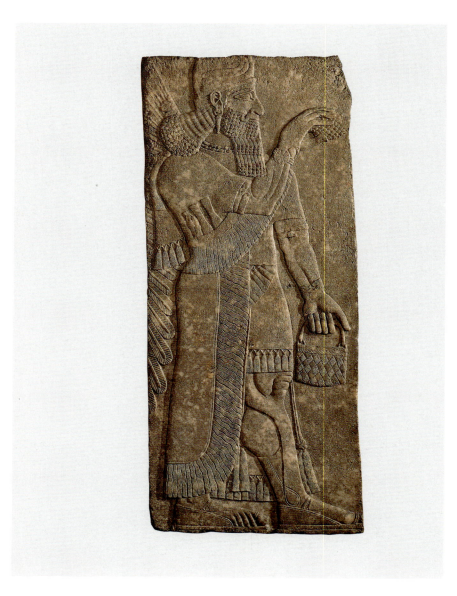

23. *Pair of gypseous alabaster wall reliefs*

Height: 155 cm., and 162 cm.; width of each, 65 cm.;
 original depth unknown (the slabs were probably cut
 down at the back)
Mesopotamia, Assyrian, from Nimrud (?), ninth
 century B.C.

A winged human-headed figure is depicted on each relief.
The figures face in opposite directions and may be charac-
terized as divinities by the three pairs of horns on their caps.
Each holds a cone-shaped object in his right raised hand and
a bucket in the left hand, suggesting that the two are
probably performing some purifying ritual or apotropaic
magic. The function of these divine figures was to keep
watch over the king and his court, and they represent a kind
of spiritual power in the protection against evil demons.

Both of these reliefs originally formed a single slab, with
a sacred tree shown between them. A similar arrangement
of figures is found on a slab in the Metropolitan Museum
(32.143.3; V. E. Crawford, P. O. Harper, and H. Pittman,
Assyrian Reliefs and Ivories, New York, 1980, p. 23, fig. 15).

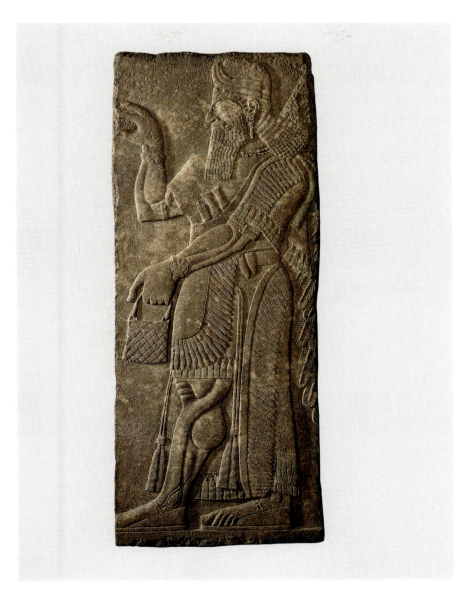

Lesser divinities or genii of this type appear several hundred times in the flat reliefs decorating the walls of many of the rooms in the Northwest Palace at Nimrud, the capital city of the Assyrian Empire during the reign of its founder, Ashurnasirpal II (883–859 B.C.). However, it is customary for the imagery on all of these slabs to be partly obscured by the so-called standard inscription: A band of horizontal lines of cuneiform signs, incised in the stone, mostly covers the garments and other parts of the figures. There are only some exceptions to this scheme, and these originated in an unidentified building at Nimrud (J. Meuszyński, *Archäologischer Anzeiger*, 1976, p. 479). As the two slabs in the Levy collection do not show any traces of an inscription, they, too, are an exception.

These reliefs are cut down on all sides, so that the edges of the wings of the divinities are partly missing.

The alabaster reliefs were formerly in the collection of Raymond Pitcairn.

E.B.

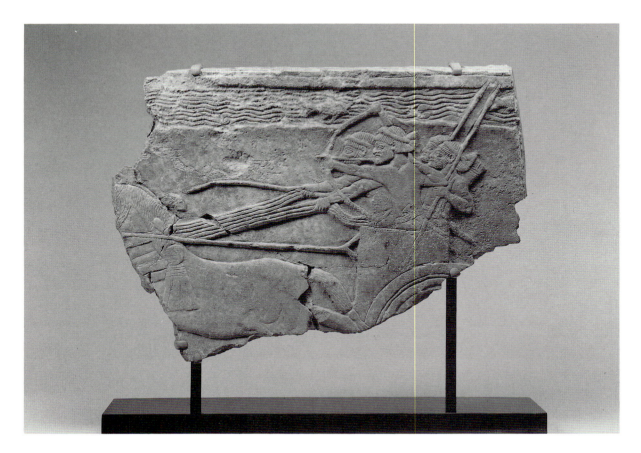

24. *Fragment of an alabaster wall relief*

Height, 31.2 cm.; width, 42.6 cm. (cut down at the
 back)
Assyrian, from Nineveh (reign of Ashurbanipal),
 668–627 B.C.

The slab, part of the lower register of a relief depicting one
of Ashurbanipal's campaigns against Elam, shows a horse-
drawn chariot with a team of four Elamites, who may be
identified by their headbands knotted at the back. The
charioteer grasps the reins in both hands as well as a kind of
whip in his right hand, with which he is urging the horses
to speed up. To the charioteer's left, an archer is discharging
an arrow. Behind these two figures, two Elamite soldiers
with quivers on their backs are holding their lances upright.
Above this scene a narrow watercourse with fish is shown.
Only traces of the upper register remain, on which one can
recognize parts of the feet of soldiers or deportees.

Just a portion of the left horse and the upper front part of a
wheel of this two-wheeled chariot are still discernible. Yet,
as the charioteer holds three reins in each hand, the chariot
should have two teams (T. A. Madhloom, *The Chronology of
Neo-Assyrian Art*, London, 1970, p. 22, pl. X.4).

Very similar scenes with Elamite soldiers are represented
in the reliefs in Room H of Ashurbanipal's North Palace at
Nineveh (R. D. Barnett, *Sculptures from the North Palace of
Ashurbanipal at Nineveh: 668–627 B.C.*, London, 1976, pl.
XXIII). However, the chariots in these series of reliefs do not
have cars and seem to be drawn by a single mule, moving in
the opposite direction. As only four of the twelve reliefs
numbered on the excavator's plan remained in Room H of
the North Palace, we may assume that the Levy fragment
was part of a slab at the opposite side of this room, where it
was probably discovered among the debris.

E.B.

BIBLIOGRAPHY
Cat. Sotheby's (London) 14 July 1986, no. 119.

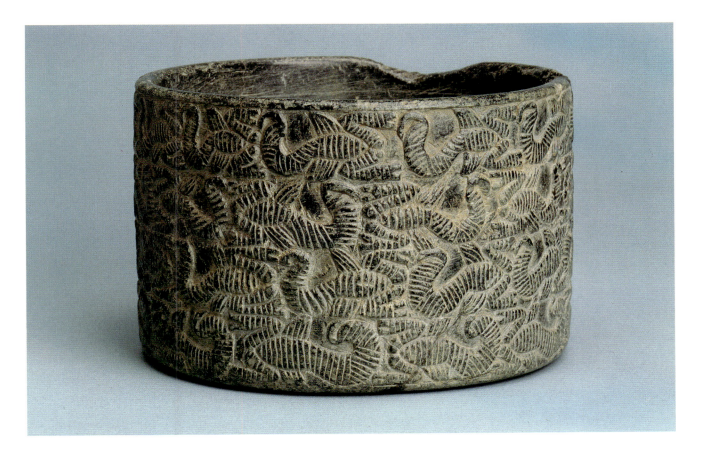

25. *Chlorite cylindrical container*

Height, 8 cm.; diameter, 11.5 cm.
Southern or eastern Iran, early third millennium B.C.

This cylindrical vessel, with its plain rim and flat bottom, is covered with what at first seems to be a random mass of simply rendered scorpions, their bodies patterned with roughly incised hatchings. On closer examination, one sees that the scorpions are organized in four superimposed rows. Those in the top row face right; in the next row, left; in the row beneath that, right; and in the bottom row, again left. These rows are separated by faintly incised lines, and a similar line forms a narrow boundary at the base and the rim of the container.

Chlorite vessels of cylindrical and other shapes have frequently been recovered at early and mid-third millennium B.C. sites in Mesopotamia, Iran, and along the southern shore of the Persian Gulf. A double cylindrical vessel of the same proportions was excavated at Susa in Iran (P. Amiet, *Elam*, Auvers-sur-Oise, 1960, p. 199), but it does not bear the scorpion pattern. Scorpions do appear on vases from southern Iran and particularly from southern Mesopotamia, where they were first excavated. Once thought to be Sumerian artifacts, the chlorite vessels are now considered Iranian products, and unfinished pieces have been excavated at production sites at Tepe Yahya in southern Iran (P. Kohl, "Carved Chlorite Vessels: A Trade in Finished Commodities in the Mid-Third Millennium," in *Expedition* 18, 1, Fall 1975, pp. 18–31). As few scorpions are represented on the carved chlorite objects from Tepe Yahya, it is likely that the Levy vessel was produced elsewhere in Iran.

The choice of the poisonous scorpion as a decorative motif may reflect a respect for the power of the small creature to inflict pain. Scorpion motifs also appear on ceramics and particularly on seals from the Persian Gulf region.

T.S.K.

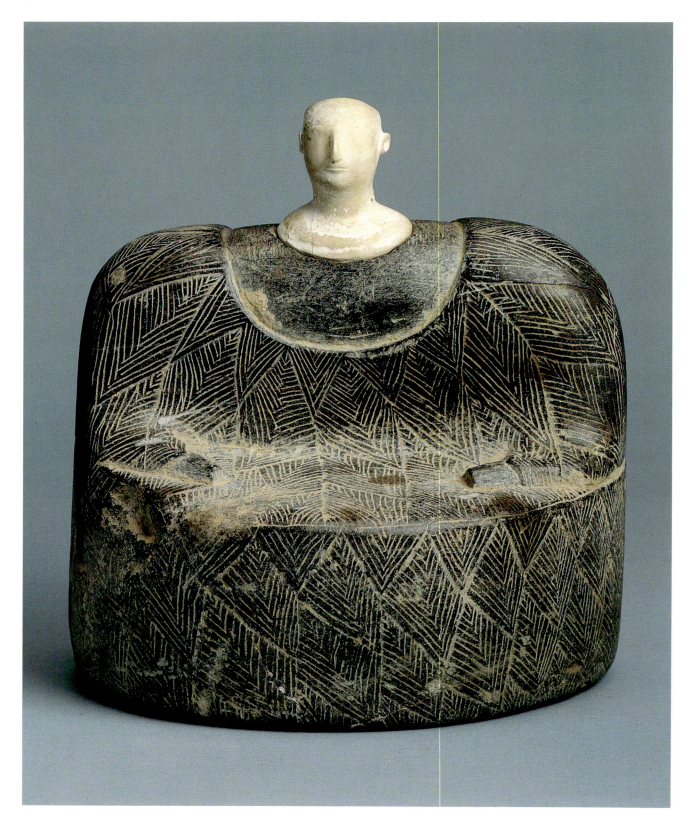

26. *Stone statuette of a seated female figure*

Height, 13 cm.; width, 11.5 cm.
Bactria (modern northern Afghanistan), late third
 millennium B.C.

The dark gray stone statue depicts a seated female clad in a voluminous fleecy or tufted garment. The heavy robe, actually a mantle, has a V-shaped neckline in back and wraps around the front of the figure twice, once below the neck and again at knee level. The forms of the figure have been simplified to the point that, from the front, the body appears to be a solid rectangle with a projecting semicircular step forming its lap. The figure does not sit upright, however, but leans forward at a twenty-degree angle from the vertical. The lap also tips forward, providing a curiously unstable profile view. The tiny hands that emerge from the "fleece" on either side of the lap are merely small tapered rectangles with no indication of fingers or joints. The small white stone head set into the rounded shoulders contrasts with the dark, garment-clad body. The smooth rounded forms of the head and neck and the delicately modeled features of the face further emphasize the differences between the head and body.

The curious red stains on the back of the figure were analyzed by the Department of Objects Conservation at the Metropolitan Museum. The absence of both iron oxide and bromine rules out the possibility that either earth pigment or Tyrian purple—two major sources of red coloring in antiquity—produced the stains. The presence of potassium and aluminum suggests, rather, that the color was a lake pigment—that is, a pigment derived from dyes. It is probable that this stain came from the textiles with which the piece was buried.

Such enigmatic statuettes, apparently tomb gifts, are known from uncontrolled digs in northern Afghanistan (V. Sarianidi, *Die Kunst des Alten Afghanistan*, Leipzig, 1986, pp. 146–50, plates 37–41; P. Amiet, *L'Âge des échanges inter-iraniens . . .* , Paris, 1986, pp. 199, 296, 330–31). All published parallels depict schematic, seated figures of dark stone with small, inset white stone heads. Some examples have turbans of dark stone.

Seated figures rendered as compact or cube-like forms appear in the arts of northern Afghanistan and northeastern Iran, both in metalwork and seal impressions (A. Hakemi, *Catalogue de l'exposition: Lut. Xabis (Shahdad)*, Tehran, 1972, nos. 300, 323, 324, plates XXVI and opp. p. 16 [Persian section]; P. Amiet, op. cit., pp. 288–91, 328–29). The most naturalistic representation, however, occurs on an inscribed Elamite silver beaker from south central Iran, now in the Iran Bastan Museum, Tehran, where the seated female is identified as a priestess of the goddess Narunde (P. Amiet, op. cit., pp. 187, 197, 288). Our scant knowledge of the relationship between Bactria and Iran in the late third millennium B.C. cannot yet determine in which area these distinctive figures had their ultimate source.

T.S.K.

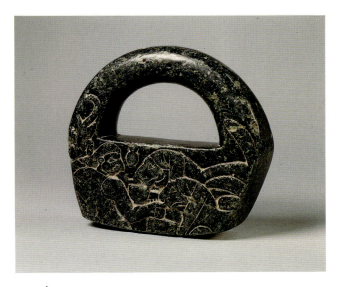

27: obverse

27. *Steatite or chlorite handled weight (?)*

Height, 17.8 cm.; length, 19.2 cm.; thickness, 3.8 cm.
Highland Iran or northern Afghanistan, late third–early
 second millennium B.C.

This is the smaller of two related objects in the Levy collection shaped as rectangular slabs with semicircular handles (see cat. no. 28); both are cut from steatite or chlorite. While their function is entirely unknown, they may have served as weights.

Although the surface of the weight is extensively worn and there are obvious signs that it was cut down and smoothed on one side and on the bottom, it is still possible to discern the subject of the imagery carved in low relief on both sides. On the obverse is a clean-shaven male figure with long hair who was probably shown in a squatting posture.

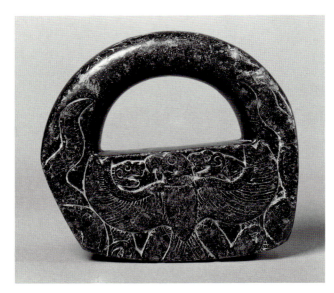

27: reverse

He extends his right hand, fist clenched, toward one of a pair of animals—probably felines but possibly dogs—who face him with their thick tails raised. Between the animals and the figure are a footed vessel and a bowl; beneath his fist is a square form that is cut off at the bottom; behind him and extending up on the handle is a scorpion.

On the reverse is a heraldically placed bird of prey with its wings spread. Its beaked head is shown in profile, and its splayed talons grasp lion-headed snakes whose writhing bodies cover the sides of the object and extend onto the body of the handle.

There are two objects of this type with secure provenances; one is from Nippur, in southern Mesopotamia, and the other is from Soch, in Soviet Uzbekistan. Other examples, perhaps prototypes for these works, are known in alabaster, and are from sites in highland Iran (P. de Miroschedji, "Un Objet culturel d'origine iranienne provenant de Nippur," in *Iran* 10, 1972, pp. 159–61).

The imagery of the Levy handled weight and of the excavated parallels suggests that this object dates within the second half of the third millennium B.C. (P. L. Kohl, "Carved Chlorite Vessels: A Trade in Finished Commodities in the Mid-Third Millennium," in *Expedition* 18:1, 1975, pp. 18–31). What its relationship is to the so-called Intercultural Style and whether it was made in highland Iran or to the north, in ancient Bactria, is impossible to know with certainty.

H. P.

EXHIBITIONS
The Metropolitan Museum of Art, New York, from 1987.

28. *Steatite or chlorite handled weight (?)*
Height, 22 cm.; length, 24.5 cm.; width, 3.5 cm.
Highland Iran or northern Afghanistan (?), late third or early second millennium B.C. (?)

This second handled object in the collection is larger and its relief decoration different from any other known of this type. Both sides contain confronted felines whose frontal heads are sculpted in full relief. The felines on the arbitrarily designated obverse can be identified by their spots as leopards; each paws a mountain goat shown upside down between them. Above the mountain goat is a small animal, with raised and pointed ears and a long tail, that resembles a wolf. On the back of each leopard is a bird of prey, shown as if seen from below. The composition on the reverse has a parallel theme: This time the felines are lions with full manes; at the shoulders are hair whorls. Between the lions—and being attacked by them—is the head and neck of a bull represented upside down. A single leg of the bovine emerges from behind each of the feline's backs.

Although there are many details in the rendering of the animals that relate it closely to the relief decoration on similar objects, the posture of the animals and the frontally depicted heads of the felines are unique.

H. P.

EXHIBITIONS
The Metropolitan Museum of Art, New York, from August 1987.

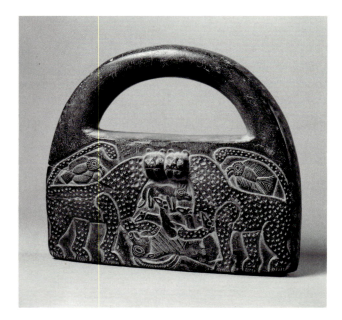

incision (among them are those in P. Amiet, *L'Âge des échanges inter-iraniens . . .* , Paris, 1986, figs. 201, 202). Distributed over the full height of the vessel in from one to three registers are two kneeling archers pointing drawn arrows toward a herd of four ibex who, in turn, are being chased by six dogs. This scene of the hunt is followed by a larger, standing, bearded male figure who carries a barbed prod or whip in his right hand. Behind him is a small naked figure with a single stick and a bunch of barbed prods who, most certainly, supplies the larger figure with his weapons.

The large hunter and both bowmen wear garments patterned with opposed semicircles and boots with turned-over tops. The large figure has a barrette in his hair that is very probably a biconical agate with gold tips. Around his neck are two amulets that may also be of a similar type.

Unfortunately, neither this vessel nor those like it have any controlled provenance, so their place of manufacture, function, and date have to be determined solely by stylistic and iconographic comparison with other objects that also

29. *Bronze nude ithyphallic male figure mounted on horseback*

Height, 14 cm.
Bronze Age, highland Iran or northern Afghanistan,
 third–second millennium B.C. (?)

This small but striking bronze sculpture of a nude, belted male figure mounted on the back of an equid—probably a horse—is unparalleled. It can be assigned to the Bronze Age in Central Asia both on the basis of its type and the treatment of the body of the figure.

H. P.

EXHIBITIONS
The Metropolitan Museum of Art, New York, from November 1985.

30. *Silver cylindrical cup*

Height, 10.1 cm.
Highland Iran or northern Afghanistan, first half of the
 second millennium B.C.

This is one of a small number of silver cylindrical cups on which elaborate figural imagery is rendered in low relief and

float without provenances. Thus, the assignment of this cup and others like it to the first half of the second millennium in ancient Bactria or northeastern Iran can only be offered tentatively through indirect links to such controlled material as the Fullol hoard (see M. Tosi and R. Wardak, "The Fullol Hoard: A New Find from Bronze-Age Afghanistan," in *East and West* 22, 1972, pp. 9–17).

The specific symbolic significance of the hunt scene is uncertain. Another vessel shows the results of the hunt, with successful hunters, accompanied by a pack of dogs, carrying their quarry over their shoulders (P. Amiet, op. cit., fig. 201). Of the other vessels of this type that are known, the most elaborate bears a multiregister scene of seated and squatting figures receiving tribute (P. Amiet, op. cit., fig. 202). The details of the garments, hair, and animal bodies strongly indicate that the Levy vessel was engraved in the same workshop, if not by the same hand. Although further evidence is necessary, it is possible that these silver objects represent the beginning of a northeastern tradition of display vessels in precious metals on which are rendered ritual and mythological or cosmological scenes. At the other end of the tradition may be such vessels as the famous gold bowl from Hasanlu and the fine gold cups from Marlik.

H. P.

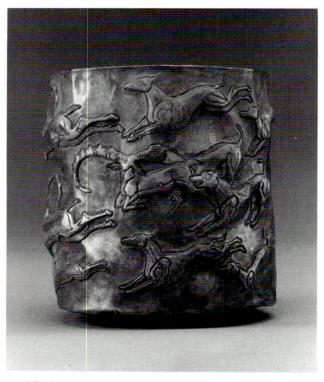

30: The hunt

Figure 1: Roll-out drawing by Elizabeth Simpson of catalogue number 30

31. *Ceramic footed cup*

Height, 10.9 cm.; diameter, 12.8 cm.
Northern Iran, Sialk region, fourth millennium B.C.

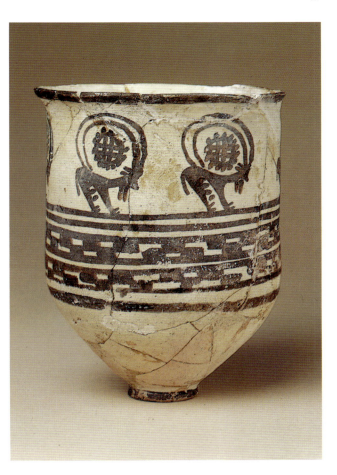

This thin-walled, wheel-thrown conical cup has straight flaring sides and a tapering foot similar in proportion to the body. Of fine, buff clay, it is painted with a dark brown slip. The upper half of the cup, marked off by a triple line, is divided into three segments by wide vertical bands of chevrons. Between each chevron band is a double "comb" motif—a curious form featuring a long, solid horizontal band with a fringe of "teeth," "legs," or perhaps even "oars" along one edge. Cups of the same shape have been excavated from tombs in northern Iran at Tépé Hissar, Level I (E. F. Schmidt, *Excavations at Tépé Hissar Damghan*, Philadelphia, 1937, pp. 41, 51, plates IX, XI), and at Tépé Sialk, Period 3 (R. Ghirshman, *Fouilles de Sialk*, Paris, 1938, vol. 1, pl. LXIII, p. and pl. LXIV). The Levy cup probably comes from the immediate vicinity of Sialk, where a virtual duplicate was found (excavation no. S.257; R. Ghirshman, op. cit., pl. LXIII) that even has the same petal-like triangles painted on the foot.

The curious "comb" motif appears widely on the pottery from Sialk: As many as six "combs" may be painted, one above the other, on the sides of vessels (R. Ghirshman, op. cit., frontispiece and plates XV, LXIII–LXIV, LXXVII). On one carefully painted example, the fringe is shown only on the upper part of the motif, but on later examples from Sialk the "comb" element degenerates into short bands of diagonal lines.

T.S.K.

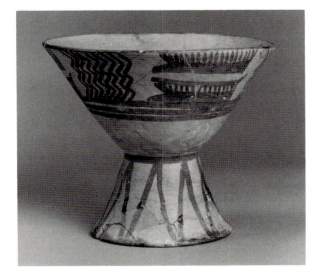

32. *Ceramic painted beaker*

Height, 14 cm.; diameter, 10.2 cm.
North central Iran, Tepe Sialk region, fourth
 millennium B.C.

The body of this thin-walled beaker rises from a small disk-like base and swells toward a plain, slightly everted rim. The beaker bears a row of simplified "skidding" goats whose tails, beards, and ears are rendered with sharp, witty lines. The great curving horns of each goat surround a cross-hatched circle with a dotted border painted in dark brown slip. The goats stand on a double groundline beneath which are two narrow checkered bands.

Beakers of this shape have been excavated in Level III at Tepe Sialk in north central Iran and are dated in the fourth millennium B.C. (R. Ghirshman, *Fouilles de Sialk*, Paris, 1938, vol. 1, plates LXXII, LXXIII). Some of the Sialk beakers are also ornamented with a row of "skidding" goats.

While a few Sialk examples have a flower-like rosette within the sweep of their horns (R. Ghirshman, op. cit., plates LXXX–LXXXII), none of the excavated parallels exhibits the crosshatched circle of the Levy beaker.

Sialk-type beakers, with their delicate, thin walls, fine sense of geometric ornament, and lively though abstract animal imagery are considered among the best early exemplars of the five-thousand-year-old tradition of fine ceramic production on the Iranian plateau.

T.S.K.

33. *Ceramic storage jar*

Height, 32.5 cm.; diameter of rim, 27.9 cm.
Western Iran, early second millennium B.C.

This large, round-bottomed jar, completely intact except for a single continuous break around its lower circumference, is of a coarse buff fabric covered with a thin cream-colored wash and painted with a chocolate-brown slip. The shoulder of the vessel is marked by a thick, well-defined horizontal ridge above which the shoulder tapers inward to a wide mouth with a shallow ledge-like rim. A pair of thick vertical lug handles placed close together curve from the shoulder ridge to just below the neck of one side. The painted decoration begins below the shoulder ridge with a band of wavy lines enclosed between sets of straight lines. The shoulder area is divided into four segments by decorative blocks featuring crosshatched confronted triangles with diamond-shaped interstices. Between these blocks, on the shoulder ridge, is a single, simply painted swimming water bird. Two sets of triple wavy lines above the bird suggest its watery ambience. The flat surface of the rim is also painted with a regular series of small blocks.

Large storage jars of this general shape are well known from excavations in western Iran. The ridged shoulder, which developed earlier, links this vessel to the Godin III: 2 phase of the western Iranian pottery tradition, which dates to between 1900 and 1600 B.C. (T. C. Young, Jr., *Excavations at Godin Tépé: First Progress Report* [Royal Ontario Museum, Art and Archaeology Occasional Paper 17], 1969, pp. 90–91; T. C. Young, Jr., and L. D. Levine, *Excavations of the Godin Project: Second Progress Report* [Royal Ontario Museum, Art and Archaeology Occasional Paper 26], 1974, pp. 102–3; R. C. Henrickson, "The Chronology of Central Western Iran 2600–1400 B.C.," in *AJA* 89, 1985, pp. 576–77, 581). The offset lug handles, however, do not

appear in the published ceramics of Godin Tépé, but examples with them were excavated at Tépé Djamshidi, near Nihavand (G. Conteneau and R. Ghirshman, *Fouilles du Tépé-Giyan*, Paris, 1935, Tomb 5, no. 1, pl. 75, Tomb 19, no. 3, pl. 81). On the pot found at Tépé Djamshidi, the handles generally curve from the shoulder to the rim, rather than from the shoulder to the neck, and the painted decora-

tion differs from that of the Levy jar. This unusual placement of the handles, unlike the arrangement on most excavated examples, may be a clue as to how the vessel was carried. A pair of these vessels would be more easily secured on either side of a pack animal than would vessels with opposing handles.

T.S.K.

34. *Copper or bronze ornamental ax*

Length, 24.2 cm.
Eastern Iran or Bactria (modern northern Afghanistan),
 late third millennium B.C.

The sinuous lines of this beautiful though enigmatic object, with its blunt, rounded "blade," angled haft, and curving, pennant-like appendage at the back, find echoes in a number of similar axes and related standards excavated both in Iran and in Bactria (northern Afghanistan) (P. Amiet, *L'Âge des échanges inter-iraniens . . .* , Paris, 1986, p. 195, plates 166–173; V. Sarianidi, *Die Kunst des Alten Afghanistan*, Leipzig, 1986, pp. 213–16, plates 79–83; A. Hakemi, *Catalogue de l'exposition: Lut. Xabis (Shahdad)*,

Tehran, 1972, p. 33, pl. XX A). Since the first known examples were excavated at the Elamite city of Susa in southwestern Iran, the type initially was regarded as Elamite in origin. Subsequent excavations in eastern Iran and particularly in Bactria have demonstrated that this type of object, whose original function is not yet clear, originated in Bactria and the surrounding area and spread into Iran. The appearance of the Susa axes and similar hammer-like objects, some of which bear dedicatory inscriptions of local rulers (P. Amiet, *Elam*, Auvers-sur-Oise, 1968, nos. 175, 176, pp. 242–43), was a result of the trade relations that existed between the two regions.

T.S.K.

35. *Silver and gold footed beaker*

Height, 12.9 cm.
Twelfth–tenth century B.C.

This elegant vessel features two rows of bulls in high relief. Their projecting heads, worked completely in the round, were added separately. The upper row of four bulls moves sedately to the viewer's left. The four bulls in the lower row face right, and lie with their legs folded beneath them. The tail of each recumbent bull swings under its hindquarters and over its right hind leg so that it not only hangs over this leg but also over the register line on which the bull reclines. Although much damaged by pressure and corrosion, the bulls retain their muscular form and the naturalistic modeling. Incised details of hair, hooves, and eyes may still be discerned, but the profiles of the heads and the angle at which they were carried, as well as projecting ears and horns, have been much altered. The once inlaid eyes are now blank.

The bottom of the small circular foot of the beaker is incised with a six-petaled rosette laid out with a compass. Arcs are drawn between each petal and intersect the outer edge of the foot. The resulting concave triangles are filled with incised dots. A broad gold band with a double guil-

35: bottom of foot showing incised designs

loche chased on the exterior is crimped over the rim of the beaker.

A very similar beaker of bronze, with four recumbent bulls above and four horses (or, more probably, onagers) striding in the opposite direction below, was excavated at Susa in southwestern Iran early in this century (P. Amiet, *Elam*, Auvers-sur-Oise, 1966, pp. 472–73, no. 356). Other related vessels featuring single rows of bulls, lions, and gazelles have been excavated at Marlik (E. O. Negahban, *Metal Vessels from Marlik*, Munich, 1983, nos. 8, 57, pp. 12–15, 82–84) and at Kalar Dasht (E. Porada, *Ancient Iran*, New York, 1965, pp. 91, 94), and have been reported from uncontrolled digging in the same region. It would appear, then, that elegant beakers from artistic centers like Susa provided the models, which were copied by craftsmen from other areas of Iran. It is not clear whether the Levy beaker came from Susa, although its craftsmanship and style are closer to those of the Susa example than to works from northern Iran. However, the use of a separate gold band with a double guilloche on the rim finds many parallels on vessels from Marlik. Indeed, it is probably naïve of us to suppose that there were only two production centers for such luxury objects.

T. S. K.

35

three figures stand on the backs of a pair of crouching rabbits that form the base of the composition.

It has been customary to regard these horse bits and other fantastic metalwork of the so-called Luristan culture as the reflection of a rich although isolated artistic tradition. However, these Luristan bronzes, and the Levy horse bit in particular, have links to the art of the great Elamite city of Susa in southwestern Iran. Excavations at Susa have uncovered glazed ceramic tiles featuring frontal standing figures between rampant griffins or other composite beings. One

example, dated to the eighth century B.C., even shows a figure with little claw-like feet standing on the backs of a pair of small recumbent griffins—a composition almost identical to that of the Levy horse bit (P. Amiet, *Elam*, Auvers-sur-Oise, 1966, nos. 383–384, 390, pp. 508–10, 514). While one may speculate that Luristan metalsmiths once visited Susa, it is also possible that such perishable goods as textiles may have served in the transmission of images from the Susa region to the mountains of Luristan.

T.S.K.

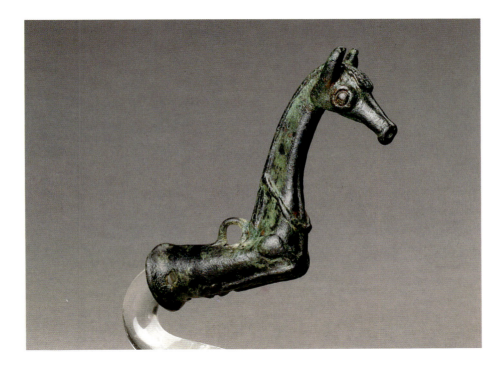

40. *Bronze whetstone handle*

Length, 8.7 cm.
Western Iran, eighth–seventh century B.C.

This whetstone handle is in the form of a simplified horse's head. The broad forelock, composed of three thick strands of hair, and the nicely modeled ears contrast with the long, slim muzzle and the elongated neck, ornamented by the thin ridge of the roached mane and encircled by a narrow collar. Small round shoulders mark the base of the neck, and attenuated forelegs extend along the underside of the handle. A loop at the withers served to suspend the whetstone handle from a belt.

Ornate interpretations of utilitarian tools, such as this whetstone handle, characterize the artistic production of as yet unidentified groups of presumed pastoralists who inhabited the mountainous regions (the Luristan area) of southwestern Iran in the earlier first millennium B.C. These elaborate metal creations, known originally from random digging, have also been scientifically excavated from tombs. Horse gear, especially bits, figured prominently in the art of these peoples, and objects like the Levy whetstone handle demonstrate that the horse itself was used as a decorative motif as well.

T.S.K.

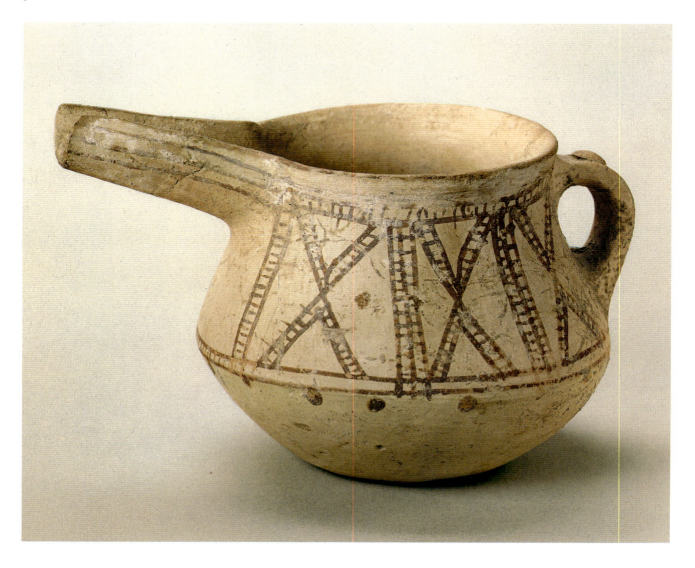

41. *Ceramic spouted vessel*

Height, 11.5 cm.; diameter, 12 cm.
Western Iran, eighth–early seventh century B.C.

The squat, round vessel has a carinated shoulder, a long trough spout, and on the side opposite the spout a strap handle with a decorative pellet. It is not clear if the present length of the spout corresponds to its original size, as there is evidence of damage and repair, perhaps in antiquity. The fine buff ceramic body is decorated on the shoulder with a series of panels with narrow hatched borders painted in a dark red-brown slip. Each panel is quartered by an awkwardly painted X whose hatched bands echo the panels'

frames. The lower edge of this painted zone terminates in a row of pendant dots.

Red-on-buff ceramics are characteristic of the Late Iron Age in western Iran. Trough-spouted vessels with similar hatched bands have been excavated at Baba Jan, where they appear in levels dated to the eighth and the early seventh century B.C. (C. Goff, "Excavations at Baba Jan: The Pottery and Metal from Levels III and II," *Iran* XVI, 1987, pp. 30–32, 44, 50–52). The decorative patterns of the Baba Jan ceramics are not identical to those of the Levy pot, which undoubtedly comes from elsewhere in the region.

T.S.K.

42. *Silver-gilt bowl*

Height, 5.4 cm.; diameter, 11.3 cm.; weight,
270.5 gms.
Iran or Afghanistan, fourth century A.D.

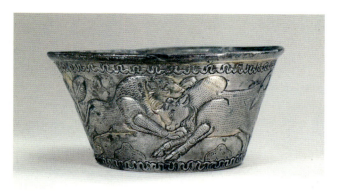

The stiff and hieratic poses of the animals, the rich pattern-
ization of their body surfaces, and the three-leaved tree are
distinctive elements in the ornamentation on this silver-gilt
bowl that are comparable to the figural design on a Sasanian
gilded-silver rhyton dating to the fourth century A.D. in
the Arthur M. Sackler Gallery, Washington, D.C. (P. O.
Harper et al., *The Royal Hunter, Art of the Sasanian Empire*,
New York, The Asia Society, 1978, pp. 36–38, no. 5). In
all probability, the bowl and the rhyton were both made in
the first half of the fourth century A.D.

More unusual than the design on the bowl in the Levy
collection is the shape—a form that is unknown in the
corpus of Sasanian luxury vessels dating from the early first
millennium A.D. A close but not exact parallel is a silver
vessel in the Davids Samling, Copenhagen, that rests on a
low foot ring. This bowl is decorated with hunting scenes
modeled on Sasanian prototypes. It is a work that was
probably made in ancient Bactria (modern Afghanistan)
about the middle of the fourth century A.D., perhaps in
some area under Sasanian control (P. O. Harper, "A
Kushano-Sasanian Silver Bowl," in *Archaeologia Iranica et
Orientalis* . . . II, Ghent, 1989, pp. 847–66). Since the
shape of the bowl in the Levy collection has no parallels
among Sasanian works of art, it may also be a product of a
workshop located in the region east of Iran rather than in the
central Sasanian kingdom.

The unrealistic and stylized appearance of the animals
represented on the present bowl is reminiscent of much
earlier figural designs on metalwork made in Iran and
Bactria in the second and first millennia B.C. (E. O. Ne-

ghaban, *Metal Vessels from Marlik*, Munich, 1983; O. W.
Muscarella, *Bronze and Iron, Ancient Near Eastern Artifacts in
The Metropolitan Museum of Art*, New York, 1988, pp.
192–202, 248–52; P. Amiet, *L'Âge des échanges inter-
iraniens* . . . , Paris, 1986, figs. 194–202). There is no
evidence of the realism or naturalism that characterizes the
art of the contemporary Roman world. However, the com-
position of the scenes on this bowl—pairs of animals in
combat separated by plant forms—has a close parallel on a
Roman silver bowl of the third century A.D. in the Cabinet
des Médailles, Paris (Fr. Drexel, "Alexandrinische Silber-
gefässe der Kaiserzeit," in *Bonner Jahrbücher* 118, 1909,
p. 193, fig. 5). Exchanges and contacts through trade and
colonization led to the diffusion of motifs and designs over a
wide area from the Mediterranean seacoast to Central Asia
in the centuries immediately after the beginning of the
Christian era. The bowl in the Levy collection is a product of
this rich and varied artistic environment, an unusual work
of art made in Iran or on the eastern border of that country
during the early first millennium A.D.

P.O.H.

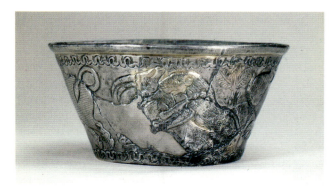

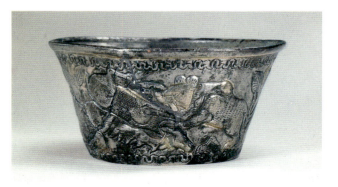

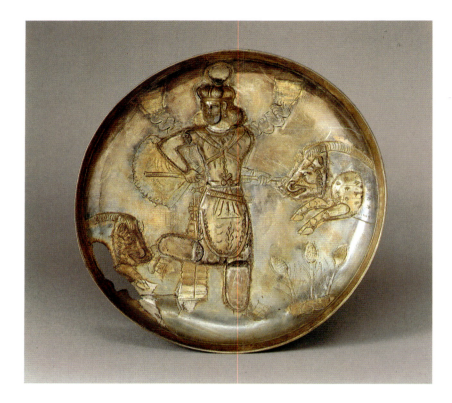

43. *Silver-gilt plate*

Height, 5 cm.; diameter, 23.4 cm.; weight, 638 gms.
Provincial Sasanian, Afghanistan, late fourth or early fifth
 century A.D.
Inscribed (on the reverse): This vessel belongs to Tudak /
 39 stēr, 1 drahm, 4 dāng.

Preeminent among Sasanian silver vessels is the picture
plate decorated with an image of the ruler, identifiable by
the form of his crown. These crowns, which changed at the
accession of each new king, are represented on the coinage of
the realm. On the basis of this numismatic evidence, Sasa-
nian rulers can be identified when they are portrayed in
other mediums, and a chronological sequence of the crowns
can be established. On silver vessels, the Sasanian ruler is
usually depicted hunting on horseback or, more rarely, on
foot. The designs are formal and stylized, primarily sym-
bols of royal and perhaps superhuman power, rather than
naturalistic depictions of court life.

The plate in the Levy collection is similar to the royal
Sasanian vessels and was identified previously as a Sasanian
work of the fourth century A.D. on which the ruler Ardashir
II (r. A.D. 379–83) is represented (F. Grenet,"Un plat sasa-

nide d'Ardašir II (379–383) au bazar de Kabul," in *Studia
Iranica* 12, 1983, pp. 195–205). This attribution cannot be
accepted, as the headdress worn by the hunter is not a
known Sasanian crown type and the scene is not a standard
Sasanian representation of a hunt (P. O. Harper, "An Iranian
Silver Vessel from the Tomb of Feng Hetu," in *Bulletin of the
Asia Institute*, in press). The king, attacked by two boars,
spears one animal, charging at him, and wards off the other
animal with an awkward backward thrust of his bent right
leg. Two inscriptions are incised, rather than dotted in the
customary Sasanian fashion, on the reverse of the plate,
within a foot ring. The larger, and probably primary, in-
scription gives the weight of the vessel in Pahlavi, the
Middle Persian script of the Sasanian world. A smaller,
secondary legend, in a Graeco-Bactrian script used in the
lands immediately east and north of Iran, contains the name
of the owner, Tudak.

The probable place of manufacture of the vessel is the
region of Afghanistan, the ancient Kushan realm in Bactria,
where the plate originally appeared on the art market.
During the early Sasanian period this region was, for a time,
under the control of the Iranian monarchs. Their appointed

governors as well as colonists and craftsmen from Sasanian Iran were present at the provincial court, and the influence of Sasanian art on works made in this region is pronounced. At intervals the Kushano-Sasanian lands achieved a degree of independence from Iran, and the rulers minted their own coins and made their own silver vessels based on Sasanian models.

The technique of manufacture used for the plate in the Levy collection is characteristic of both Sasanian works and the provincial imitations of Sasanian silver vessels. The highest parts of the relief (the hunter's head and body, and the head and foreleg of one of the boars) are separate pieces of metal held in place by a lip cut and raised up from the background of the hammered shell. Metal fillers at certain places further secured these added pieces of metal and are still visible at the knees of the hunter where the lower legs have broken away. On the exterior the absence of a chased line immediately beneath the rim is a detail that characterizes provincial vessels but not the Sasanian prototypes, which almost invariably display this non-decorative tool-mark (P. O. Harper and P. Meyers, *Silver Vessels of the Sasanian Period I*, 1981, p. 157).

Details on the plate—notably the crescentic hemline of the tunic—suggest a date late in the fourth or early in the fifth century A.D., just before Kidarite and Hephthalite invaders finally brought to an end Kushano-Sasanian and

Sasanian authority in the lands on Iran's eastern border. The royal status of the hunter is suggested by the partially destroyed globe rising above his headdress, a symbol signifying kingship in the Parthian and Sasanian worlds. The overall design of this headdress, however, differs from the known crown types of the Sasanian and Kushano-Sasanian kings. Consequently, the identity and the degree of independence of the personage who commissioned and is represented on this plate remain uncertain.

The unusual hunting scene on the plate is almost exactly repeated on a provincial Sasanian vessel recently recovered from a tomb in China and dated to the end of the third century A.D. (*Wen Wu* 8, 1983, pp. 1–12; P. O. Harper, op. cit.). The appearance of such an unusual design on two vessels separated in date by almost a century may be an indication that the scene illustrates some legendary feat rather than a symbolic royal hunt of the standard type. Iranian epics abound with descriptions of heroic deeds in war and in the hunt, and the distinctive scene on the two plates may have been intended to call to mind events in the life of some legendary hero or ancestor.

In spite of the uncertainties concerning the historical identity of the royal hunter, this silver plate is a work of considerable importance, providing evidence for the reconstruction of the material culture of a little-known period and region.

P.O.H.

43: reverse, with incised inscriptions

Note on the inscription:

The inscription on the plate is in four lines:

1. todako xobo
2. elo (?) zamo
3. MP (?) xx-x iii iii iii
4. ZWZN (?) i M-iiii

The first two lines of writing are in cursive Graeco-Bactrian script, running from left to right; the following two lines in Pahlavi (Middle Persian), running from right to left. One may suppose that the Pahlavi text, which takes up the central portion of the space available, was written first, and that the Bactrian text was subsequently squeezed into the blank area above the former. However, it would also be possible to interpret the four lines as a single inscription consisting of the two parts commonly found in inscriptions on Sasanian silver vessels: a statement of ownership and a statement of weight. The writer—or writers—seems to have been hindered by the circular base within which the text is scratched, for the shapes of some letters are rather ungainly, making it difficult to read the text with assurance.

N.S.-W.

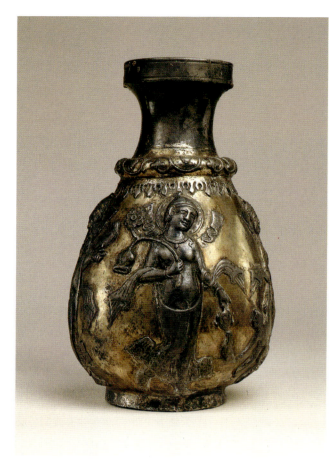

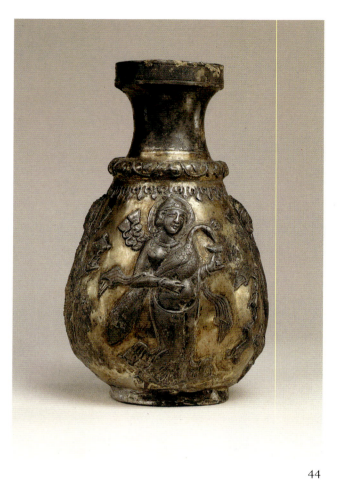

44

44

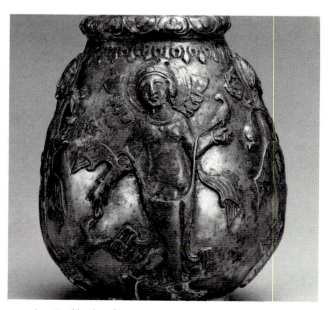

44: detail of body of vase

44. *Silver-gilt vase*

Height, 18.6 cm.; weight, 538 gms.
Sasanian period, fifth–seventh century A.D.

This globular vase, which rests on a flat circular base, has a
tapering shoulder and a concave neck with a sharply defined,
collar-like rim. The zone of the neck is separated from the
body of the vessel by a thick rib bearing a decorative grape-
vine in relief. Below the rib is a narrow border of pendant
foliate forms in low relief.

The body of the vase is occupied by four apparently
dancing female figures rendered in repoussé. Each wears a
sheer, revealing robe, whose fine wrinkles have disappeared
on the more worn surfaces. Their legs are covered by heavy
mantles whose ends, wrapped over each arm, flutter vigor-
ously. The hems of the mantles are equally animated, rip-
pling upward in rising folds. Each female—whose haloed
head is framed by fluttering ribbons—holds a pair of attri-

45. *Silver-gilt vase*

Height, 18.9 cm.; weight, 525 gms.
Sasanian period, fifth–seventh century A.D.
Inscribed (on the border): *Wēnrēw* [?] *s*[*taters*] 20 *drachms* 2; (in a later hand): *Dādweh*.

The vase has the same shape as catalogue number 44 and also bears four dancing female figures with virtually the same attributes. It is not a copy, however, because some of the figures here are mirror images of the others, and their attributes are paired in a different order. The style of these figures also differs; it is less naturalistic and more reliant on varied surface patterns for visual appeal. However, the most pronounced difference between the two vases is in the use of an arcade with double columns to frame each figure. The arcade originally was a Classical motif derived centuries earlier from Roman art. In this example, the arcade itself is

45

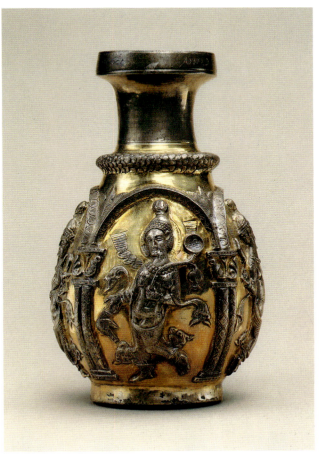

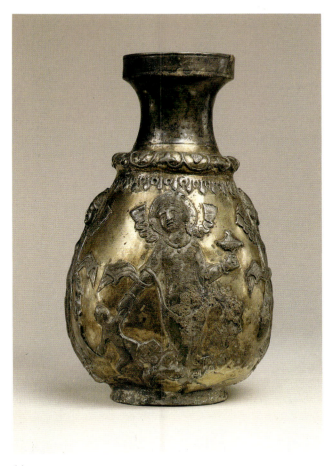

44

butes. One has a peacock and a footed cup, another a small dog and a bird, the third a poppy stalk and a grape cluster, and the fourth a vine and a covered cup with a tall foot. Luxurious vessels such as this were once thought to illustrate aspects of the Zoroastrian cult of Anahita, the goddess of pure waters and thus of fertility. It now appears that these vases served a secular function, enhancing the prestige of the princely rulers whose tables they graced with general references to well-being and abundance (M. L. Carter, in P. O. Harper, ed., *The Royal Hunter*, New York, 1978, pp. 60, 61). The wide and long-lasting appeal of these sumptuous vases is documented by their discovery outside Iran proper in archaeological contexts of post-Sasanian date (P. O. Harper, op. cit., p. 51; K. V. Trever and V. G. Lukonin, *Sasanidskoe Serevro*, Moscow, 1987, nos. 30–32, pp. 46–117, plates 90–98).

T. S. K.

richly decorated. Grapevines are incised on the columns and over the arches, and the foliate capitals have upper and lower borders of dotted circles. In addition to the criteria for dating discussed in the entry for catalogue number 44, the paired columns provide further evidence of a Late Sasanian date, as they also occur in early Islamic architecture (T. S. Kawami, "Kuh-e Khwaja, Iran, and Its Wall Paintings: The Records of Ernst Herzfeld," in MMA *Bulletin* 12, 1987, p. 24).

On the border are two inscriptions: One is carefully engraved and gives the name of the original owner and the weight of the vase, 525 grams; the other clearly was added later by a much less skillful engraver and notes the name of a subsequent owner. According to P. Oktor Skjaervo, the name in the original inscription, preceded by what appears to be an ornamental wavy line, means "See the riches"; the second inscription, a common Zoroastrian name, means literally "Created the best."

T. S. K.

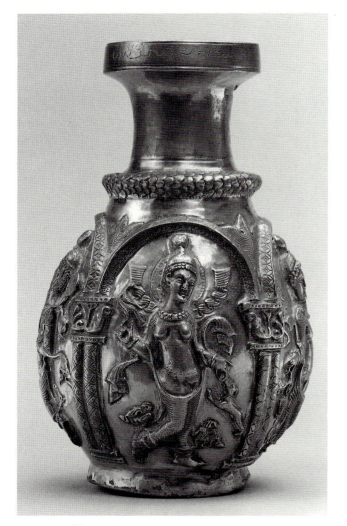
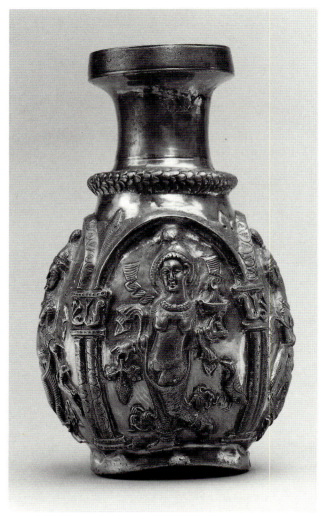

45: two additional views

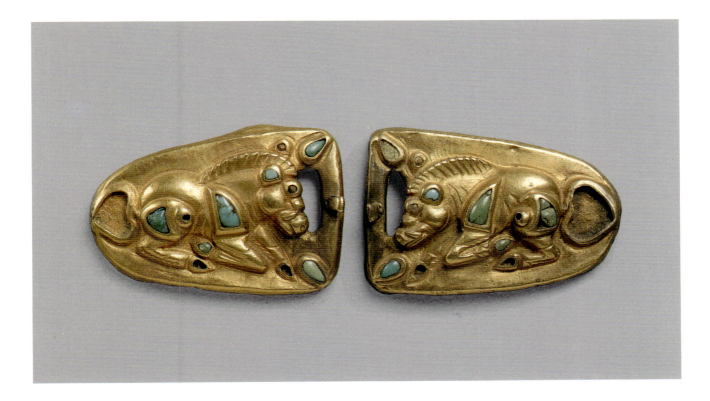

46. *Pair of gold plaques*

Height of each, 4.5 cm.; width of each, 3.1 cm.
Second century B.C.–first century A.D. (?)

These two gold plaques, decorated with recumbent boars, are almost mirror images. While the animal forms vary slightly in proportion and detail, technically the plaques are similar. Elements of the animals' bodies, as well as areas in the fields of the plaques, contain inlay cells, many of which remain filled. Most of the inlays are turquoise, although one teardrop inlay on the right plaque and the now-faded ear and eye inlays are glass, and are severely deteriorated. According to technical analyses and explanations provided by

Richard E. Stone of the Department of Objects Conservation at The Metropolitan Museum of Art, the tear-shaped glass inlay is badly crizzled—a condition often characteristic of ancient glass. This glass inlay and the two faded ones in the ears were once turquoise in color and opaque, duplicating the appearance of the stone inlays. In contrast, the virtually identical composition of the eye inlays of the two plaques is different from the other glass inlays, indicating that the eyes originally would have been some color other than turquoise. The plaques are hammered in relief from the reverse, and details are chased on the obverse. A small, upright pin, visible on the underside, has been inserted just

before the oblong opening at the front of each plaque. This method of attaching an element has a parallel on a plaque found in the Zaporozhe kurgan, from the eponymous region of the Ukraine (A. P. Mantsevich, in A. I. Melyukova and M. G. Moshkova, *Skifo-sibirskii zverinyi* . . . , Moscow, 1976, fig. 2). On the reverse of each Levy plaque, at the end opposite the pin, is the remains of a silver loop, attached, like the upright pin, by now-corroded silver solder. There is, at present, no way of knowing whether the plaques are a true pair—buckles for clothing, perhaps—or two examples of a larger group of objects that had some other function.

Formally, the two plaques are the same, albeit mirror images, both containing a representation of an animal whose rear leg and near foreleg are tucked underneath, while the far foreleg is extended. Each animal's shoulder is marked by a rounded triangular inlay and the haunch by a similar rounded triangle next to a circular inlay (now lost), derived from the "dot-and-comma" motif of Achaemenid art. Although the animals are essentially shown in profile, their far ears are visible above their hatched manes. The corners of the long sides of the plaques are marked by tear-shaped inlays that echo the smaller ones in the hooves. Behind the animals' short upturned tails are heart-shaped inlay cells (now empty).

Despite the similarity of the images, the plaques are different in style. The plaque on the right is very sculptural and lively overall, while the left one is flatter and more static—as is apparent in the treatment of the forelegs: On the right plaque, the animal's near leg overlaps the other, while on the left plaque, the legs both occupy the same plane, one in front of the other. Whatever the reason for the stylistic variation, a comparable phenomenon occurs on two silver belt plaques excavated from kurgan 2 at Pazyryk, in the Altai Mountains of Siberia (S. I. Rudenko, *Frozen Tombs of Siberia*, Berkeley and Los Angeles, 1970, pl. 67, A, B).

In contrast to the majority of animal representations in the so-called "Animal Style," both forelegs but only one rear leg of the boars on the Levy plaques are depicted. Customarily, either two or four legs are represented, unless the action in the scene occludes a limb. It is primarily in art of the second century B.C. and later that animals are shown with an odd number of legs (see T. Sulimirski, *The Sarmatians*, New York and Washington, 1970, plates 36, 53; G. A. Koshelenko, ed., *Arkheologiya SSSR* . . . , Moscow, 1985, pl. LXXXVII, upper right, for a similar foreleg arrangement).

Technically and stylistically, the Levy plaques seem most closely related to works recently excavated by Soviet ar-

chaeologists in tombs at Tillya-Tepe in the vicinity of Shibarghan in northern Afghanistan (V. Sarianidi, *The Golden Hoard of Bactria*, New York and Leningrad, 1985). These tombs have been associated with the early Kushan rulers of the ancient Graeco-Bactrian Kingdom and dated to about the first century A.D. Animals depicted on objects from Tillya-Tepe have tear-shaped turquoise inlays marking elements of their bodies, eyes often filled by a reddish, translucent stone (in contrast to the turquoise body inlays), and, frequently, heart-shaped inlays, as well (V. Sarianidi, op. cit., plates 33, 35, 49, 50, 105, 107). In addition, the so-called shoe buckles from the male burial at Tillya-Tepe are actually a pair of mirror-image plaques, both with upward-pointing prongs that are otherwise unusual for "Animal Style" plaques (V. Sarianidi, op. cit., pl. 124, p. 246; *idem, Khram i nekropol' Tillyatepe*, Moscow, 1989, figs. 30,2, 32). In representations of the Kushan king Kanishka, buckles at the ankle are attached to straps that fasten the trousers to the boots (R. Ghirshman, *Persian Art*, New York, 1962, plates 350, 361), suggesting one possible use for the Levy plaques, although the Tillya-Tepe examples have four loops on the back rather than one, as on those in the Levy collection.

Although inlays occur widely in the animal art of Eurasia, the dot-and-comma inlays seen here on the haunches appear to be rarer. They are most common among various works of art in the Peter the Great Treasure, now in the Hermitage, Leningrad—the sources of which are still a matter of scholarly debate—and among objects apparently from ancient Bactria, including some in the Oxus Treasure (R. D. Barnett, "The Art of Bactria and the Treasure of the Oxus," in *Iranica Antiqua* VIII, 1968, pp. 43 ff.).

Other parallels for the distinctive "Animal Style" and the extensive use of inlays exist among Scytho-Siberian and Sarmatian art of the later first millennium B.C.—objects that come from the vast steppe area extending from the Ukraine to Siberia (A. P. Mantsevich, op. cit., 1976). Similarly dated Sarmatian remains from Iran also illustrate comparable stylistic and technical features (A. Farkas, "Sarmatian Roundels and Sarmatian Art," in MMA *Journal* 8, 1973). However, in none of these regions stretching across much of Eurasia have plaques been found that have exactly the same form and configuration as the two examples in the Levy collection. Consequently, their precise function remains uncertain. On the basis of the parallels cited above, the probable date of manufacture of the two gold plaques lies somewhere between the second century B.C. and the first century A.D.

K. S. R.

Bronze Belt Ornaments from North China and Inner Mongolia (cat. nos. 47–53)

During the first millennium B.C., the Eurasian steppes, which extend from the Great Wall of China to Hungary, were occupied by pastoral tribes whose economies were based on animal husbandry and trade. After the adoption of mounted warfare and transhumance—the seasonal migration between summer and winter pastures—a new society of mounted warrior-herdsmen emerged. In the past, these tribes had been viewed as barbarians and destroyers of culture; however, recent archaeological finds show that they created their own rich traditions and served as intermediaries between the great urban centers of the East and the West.

These tribes possessed complex artistic vocabularies, which enriched their personal ornaments, horse gear, and weapons. Some of their animal and human motifs can be traced to China; other motifs are derived from the great civilizations of the Ancient Near East and Greece; and still others appear to be original or descended from local Neolithic and Bronze Age cultures. The particular mythical requirements of each tribal group and the type of local fauna controlled the selection of the motifs that represented the group's specific symbolic system, which gave visual form to the supernatural world that governed their lives.

Belts appear to have held a magic power for all these pastoral tribes. They were made for conspicuous display and worn over hip-length jackets, where they could easily be seen, and were adorned with metal plaques alternately made of gold, silver, or tinned, gilded, or plain bronze, depending on the status of the owner. These plaques were embellished with the universally popular motif of animal combat—a theme obviously signifying power, which originated in the artistic traditions of the Ancient Near East. For the Avars, who migrated to Hungary from Central Asia in several waves beginning in the sixth century A.D, the warrior's belt was an important article of regalia denoting

clan and rank. Belt ornaments were especially favored among the many pastoral tribes living along the northern frontiers of ancient China. Numerous examples have been discovered in recently excavated graves in Inner Mongolia and in present-day northwestern China.

The Levy collection includes an important group of bronze belt ornaments that are closely related to a number of the famous gold buckles—perhaps the most misunderstood artifacts from the Eurasian steppes—in the Siberian Treasure of Peter the Great in the Hermitage, Leningrad.[1] The suggested dates for these buckles have ranged from the seventh century B.C. to the fourth century A.D., and their manufacture has been placed in Mongolia, southern Siberia, Bactria, and the Balkans. By using recently excavated material in northwestern China and Inner Mongolia, it can now be demonstrated that many of the gold belt ornaments in the so-called Siberian Treasure, and their bronze counterparts in the Levy collection, were actually made for members of the Yuezhi and Xiongnu tribes during the third through the first century B.C., when these tribes alternately dominated the East Asian steppe world.[2]

The Yuezhi were the dominant group in a huge confederacy of mixed ethnic background. They were a Europoid people with an Indo-Iranian heritage who were culturally related to the many Saka and Scythian tribes further west. Their sudden appearance on the northwest borders of ancient China late in the fourth century B.C. coincides with the tribal turmoil caused by the Central Asian campaigns of Alexander the Great, and the landmark decision of the northern Chinese feudal state of Zhao to adopt mounted archery and barbarian dress. The origins of the Xiongnu, antecedents of the Huns, are still a mystery. They are first mentioned in ancient Chinese texts as vassals of the Yuezhi residing in the Ordos Desert region of western Inner Mongolia in the third century B.C. By the second

century B.C. the Xiongnu had united all of the pastoral tribes of the eastern reaches of the Eurasian steppes into one vast nomadic empire and driven off the Yuezhi, who retreated westward to ancient Bactria (present-day Afghanistan).

The belt ornaments of the Yuezhi are distinguished by a fantastic array of real and imaginary animals that enliven their surfaces. While the real animals reflect the local fauna, the imaginary ones, imbued with auspicious power, are composite creatures with raptor-headed appendages. These are related to a poorly understood symbolic system employed between the sixth century B.C. and the first century A.D. throughout the Eurasian steppes by certain pastoral tribes with an Indo-Iranian heritage.[3] To date, the earliest evidence for this particular symbolic system comes from a sixth-century-B.C. Saka grave at Chiliktin in eastern Kazakhstan,[4] while the most recent information comes from a first-century-A.D. burial at Zaporozhe, near the Dneiper River, in the Soviet Union.[5]

The popularity of this particular mythical imagery appears to have declined after the final defeat and expulsion of the Yuezhi from the Ordos region. Instead, there is a new emphasis on naturalistic animals and human beings frequently shown in a landscape setting. The only fantastic beast favored by the Xiongnu was a dragon with a serpentine body and a wolf-like head. This change in the visual symbolism indicates a trend toward more concern with human affairs brought on by closer contact with Han China, just as in the West closer contact with Greece modified the symbolism of the Scythians. In spite of these differences, the Xiongnu shared many cultural traits with the Saka-Scythian world, such as horse racing, sword worship, and the swearing of oaths by drinking wine mixed with blood. All this, according to descriptions by the great Han historian Sima Qian, who, like Herodotus, has left the world vivid written accounts of the "barbarian" tribes "beyond the pale" of his civilized world.[6]

Although the artifacts belonging to the Yuezhi and the Xiongnu may be small and seemingly insignificant, the symbolic and artistic traditions they represent had far-reaching consequences for the history of the ancient world. These traditions are reflected not only in the culture of ancient China, but were also carried into Europe by Asiatic tribes during the so-called Migrations period.[7] The Scythian and Xiongnu practice of converting the skull of a conquered enemy into a splendid drinking cup frequently adorned with gold is echoed years later by the Lombard ruler Alhoin, who earned the undying wrath of his second wife by following this practice with her father's head.[8]

The Levy belt ornaments, adorned as they are with clan and rank symbols, may be part of the ancestry of medieval heraldry. These artifacts have survived into the present to illuminate the cultural contacts of the long-forgotten tribal groups that produced them.[9] The importance of these artifacts is that they can serve as historical footnotes. In lieu of ancient road maps, they remain to mark the movements of men and motifs.

Emma C. Bunker

NOTES

1. S. I. Rudenko, *Sibirskaia kolleksiia Petra* I, Moscow and Leningrad, 1962.

2. E. C. Bunker, "Gold Belt Plaques in the Siberian Treasure of Peter the Great: Their Dates and Origins," in G. Seaman, ed., *Ecology and Empire*, vol. 3, in press.

3. E. Jacobson, "The Stag with Bird-Headed Antler Tines: A Study in Image Transformation and Meaning," in *Bulletin of the Museum of Far Eastern Antiquities* 56, 1984, pp. 113–80; E. C. Bunker, "Dangerous Scholarship: On Citing Unexcavated Artefacts from Inner Mongolia and North China," in *Orientations*, June 1989, pp. 52–59.

4. M. I. Artamonov, *Sokrovishcha Sakow*, Moscow, 1973, no. 41.

5. *Sovetskaya arkeologiya*, 1983: 1, p. 183, fig. 5.

6. B. Watson, *Records of the Grand Historian of China*, vol. 2, New York and London, 1961, pp. 155–92.

7. Herodotus iv, 71.

8. D. Bullough, "Germanic Italy," in T. Rice, ed., *The Dawn of European Civilization*, London, 1965, p. 172.

9. For further information on the art of the pastoral tribes on ancient China's northern borders, see the section on "Ordos Bronzes," written by Jessica Rawson and Emma C. Bunker, in the catalogue of the Hong Kong Ceramic Society exhibition "Power, Wealth and Perpetuity: Ancient Chinese and Ordos Bronzes," Hong Kong, 1990.

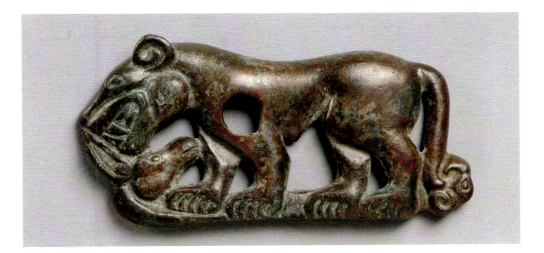

47. *Bronze belt plaque*

Height, 5.5 cm.; length, 11 cm.
Northwest China, fourth century B.C.

An animal combat scene showing a mythological carnivore in the process of dispatching the remains of a herbivore embellishes the front of this belt plaque. The carnivore is seen in a walking position with the tip of his tail transformed into an inverted raptor's head. The herbivore is represented only by its head, which is placed under the carnivore's right forepaw and jaws.

This plaque originally belonged to a mirror-image pair that, together, constituted one belt buckle. The hole that pierces the carnivore's shoulder was part of the buckling system. The reverse displays two small loops for attachment purposes, one above the other, at either end of the plaque.

This type of buckle became an important item in the "status kits" of China's northern pastoral neighbors early in the fifth century B.C. A plaque in the shape of a single tiger was recently excavated at Maoqinggou, Liangcheng county, in southern Inner Mongolia (Tian Guangjin and Guo Suxin, *E'erduosi shi qingtongqi*, Beijing, 1986, p. 281, fig. 45:2). The carnivore on the Maoqinggou plaque has a hole in its shoulder, but its tail does not end in a bird-of-prey head. The Maoqinggou plaque predates the appearance in Inner Mongolia of fantastic animals with raptor-headed appendages, which appeared with the Yuezhi in the fourth century B.C. Another plaque adorned with an animal combat scene, in which the carnivore does have a raptor-headed tail, was recently excavated at Guyuan in northwest China, in southern Ningxia province (*Tonko-Seika Oko kuten*, Tokyo, 1988, p. 33, no. 11).

Current archaeological and historical evidence suggests that the Levy plaque was cast somewhere in northwest China during the fourth century B.C. rather than in southern Siberia, the traditional attribution (E. C. Bunker, "The Ancient Art of Central Asia, Mongolia and Siberia," in P. R. S. Moorey, *Ancient Bronzes, Ceramics and Seals*, Los Angeles, 1981, no. 827). This reattribution is further substantiated by X-ray fluorescence analysis, which revealed that a plaque in Los Angeles and the Levy plaque contain lead—not present in southern Siberian bronzes (K. Jettmar, "Metallurgy in the Early Steppes," in *Artibus Asiae* XXXIII, 1/2, 1971, p. 15). The schematic rendering of the fangs and teeth here derives from the same carving tradition that produced the carnivores that adorn the fifth-century-B.C. wooden coffin from Bashadar in the Altai mountains of southern Siberia (S. I. Rudenko, *The Frozen Tombs of Pazyryk*, Berkeley and Los Angeles, 1970, fig. 136). Bashadar carnivores all display the same two rounded forms to indicate a jaw full of teeth. Recent scholarship has suggested a close connection between the Yuezhi and the burials at Bashadar and Pazyryk (K. Jettmar, "Cultures and Ethnic Groups West of China in the Second and First Millennia B.C.," in *Asian Perspectives*, XXIV, 2, 1981 [1985], pp. 145–62). Such a connection would help to explain the similarities between the carnivores represented on Altai artifacts and on those from the grasslands bordering ancient China.

E.C.B.

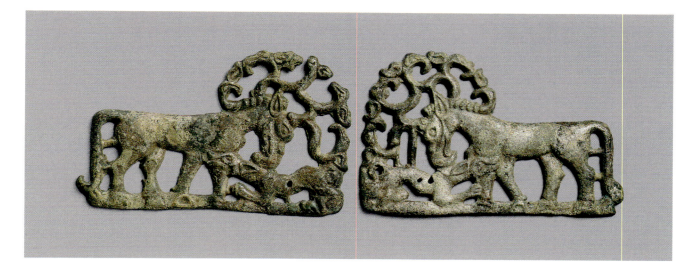

48. *Bronze belt buckle*

Height of each plaque, 7.8 cm.; length of each plaque,
 12.5 cm.
Eastern Eurasian Steppes, third–second century B.C.

This pair of mirror-image belt plaques depicts a mythologi-
cal scene of animal combat. On each plaque, a small carni-
vore bites a fantastic ungulate in the chest. The ungulate has
a rapacious beak and raptor-headed antler tines and tail tip.
The (wearer's) left-hand plaque has a small hook that pro-
trudes from the front, alongside a vertical slit near the
ungulate's head. Depressions that represent vestigial inlay
cells mark the hooves and ears. The reverse is slightly
concave but displays no loops; attachment was probably
achieved through the openings in the composition.

An almost identical pair of plaques was recovered from a
cemetery at Xichagou in northern Liaoning province. This
cemetery contained numerous graves dated numismatically
to the second century B.C. Some graves belonged to local
tribesmen, but others are attributable to the Xiongnu, who
had conquered the local tribes in this area early in the
second century B.C. (*Wen Wu*, 1960:8/9, p. 33:6). These
fantastic ungulates are related to those on the tattooed man
from Tomb 2 at Pazyryk (S. I. Rudenko, *The Frozen Tombs of
Pazyryk*, Berkeley and Los Angeles, 1970, figs. 130, 131)
and on the glorious gold example that surmounts the re-
mains of a crown found at Nalingaotu in northern Shaanxi
province (*Wen Wu*, 1983:12, pl. IV:1). Both sites date to
the later fourth century B.C. and have been associated with
the Yuezhi. Why these beaked ungulates continued to be

represented after the Yuezhi had fled from the area is not
clear, but occasionally they were.

The proper left Levy plaque is almost identical to a gold
plaque discovered near Verkhneudinsk in the vicinity of
Lake Baikal in Outer Mongolia, with two exceptions (S. I.
Rudenko, *Sibirskaia kolleksiia Petra* I, Moscow and
Leningrad, 1962, pl. IV:2). The ungulate on the gold
example has several animals superimposed on its body—a
detail not found on any of the bronze versions of this
composition. However, the major difference is the occur-
rence of a woven-textile pattern on the reverse of the gold
Verkhneudinsk plaque, which reproduces the coarse fabric
that originally supported the wax model from which the
plaque was cast. This particular casting feature only occurs
on plaques made of gold, silver, and gilded bronze, and not
on those made of plain bronze (E. C. Bunker, "Lost Wax and
Lost Textile," in *Beginnings of Metals and Alloys, Proceedings
II*, R. Madden, ed., Cambridge, Massachusetts, 1988, pp.
222–27). To date, many examples of this technique have
been discovered in graves associated with the Yuezhi and
the Xiongnu. This technique has only recently been ac-
knowledged in the People's Republic of China, so it is not
discussed in the available archaeological literature.

E.C.B.

BIBLIOGRAPHY
Mostra d'arte cinese (exhib. cat.), Venice, 1954, no. 147 [one
plaque].

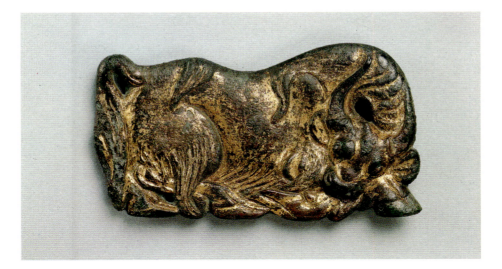

49. *Gilded-bronze belt plaque*

Height, 5.5 cm.; length, 10 cm.
North China and Inner Mongolia, second–first
century B.C.

A recumbent yak adorns the front of this gilded-bronze belt plaque. The yak is shown with its head *en face*, resting on one of its forelegs, its body in profile. Large tufts of shaggy hair, highlighted in places with a silvery mercury amalgam, indicate its heavy fur coat. The reverse of the plaque is slightly concave and displays two vertical attachment loops.

This was originally the right-hand half of a mirror-image pair of plaques that together formed one belt buckle. The Östasiatiska Museet, Stockholm, possesses a complete buckle made up of mirror-image plaques, each of which represents a similar recumbent yak (O. Karlbeck, "Selected Objects from Ancient Shou-chou," in *Bulletin of the Museum of Far Eastern Antiquities* 27, 1955, pl. 32 a, b). The Stockholm plaques are said to have come from Shouxian in Anhui province, but there is no archaeological proof for this provenance since they were not excavated but purchased. There is another, related gilded-bronze plaque in the Shaanxi Provincial Museum, Xi'an, but again it was collected and not excavated.

Bovine creatures appear to have been very popular subjects for belt plaques made for the Xiongnu during their heyday, as demonstrated by numerous examples in collections throughout the world. Similar plaques adorned with recumbent horses are numerous among the grave goods excavated at two cemetery sites in north China that have been associated with the Xiongnu—Xichagou in Liaoning province (*Wen Wu*, 1960:8–9, pp. 25–35, plaque unpublished) and Daodunzi in Tongxin District, Ningxia province (*Kaogu xuebao*, 1988:3, p. 345, fig. 10:7).

The Stockholm and Levy plaques are almost identical, with two technical exceptions. The gilding on those in Stockholm is not highlighted by silvery accents in the shaggy hair, and the backs display a woven pattern that is integral to the metal surface. This woven pattern is not a textile impression, but a positive that reproduces the fabric originally used to support the wax model from which each plaque was cast (E. C. Bunker, "Lost Wax and Lost Textile," in *Beginnings of Metals and Alloys, Proceedings II*, R. Madden, ed., Cambridge, Massachusetts, 1988, pp. 222–27).

X-ray fluorescence analysis by Dr. John Twilley of the Department of Conservation at the Los Angeles County Museum of Art reveals that the alloy employed to cast this plaque is a copper or tin bronze, and that the composition of the gilding differs in different areas—one material was applied to the entire surface and another, with a more silvery appearance, to achieve the highlights. This use of gilding with silvery highlights and the lack of fabric in the casting process suggest that the techniques employed to fabricate the Levy plaque differed from those used to make the Stockholm plaques. The bimetallic surface enrichment is characteristic of Chinese metalwork produced under the Western Han—for example, the sumptuous objects excavated at Mancheng in Hebei (*Mancheng Han mu fajue baogao*, 2 vols., Beijing, 1980)—while the woven-fabric pattern

belongs to the casting traditions of the Yuezhi and the Xiongnu (see cat. no. 48). Technical evidence suggests that the Chinese may have made the Levy plaque specifically to trade with the Xiongnu, basing it on an accepted Xiongnu design. Microscopic examination has demonstrated that the green corrosion layer preserves microscopic details of the cast structure of the metal itself and is perfectly consistent with a second-century-B.C. date.

E.C.B.

BIBLIOGRAPHY
Collection D. David-Weill, Bronzes des Steppes et de l'Iran, Cat. Hôtel Drouot (Paris) 27 juin 1972, no. 26.

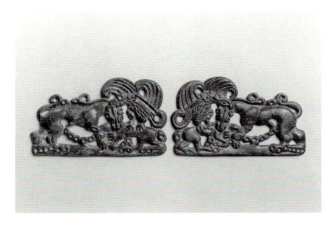

50. *Bronze belt buckle*

Height of each plaque, 7 cm.; length of each plaque,
 11.7 cm.
Northwest China, third century B.C.

This belt buckle consists of two mirror-image plaques. Each depicts a complex animal combat scene in which a fallen ibex is under attack by a mythological carnivore who, in turn, is being attacked by a griffin-headed eagle with an almond-shaped eye. The carnivore's tail and mane-like crest each terminate in a stylized raptor's head, which associates this motif with the zoomorphic symbols introduced into Inner Mongolia and northwest China by the Yuezhi.

The animal combat motif represented here is quite similar to the combat between a raptor, a wolf, and a tiger depicted on a gold ornament excavated from a third-century-

B.C. grave site at Xigouban in Jungar Banner, western Inner Mongolia (*Wen Wu*, 1980:7, p. 2, fig. 3:2). Another plaque exactly like one of the pair under discussion here recently was found in a Qin period (221–206 B.C.) tomb excavated at Zao Miao, Tong Chuan, Shaanxi province (*Kaogu Yu Wen Wu*, 1986:2, p. 10, fig. 4:17), a discovery that further substantiates a third-century-B.C. date for the Levy buckle.

The horizontal B shape and certain stylistic details in the design of the Levy plaques relate them to similar gold buckles in the Siberian Treasure of Peter the Great (S. I. Rudenko, *Sibirskaia kolleksiia Petra* I, Moscow and Leningrad, 1962, pl. IV:3). Each of the gold buckle plaques is cast in the same horizontal B shape and depicts a yak being attacked by a griffin-headed eagle almost identical to the eagle on the Levy plaques. These close similarities suggest that the Peter the Great gold buckle and the Levy bronze buckle are roughly contemporary.

E.C.B.

51. *Bronze belt plaque*

Height, 6.5 cm.; length, 12 cm.
Eastern Eurasian Steppes, second–first century B.C.

Two standing ibex in a wooded area make up this rectangular openwork belt plaque. The pair is shown back to back, their bodies in profile and their heads and horns presented frontally. Four trees, their leafy branches entwined with the horns of the ibex, suggest a forest landscape. Frequently, a third ibex is represented in such compositions, but it has been omitted here, although vestiges of its horns remain in the middle of the composition, amidst the branches. The trunks of two trees are shown vertically behind the bodies of the ibex, and two more tree trunks form the sides of the plaque. The foreleg of each ibex is raised and is situated behind the nearby bordering tree trunk. Depressions mark the tear-shaped leaves and the hooves, as on the other plaques in the collection. The reverse is concave and lacks attachment rings.

Originally, this was the matching plate of a mirror-image pair of plaques that, together, formed one belt buckle. The other plaque would have been equipped with a hook that protruded from the front on the wearer's right side. The attachment of these plaques to a belt was accomplished through the pierced design.

The plaque is stylistically related to numerous plaques that have been excavated from Xiongnu tombs, and reflects

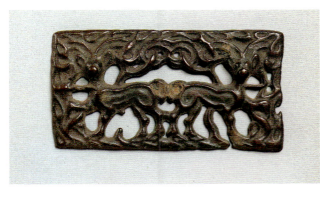

51

hindquarters inverted one hundred and eighty degrees while the tiger bites him in the belly. The reverse is basically flat, and displays no loops.

An almost identical ungilded example was published years ago by A. Salmony ("Lead Plates in Odessa," in *Eurasia Septentrionalis Antiqua* XI, 1937, p. 99, fig. 9). To date, no identical plaques have been excavated, but numerous examples with similar openwork animal combat designs exist in collections around the world (see, for example, V. Griessmaier, *Sammlung Baron Eduard von der Heydt*, Vienna, 1936, no. 15).

a new emphasis on real animals in naturalistic settings. During the second and first centuries B.C., the Xiongnu controlled the majority of the eastern Eurasian steppelands, so that this type of plaque has been found over a vast territory. Recent excavations at Lijia Taozi, Tongxin District, Ningxia province, have yielded an identical plaque in a Xiongnu tomb, along with Han period *wuzhu* coins minted no earlier than 118 B.C. (*Kaogu Yu Wen Wu*, 1988:3, p. 19, fig. 6:2). During the middle and late Western Han, the Chinese government established many offices to deal with the Xiongnu, and Tongxin was under the jurisdiction of one of these offices.

Plants and herbivorous animals shown together carry connotations of plenty, fertility, and abundance. This symbolism has a long tradition in the artistic vocabulary of the Ancient Near East. Similar trees to those on the Levy plaque also occur on some of the Peter the Great gold buckles (S. I. Rudenko, *Sibirskaia kolleksiia Petra* I, Moscow and Leningrad, 1962, plates I:5, V:1–3). The intermediary links between the West and the East, which introduced these plant forms into the Xiongnu repertory, may have been the oases trading centers of Central Asia where numerous foreign styles proliferated.

E.C.B.

52. *Gilded-brass belt plaque*

Height, 5.2 cm.; length, 9.5 cm.
North China and Inner Mongolia, second–first
 century B.C.

An openwork design representing a tiger attacking a stag decorates this belt ornament. The stag is shown with his

52

Qualitative X-ray fluorescence spectrometry has shown that the metal alloy is brass (an alloy of copper and zinc), and that the gilding was achieved by the mercury gilding process. The use of brass is rather unusual for this period, and was probably accidental. It has been suggested that by the late first millennium B.C. bronze tools and weapons had become obsolete, and were being recast to make ornaments (K. Jettmar, "Metallurgy in the Early Steppes," in *Artibus Asiae* XXXIII, 1/2, 1971, p. 15). It is, therefore, possible that some exotic brass object was melted down to make a belt ornament. Microscopic examinations by Pieter Meyers (August 1984) and Richard Stone (January 1990) have revealed that the corrosion products are consistent with the suggested date of manufacture. Thus far, few such scientific examinations and analyses have been performed on published Ordos bronzes, and much further research is needed to clarify metallurgical practice in the eastern Eurasian steppe world.

E.C.B.

53. *Bronze garment hook*

Height, 3.8 cm.; width, 11.3 cm.
North China, western Han, 206 B.C.–A.D. 9

Two heraldically opposed dragons distinguish the rectangular body of this garment hook. The dragons have long, sinuous bodies and wolf-like heads with flowing crests. The reverse of the hook is flat and has an unusually large round knob that projects from its center.

Recent archaeology substantiates a second-to-first century B.C. date for this belt ornament. A garment hook with a similar rectangular body and animal-headed hook was excavated not long ago from a newly discovered Han tomb (*Wen Wu*, 1984:12, pl. IV:5).

The Levy garment hook presumably was created for some Xiongnu dignitary. Its decoration is a Sinicized version of a double-dragon motif frequently found on Xiongnu plaques of the late second to the first century B.C. Two bronze plaques cast in a similar openwork design were recently excavated from a Xiongnu cemetery, dated numismatically sometime between the late second and the first century B.C., at Daodunzi, Tongxin District, Ningxia province (*Kaogu*, 1987:1, pl. III:2). The dragons on the Levy garment hook are also stylistically related to those on a pair of rectangular bronze plaques excavated from a Xiongnu grave at Ivolginskoe, in the vicinity of Ulan-Ude, near Lake Baikal in Mongolia, where the Xiongnu had their summer campgrounds (*Sovetskaya arkeologiya*, 1971:1, p. 96).

The opposed dragons on the excavated Xiongnu plaques from Daodunzi are almost identical to the motif that adorns a pair of gold, openwork plaques in the Siberian Treasure of Peter the Great in the Hermitage, Leningrad (K. Jettmar, *Art of the Steppes*, New York, 1967, p. 193, fig. 39). The Peter the Great gold plaques are inlaid with colored glass paste. As the Daodunzi plaques are marked by depressions in the same places where the inlays exist on the gold examples, this provides another link between the gold belt plaques in the Peter the Great Treasure and the many plaques found among the grave goods of the pastoral tribes that inhabited ancient China's northern frontiers.

The dragons themselves are the typical serpentine creatures frequently seen in the Western Han art of ancient China. The presence of heads resembling those of wolves, which are frequently represented in the art of the pastoral tribes, has prompted the suggestion that some influence from the steppe world may have stimulated the development of the Han dragon (S. I. Rudenko, "The Mythological Eagle, Gryphon, Winged Lion, and the Wolf in the Art of the Northern Nomads," in *Artibus Asiae* XXI, 1958, pp. 101–22).

E.C.B.

BIBLIOGRAPHY
E. C. Bunker et al., *Animal Style from East to West*, New York, 1970, no. 79.

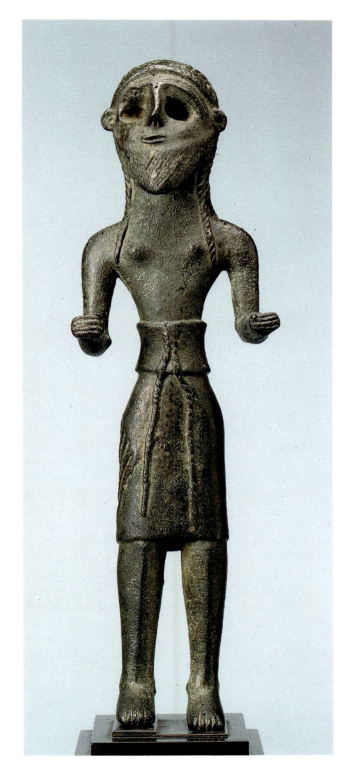

54. *Copper statuette of a male figure*
Height, 38.5 cm.
Lebanon, late third–early second millennium B.C.

The figure stands upright on stiff, straight legs, the oval head—with its sharply projecting nose and pointed beard—thrust forward from the plane of the body. The thin arms, bent at the elbows, terminate in small clenched hands, each with a circular hole to accommodate a spear, staff, or other object. This figure is distinctive for its large size and for its blend of abstract forms and naturalistic details. The head is relatively flat and, when viewed from the front, dominated by large, once-inlaid eyes set under sloping brows. The small, slit-like mouth and the little semicircular ears are geometric rather than realistic. In contrast, the figure's hair and beard are carefully indicated, with long coiled strands extending far down his back and over his shoulders in front. In back, a single thick braid falls from the top of his head nearly to the waist. Although the upper torso is slab-like, the arms and particularly the legs are rendered with some degree of three-dimensional naturalism. The two pendant cords issuing from the belt and the fringe of the kilt wrapped over the right thigh are asymmetrical details whose representation is strikingly realistic.

This curious blend of styles is not uncommon in the Levant, where artistic impulses from Mesopotamia, Anatolia, and Egypt merged, at times jarringly, to serve local needs. The figure is one of five found at Jezzine in central Lebanon in 1948 together with two torques, two pins, and a copper and bronze bead (H. Seyrig, "Statuettes trouvées dans les montagnes du Liban," *Syria* 30, 1953, pp. 24–50). The five statuettes are part of a larger body of works that also includes female figures (P. Matthiae, "Syrische Kunst," in W. Orthmann, ed., *Der Alte Orient* [*Propyläen Kunstgeschichte*, 14], Berlin, 1975, pp. 477–78, pl. 396 b). The identities of the male figures are not clear. Like the Levy statuette, they bear no overt marks of divinity and may represent mortal rulers. The now-missing objects held in the clenched hands of the Levy statue may have been identifying attributes.

The statuette was formerly in the Leon Pomerance collection (E. L. B. Terrace, in *The Pomerance Collection of Ancient Art*, The Brooklyn Museum, New York, 1966, no. 15, pp. 22, 23; H. Seyrig, op. cit., pp. 29, 35–39, pl. XI,2).

T.S.K.

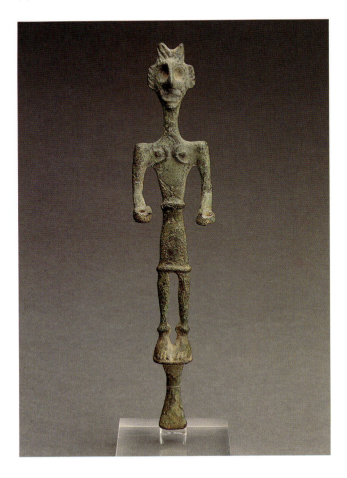

formed by the upper and lower edges of the kilt and what seem to be thick anklets.

This figure belongs to a series of votive statuettes deposited in shrines in Syria during the second millennium B.C. The style of this series of figurines varies somewhat from place to place, but all examples have the same flat, angular body, stiff pose, and small scale, and are considered to reflect local artistic traditions. Closest to the Levy figurine is an example excavated at Ras Shamra (ancient Ugarit) and dated to the twentieth century B.C. (A. Kempinski and M. Avi-Yonah, *Syria-Palestine* II, Geneva, 1979, pl. 15). This figure, too, is the same in stance, proportions, and style, and, in addition, carries a gilt mace in the left hand and wears a kilt of gold foil.

T.S.K.

55. *Copper or bronze standing figure*
Height, 25.3 cm.
Syria, about the twentieth century B.C.

This figure has the same flat, stylized form and stiff angular posture as the similar figure in the Levy collection (cat. no. 54), but it is rendered on a smaller scale and even more schematically. The flat face has a sharply projecting nose, a horizontal gaping mouth, and two large eye sockets once presumably filled with a contrasting material. The hair, arranged in short, patterned plaits on the back of the head, stands out at the sides like elongated ears and rises to form two horn-like points on the top of the head. These projections raise the possibility that a deity is represented rather than a mortal, for horned headgear is a standard attribute of divine figures in the culture of the Ancient Near East. The back of the figurine is virtually smooth except for the ridges

56. *Bronze standing god*
Height, 21.5 cm.
Syria, late second millennium B.C.

The figure, identified as a god by his horned headgear, raises his right arm, now bent awkwardly behind his head, to brandish the weapon once held in his clenched hand. Clothed in a short kilt, wide belt, and long, thin mantle thrown over his left shoulder, the barefoot deity probably held another weapon or attribute in his (now missing) left hand. The gold foil that originally covered the skin areas of the figure is secured in the broad seams extending up the backs of the legs, the sides of the torso, and on the head behind the ears. Bits of gold are still visible wedged in the crevices on the figure's left side, above and below the kilt and between the left shoulder and the neck, on the right side of the torso, and on the face near the eye. Stubs of gold horns remain on either side of the headdress. The eyes and perhaps the eyebrows at one time were inlaid, and a hole in the center of the belt suggests that it, too, was ornamented with a precious material.

The clean-shaven upper lip; long, straight beard; and narrow mantle identify the god as Syrian, but which of the gods is more difficult to determine, since the identifying attributes are missing. Because the raised right hand suggests an active if not an aggressive nature, the figure may well be one of the weather gods so prominent in the Syrian pantheon. The tapered top of the headgear—now broken off—may have resembled that of another weather god on a

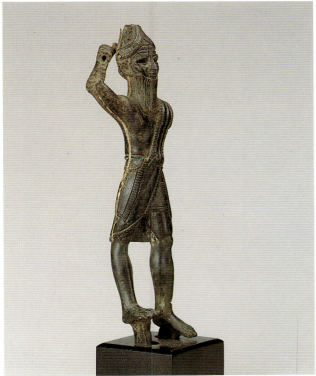

56

sides, while the lower arms and the hands extend over his lap. The clenched left hand once held an object, while the right one is raised, with palm open toward the viewer. The head is topped by a tall, almost conical headdress. There are no folds or wrinkles in the smooth clothing, which clings to the clearly defined torso.

The head and neck, arms, torso, and feet still retain the gold foil that once covered the entire figure. A silver ring encircles the neck, and the earlobes retain the stubs of silver earrings. The thin inlaid eyebrows and elongated, enlarged eyes; the flat, broad face, with its small chin; the cup-shaped ears; and the rather long, broad feet clad in sandals with round straps that have parallels in Egyptian art are signs of Egyptian influence probably reflecting the wide cultural impact of the New Kingdom, particularly the XVIIIth Dynasty.

The tall, almost conical headgear, probably based on the Egyptian Pharaonic White Crown, appeared in the art of the Levant as early as the nineteenth century B.C., when

57

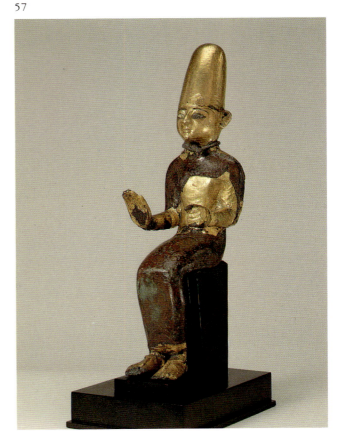

relief from Ras Shamra (ancient Ugarit) (H. Frankfort, *The Art and Architecture of the Ancient Orient*, 3rd ed., New York, 1970, p. 256, fig. 294). Bronze statuettes of deities with the same broad seams to secure gold-foil overlays have been excavated at Ras Shamra, as well (H. Weiss, ed., *Ebla to Damascus*, Baltimore, 1985, nos. 135, 136, pp. 287, 288).

T.S.K.

BIBLIOGRAPHY
Sauvegard de Tyr: Ville aux huit civilisations, Paris, UNESCO, 1980, no. 25, p. 17, cover ill.

57. *Statuette of a seated male figure*
Height, 28.5 cm.
Copper or bronze, with gold foil, shell or stone ?, and
 silver
The Levant, second half of the second millennium B.C.

The seated figure is fully modeled in the round except for the backs of the legs. The figure's upper arms are held to his

elongated gilt-bronze figurines were deposited in the Obelisk Temple at Byblos (E. A. Wein and R. Oppificius, *7000 Jahre Byblos*, Nuremberg, 1963, nos. 20, 21, 24, pp. 39, 40; N. Jidejian, *Byblos through the Ages*, Beirut, 1968, p. 38, plates 74, 76–78). Closer in style to the Levy figure are the richly adorned metal statues, usually considered deities, excavated from the religious precincts at Ras Shamra (ancient Ugarit) where they had been dedicated in the mid- to late second millennium B.C. (H. Weiss, ed., *Ebla to Damascus, Art and Archaeology of Ancient Syria*, Baltimore, 1985, nos. 132–135, pp. 285–87, 315). The degree of Egyptian influences varies from work to work and does not seem to be a specific indication of date.

The gesture of the figure—the right hand extended with palm raised toward the viewer—does not have any royal or divine Egyptian counterpart. This gesture appears consistently in Syrian art throughout the second millennium as well as later, and may be taken as an indigenous motif. The identity of this figure, as well as that of similar votive offerings from Byblos and Ras Shamra, is not clear: By combining aspects of the royal and the divine, it continues to intrigue the viewer.

T. S. K.

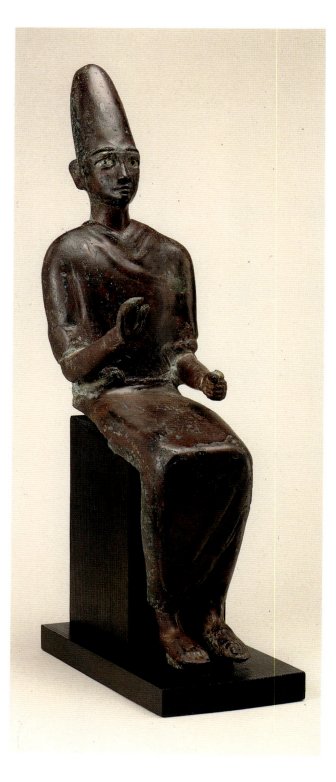

58. *Copper or bronze statuette of a seated male figure*

Height, 41 cm.
The Levant, possibly first millennium B.C.

The seated beardless figure wears a long robe that falls in faint diagonal folds across his chest and lower legs. The garment also covers his upper arms to the elbow. The left arm, with hand clenched to hold a now-missing object, extends over the left thigh, while the right hand is slightly raised with the palm open toward the viewer. The eyes and eyebrows were once inlaid, and the head is topped by a tall, rounded headdress that at present merges seamlessly with the head. Traces of gold foil on the right eyebrow indicate that the face and probably other portions of the figure were once covered with gold foil. The man has a wide cuff or bracelet on each wrist, and he wears sandals that have a broad heel support and a thick strap across the instep. Despite the elongated proportions and the small hands and feet, the modeling is naturalistic, with the limbs rendered convincingly through the drapery. However, the statue is

not fully in the round but is flat and unfinished on the back; indeed, when observed from the side, it is slab-like and angular. Seen from this viewpoint, the skill of the artist in suggesting a fully rounded figure is all the more remarkable.

The dress and the tall headgear are based on Egyptian parallels, both royal and divine, but are not truly Egyptian in their details. Similarly, the raised right hand does not correspond to any Pharaonic pose but is a common gesture in portrayals of Syrian deities from as early as the beginning of the second millennium B.C. One is tempted to identify the gesture as one of greeting or address. While these details all appear in Syrian works of the second millennium B.C., the realistic modeling of the curved right hand, long jaw, and full lips raises the possibility that the statue was made later—perhaps in the first millennium B.C. The sandals, with their wide heel supports, are closer to Assyrian examples of the ninth through the seventh century B.C. rather than to the Egyptian-style sandals common on second-millennium figures. Ivory carving in the Egyptian style continued in the Levant in the earlier first millennium B.C. (I. J. Winter, "Phoenician and North Syrian Ivory Carving in Historical Context: Questions of Style and Distribution," *Iraq* 38, 1976, pp. 7–9), and Egyptianizing anthropoid sarcophagi were made even later (D. Harden, *The Phoenicians*, New York, 1962, pp. 106, 112, 113, plates 16–18). Therefore, it would not be surprising if bronze figurines in an Egyptianizing style were also produced at that time.

T.S.K.

BIBLIOGRAPHY
D. Wildung, *L'Âge d'or de l'Égypte*, Fribourg, 1984, fig. 164, p. 86, ill. p. 87.

tassel or pendant band suspended from a wide belt and a tall rounded helmet with two pairs of long spread horns springing from its center and what appear to be streamers fluttering from the back. Two beardless men flank this monstrous figure, and, with raised arms, each grasps a horn as he interlocks one of his legs with a leg of the central figure. This group, with its complicated interlacing of limbs, stands on the heads and wings of two seated sphinxes who, in turn, are resting on a pair of pendant lotus-like forms. A finely incised, continuous spiral band extends around the upper, unperforated edge of the appliqué.

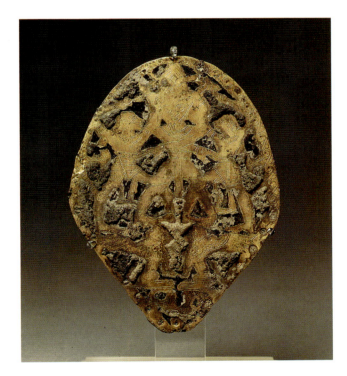

59. *Gold and silver appliqué*

Height, 9.8 cm.; width, 7.2 cm.
The Levant, late second millennium B.C.

This unusual appliqué, with regularly spaced holes for attachment along its lower edges, bears an incised symmetrical composition of figures and decorative patterns silhouetted in gold against a silver background that is now badly corroded. In the center stands a bearded male facing front, his legs flexed to each side and his arms extended and crossed in front of his body. He wears a kilt with a central

The composition has a strongly Egyptian flavor. The central figure closely resembles Bes, the squat Egyptian deity of domestic well-being, who is usually shown frontally. The garb of the flanking figures and their clean-shaven faces also evoke Egyptian rather than Near Eastern parallels, as do the sphinxes and the lotus flowers. The scene as a whole, however, would be unthinkable to an Egyptian, for deities are never shown being subdued by lesser beings.

Instead, it may be that these "exotic" Egyptian images are used to illustrate a Near Eastern story—that of the hero Gilgamesh and his companion Enkidu, who slay Humbaba [Huwawa], the monstrous Guardian of the Cedar Forest. (For a summary of the tale and its history see T. Jacobsen, *The Treasures of Darkness*, New Haven, 1976, pp. 195–203.) Similar scenes also occur in clay and stone reliefs dated to the early first millennium B.C. (H. Frankfort, *The Art and Architecture of the Ancient Orient*, 3rd ed., New York, 1970, p. 296, fig. 346), and copies of the epic, known since at least the sixteenth century B.C., have been found in the seventh-century-B.C. palace of Ashurbanipal at Nineveh.

T. S. K.

Figure 1. Drawing by Elizabeth Simpson of catalogue number 59

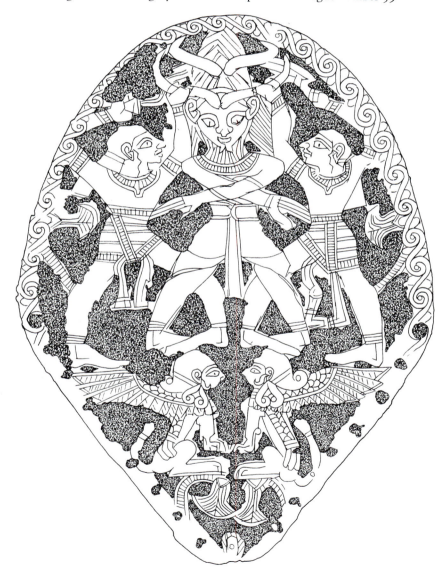

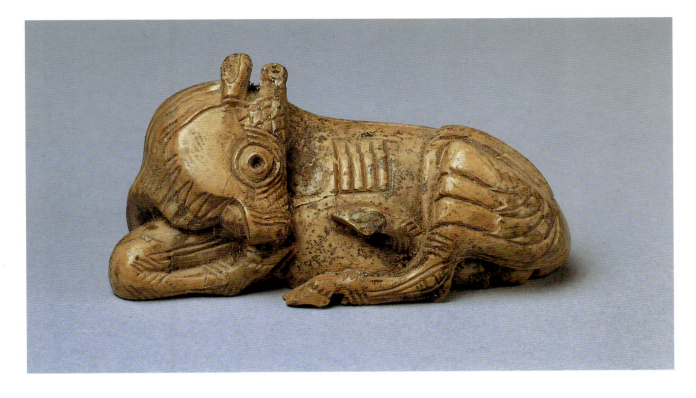

60. *Ivory recumbent bull*

Length, 5 cm.
North Syria, ninth–eighth century B.C.

The small bull, one of whose horns is partly missing, lies with its forelegs folded under its body. The bull's head is turned sharply to its left. Both hind legs extend forward along the left side of the body so that the hooves are visible against the flank. The tail curves under the left haunch and back over the rump. The animal is carved vigorously, with the major segments of the body rendered as fully three-dimensional forms merging organically one with the other. In contrast to this plasticity of form, the sharp, thin lines that delineate hair and musculature create geometric patterns. The contrast between the linear and the sculptural is most keenly seen on the sides of the bull, where the undulations of the ribs beneath the skin are shown by means of three or four straight vertical incisions within a rectangle. A happier combination of line and shape occurs on the left haunch, for there the muscles are indicated by three long, flame-like forms sweeping from left to right. The bottom of the bull is flat and plain, and has only a wedge-like slot with five small holes drilled into the surface.

In the general style of the carving—specifically, such linear details as the flame-like muscles of the hindquarters and the rectangular ribs—the little bull may be associated with the north Syrian school of ivory carving that was active in the ninth and eighth centuries B.C. (R. D. Barnett, *Ancient Ivories in the Middle East* [Qedem 14], Jerusalem, 1982, pp. 40–41, 43–46; I. J. Winter, "Phoenician and North Syrian Ivory Carving in Historical Context: Questions of Style and Distribution," *Iraq* 38, 1976, pp. 1–22).

This little bull closely resembles a group of bulls and calves excavated at Nimrud, an Assyrian royal capital (M. Mallowan, *The Nimrud Ivories*, London, 1978, pp. 50, 51), where they formed part of a vast collection of carved ivories from various Near Eastern sources. The Nimrud objects seem to have fitted on the elaborate lid of a pyxis or circular box (R. D. Barnett, op. cit., p. 44, fig. 17). As the collecting of such *objets de luxe* was a royal prerogative, it is likely that the Levy ivory came from a similar hoard at a royal installation somewhere in the Assyrian Empire.

T. S. K.

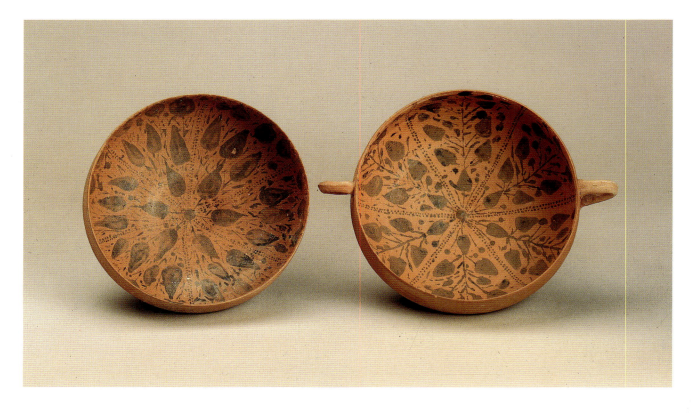

61. *Footed ceramic bowl*

Height, 5.4 cm.; diameter, 11.8 cm.
Nabatean culture (Jordan), first century B.C.—first
 century A.D.

This lovely bowl, which has the same profile as catalogue
number 62, is distinguished not only by its fine fabric and
thin walls but also by the delicacy of its ornament. Lines of
double dots in black slip on the red-clay ground divide the
interior of the bowl into six equal wedge-shaped sections.
Each wedge is fitted with freely painted black leaves inter-
spersed with thin nervous lines, which radiate outward to
the rim. The small round foot is ornamented with a distinc-
tive whorl-like pattern made by multiple impressions with a
straight-edged instrument. In modern times potters often
place distinctive marks on the base of a vessel as a sort of
signature, and one is tempted to read this ancient whorl as
such a distinguishing mark.

T.S.K.

62. *Ceramic bowl with two handles*

Height, 6 cm.; diameter, 11.8 cm.
Nabatean culture (Jordan), first century B.C.—first
 century A.D.

Finely potted, two-handled, red-orange bowls with painted
interiors are characteristic of the best ceramics produced by
Nabatean potters (G. H. Salies and H. G. Horn, eds., *Die
Nabatäer*, Bonn, 1978, p. 84). The interior of the bowl is
divided into six equal wedge-like sections by double dotted
lines that radiate from the center of the vessel. Each wedge
is filled with a leafy branch that springs a single leaf at the
innermost point of the wedge. Sexpartite patterns are com-
mon in the painted ware of the Nabateans. A potter's
workshop has been excavated at Oboda, a caravan stop in
the Negev Desert (A. Negev, *Nabatean Archaeology Today*,
New York and London, 1986, pp. 24, 25), and additional
examples have been excavated at Petra (G. H. Salies and
H. G. Horn, eds., *Die Nabatäer*, Bonn, 1981, p. 130, fig.
8; G. Lankester Harding, *The Antiquities of Jordan*, New
York, 1967, p. 129, pl. 17).

T.S.K.

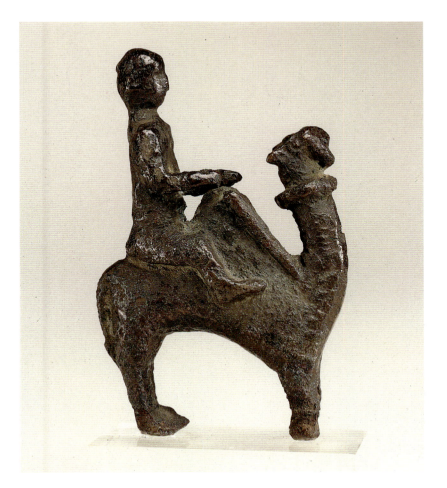

63. *Copper or bronze statuette of a dromedary and rider*

Height, 6.2 cm.

Nabatean culture (Jordan), first century B.C.—first century A.D.

The tall, beardless figure sits behind the dromedary's hump, his right hand resting on a long "stick" that extends along the hump toward the base of the camel's neck. The animal stands with its feet close together and its head thrown back.

The dromedary, or one-humped camel, was the basis of the wealth of the Nabateans, for caravans were an integral part of international commerce in spices between the Red Sea and the Roman ports and markets on the eastern Mediterranean coast. A small dromedary sculpture from Petra of a camel with its head thrown back is very much like the Levy

example (G. H. Salies and H. G. Horn, eds., *Die Nabatäer*, Bonn, 1978, p. 94), while a clay statuette of a laden camel, from the Negev Desert, indicates that the thick rings around the muzzle and upper neck of the Levy dromedary are the remains of a halter (A. Negev, *Nabatean Archaeology Today*, New York and London, 1986, p. 106, fig. 59). The identification of the Nabateans with their camels is illustrated by a sculpture of a camel with a Graeco-Nabatean inscription deposited near modern Naples (the ancient Greek Neapolis) by a far-traveled Nabatean in the early first millennium A.D. (N. Gluck, *Deities and Dolphins*, New York, 1965, pp. 379–80).

T.S.K.

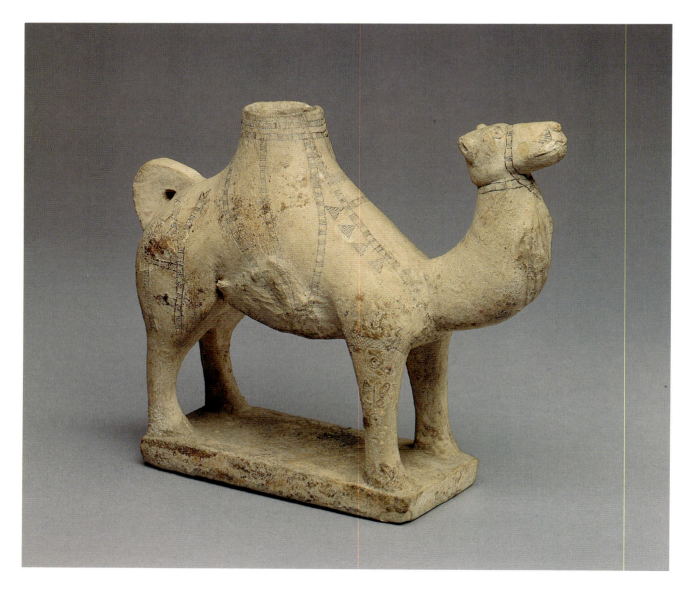

64. *Dromedary incense burner*

Height, 17.1 cm.; length, 20 cm.
Plaster
The Levant or Arabia, early first millennium A.D.

This dromedary, or single-humped camel, is smoothly molded and has a wide array of straps, tassels, and decorative patterns impressed into its surface. Many of the straps, with their decoratively hatched sections, are arranged so that they seem to secure the shallow open cup for the incense to the hump, like a pack.

Although camels play an important role in the lives of the peoples of the Arabian and Sinai peninsulas and appear, as well, in their art, plaster examples are highly unusual. Far more common are small reliefs and figurines carved of a much coarser plaster than the material from which this finely made piece was fashioned. While there is no question of the antiquity of this work, its exact date and place of origin are more difficult to determine.

T.S.K.

65. *Alabaster beardless head, with stone or ceramic eyes*

Height, 31.1 cm.
Southern Arabian Peninsula (modern Yemen), first
 century B.C.—early first century A.D.
Inscribed (on the base): *gubbâ°* / [of the family] *Mašâmân*.

The head and neck, based on simple geometrical forms, rise
from a three-stepped inscribed base. The eyes, the most
prominent feature, are inlaid with what appears to be dark
stone and set under sharply beveled brows divided by a
long, angular nose. The lips are merely a roughly bisected
oval, while the flat ears are surprisingly naturalistic. The
apparently female head was meant to be installed against a
wall or similar surface, as the backs of the base, neck, and
head, and the top of the head as well, are only roughly
finished.

Similar freestanding alabaster heads, along with small
figures in the round, are known from cemeteries, where they
functioned as portraits of the deceased; from sanctuaries,
where they served as votive dedications; and from small
shrines within private houses. These sculptures not only had
inlaid eyes but at times also inlaid eyebrows, hair, and even
moustaches (G. van Beek, *Hajar bin Hameid: Investigations at
a Pre-Islamic Site in Southern Arabia*, Baltimore, 1969, pp.
37, 38, 269, pl. 47 b, c; R. L. Cleveland, *An Ancient South
Arabian Necropolis*, Baltimore, 1965, plates 24, 25; J.
Schmidt, "Ancient South Arabian Sacred Buildings," in W.
Daum, ed., *Yemen, 3000 Years of Art and Civilization in
Arabia Felix*, Innsbruck and Frankfurt, 1987, pp. 78–98).

Little evidence exists for portrait sculpture in south Ara-
bia in the first half of the first millennium B.C. Successive
waves of influence from the Graeco-Roman world, com-
bined with the indigenous tradition of ancestor respect,
gave rise to this distinctive series of images. Despite the
Classical influences, south Arabian alabaster sculpture has a
particular geometric style that is readily distinguished from
provincial Graeco-Roman art.

A date in the first century B.C. is suggested by the form of
the characters in the inscription, as read by Fr. Albert
Jamme of the Department of Semitics, Catholic University,
Washington, D.C.

T.S.K.

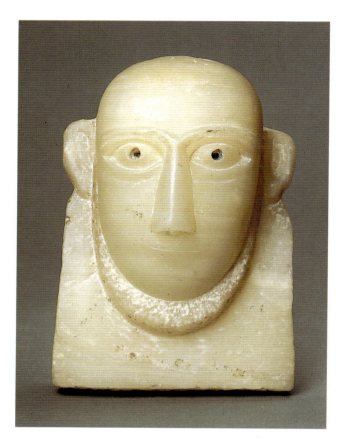
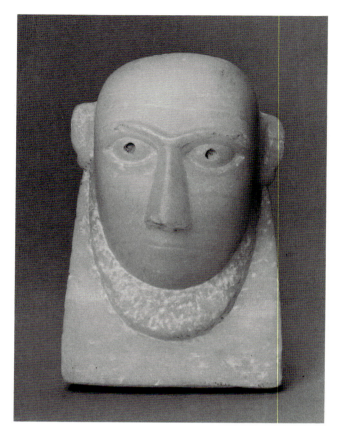

66. *Pair of alabaster relief plaques with male heads*

Height, 18.3 cm. and 17.5 cm.
Southern Arabian Peninsula, Marib region of Yemen,
 first century B.C.–early first century A.D.

Each plaque depicts an oval, seemingly bald head with protruding ears, large eyes with small inlaid pupils (now missing), a long, triangular nose, and a short, thin mouth. The bottom parts of both faces are framed by a flat, narrow beard whose rough texture contrasts with the smoothly polished surface of the head and the lower portion of the plaque. The roughened surfaces of the backs and sides, as well as traces of gypsum on the reverse of one plaque, suggest that both were once installed in walls. Relief plaques with single heads in a variety of styles, including some very close to the Levy examples, are known from the upland region around Marib, the ancient center of the Sabaean Empire. This area contains numerous stone ruins dating from

throughout the first millennium B.C. into the early first millennium A.D.—a period when the region was enriched by the burgeoning Roman demand for spices that linked south Arabia, Ethiopia, and the cultures of the Indian Ocean in a complex trade network (B. Doe, *The Monuments of South Arabia*, New York, 1983, pp. 120–24; R. Bowen and F. Albright, *Archaeological Discoveries in South Arabia*, Baltimore, 1958, pp. 215–75). Excavated relief plaques are known from the cemetery at Timna', whose neighboring city was abandoned in A.D. 10 (R. L. Cleveland, *An Ancient South Arabian Necropolis*, Baltimore, 1965, pp. 16–17, 26, pl. 52 [TC 2173]).

The material was identified as alabaster by the Department of Objects Conservation at The Metropolitan Museum of Art.

T.S.K.

Greek and Etruscan

67. *Wide-mouthed jar*

Height, 57–58 cm.
Terracotta
Probably Minoan, Middle Minoan III, about 1700 B.C.

The bucket-shaped jar is made of a coarse reddish clay. The lip, which occupies the entire space above the handles, is articulated into a thick, plain torus at the very top and two moldings in relief that have been rapidly tooled with a pattern of linked circles or spirals. At east and west there is a horizontal handle, and at north and south a small ring in relief that may be a decorative vestige of a spout; on one side, which may be considered the primary one, this ring marks the center point of the decoration. The bottom of the vase gives the impression of being stepped into three tiers of diminishing circumference, each marked by a tooled molding in relief, comparable to the ones above. The base is flat.

The painted decoration is in a dilute, brownish-gray glaze that, at the top and bottom, covers the whole surface. On the body—which is demarcated below by a reserved band—the glaze has been applied in such a way that a reserved spiral with a dark center seems to spring from each handle. The boundary between glaze and reserve is summarily painted over with a light, transparent color that is also used for the vertical *S*-spiral at the center of each side and for the butterfly-like motifs, as well as for the single flecks that serve as filling ornaments. Directly below each handle is a bud-like form in glaze, as uncouthly drawn as the spirals to either side. Indeed, the heavy potting, coarse clay, mottled glaze, and bold decoration combine to give this vase a quality of rustic vigor.

The center that produced pottery comparable to this jar—and often of higher quality—is Phaistos, the second most important palace on Crete. As Gisela Walberg has demonstrated (*Kamares*, Uppsala, 1976, especially pp. 170–71), jars of a great many varieties were favored on Crete during the later phases of the Middle Minoan period. Although of a different form than that of the Levy example, several vessels from Phaistos show a similar combination of relief and painted decoration, a dark-on-light color scheme, and the use of light outlining (L. Pernier, *Il Palazzo minoico di Festòs* I, Rome, 1935, pp. 146–47). For the date, see G. Walberg, op. cit., p. 111. See also D. Levi, *Annuario della scuola archeologica di Atene*, n.s. 14–16, 1952–54, pp. 403, 411.

J. R. M.

68. *Rhyton*

Height, 27.9 cm.; diameter: of body, 12.2 cm., of
 mouth, 7.53 cm.
Late Helladic II A, 1450–1400 B.C.

Similar elegant rhyta have been found throughout Crete, on
Keos, and on Naxos, but they differ in decoration. The body
of this rhyton has three zones containing variations of the
ogival canopy motif (A. Furumark, *The Mycenaean Pottery*,
1941, pp. 274–76, fig. 37). On the shoulder (which is
slightly offset) are interlocked esses with dots above and
below them; on the bottom (which is perforated) is a star-
shaped curvilinear rosette with dots in between the points.
The canopy motif is also known from three-handled jars
found at Mycenae and at Dendra (see A. J. B. Wace,

"Chamber Tombs at Mycenae," in *Archaeologia* 82, 1932,
chamber tomb 518, pl. 41,16; A. W. Persson, *New Tombs
at Dendra near Midea*, Lund, 1942, chamber tomb 8, p. 43,
fig. 46).

In the absence of a known provenance, it is difficult to
identify with certainty the local style employed here: A
somewhat similar rhyton with coarser decoration was sold
at auction in 1975 (Münzen und Medaillen AG, Basel,
Auktion 51, 14/15 März 1975, p. 12, no. 29, pl. 4); it
was dated to Late Minoan I B–III A (about 1550–about
1380 B.C.), but the attribution to Crete is not entirely
convincing.

D.V.B.

69. *Pyxis*

Height, 21.7 cm.; width, 30.6 cm.; diameter of body, 28.2 cm.

Late Minoan III B—early Late Minoan III C, about 1300–1200 B.C.

The clay and the glaze of this stamnoid vase suggest that it was made on Crete. Its decoration is highly original and without close parallels: On each side, set within a narrow panel, is a double-headed ax with a scalloped-edge shaft. As Costis Davaras has noted (*Arch. Eph.*, 1979 [1981], p. 117), the rendering of the shaft is related to that of the trunks of the two palm trees that appear aslant in each of the flanking panels on the obverse. On the other side, in the panels to either side of the double-headed ax, highly stylized "trunks" replace the palm trees. The trunks, which describe strong diagonals in the flanking squares, have sessile foliage (needles on top; leaves below) sprouting from them. Ornamentation consisting of scale-patterned baskets fills the side panels as well as the spaces between the upper border and the top of the axes in the narrow central panels. The shoulder is covered with a latticework pattern, except for the areas adjacent to the handles. The tops of the handles have broken off, but originally each must have been in the shape of an inverted *U*.

Jane Lloyd has addressed at length the question of parallels and antecedents, and with her kind permission I quote from her extensive notes:

For the shape compare pyxides from the Tholos tomb in the Phourni cemetery at Archanes (I. Sakellaraki, in *Praktika*,

1975 [1977], pp. 264–66, plates 234 d, 236 a, 229 a) and from the north slope of the Acropolis in Athens (*Hesperia* 2, 1933, pp. 367–68, fig. 39 a).

For the panels compare, for example, the decorative scheme on larnakes from Milatos (A. Kanta, *The Late Minoan III Period in Crete*, Göteborg, 1980, p. 128, pl. 52,6), Palaikastro (ibid., pp. 291–92, pl. 102,5), Episkopi (*Arch. Delt.* 6, 1920–21, pp. 158–59, fig. 6), and Kalsampas (A. Kanta, loc. cit., pp. 291–92, pl. 71, 10–11).

For the double-headed ax on a shaft (common in Cretan pottery and on larnakes from Late Minoan I through Late Minoan III B–C) compare vases from Pseira (C. Zervos, *L'Art de la Crète*, Paris, 1956, p. 379, fig. 557), Knossos (ibid., p. 304, fig. 440), Phaistos (ibid., p. 363, fig. 533), Palaikastro (*BSA* 65, 1970, p. 231, pl. 59 c), and Mallia (*Praktika*, 1915, p. 124, fig. 9 center).

For the palm tree, naturalistic renderings of the trunk and the fronds occur in Minoan art as early as Middle Minoan II (about 1900–1700 B.C.) in Knossos (A. Evans, *The Palace of Minos* II, 2, London, 1928, p. 496, fig. 301 A, B) and later in mainland Greek pottery in Late Helladic II (about 1550 B.C.), while more stylized renderings, reduced to mere linear forms, appear first in Late Minoan II and Late Helladic III (1400–1150 B.C.) both on Crete (A. Evans, op. cit., p. 496, fig. 301 D–E, p. 497, fig. 302) and on the mainland (W.-D. Niemeier, *Die Palaststilkeramik*, Berlin, 1985, p. 75, n. 437).

D.V.B.

70. *Stirrup jar*

Height, 23.3 cm.; diameter, 20.6 cm.
Late Minoan III C, about 1200 B.C.

Octopod

The upper part of this almost spheroid vase is decorated on each side with a neatly centered, large, six-tentacled octopod; it occupies more than half the vase, stretching from the spout on one side and the false neck on the other to well below the equator. The tips of the tentacles of one octopod touch those of the creature on the other side. Each octopod's eyes are large, glazed disks bordered by circles, and its body proper, in solid glaze, is heart shaped and outlined with an ornamental border. Horizontal stripes of varying thick-

nesses encircle the lower part of the jar, which has a ring base. Lozenges, chevrons, herringbone patterns, and curved lines comprise the ornamentation that fills the background in the picture zone almost completely. Herringbone patterns are also applied to the outsides of the handles and to the top of the false neck, which is decorated with a spiral set in a circle.

The closest parallels for the shape of the vase are stirrup jars from the island of Rhodes. Representations of octopods with only six tentacles are known from Crete (A. Kanta, *The Late Minoan III Period in Crete*, 1980, pl. 80, 5–6), Rhodes (*CVA* Rhodes, fasc. 2, pl. 2,7–8), Kos (see M. L. Morricone, "Eleona e Langada," 1965–66, pp. 188–89, figs. 196 a–b), Naxos (C. Kardara, *Aplomata Naxos*, 1977, pl. 20, 914, fig. 8, p. 19), and Perati (S. Iakobides, *Perate*, 1969, pl. 93 d, 198, pp. 142–48).

The surface under one handle is somewhat smudged, and the slip has worn off in places. The top of the spout is broken, and the rim is missing.

D.V.B.

BIBLIOGRAPHY
Antiken aus dem östlichen Mittelmeer, Galerie Heidi Vollmoeller, Zurich, 1987, no. 12, ill.

71. *Two armlets (armillae)*
Carpathian, Koszider period, about 1400–1200 B.C.

a. Length, 12.8 cm.; width, 11.43 cm.; depth, 2.75 cm.

b. Length, 12.5 cm.; width, 11.13 cm.; depth, 2.44 cm.

These massive bronze armlets are slightly carinated. Their ends have been hammered into triangular finials, the edges of which are rolled inward. The incised linear decoration— straight lines, zigzags, and triangles—begins on the ends of each armlet and extends to parts of the band of the armlet itself. (For a discussion of finds from Hungary, see Amalia Moszolics, *Bronzefunde des Karpatenbeckens*, Budapest, 1967, pp. 80–81, fig. 24, pp. 235–36, plates 29, 28, and 30,2,3,5.) These early armlets invite comparison with the considerably later armlet in the collection (see cat. no. 80).

D.V.B.

BIBLIOGRAPHY
Origins of Design: Bronze Age and Celtic Masterworks, New York, Michael Ward, Inc. [n.d.], no. 23, ill.

72. *Statuette of a horse*

Height, 11.46 cm.; length, 7.87 cm.; width of plinth:
in front, 5.27 cm., in back, 4.94 cm.
Laconian, third quarter of the eighth century B.C.

This horse, cast in the lost-wax process, is remarkable for
the reduced volume of the trunk and the flat neck and
shoulders, which place it stylistically in the Late Geometric
period. Although less stiff and somewhat lankier than most
contemporary Laconian horses, it is compatible with the
ears, and the rigid tail that joins an extension of the plinth.
The rounded and rather substantial modeling of the hooves
reveals a certain influence of the Argive type.
hooves reveals a certain influence of the Argive type.

By contrast, the plinth, with its eighteen small openwork
triangles arranged in four rows that describe two zigzags, is
typically Laconian. As is customary, the plinth and its
extension for the tail were hollowed out before casting. The
frame of the plinth, as well as the borders of its two

openwork fields separated by a channel, are in relief, like the
lateral borders of the caudal extension.

Both in the resemblance of its head to that of a dog and
in its rather cumbersome form (except for the neck and
shoulders), this horse can be compared with two in Geneva
(see J.-L. Zimmermann, *Les Chevaux de bronze dans l'art
géométrique grec*, Mainz and Geneva, 1989, LAC 98, 99). It is
close to the group of two yoked horses, in The Metropolitan
Museum of Art (1972.118.56; D. von Bothmer, *Ancient Art
in New York Private Collections*, 1961, p. 32, no. 125, pl.
42), and its proportions are similar to those of a horse from
Olympia in the Louvre (A. de Ridder, *Bronzes antiques du
Louvre* I, Paris, 1913, p. 19, no. 89).

The surface has suffered from overcleaning, but the
patina—dark to blackish green—remains on the underside
of the plinth, together with soil incrustation.

J.-L.Z.

There are dotted circles on the legs, and multiple zigzags on the sides of the plinth.

The horse was formerly in the collections of Breckenridge Long; B. D. Palmer; Eric de Kolb.

J.-L. Z.

BIBLIOGRAPHY
D. G. Mitten and S. F. Doeringer, *Master Bronzes from the Classical World*, Mainz, 1967, p. 38, no. 19; H. Hoffmann, *Ten Centuries that Shaped the West . . .* , Houston, 1970, p. 127; N. Himmelmann, in *AA*, 1974, p. 550, n. 17; P. J. Connor, in A. Cambitoglou, ed., *Studies in Honour of A. D. Trendall*, 1979, pp. 62–63; J. M. Eisenberg, *Art of the Ancient World* 4, Royal-Athena Galleries, New York and Beverly Hills, 1985, no. 17; J.-L. Zimmermann, *Les Chevaux de bronze dans l'art géométrique grec*, Mainz and Geneva, 1989, pp. 243, 248, THE 12, pl. 56.

73. *Statuette of a horse*

Height: overall, 8.05 cm., of base, .67 cm.; length: overall, 7.7 cm., of base, 6.15 cm.; width of base, 1.8 cm.
Thessalian, last quarter of the eighth century B.C.

The elegant horse is Corinthian in type, judging by its manufacture, which involved the modeling in wax of fine rods and cutout plaques that were later assembled. The base, decorated with seven large openwork triangles arranged in a zigzag pattern, also follows a Corinthian tradition. Nevertheless, the stiff contours of the dryly defined forms and the angular joins of surfaces that are as thin as sheet metal reveal Thessalian workmanship, as do such characteristic details as the rounded articulations, and the ears disassociated from the head. The large and rather low hooves, the bell-shaped croup, and the widened shoulders, which add depth to the composition, are elements common to a number of Thessalian animal bronzes of the Late Geometric period. This horse can be compared with three horses from Pherai (H. Biesantz, *Die thessalischen Grabreliefs*, 1965, pp. 32, 109, 159, no. L 67, pl. 52; J.-L. Zimmermann, *Les Chevaux de bronze dans l'art géométrique grec*, Mainz and Geneva, 1989, pp. 244, 249, THE 11, 14).

The bronze is dark to reddish brown, and the blackish patina is partially preserved. Chasing occurs on the ears, the anterior edges of the shoulders, the mane, and the tail.

74. *Statuette of a horse*

Height, 5.91 cm.; length, 5.18 cm.; diameter of base, 3.41 cm.
Thessalian, last quarter of the eighth century B.C.

This horse, whose surfaces are exaggerated at the expense of its volume, stands on an openwork plinth in the shape of a

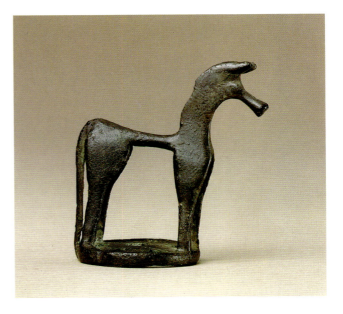

wheel, with six spokes—perhaps an indication that the statuette was intended to represent a draft horse. The wheel and its hub are in relief.

In style and technique, this horse is in the Corinthian tradition, although it is of Thessalian workmanship. The rhythm of the contours, the sinuous mane, the eyes in relief, and the attachment of the ears mark the style as Thessalian, as well. The raised hindquarters, in contrast to the lower positioning of the foreparts, together with the asymmetrical shoulders and hind legs and the radial wheel, argue for the inclusion of this statuette among Late Geometric votive bronzes. Comparable in style and period are the horse from Pherai, in Athens (NM 18739; H. Biesantz, *Die thessalischen Grabreliefs*, Mainz, 1965, pp. 32, 109, 159, no. L 65, pl. 51), and a horse in the Ny Carlsberg Glyptotek, Copenhagen (3313; F. Johansen, *Meddelelser fra Ny Carlsberg Glyptotek* 38, 1982, p. 98, fig. 8, pp. 91, 95, n. 21 b). The head of this horse recalls that of a Thessalian horse in the Ortiz collection (J. Dörig, *Art antique: Collections privées de Suisse Romande*, Geneva, 1975, no. 105). An example comparable in date is a Corinthian horse (Samos B 1206) that, likewise, stands on a wheel (H. Walter and K. Vierneisel, *AM* 74, 1959, pp. 16–17, pl. 27,1). It was found in a context datable to 730–670 B.C.

The Levy horse has a dark green and blackish patina, with chasing on the mane. It was formerly in the collections of Kurt Deppert; Eric de Kolb.

J.-L.Z.

BIBLIOGRAPHY
J. M. Eisenberg, *Art of the Ancient World* 4, Royal-Athena Galleries, New York and Beverly Hills, 1985, no. 20; J.-L. Zimmermann, *Les Chevaux de bronze dans l'art géométrique grec*, Mainz and Geneva, 1989, pp. 244, 252, THE 27 b, n. 79, pl. 58.

75. *Statuette of a doe*

Height, 7.8 cm.; length, 4.8 cm.; width, 2.15 cm.
Thessalian, end of the eighth century B.C.

This Late Geometric doe is modeled with short rods and large plaques, which form its shoulders and legs. The spots on the fur are rendered with dotted circles. It stands on two rhomboid openwork cages. Originally, such objects were worn as pendants, and some perhaps may even have served as rattles to decorate the harnesses of horses, but in the second half of the eighth century B.C. numerous pendants of this kind were created as votive offerings to be hung in the Thessalian sanctuaries at Pherai and Philia. This doe may be compared with a stag from Philia (I. Kilian-Dirlmeier, *Anhänger in Griechenland* [*Prähistorische Bronzefunde*, XI, 2], Munich, 1979, p. 109, no. 611, pl. 32), a ram, in the British Museum (op. cit., p. 120, no. 654, pl. 34), and a horse, perhaps from Philia, in Copenhagen (F. Johansen, *Meddelelser fra Ny Carlsberg Glyptotek* 38, 1982, p. 82, fig. 14, p. 87).

The animal and its support were cast from below in one piece. There are engraved lines on the hooves. It was formerly in the collection of Eric de Kolb.

J.-L.Z.

BIBLIOGRAPHY
D. G. Mitten and S. F. Doeringer, *Master Bronzes from the Classical World*, Mainz, 1967, p. 39, no. 21; I. Kilian-Dirlmeier, *Anhänger in Griechenland* [*Prähistorische Bronzefunde* XI, 2], Munich, 1979, p. 109, no. 610, pl. 32; J. M. Eisenberg, *Art of the Ancient World* 4, Royal-Athena Galleries, New York and Beverly Hills, 1985, no. 17; F. Floren, in W. Fuchs and F. Floren, *Handbuch der griechischen Plastik* I, Munich, 1987, p. 67, n. 339.

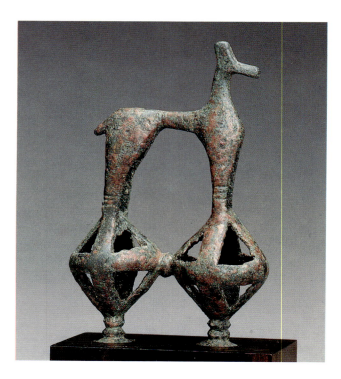

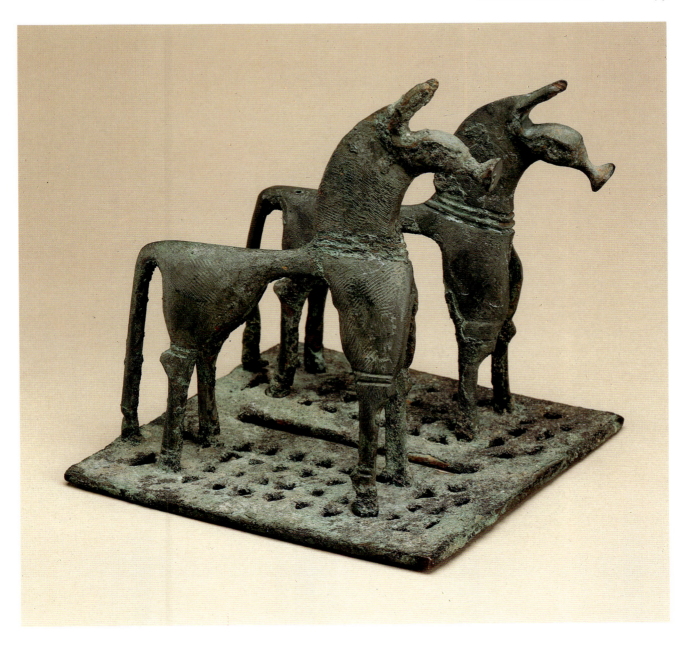

76. *Team of horses*

Height with plinth, 13.5 cm.

Late Geometric, Corinthian (?), second half of the eighth
century B.C.

Unlike other known representations of teams of horses, this
pair, which is attached to a shallow plinth perforated with
triangles, is not connected by a yoke but—like the horses
on the lids of Attic Geometric pyxides—is freestanding.
The flat plinth, which is slit lengthwise between the two
horses, has triangular cutouts that are arranged regularly
but unevenly: Under the left horse the base of each triangle
is formed by the frame of the plinth and a single connecting
rod between the opposed rows; under the right horse there
are two connecting rods, and the tips of the triangles point

toward the lateral frames. Symmetry prevails under the tails, where the triangle below each horse is aligned and its apex points inward. The same symmetry is applied to the space in front of the forelegs, where the cutouts produce two exes linked horizontally in the middle.

The style of the horses owes much to Corinthian conventions—straight backs; thin trunks; trumpet-shaped, flattened muzzles; horizontal, engraved lines above the shoulders, hocks, and knees; and ornamentalized ears with curved contours—but other details are not easily matched elsewhere, making the precise attribution to a Greek site more difficult.

The pair of horses is said to have been found on Corfu, and for at least twenty years was in a collection in Austria. In October 1970, the group was lent to the Kunsthistorisches Museum in Vienna for restoration. At that time the horses were covered with a very heavy incrustation that was removed mechanically, leaving numerous file marks.

The statuettes and their plinth are cast in one piece. The right hind leg of the left horse has become detached from the base, and both horses have been bent slightly out of shape, so that they are now somewhat askew.

The team of horses is unpublished, but some of the salient features noted above can be compared with the horses assigned to Corinth by J.-L. Zimmermann in his monograph *Les Chevaux de bronze dans l'art géométrique grec*, Mainz and Geneva, 1989, plates 42–43.

<div align="right">D. v. B.</div>

77. *Fibula*

Height, 6.12 cm.; length, 9.1 cm.
Thessalian, late eighth century B.C.

The catch plate of this fibula is engraved on both sides. On the outside, within a scalloped border drawn with a compass, a horse is shown in a landscape indicated by a branch in the upper left-hand corner and two triangular elevations on the ground. The space between the horse's left foreleg and hind leg is filled with a bird and a lozenge. The horse's neck and part of its trunk are decorated with fine lines bordered by two broad bands. On the other side, which has the same scalloped outer border, a smaller panel framed by a broad key pattern depicts a stag with its head raised. The field

contains a triangle and a lozenge, and on the ground there is a triangular elevation.

For the style, compare the very close fibula sold at auction in Basel (Münzen und Medaillen AG, *Auktion 51, 14/15 März 1975*, pp. 31–32, pl. 13, no. 83).

The fibula was formerly in the collection of Audrey B. and Stephen R. Currier.

<div align="right">D. v. B.</div>

BIBLIOGRAPHY
D. G. Mitten and S. F. Doeringer, *Master Bronzes from the Classical World*, Mainz, 1967, p. 42, no. 26 (with parallels cited); *Cat. Sotheby's (New York) November 21–22, 1985*, no. 37.

78. *Fibula*

Height, 9.7 cm.; length, 17.3 cm.
Boeotian, eighth century B.C.

The crescent-shaped bow of this fibula terminates in a smaller catch plate. Both the bow and catch plate are decorated with engraved designs. On the obverse of the crescent two horses tied to the same leash flank and face a circular ornament with a rosette in the center. Behind the horses, a dolphin swims toward each corner. Between each horse's head and the central disk is a bird. The scene is framed above and below by linear decorations. Above a zigzag on the catch plate a horse and a fish are shown back to back.

On the reverse of the crescent a man leading a horse appears to the left of the central disk. The design to the right of the disk is much damaged, but may have been the same. On the catch plate a man with arms raised faces an animal.

Although smaller than the most elaborate fibulae of this type in London and in Berlin (R. Hampe, *Frühe griechische Sagenbilder in Böotien*, Athens, 1936, nos. 100–101, plates 1–3, nos. 62 a–b, plates 4–5), the decoration on this fibula follows the same scheme and may well be contemporary. The central disk dominates the scene and the men and fauna are subordinated to it.

The exact chronological sequence of these fibulae is not yet established with certainty, but the eighth century does supply the closest stylistic comparisons, at least in painted vases.

D.V.B.

79. *Finial*

Height, 6.39 cm.; width, 9.12 cm.; depth, 2.38 cm.
Italic (Villanovan), eighth century B.C.

The term Villanovan, named after a site near Bologna, is used to describe the prehistoric culture of central Italy. Its settlements later became the cities that were the centers of Etruscan civilization. Artifacts from the second Villanovan period (about 880–700 B.C.) reflect the influence of imports from Greece, and it is not surprising that the stylized protomai of horses on this finial bear some resemblance to the Greek Geometric statuettes so well represented in this collection.

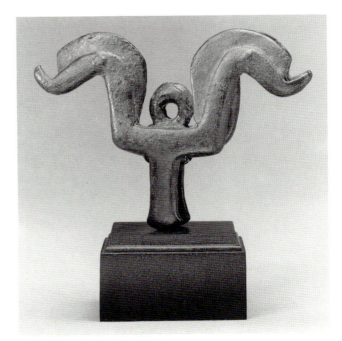

The precise function of this bronze utensil eludes us. The three necks and heads of horses (originally there were four) are joined to a square platform surmounted by a ring that rests on two legs. The sculptor has selected for emphasis the salient features of the horse—a full mane, and a powerful eye, here rendered like a button and placed above the sharp bend of the elongated, upturned muzzle.

D.V.B.

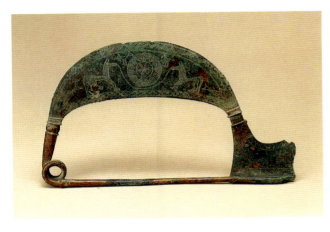

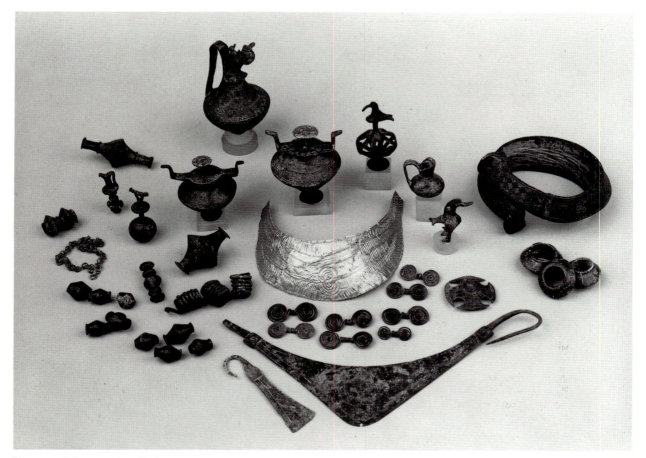

Figure 1. The complete find

80. *Part of a find*
Northern Greece, late eighth–early seventh century B.C.

a. Armlet
 Diameter, 14 cm.
b. Lidded pyxis
 Height, 9 cm.
c. Lidded pyxis
 Height, 7.15 cm.
d. Oinochoe
 Height, 13.5 cm.

The armlet, pyxides, and oinochoe once formed part of a much larger hoard, comprising forty bronze objects and one gold pectoral, known only from an old photograph (see fig. 1). The massive armlet is of a well-known type: carinated on the outside, with blunt, flattened ends, and decorated with punched circular and engraved linear designs. Such bracelets have been found in burials all the way from the northern

Balkans to the Illyrian coast and Albania, as well as in Greek sanctuaries. The two pyxides are each equipped with two lateral extensions to accommodate special lids that fit on the rim; holes in the extensions on both lid and rim line up, so that a string can be inserted through them, allowing the pyxides to be worn as pendants. The present examples are richly decorated with punched concentric circles, chevrons, and lozenges. The beaked oinochoe has two conical bosses on the neck that suggest nipples, and a tubular mouth, open on top like a spout and flanked on either side by perforated lugs to which a bird was attached (one is now missing).

The photograph of the complete find (fig. 1) reveals that, in addition, there was a semicylindrical gold neck ornament with a herringbone pattern; a large triangular pectoral; a small bird pendant in a spherical, openwork cage; a tiny oinochoe; a plump bird modeled like a statuette; a flat strip, which flares out and bears a curved handle; a flat ornament

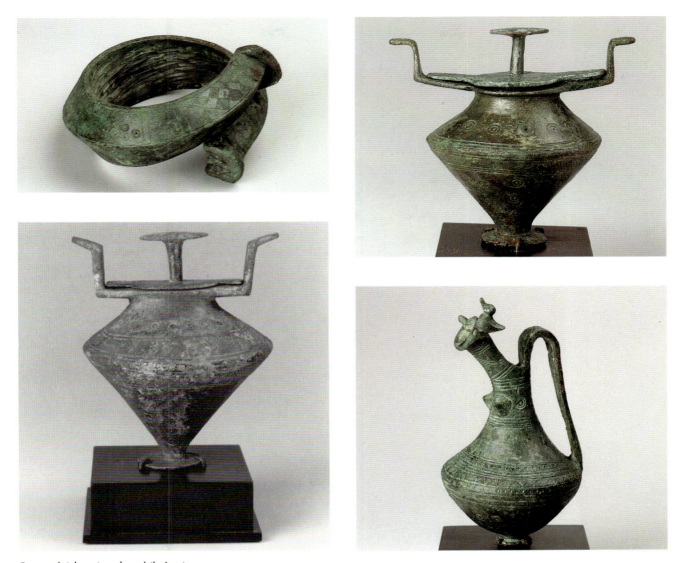

80: *a, b* (above) and *c, d* (below)

in the form of a Maltese cross; eight especially primitive double spirals; a dozen beads; three coils; three rings; two distinctive pendants; and a small chain.

The armlet is perhaps the most impressive object in this group (close parallels exist in two other New York private collections), and the elements of its highly disciplined design—hatched lozenges and triangles; dicing on the flat ends; facing zigzags; and punched dots and circles—preserve both individually and in their juxtapositions many of the admirable features of Geometric period vases. Jan Bouzek, in his excellent monograph (*Graeco-Macedonian Bronzes*, Prague, 1974), has traced the development of this distinct group of bronzes. (Some scholars have begun their investigations of the class with an examination of Central European Hallstatt culture, placing its origins as early as the eighth and as late as the fifth century B.C. [see J. Bouzek, op. cit., p. 163], while others have focused on the comparisons with Late Geometric and sub-Geometric styles.) The wide dissemination of these primarily Macedonian objects suggests that, in antiquity, there was considerable trading, adding to the confusion, but the random incidence of Macedonian artifacts in Greek sanctuaries has also helped to clarify a chronology through the context of the finds, which the many isolated provincial finds do not furnish quite so easily.

D. v. B.

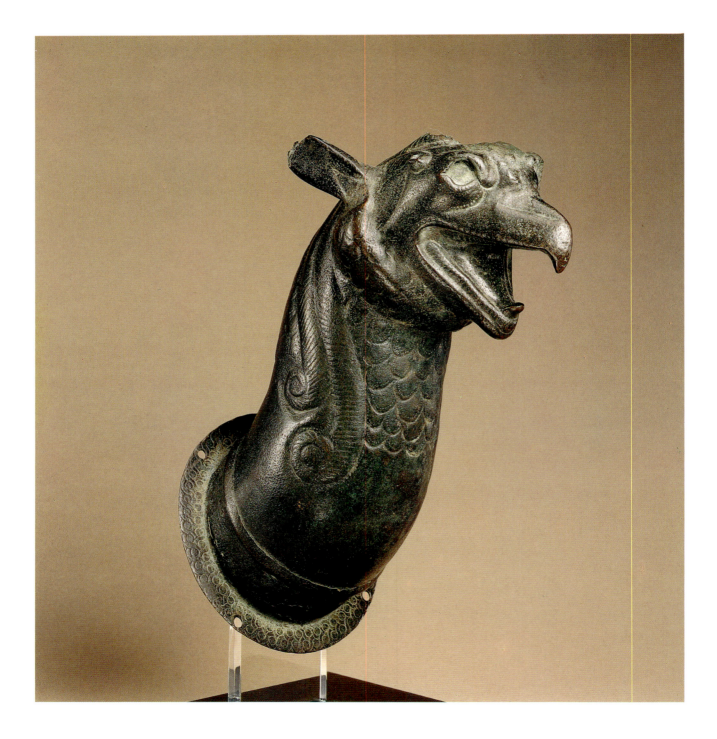

81. *Protome of a griffin*

Height, 24.7 cm.; diameter of collar, 11.1–11.685 cm.
From Olympia, about 680–670 B.C.

Together with two others, this griffin protome once decorated the shoulder of a cauldron to which it was riveted, as indicated by the four rivet holes on the collar. Its beak is wide open, revealing the tip of the tongue and rows of teeth above and below. Two long curls fall on either side of the neck from behind the ears, and the feathers on the upper part of the neck are rendered like the scales of plate armor. The eye sockets are hollow and once may have been filled in with another material. The warts on the forehead and behind each eye are traditional. The knob that normally rises from the forehead has broken off, and one ear has been bent out of shape so that the two are no longer symmetrical. The collar was worked separately and welded to the neck; on its brim is a guilloche.

The earliest cauldron protomai date from the last quarter of the eighth century B.C. and are hammered rather than cast. Hammered griffins continued to be made until the last quarter of the seventh century B.C., but by the second decade of the seventh century such protomai began to be cast; ten years later, cast heads were attached to hammered necks (a tabulation of the duration of the different techniques is given by H.-V. Herrmann [*Die Kessel der Orien-*

talisierenden Zeit (*Olympische Forschungen*, XI), pt. 2, 1979, p. 154]).

The guilloche on the collar is of special interest, as it recurs on the lion protomai of the cauldron found in Vetulonia (*NSc*, 1913, p. 429, fig. 8) and on the griffin protomai from the Tomba Bernardini in Praeneste (U. Jantzen, *Griechische Greifenkessel*, Berlin, 1955, pl. 9,5). Jantzen (op. cit., pp. 36 ff.) has drawn attention to this coincidence and has argued for a Greek manufacture of the protomai from Vetulonia and Praeneste.

The griffin protome was formerly in the collections of von Streit (Athens); J. Scharpf (Münchenstein); M. Schuster (Lausanne).

D. V. B.

BIBLIOGRAPHY
U. Jantzen, *Griechische Greifenkessel*, Berlin, 1955, p. 14, no. 23, pp. 36–37, plates 7, 8.2; P. Amandry, "Objets Orientaux en Grèce et en Italie aux VIIIᵉ et VIIᵉ Siècles avant J.-C.," in *Syria* 35, 1958, p. 88, fig. 2, p. 91; K. Schefold, *Meisterwerke griechischer Kunst*, Basel, 1960, pp. 13, 136–37, II 86; H.-V. Herrmann, *Die Kessel der Orientalisierenden Zeit* [*Olympische Forschungen*, XI], *Kesselprotomen und Stabdreifüsse*, pt. 2, A. Mallwitz, ed., Berlin, 1979, p. 25, no. G 38, pl. 17, pp. 16, 72, 73, 75, 147, 154, 163; *Cat. Sotheby's (London) 10 July 1989*, pp. 61–62, no. 83.

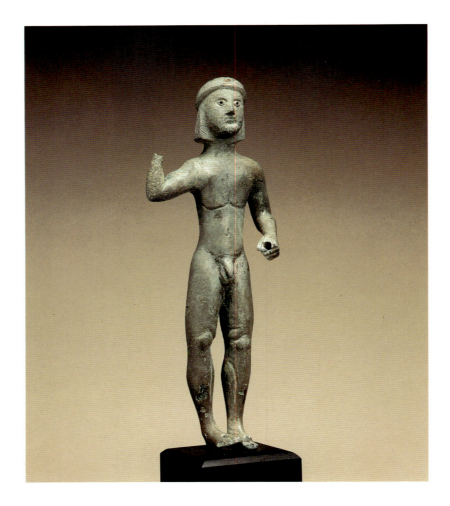

82. *Statuette of a nude warrior*

Height, 18.6 cm.; width, 6.79 cm.
About 650–625 B.C., or later

The raised right arm suggests that the youth once carried a spear, and the bent left arm may well have held a shield. The hair is worn in the fashion associated with the so-called Daedalic style but does not flare out; individual strands are lightly incised at the back. Rivet holes in both feet indicate that the statuette was once attached to a plinth or small pedestal. A gash on the right shoulder and a cutting in the left shoulder blade may be intentional, to accommodate a quiver and a baldric. The pupils of the eyes are hollowed out and may have been inlaid. The navel is rendered by two lightly incised circles and the pubic hair by incised dots. The modeling is rather rough and the workmanship provincial (perhaps northern Greek). Except for the missing right hand and wrist, the state of preservation is good, although the legs are bent somewhat out of shape.

D. V. B.

83. *Bowl with swinging handles*

Height, 3.09 cm.; width across extended handles,
46.5 cm.; diameter, 31.3 cm.
Rhodian, about 630–620 B.C., or perhaps later

The bowl proper is raised from a disk of bronze; two arcs,
equipped with a pair of rings each, are riveted and soldered
to the rim of the bowl, facing each other. The omega-shaped
handles of heavy, cast wire are slipped through the rings,
allowing the bowl to be carried with ease when the handles
are upright. The interior contains engraved ornamentation
in a style identified as Rhodian. In the center a compass-
drawn tondo is filled with a twelve-petaled rosette; the
spandrels between the tips of the petals are stippled to
suggest a background. The radius of the tondo is 3.81
centimeters; at a distance of 7.8 centimeters from the cen-
ter, a decorative engraved zone 3.35 centimeters wide be-
gins, comprising a chain of seventeen palmettes alternating
with as many lotus buds.

While the shallow bowl with swinging handles is not
unique (see F. Villard, in *Mon Piot* 48,2, 1956, p. 36, n. 1),
very few other examples with linear decoration are known.
The finest of these is in the Louvre (Br. 4351; F. Villard, loc.
cit., pp. 25–28, figs. 1–2, pl. 3, pp. 36–41, pl. 4), its
dimensions (height, 3.1 cm.; width, 48.5 cm.; diameter,
29.8 cm.) remarkably similar to those of the present bowl,

as is its decorative scheme: a tondo of four large palmettes
surrounded by two decorated zones separated from each
other and from the rim and central medallion by undeco-
rated areas of differing widths. The design on the Louvre
bowl is more ambitious, for the band near the rim shows a
hare hunt, with a hound and a youth running after the hare
at full speed; the rest of this zone is occupied by a peaceful
procession of ducks. The innermost zone around the tondo
contains a commonplace festoon of addorsed palmettes and
lotuses—a design that continues in vase painting until the
middle of the sixth century B.C.

The Louvre bowl was found with a Rhodian bronze
oinochoe, a small bronze basin and a large bronze dinos
(both undecorated), and three Etruscan terracotta oinochoai
(Bucchero, with incised animal friezes) in a tomb at
Tarquinia.

Villard (op. cit., pp. 36–37) has noted that the Louvre
bowl bears comparison with a somewhat smaller bowl from
Sovano (in Etruria), known until recently only from the
illustration in W. Fröhner, *La Collection Tyszkiewicz*,
Munich, 1892, pl. 15; it was bought for 250 francs at the
Tyszkiewicz sale in Paris, June 8–10, 1898, by Théodore
Reinach. About ten years ago it was rediscovered by Alain
Pasquier in the Villa Grecque Kérylos in Beaulieu-sur-Mer,
and will be published by him in full. The tondo of the

Beaulieu bowl bears a compass-drawn hexafoil rosette with six additional petals, placed sideways along its circular border; the triangular interstices between the center and the petals are stippled, as on the New York bowl. The tondo is framed by scallops and has, in addition, six griffin protomai neatly placed beyond the tip of each petal. These griffins enliven the blank zone around the tondo. A circular band nearer the rim presents a procession of a fallow deer, two panthers, two ibexes, two lions, and two sphinxes, and concludes with a grazing deer.

Clearly, the three bowls are closely interrelated. The third, published here for the first time, will no doubt figure in the lively discussions of Rhodian or other Greek imports into Italy in the late seventh century B.C. (see B. Shefton, *Die "Rhodischen" Bronzekannen*, Mainz, 1979, pp. 21 ff.).

D.V.B.

84. *Statuette of a lion*

Height, 6.68 cm.; width, 2.46 cm.; length, 6 cm.
Laconian, early sixth century B.C.

This little lion, seated on its hind legs, looks more like a pet than the king of beasts. His well-coiffed mane shares the

ornamentalization of a similar statuette in The Metropolitan Museum of Art (25.78.113; MMA *Bulletin* 22, 1927, p. 21), which is said to have been found at Olympia, as well as of the lion adjuncts on one of the earliest bronze hydriai, from Graechwil, now in Bern (E. Diehl, *Die Hydria*, 1964, p. 213, no. B 1). On the hydria in Bern the lions flank and surmount a statuette of Artemis, the mistress of the beasts, who holds two hares and has an eagle perched on her polos. The lions on the rim of the vessel step on snakes, while those on the shoulder are grouped heraldically and are rampant, as on the much earlier lion gate at Mycenae. Those lions, like the small one in the Metropolitan Museum, do not conceal their ferocity, but appear to roar. On later hydriai, of which the newly acquired hydria handle in the Metropolitan Museum (1989.11.1; MMA 119th *Annual Report*, 1988/1989, p. 29) is a splendid example, lions on the lip of a vase are shown couchant. In vases of the last quarter of the sixth century, lions on the lip are paired with recumbent rams on the shoulder; the lions lie down with the lambs, as it were.

The Leon Levy lion once had a tail, which was cast separately; it is now lost, although a hole for attachment, on the back, is preserved.

D.V.B.

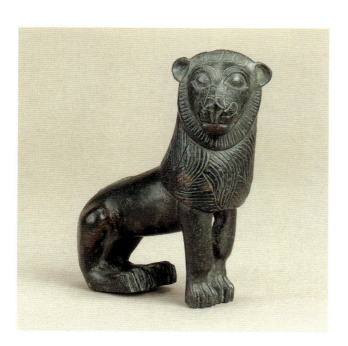

85. *Mirror with columnar base*

Height to top of ring, 32.3 cm.; diameter of disk, 13.8 cm.
Late sixth century B.C.

The highly polished surfaces of Greek mirrors are convex, thus allowing an entire face to be reflected even when the diameters remain relatively small. Two chief types are distinguished: mirrors that have a handle or are equipped with a stand and, later, those resembling modern cosmetic compacts in which the reflecting surface is protected by a hinged cover. Mirrors with a stand often have anthropomorphic supports; on examples from the East women are favored, while in Magna Graecia many supports are of males. A variant is introduced by a small series in which the stand is in the form of a column (see K. A. Neugebauer, *Berliner Museen* 31, 1930, pp. 135 ff.; W.-D. Heilmeyer, *Antikenmuseum Berlin*, 1988, pp. 144–45, no. 11). Mirrors of this type are found both in the East and in the West.

The column of this mirror is fluted on one side only. It terminates above not in a capital but in a torus decorated

with vertical lines on the obverse, and surmounted by an arc that serves as an intermediate member between the column and the disk. Like the column, the arc is decorated on one side only, and has engraved zigzags and a row of small punched holes; its lateral ends are stylized ducks' heads. The nonreflecting, concave side of the disk is richly ornamented: A rosette in the center with forty-two petals is surrounded by eight fan-shaped lotuses, each with a punched dot in the rounded tips of the sepals. The inside of the rim bears the same zigzags as the support. On the convex, mirror side of the disk the frame has a tongue pattern and the edge is beaded. Although equipped with a stand, this mirror also has a swivel ring on top, allowing it to be suspended when not in use.

D.V.B.

86. *Statuette of a centaur*

Height, 6.02 cm.; width, 2.98 cm.; length, 7.12 cm.
East Greek, late sixth century B.C.

The centaur is represented as a naked bearded man to whom the trunk and hindquarters of a horse have been attached. Stylistically, the statuette belongs to a rather large group of primitive bronzes. The nucleus of this group was assembled in 1952 by D. E. L. Haynes (*JHS* 72, 1952, pp. 74–79), who has also shown that the only secure findspot for these bronzes is Cesme, on the coast of Anatolia, about fifty miles west of Smyrna. Although the modeling is rather rough, the centaur is most expressive and his eyes and gesture are rather friendly. A similar centaur, in the British Museum (D. E. L. Haynes, loc. cit., p. 75, no. 10, pl. II d), varies only slightly, and a swimming merman from the group, which is somewhat more detailed, shares the gesture of the arms (op. cit., pl. II e).

The statuette was formerly in the collections of T. L. Fraser; S. Sevadjian; de Frey; Sigmund Morgenroth; Eric de Kolb.

D.V.B.

BIBLIOGRAPHY
D. G. Mitten and S. F. Doeringer, *Master Bronzes from the Classical World*, Mainz, 1967, p. 74, no. 68 (with earlier bibliography).

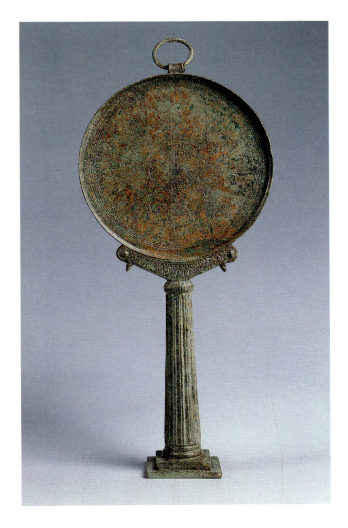

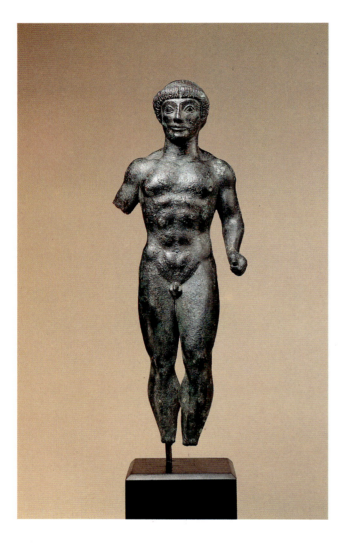

87. *Statuette of a nude youth (kouros)*

Height as preserved, 26.7 cm.
Probably from Magna Graecia rather than Etruria, about
480–470 B.C.

This powerful kouros is represented with his left leg advanced, his left arm slightly bent and held close to his body, and his fist clenched. The right arm is missing above the elbow. The youth's hair is rolled up and tucked under a fillet in back, leaving the ears free. The shorter hair in front ends in tight curls above the eyebrows. The nose, lips, and eyes are well articulated, and the eyebrows as well as the lids are prominent. The body is very athletic: The pectorals are strong; the rectus abdominis, with its many subdivisions, well defined; and all the muscles of the back are indicated. The nipples are inlaid in copper.

The statuette bears a striking stylistic resemblance to that of the bronze javelin thrower, in the Louvre (Br. 3), recently reexamined by J.-R. Jannot and F. Drilhon (*RA*, 1987, pp. 227–50). The Louvre statue, almost twice as big as the Levy kouros, entered the royal collections of France before the French Revolution. Nothing is known of its provenance before then, which has permitted archaeologists to speculate on its stylistic history. While attributions regarding its origins have ranged from Etruscan to Greek (see J.-R. Jannot, op. cit., p. 227, with references), Jannot's verdict that the Louvre bronze "nous semble en tout état de cause le plus étrusque des bronzes grecs" can with equal justification be applied to the Levy bronze.

The missing right arm must have been quite different from the left. Perhaps the right hand was represented with the palm open, so as to accommodate a libation bowl. The bronze from Selinus, now in Castelvetrano (E. Langlotz, *Ancient Greek Sculpture of South Italy and Sicily*, 1965, pl. 81), gives us a complete although artistically poor impression of the probable appearance of the Levy kouros. By the same token, the statue of Apollo, in Bari (E. Langlotz, op. cit., plates 82–83), while somewhat smaller, shares with the statuette published here the same treatment of the dorsal muscles, arched eyebrows and large eyes, and, to a certain extent, even the facial expression.

The cleft in the hair on the forehead does not look accidental; the fillet once may have had an ornament attached that is now lost.

To date, not enough bronzes from southern Italy and Sicily are preserved to allow specific attributions to local workshops to be made. It also must be considered that the arts of Magna Graecia were exposed to many influences— Etruscan, native Italic, as well as the styles of the many immigrants from different parts of Greece who settled in southern Italy.

D. V. B.

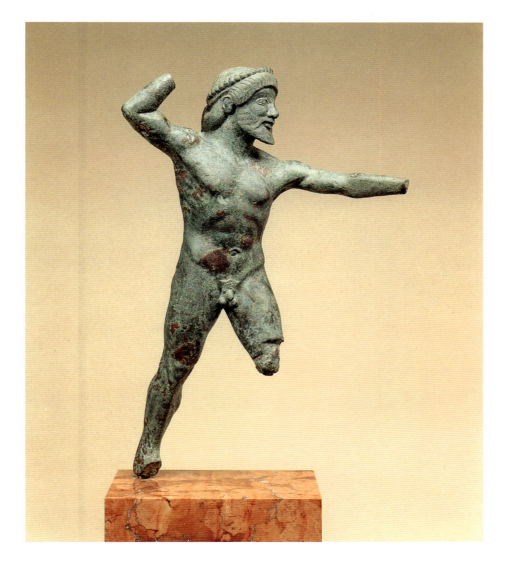

88. *Statuette of Zeus or Poseidon*

Height as preserved, 23.4 cm.
Late sixth–early fifth century B.C.

A nude god is shown in a fighting pose. Carefully balanced on both legs with the left one advanced, he has raised his right arm to hurl a spear, trident, or thunderbolt. His left arm is extended, and in his hand he may have held a fish or an eagle, but as both hands are missing this is only speculation. As J. R. Mertens has observed, the god somewhat resembles a similar statuette in The Metropolitan Museum of Art (21.88.24; G. M. A. Richter, in MMA *Bulletin* 18, 1923, pp. 73–75, fig. 6; *idem*, *Handbook of the Greek Collection*, 1953, pp. 67, 208, fig. 48 b, p. 299, n. 5), which has been variously interpreted as Zeus or a giant (E. Langlotz, *Frühgriechische Bildhauerschulen*, Nuremberg, 1927, p. 100, pl. 55 b). However, the left arm of the latter statuette is lowered, and the right arm is held at a different angle, so that the pose of this figure has more in common with that of the Herakles in Thebes and with the one in the Louvre (E. Langlotz, op. cit., pl. 30). Yet, the long hair tucked in back under the knotted fillet and the long spade-shaped beard preclude identification of the figure as the hero, whose hair and beard are always shown trimmed.

D. V. B.

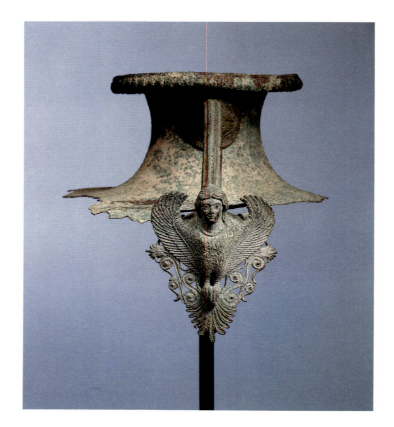

89. *Upper part of a hydria (mouth, neck, shoulder, and vertical handle)*

Diameter of mouth, 15.6 cm.; height of handle, 18 cm.
Mid-fifth century B.C.

The body of the hydria was hammered from sheet bronze and thus suffered more when the vase was in the ground than did the fluted handle, which was cast. For the lower attachment of the handle, which was soldered to the wall of the vase, the artists preferred winged figures and scroll-work, since the decorative devices gave them more surface for a firmer solder. Here—as on the majority of bronze hydriai in the Early Classic and Classic periods—the frontal figure is a siren. Both her wings are raised, and her talons grip the center of a palmette. The siren's head is indistinguishable from that of a beautiful maiden, and her hair, which is parted in the middle, falls in tresses over her shoulders. The incised feathers on the chest (although not the coiffure) recall a hydria in the Harvard University Art Museums (1949.89; E. Diehl, *Die Hydria*, 1964, p. 211, no. B 147), one from Thebes, in Athens (NM 7914; op. cit., no. B 148), one in London (1927.7–13.1; loc. cit., no. B

146), and a fourth in the Ceramicus in Athens (13789; loc. cit., no. B 149).

D. V. B.

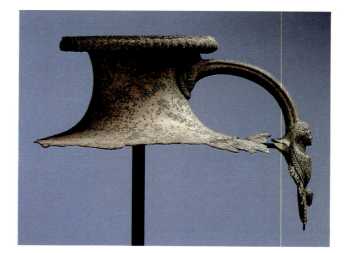

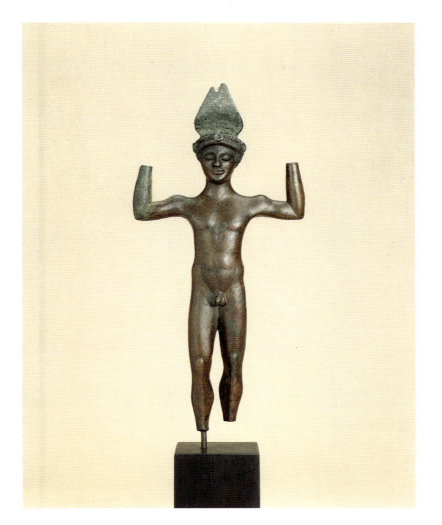

90. *Mirror handle*

Height, 17 cm.; width, 8.16 cm.
About 460 B.C.

The style and workmanship of this statuette of a nude youth, which once served as a handle, suggest that it originated in southern Italy (Magna Graecia), where many anthropomorphic handles have been found, the majority of which are mirror supports (see U. Jantzen, *Bronzewerkstätten in Grossgriechenland und Sizilien* [*JdI* suppl. 13], 1937, pp. 66–68). The size and curvature of the ivy leaf behind the youth's head indicate that the figure was the support of a mirror rather than of a shallow pan, the most splendid example of which is the patera from Pozzuoli (near Naples), in the Cabinet des Médailles, Paris (1428; C. Rolley, *Greek*

Bronzes, 1986, p. 136, no. 117). Since the youth's legs are somewhat apart, the feet (now missing) must have stood on a base—perhaps a rectangular one—as does the similar figure of a youth, in the Cabinet des Médailles, Paris (99; U. Jantzen, op. cit., p. 7, n. 1, pl. 31, figs. 130–131). The figure in Paris has the same facial features, breasts, nipples, and stance (the right leg advanced), and the same slender proportions; however, his arms are not raised, and the fillet in his hair is not decorated with three rosettes.

This mirror handle was once lent by its previous owner (N. Heeremanek) to The Brooklyn Museum (L 78.17.45).

D. V. B.

91. *Greave for the left leg*

Height, 50.4 cm.; width, 10.7 cm.; average depth,
.295 cm.
Apulian (?), sixth–fifth century B.C.

Greaves were an important part of ancient armor, especially
in the Greek and Roman world, where warriors, unlike the
Celts in the North or the Scythians, Thracians, and Persians
in the East and Northeast, did not wear trousers but short
tunics.

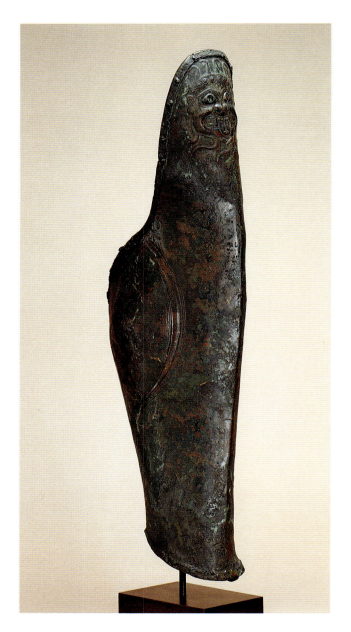

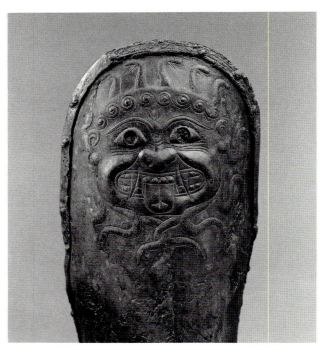

91: detail of kneecap

The desire to decorate bronze utensils goes back to
the beginning of Greek art, and armor was no exception,
as we recall from Homer's description of the smithy of
Hephaistos, who was asked by Thetis to make (in record
time) a new set of armor for her son, Achilles. Helmets and
cuirasses often have delicate engravings or reliefs; cheek-
pieces are engraved or strengthened by figural reliefs;
shields have artistic blazons. Greaves do not provide quite
the same surface for artistic embellishment, but the upper
part that covered the kneecap was ideal, as on the present
greave. What better subject for the knee, this most sensitive
part of the leg, than the image of a terrifying gorgon to
protect it! A pair of greaves in Karlsruhe (727; K. Schu-
macher, *Beschreibung der Sammlung Antiker Bronzen*, Karlsruhe,
1890, p. 141, pl. 13) bears only the severed head of Me-
dusa, the gorgoneion, but a similar pair in the British
Museum, likewise from Ruvo in Apulia, shows the whole
figure of a running gorgon (H. B. Walters, *Bronzes, Greek,
Roman, and Etruscan in the Department of Greek and Roman
Antiquities, British Museum*, 1899, p. 26, no. 249; *A Guide
to the Exhibition Illustrating Greek and Roman Life²*, London,
1920, p. 89, fig. 87, no. 223). On both pairs of greaves,
the eyes, teeth, and tongues are inlaid in ivory. The heads
are worked in repoussé, but the bodies that the artist of the
London pair has added are merely engraved. On a more
barbaric example of this greave type, from Vratsa in Bul-

garia (MMA *Bulletin* 35, 1977/78, p. 35), dated to the early fourth century B.C., the gorgon's head has become less monstrous, but her hair ends in ferocious lions, and other snake-like monsters enliven the lower part of the greave.

The pupils of the eyes on the present greave are inlaid in amber. It is closest to the pair from Ruvo, in the British Museum, and may have been made in Magna Graecia.

<div align="right">D.V.B.</div>

BIBLIOGRAPHY
Münzen und Medaillen AG, Basel, *Auktion 51, 14/15 März 1975*, pp. 97–98, pl. 57, no. 216.

92. *Candelabrum*

Height: overall, 122.7 cm., of figures on finial,
 9.48 cm.
Etruscan, mid-fifth century B.C.

This elaborate candlestand was made in separate pieces. It is supported by a tripod with three feline feet and crowned by a capital decorated with a kymation and beading, into which a long fluted shaft has been fitted. On the upper end

92: detail of finial

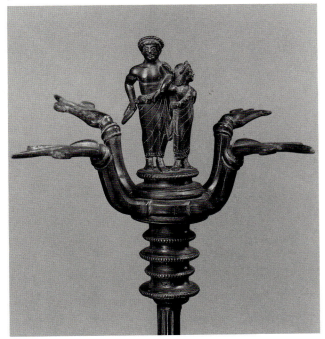

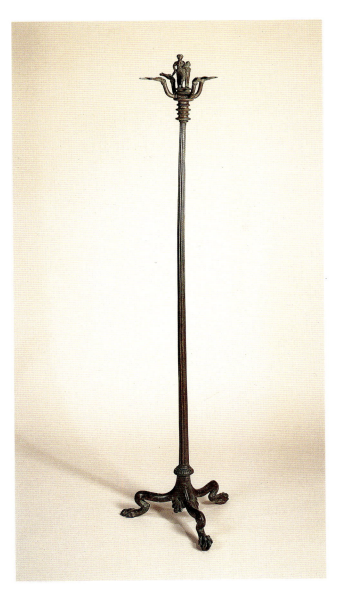

of the shaft four reels furnish the transition to the four-pronged ring, which is surmounted by the finial. The figural finials of such candelabra are among the finest Etruscan bronzes preserved and transcend the level of mere sculptural adjuncts. These candelabra are composed not only of single statuettes of athletes and warriors but also of groups of two figures walking side by side: Here, a youth has placed his left hand on the shoulder of a smaller boy who looks the other way. The composition and the style are comparable to those of an Etruscan candelabrum of the same period in the collection of E. Borowski in Toronto, on which

the companion of the youth is a little girl who looks up at her friend. These groupings also include warriors (for example, Berlin, Fr. 696), heroes (The Metropolitan Museum of Art, 61.11.3; MMA *Bulletin* 20, 1961–62, p. 52), and satyrs and maenads (London, 590; *JdI* 58, 1943, p. 260, fig. 41).

Two of the prongs that held the candles are bent out of

shape, and the right hand of the youth was damaged and has been restored.

For the use of candelabra in Etruria see A. Testa, in *Mélanges de l'École française de Rome: Antiquité* 95, pt. 2, 1983, pp. 599 ff.

D.v.B.

93. *Strainer*

Length, 24.3 cm.; diameter, 10.855 cm.
Third century B.C.

Wine strainers were essential at ancient banquets, for the wine drawn from kraters with ladles or oinochoai was not free from dregs and had to be strained before being poured into drinking cups. The handle is worked separately and soldered to the strainer proper; it terminates in the head and neck of a duck. The finial is turned sideways, allowing the strainer to be suspended when not in use.

The perforation of the sieve follows the configuration of a hexafoil rosette. The artist was not bound by tradition and had considerable freedom arranging the holes in pleasing patterns. The conceit of having the handle terminate in a duck's head goes back to the sixth century B.C., especially to East Greek or Achaemenid bronze and silver strainers (see The Metropolitan Museum of Art, 68.11.58; MMA *Bulletin* 42, 1984/85, p. 43, no. 66). On Attic vases, such strainers are often shown carried by young attendants at banquets.

D.v.B.

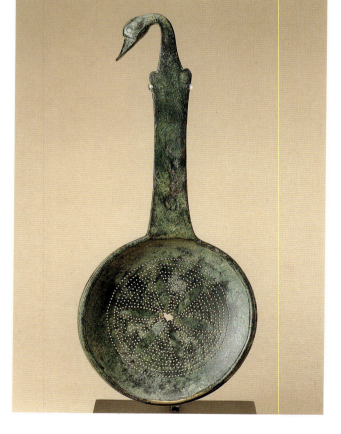

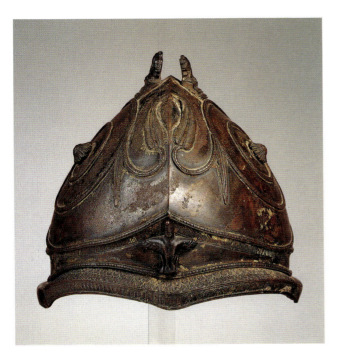

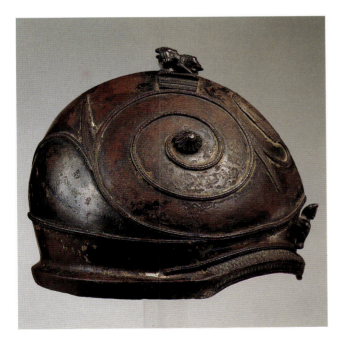

94. *Helmet*

Height, 20.5 cm.; length, 22 cm.; width, 20.3 cm.
Italic, late fifth–early fourth century B.C.

Helmets with a pronounced brim were developed in Italy in the seventh century B.C. and were extremely popular. In addition to rather simple, more utilitarian than decorative versions, armorers also made elaborate helmets, the so-called parade helmets (or *Prunkhelme*), which are masterpieces of design and execution.

This helmet, a recent Levy acquisition, is closest to a helmet allegedly found in Pisa and now in Berlin (H. Pflug, in *Antike Helme, Sammlung Lipperheide und andere Bestände des Antikenmuseums Berlin*, Mainz, 1988, p. 485, no. 85). The narrow brim on each example is decorated with a scale pattern, and the frontlet has a sculptural adjunct: on the Berlin helmet, a gorgoneion; here, a frontal sphinx. Two reliefs of lions on top of the helmet served in antiquity to hold the crest. The two bosses halfway down the bowl—originally, rivet heads by which a leather liner was fastened to the helmet—have now become the centers of ornamental spirals: On the Berlin helmet the two spirals are joined in the back; on the Levy helmet their direction is reversed and the volutes merge with the upper border of the pedimental frontlet, with branches ending in fern-like leaves curving elegantly across the upper part of the front. These two tendrils are applied symmetrically but are not joined together. Other elongated leaves issue from the spandrels between the tendrils and the spirals.

Pflug (loc. cit.) calls the elements that make up the pattern on top of the brim—which are the same on both helmets—scales, and relates them to the aegis to which Athena attached her gorgoneion, shown on the frontlet of the Berlin helmet. On the Levy helmet, however, as noted above, a frontal sphinx takes the place of the gorgoneion. Therefore it may be argued that the scales there actually represent the feathers that sphinxes sported on their chests in images of them dating from as early as the sixth century B.C.

D.V.B.

BIBLIOGRAPHY
Cat. Christie's (London) 6 June 1989, pp. 60–61, no. 518.

95. *Set of armor from a burial*
Apulian, about 330 B.C.

a. Carinated "south Italian-Chalcidian" helmet, with
 volutes over the temples
 Height, 26.3 cm.; width, 19.2 cm.; depth, 25 cm.;
 thickness, 1.3–1.8 mm.

b. Long "muscle" cuirass
 Height: in front, 41.1 cm., in back, 48.8 cm.;
 width: in front, 25.6 and 33.2 cm., in back, 33.2
 and 36.5 cm.; depth: in front, 1–1.5 mm., in
 back, 1–1.5 mm.

c. Pair of greaves
 Height: of left greave, 43.3 cm.; of right greave,
 41.1 cm.; diameters: of left greave, 8.9 cm. and
 4 cm., of right greave, 7.1 cm. and 4 cm.

d. Chamfron
 Length, 48.3 cm.; width, 18.4 cm.; depth, 1 mm.

e. Muzzle of a horse
 Length, 27.1 cm.; width, 11.4 cm.; depth, 1.8–3
 mm.

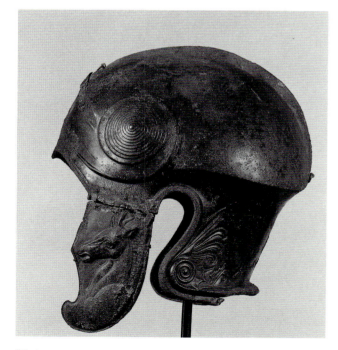

95 *a*

a. The cheekpieces are decorated with the protomai of
horses in low relief. The horse at the left has a topknot. On
the nape of the helmet a palmette is rendered above a volute
tendril; the lateral spandrels behind the cutouts for the ears
are filled with volutes that terminate in half-palmettes, and
acanthus and flower tendrils. The double profile of the brim
terminates on the level of the nape in a folded leaf with a
central rib. The carination of the bowl is unusually high; on
its ends it is equipped with small rings for the fastening of
the crest. A ridge setting off the nape guard from the bowl
extends to the area of the temples, which are decorated with
large spirals, connected above the forehead by an engraved
diadem whose apex is directly below the beginning of the
longitudinal rib. In the middle of the pediment formed by
the edge of the forehead and the diadem is an engraved
palmette with lateral tendrils. Below the ovolo of the pedi-
ment, bands with engraved locks of hair terminate in the
heads of lions. The spandrels between the spirals over the
temples and the triangular frontlet are filled with palmette
tendrils and lotus flowers.

Even in antiquity, the engraved decoration became so
effaced that the helmet had to be redecorated. A strip of
silver, embellished with a chased lotus blossom, was sol-
dered over the engraved ornamentation. In the center of the
frontlet, traces of an oval appliqué can still be discerned.

Both cheekpieces are worked separately and are riveted to
the helmet by means of hinges. On the poll of the helmet,
on either side of the central rib, there are traces of solder
from a transverse crest support. Both cheekpieces are bro-
ken off and their hinges damaged. Only a fragment of the
silver strip added later to the frontlet remains on the left
side of the forehead.

The type of helmet (D. Cahn, *Waffen und Zaumzeug*,
Basel, Antikenmuseum, 1989, p. 41, fig. 14, p. 71, fig.
36), which has been found in southern Italy in Apulia, the
Abruzzi, around Capua, and at Paestum, has been subdi-
vided into four distinct groups. The Levy helmet, with its
longitudinal rib and lateral spirals, belongs to the fourth
subgroup, dated to the second half of the fourth century
B.C. The date of the helmet is based on the many finds of
armor in Apulia buried with Apulian red-figured vases, for
which we have an established chronology.

The archaizing style of the engraving, which follows a
tradition of Chalcidian helmets from Magna Graecia of the
late sixth century B.C., is remarkable. For horse protomai
on cheekpieces few parallels are published (H. Pflug, *Schutz
und Zier*, Basel, Antikenmuseum, 1989, p. 93, no. 84); for
the (lost) appliqué on the frontlet compare an Apulian
helmet in a private collection (D. Cahn, op. cit., p. 35, W
20).

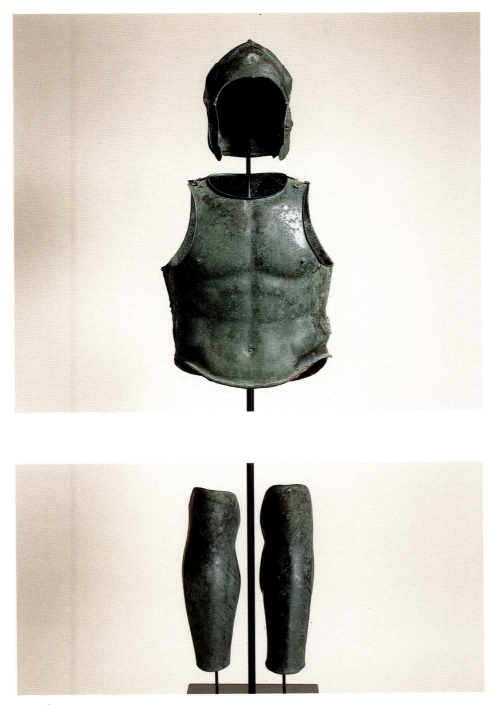

95 *a*, *b*, *c*

b. Apulian "muscle" cuirasses are always without shoulder flaps; the fronts and backs originally were held together by two tubular hinges on each side, through which a bronze pin was inserted. In addition, provision was made to wear the cuirass by fastening the front and back, independent of the hinges, with thongs or chains attached to rings situated

95 *d*

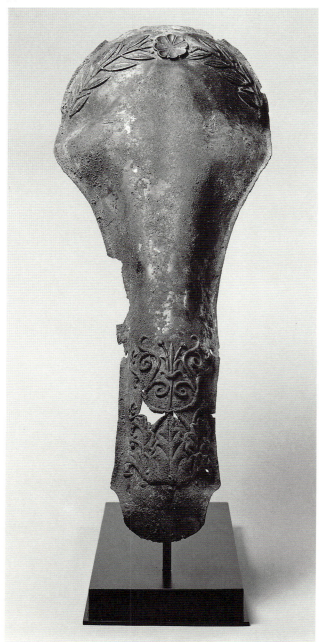

behind the hinges. The shoulders of the front and back of this cuirass were held together only by thongs attached to rings.

The neck opening is large, as is usual for this group. Traces of solder on the shoulder (perhaps also on the sides) indicate that the fastenings were decorated with palmette appliqués. In the course of an ancient repair the hinges on the right side were replaced by soldered bands decorated with a tendril and closed off by an oblong strip of bronze, crimped above and below, that was fitted over the edges of the front and back. This allowed successive owners greater flexibility in adjusting the fit. The muscles indicated on the front follow the idealized anatomy of the wearer, with the pectorals, the rectus abdominis, the navel, the linea alba, and even the nipples clearly indicated; the serratus anterior and the external oblique are tensed, and the iliac crest follows the lower edge of the breastplate. The muscles on the back—intraspinatus, teres minor and teres major, trapezius, and latissimus dorsi—are carefully marked, as is the spine. The lower edges of the front and back are reinforced by an iron hoop.

95 *e*

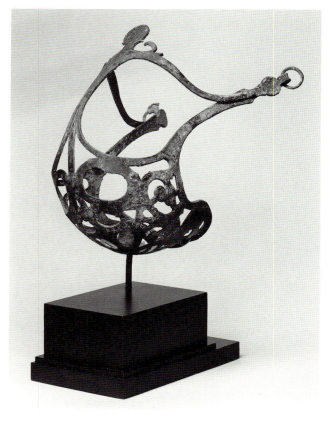

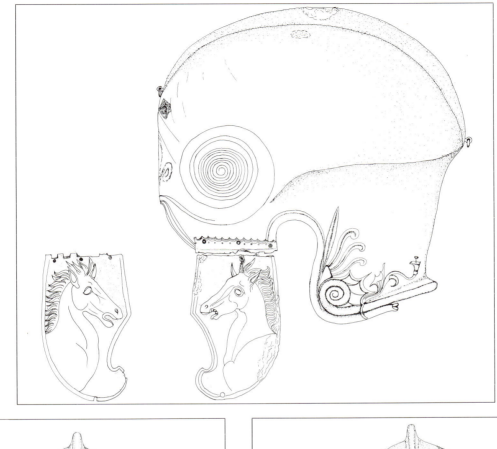

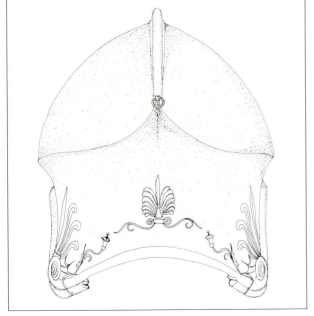

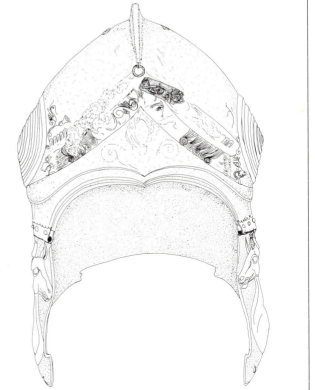

Figures 1, 2, 3. Drawings (scale 1:3) by David Cahn of the helmet, catalogue number 95 *a*: side view (top), back view (above left), front view (above right)

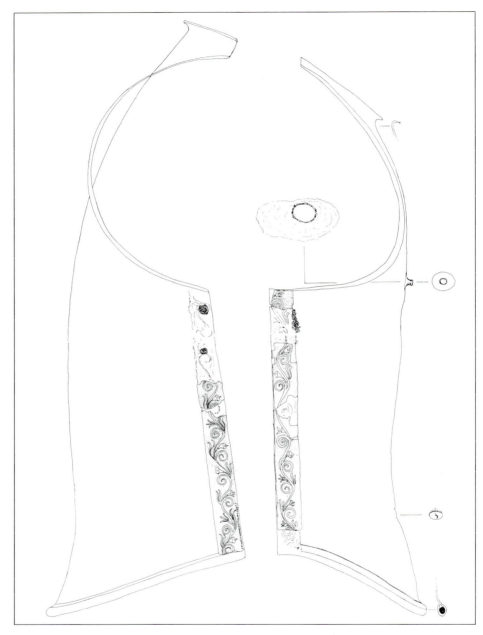

Figure 4. Drawing (scale 1:3) by David Cahn of the side view of the cuirass, catalogue number 95 *b*

Figure 5. Cross-section drawing (scale 1:3) by David Cahn of the cuirass, catalogue number 95 *b*, showing the (a) view of the shoulders; (b) cut through the cuirass at breast level; (c) cut through the cuirass at the height of the umbilicus

Figure 6. Drawing (scale 1:3) by David Cahn of the left side of the cuirass, catalogue number 95 *b*, showing the hinges

Figure 7. Drawing (scale 1:3) by David Cahn of the right side of the cuirass, catalogue number 95 *b*, showing the interconnected strip of bronze

Figure 8. Drawing (scale 1:3) by David Cahn of the front of the chamfron, catalogue number 95 *d*, showing the repair on the inside

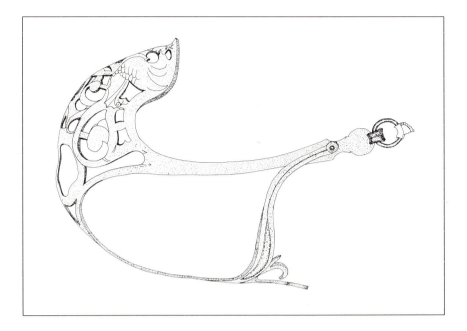

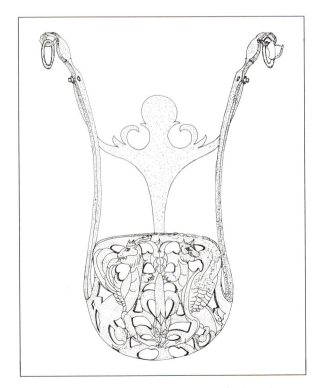

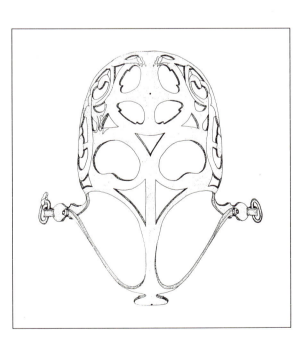

Figures 9, 10, 11. Drawings (scale 1:3) by David Cahn of the muzzle, catalogue number 95 *e*: side view (top), view from above (left), view from below (right)

More than thirty cuirasses have been found, mostly in Apulia, and these may be classified into several types (D. Cahn, op. cit., p. 43, W 23 b, with full bibliography). The Levy cuirass belongs to the group characterized by narrow shoulders not requiring hinges, and especially wide neck openings (see J.-L. Zimmermann, in *J. Paul Getty Museum Journal* 10, 1982, p. 137). The increasing girth of the lower edges of this armor demonstrates that it was used by horsemen who, seated on their mounts, needed more protection in those parts, whereas foot soldiers would have been hampered by it. Like the helmet, cuirasses of this type have come to light, usually with a wealth of ceramic material, in many monumental chamber tombs in Apulia. A date between 340 and 320 B.C. has been suggested for these finds.

c. The kneecap of each greave terminates below in a triangle centered on the ridge of the shinbone. The calf muscles are outlined by an ess-shaped depression. The ornamentalization recalls the style of the sixth century B.C.: Perhaps the greaves were used by several generations, or the south Italian armorers continued the type over a long period of time. In Greece, in the course of the fifth century, greaves were no longer worn quite so universally, but in the Greek periphery their use continued unabated (see the greave in this collection, cat. no. 91).

d. This chamfron completely covers the head of a horse like a second skin, from the forehead to the nostrils, subtly revealing the underlying bone structure. The head is crowned with a laurel wreath tied with a central rosette. The nose is covered with an acanthus calyx, a central lily, bluebells, and other blossoms, as well as tendrils with poppies. A break below the calyx was repaired in antiquity with a bronze sheet attached to the underside of the chamfron with four rivets. The edge is slightly everted. Three holes—one on each side and one on top—served for the attachment to a halter made of thongs. Small leaf-shaped traces of solder above the eyes mark the places where additional decorative elements—perhaps plumes—once were attached.

This chamfron is closely related to three others from a single workshop (see D. Cahn, op. cit, p. 46, no. W 23 d, p. 64, no. W 24, with full bibliography). All four chamfrons were found with "south Italian-Chalcidian" helmets, long "muscle" cuirasses, and greaves; three of the four come from tombs that also contained Apulian red-figured vases (see D. Cahn, op. cit., p. 39). Each chamfron was a singleton, and hence did not belong to a team of horses but to the mount of the rider buried in the tomb.

e. Mounted horses were not muzzled, but such restraints were needed when the horse was unbridled and had to be curried. This muzzle, of delicate à jour workmanship, is covered with green patina that all but obscures the fine engraved decoration: A central palmette with a lotus bud grows out of an acanthus calyx between two rampant winged lion-griffins whose heads are turned back. Their bodies terminate in long acanthus tendrils that frame the kidney-shaped openings for the nostrils. The two lateral curved straps end in eyelets that hold the rings for the leather thongs. They are connected by crosspieces with decorative rivets that issue from the back of the nosepiece. The latter is flanked at its decorative finial by two addorsed volutes.

There is a rare precursor of this muzzle, from the sixth century B.C., on loan to the museum in Basel (D. Cahn, op. cit., p. 14, e); it is simpler in form, and is hammered and riveted, while the later Levy muzzle is cast. The one in Bern is closest to a muzzle in Berlin (E. Pernice, *Berliner Winckelmann-Programm* 56, 1896, pp. 6 ff., pl. 1) that shares the engraved lion-griffins, and may be a product of the same workshop.

D.C.

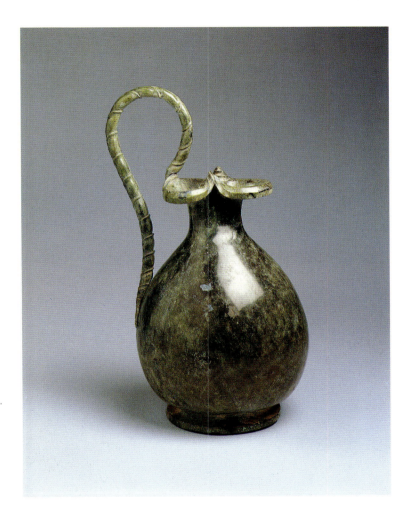

96. *Trefoil oinochoe*

Height, 23.9 cm.; diameter, 11.8 cm.
Northern Greek, fourth century B.C.

The elegant braided handle rises above the trefoil mouth of the oinochoe and terminates below in an acanthus, the lower part of which is missing but is nonetheless discernible in the traces of solder that remain.

The closest stylistic parallel to this bronze oinochoe is furnished by one found in Tsotyli (western Macedonia) and now in the museum in Kozani (*The Search for Alexander: An Exhibition*, Boston, 1980, p. 158, no. 112). The Kozani oinochoe is a trifle bigger (height, 26.5 cm.), but corresponds so closely in every detail to the oinochoe published here that it is safe to assume that the two are from the same workshop.

D. V. B.

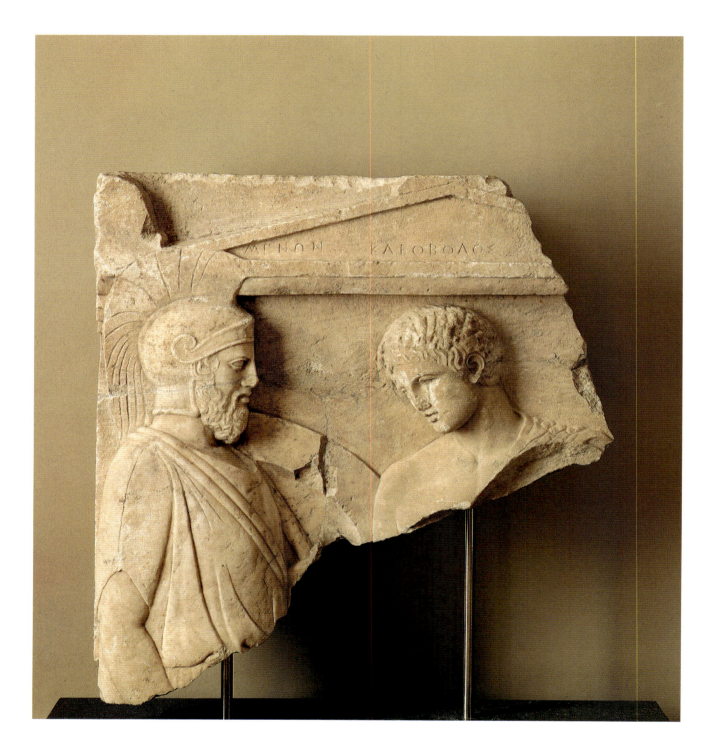

97. *Fragment of a grave stele with a warrior and a youth*

Height as preserved, 91.44 cm.; width: as preserved, 87.63 cm., from left edge to apex of pediment, 60 cm.; depth: at top of stele, 19.69 cm., at background of relief, 12.7 cm.; distance from youth's chin to central hair part, 17 cm.

About 400–375 B.C.

The upper left corner of a large stele, including half of the pediment, over one-third of the left anta, and the upper parts of a warrior and a youth, has been reassembled from three joining fragments. One break, running almost horizontally across the relief, cut through the two faces and damaged the youth's left eye. The other break passed vertically through the warrior's shield, chipping its inner rim. There is an area of modern fill in the background between the two heads. Aside from some chips and battered edges, the rest of the surface is in good condition. The white, medium-grained marble has micaceous veins, which run parallel to the relief surface.

Although, in overall design and subject matter, the stele is similar to Attic grave reliefs of the late fifth and early fourth century B.C., it is difficult to determine where it might have been carved, for it has a number of unusual features.

The figures are framed by a pediment and anta carved in fairly low relief. The three-stepped capital of the anta and the ovolo molding of the epistyle are carried around to the outer side of the stele, which is dressed with claw chisel. In front, two names, Menon and Kleoboulos, are incised on the tympanon of the pediment. Vestiges of a paint stripe parallel to the raking cornice are barely visible on the tympanon, just above the inscriptions.

The background between the corner palmette and the narrow rectangular platform of the central acroterion has not been cut away. This acroterion must have been added as a separate piece of marble. On top of the stele, just behind its base, there are two small holes with the remains of iron dowels, and the rough-picked surface has been smoothed with claw chisel over a fairly large, irregularly shaped area. The piecing of an acroterion onto a grave relief is uncommon, especially when the corner palmette and raking cornice are rendered in relief. The only example of the practice known to me is a fragmentary relief from the Lansdowne collection, now in the Metropolitan Museum (30.11.3), on which the central acroterion was attached to a carefully dressed, rectangular base, with a large dowel hole in the middle.

The figure of a bearded warrior, preserved to just below the waist, stands, facing right, at the extreme left edge of the stele. His body overlaps the anta, and the plume of his helmet conceals the juncture of the pilaster and epistyle. Dressed in a short chiton, with a baldric across his chest, he carries a round shield on his left arm and grips a spear in his left hand. His right arm, slightly bent at the elbow, is held alongside his body. (Warriors are frequently found on Attic grave monuments; for a discussion of this type, with many examples, see R. Stupperich, *Staatsbegräbnis und Privatgrabmal im klassischen Athen*, Inaugural diss., Westfälische Wilhelms-Universität, Münster, 1977, pp. 162–82.)

This warrior differs from the Attic norm not only in the rendering of his drapery but also in certain details of dress. The drapery of his chiton, carved in an extremely simple manner, with folds denoted by incised lines and slightly raised, flat, triangular planes, is very different from the complex, tubular style current in Athens during the late fifth and early fourth century. The design of his short chiton is also unusual. Instead of the short, loose, cap-like covering over the upper arms that is typical of the short chiton—which was made from a relatively narrow length of material—the covering reaches to the middle of the warrior's upper arm, with a wide opening that extends to the level of his elbow at the edge of the stele. Such long, sleeve-like coverings are typical of women's chitons, which were usually made from wider lengths of fabric than were men's short chitons. They can also occur on the long chitons worn occasionally by men. (For a discussion of male dress, see M. Bieber, *Griechische Kleidung*, Berlin, 1928, pp. 20–21, plates 17–19.) There is no reason, of course, that a short chiton could not have been made from a wide fabric, but no ready parallel to the chiton depicted here comes to mind.

The warrior's helmet, too, shows a curious deviation from the norm. Although he wears a so-called Attic helmet, his ear is not visible. Since, on the human head, the distance between the base of the nose and the eyebrows is the same as that between the outer corner of the eye and the tragus of the ear, the location of this figure's ear can easily be calculated: It is not concealed by hair but must be under the helmet. Yet, the Attic helmet, a variant of the Chalcidian, leaves the ears exposed, unless the cheekpieces are lowered (H. Pflug, *Antike Helme*, 1988, pp. 143–45). In all medium- or large-scale sculptural depictions of the Attic helmet, the ear is clearly shown in front of the anterior edge of the neck guard. Even on the small, shallow reliefs of funerary lekythoi the ear is usually visible; in one instance, where the ear is concealed by hair, strands are carefully brushed back over the edge of the neck guard to indicate this (Athens, Na-

tional Archaeological Museum, 3474; B. Schmaltz, *Untersuchungen zu den attischen Marmorlekythen*, Berlin, 1970, A 14, pl. 7).

Like the warrior, the youth, seen from the front, his head turned to his right and slightly inclined, was a common figure type on Attic grave reliefs (see, for example, A. Conze, *Die Attischen Grabreliefs* II, Berlin, 1900, plates 185 ff.). His short hair is worked in individual locks around his face, but is left unfinished on top of the head and behind the ear, where it would not have been easily visible. A few folds on his left shoulder indicate that he was draped in a himation that allowed the right shoulder to remain bare.

Enough remains of this stele to provide some idea of its original size and composition. It was 120 centimeters wide and, with slightly under-life-size figures, must have stood approximately 150 centimeters high. Four fingertips are carved on the youth's left shoulder. These must belong to a figure that stood at the right edge of the stele, facing inward, in a pose similar to that of the warrior. In all probability, it was a woman, who rested her right hand on the youth's shoulder in much the same way as Krito and Timarista, who console one another on the famous stele from Rhodes (Archaeological Museum, 13638; E. Pfuhl and H. Möbius, *Die Ostgriechischen Grabreliefs* I, Mainz am Rhein, 1977, no. 46, pl. 12). While a composition of three standing figures is known on Attic funerary reliefs, they are never arranged in such a symmetrical manner. Although the warrior and the youth are closely juxtaposed, it is difficult to determine their relationship. Almost without exception, standing warriors on Attic grave reliefs shake hands with the person they face. Here, the arms are not extended enough to reconstruct a handshake. The warrior's lower arm is slightly advanced, and it is unlikely that the hand was empty. He might be imagined holding a phiale or a dagger, based on the examples of two isolated warriors on small-scale reliefs—one, on an Attic lekythos, holds a dagger (B. Schmaltz, loc. cit.); the other, on a small relief from Boeotia, has a phiale (C. Blümel, *Die klassisch griechischen Skulpturen der Staatlichen Museen zu Berlin*, Berlin, 1966, no. 67, pp. 58–59, pl. 104). On Attic monuments, young men posed like this youth are usually shown alone, reaching down to a pet or a small servant boy, but it cannot be ascertained whether the youth here was accompanied.

The unusual details of the warrior's dress and the plain, flat rendering of his drapery suggest that this stele was not carved in an Attic workshop. Moreover, the stele seems to lack a certain clarity in the organization of its forms that is a hallmark of most Attic work. Rare is the Attic grave relief where the juncture of anta and pediment is totally concealed, as it is here, by the warrior's plume. Seldom are two figures, like the warrior and youth, so closely juxtaposed without having their relationship made clear by some logical or conventional gesture, such as a handshake.

The stele must have been carved in an area of the Greek-speaking world, such as the Cyclades or the western coast of Asia Minor, where Attic influence was particularly strong in the late fifth and early fourth century. In those regions, a number of grave reliefs have been found on which Athenian figure types appear, modified by local taste and sculptural skill (see, for example, G. Despinis, "Kykladische Grabstelen des 5./4. Jhr. v. Chr.," *Antike Plastik* 7, 1967, pp. 77–86; E. Pfuhl and H. Möbius, op. cit., pp. 8–37). Until a telling parallel for this particular relief is found, it is not possible to be more precise about its place of origin.

E. J. M.

98. *Head from a statue of a servant girl*

Height: as preserved, 25.8 cm., of face from chin to
center of front edge of saccos, 16 cm.; width: as
preserved, 18.5 cm., of face at level of eyes, 13.5
cm.; depth as preserved, 17.5 cm.; distance between
outer corners of eyes, 9.18 cm.

Attic, about 330–320 B.C.

The forms of the head are full, with broadly conceived,
simplified planes. The ovoid face appears elongated because
the narrow, almond-shaped eyes are set high in the head.
The carving of the lids is shallow and delicate, and the tear
duct at the interior corner of each eye is unusual in its length
and downward tilt.

Although part of the hair in back is sheared away in a
vertical break, enough remains of the nape of the neck to
show that the head was carved fully in the round and not as
part of a high relief. The left side of the bridge of the nose,

the entire nose, and the left side of the upper lip are broken
away. There are also large chips just above the center of the
forehead, on the right side of the chin, and on the front of
the neck. All the remaining surfaces are in good condition.
The fine-grained marble with micaceous seams is probably
Pentelic.

Originally, the eyes must have been deep set, for the bridge
of the nose was broad and projected strongly forward, while
the area just below the eyes is deeply recessed before it swells
out at the cheekbones. This particular formation of the nose
and eye socket often is found on Greek sculpture of the second
half of the fourth century B.C. and suggests that this head,
too, was carved in that period. See, for example, the Ilissos
stele (Athens, National Archaeological Museum, 869;
A. Conze, *Die Attischen Grabreliefs* II, Berlin, 1900, no. 1055,
p. 226, pl. CCXI) and a stele with two women (Athens,
National Archaeological Museum, 870; A. Conze, op. cit. I,

1893, no. 320, p. 73, pl. LXXVIII); both stelai are well illustrated in N. Himmelmann-Wildschütz, *Studien zum Ilissos-Relief*, Munich, 1956, plates 19, 24, 25.

All of the girl's hair is contained within a saccos (sack). Such bag-shaped nets were made of sprang, a loose, stretchy fabric produced by twisting together vertical warp threads on a simple loom that had no horizontal weft. (For a description of these headdresses and their manufacture, see I. Jenkins and D. Williams, *AJA* 89, 1985, pp. 411–18.) The edge of the bag's opening was fitted against the forehead just below the hairline, then pulled behind the ears and drawn tight with a drawstring under the hair at the nape of the neck. Often, as here, the strings were pulled up and fastened on top of the head, thus separating with a depression the springy roll of hair that frames the face from the mass that falls at the back.

Sculpted representations of a woman wearing a saccos were not unusual in the fifth century B.C.: See, for example, the bronze caryatid holding a bowl, in Delphi (Archaeological Museum, 7723; C. Rolley, *Fouilles de Delphes*, Paris, 1969, plates 44–47), or the Kore Albani (Rome, Villa Albani, no. 749; illustrated in *Antike Plastik* 11, 1972, opp. p. 20, figs. 1, 2). In the fourth century B.C., such representations became a common feature of Attic grave monuments. On these, young women who wear a saccos are almost always dressed in an unbelted chiton with long, fitted sleeves—an Eastern style of dress that identifies them as slaves from such foreign regions as Thrace, Scythia, or Caria in Asia Minor. (For a discussion of these figures, together with earlier bibliography, see B. Vierneisel-Schlörb, *Glyptothek München, Katalog der Skulturen* III, Munich, 1988, pp. 54–55, n. 2.) Almost every Attic family owned at least a few of these household servants. On grave reliefs, they are shown attending their mistress, who is often veiled. They may fasten her sandal, proffer a mirror, or hold ready a jewel box. All these attentions bring to mind contemporary painted images of the preparation of a bride for departure from her parents' house for her new home; the scenes on grave reliefs may have deliberately drawn on that iconography to suggest preparation for the ultimate departure at death. The servants are not immune to the sadness of the occasion; they often gaze sorrowfully at their mistress or stand by, making gestures of mourning, suggesting the close-knit atmosphere that must have existed in the restricted world of the women's quarters.

This head was probably part of an elaborate funerary monument with freestanding statues displayed in a stage-like arrangement inside a covered, three-sided shrine. Although carved in the round, the head was clearly not intended to be seen from all sides, for the right side of the head is far less carefully finished than the left: The modeling of the ear is incomplete, parts of the neck are left rough, the mass of hair is less full, and the depression caused by tying the strings of the saccos is not rendered on the right side of the head. Enough remains of the neck to show that the head was turned approximately forty-five degrees to its right, so if the figure itself faced front, the right side of the head would have been almost concealed. A large, ovoid area on the saccos, behind the right ear, has been flattened and worked with claw chisel. Because of the break at the back of the head, it is impossible to know the original size, but the preserved surface is 13 centimeters high and 6.5 centimeters wide. Conceivably, this flattened area was prepared for piecing, or perhaps the back of the saccos was cut away so the statue could be fitted closely against the back wall of the shrine. A statue of a servant holding a footstool, from a very large funerary shrine found at Rhamnous, gives the best idea of the probable appearance of the statue to which the Levy head belonged (V. Petrakos, *Praktika*, 1976, pp. 22–29, plates 11, 12; for other statues of servants from tombs, see B. Vierneisel-Schlörb, op. cit., pp. 131–32, notes 1, 2). Since the surviving statues of attendants are under life size, we may surmise that this life-size head was part of a particularly splendid monument. It was funerary display of this type that led to the sumptuary laws of 317 B.C., which brought to an end the long line of elaborate sculpted tombs in Attica.

E. J. M.

99. *Pendant with a sphinx in relief*

Height, 6.25 cm.; length, 7.2 cm.; depth, 2.7 cm.
Second half of the fifth century B.C.

The sphinx is carved in low relief, with the head turned back and the legs tucked under the body. Both forelegs are suggested, while only the left side of the hindquarters is represented. The thick tail—which starts just above the haunch, curls up over the back, and reappears on the underside—is inscribed with fine diagonal lines and terminates in a triangular finial. Below the tail on the haunch are two incised lines. The coiffure of the sphinx is smooth from the crown to the bottom of the ear; from this point down to the pageboy terminus the tresses are rendered by horizontally oriented engraved lines. The large, flat, almond-shaped

eye is bordered by a fine raised line. Another similarly carved line extends from mid-chin to the shoulder, suggesting, at the neck, the edge of a garment or a necklace. Only the left wing is depicted, the scapular set off by a raised line. The feathers themselves are rendered as evenly spaced sections, with primary and secondary feathers separated by a curving groove.

The sphinx was worked from an irregularly shaped convex piece of amber that still retains its naturally formed, lump-like appearance. Before the subject was carved, surface faults and imperfections were removed, adding further to the indentations and undulations (more obvious on the back) in the amber. The nine shallow holes on both front and back, drilled either to disgorge a disfiguring area or for decorative purposes, were once filled with plugs of amber. One plug remains in place on the back. The two ends of the suspension hole are located in the top of the head and at the lowest edge of the hair. When the pendant was worn, the head of the sphinx would have been horizontal and the body vertical.

The amber is reddish brown to reddish orange, with minor pitting over the entire surface and some lighter mottling in the areas of the hair and the back. There is some chipping on the forelegs, the secondary feathers, the back of the head, and the belly. Many scratch-like natural fissures are visible on all surfaces.

While carved ambers have been found at many sites in Picenum, Apulia, Lucania, and Calabria, the richest finds are from the Picene territory. The majority of pieces from dated contexts were interred in the period spanning the second half of the fifth century to the middle of the fourth century B.C., with a scattering of burials somewhat later. The Levy sphinx shows many of the characteristic features of Italic figured ambers—large size, subjects with age-old fertility and apotropaic symbolism, and a wraparound manner of carving in which liberty has been taken with the anatomy in order to derive the utmost advantage from the precious, imported material, valued for its beauty and rarity and for its electromagnetic (hence, magical) and amuletic properties.

All fossil resin seems to have been traded in the areas south of the amber-rich sites bordering the Baltic Sea. Typical, too, in the corpus of Italic ambers is the couchant position of the Levy sphinx. Among couchant animals, real and imaginary, that are known are sphinxes, lions, boars, bulls, rams, birds, and a man-headed bull (Acheloos ?). These range in length from three to fourteen centimeters and are similarly worked, so that the salient features of the animals are accommodated to the shape of the original lump of material. All of the couchant animals and most of the large figural Italic ambers were made as pendants to be hung from belts, fibulae, and necklaces. Occasionally, large pieces also served as the bow decorations of large fibulae.

This sphinx is the largest and best preserved of the six sphinx pendants known to me. It is also the finest. The only published parallel for the subject is in the British Museum (D. Strong, *Catalogue of the Carved Ambers in the British Museum*, 1966, p. 78, no. 69, pl. 28), and is said to have come from Armento. Unpublished examples include two pendants allegedly found together, recent donations to the Virginia Museum of Fine Arts; a sphinx with a disfiguring large (secondary ?) hole in the middle, so that it could be suspended from a pin (?), in the Greek Museum, Newcastle upon Tyne (no. 596); and a small pendant in a Los Angeles private collection very much like the one in the British Museum.

For technique and style, the closest comparisons are in a dispersed group of amber female heads and satyr heads, some excavated and some said to have been found in Lucania and neighboring areas. Of the few published examples with dated contexts, a representative comparison is the female head from a rich tomb near Melfi that demonstrates a similar approach to the treatment of the hair and the form of the eye (Melfi Pisciolo, tomb 48; D. Adamesteanu et al., *Popoli Anellenici in Basilicata*, 1971, p. 125, pl. LIII).

F.C.

BIBLIOGRAPHY
Cat. Sotheby's (London) 10 December 1984, no. 254.

100. *Trefoil oinochoe*

Height, 31.5 cm.
East Greek, third quarter of the sixth century B.C.

Two Grazing Ibex

The lower neck, the shoulder, and the body of the jug are covered with a white slip that enhances its polychrome aspect. The technique is that of silhouette, with parts of the animals (the heads, belly lines, and shoulders) reserved. There are no incisions, but opaque red enlivens the silhouettes and some of the ornamentation. The glaze itself is reddish brown rather than glossy black and, in the ornamentation, is often diluted to a yellowish brown.

The local styles of eastern Greece—the islands close to Asia Minor and the coast of Anatolia—have not as yet been sufficiently differentiated to allow the origins of the

100: detail of lower neck, shoulder, and body

oinochoe to be determined precisely. The jug shows affinities with vases found on the island of Rhodes and in Miletos. The shape is closest to that of an oinochoe on the Frankfurt art market that Elena Walter-Karydi has attributed to Miletos (*Samos* VI, 1, 1973, no. 602, pl. 82); both share the maeander band on the neck. For the animals, a jug in Munich (450; *CVA* Munich 6, 1968, pl. 275), attributed to Rhodes by the same scholar (*Samos* VI, op. cit., p. 132, no. 527), should be compared. The triglyph-like ornaments in the lower zone recur with a similar alternation of black and red on a contemporary oinochoe in St. Louis (20-6:65).

The prevalence of ibex (also called wild goats) in East Greek art has prompted the term "wild goat style" in the parlance of archaeologists, who have subdivided the designation into "early," "middle," and "late" periods, lasting from the mid-seventh century B.C. to about 570 B.C.—according to R. M. Cook (*Greek Painted Pottery*[2], 1972, p. 121).

D. V. B.

101. *Lip-cup*

Height, 9.07 cm.; width, 18.1 cm.; diameter,
13.01–12.79 cm.
Samian, about 540 B.C.

Along with pottery decorated with ambitious figure com-
positions, many fine products of potters' workshops bear
only floral or abstract ornaments. However, these vessels
must have been quite popular, considering the large num-
bers that have been preserved. The inside of the bowl of this
delicate drinking cup contains twenty-eight concentric-
glaze circles, framed above by the solid black of the inside of
the lip. Decoration and dimensions are paralleled most
closely on a cup in Munich (529; E. Walter-Karydi, *CVA*
Munich 6, 1968, pp. 38–39, plates 293,5, 294,3). When

the cup was filled with wine, this pattern must have had a
dizzying effect on the s̀ymposiast. On the outside, the black
of the stem, lower part of the bowl, and handles contrasts
pleasantly with the reserved areas of the lip, handle zone,
and edge of the foot. The black line separating the lip from
the handle zone emphasizes the ceramic articulation.

The cup is from the collection of the La Jolla Museum of
Contemporary Art.

D.V.B.

BIBLIOGRAPHY
Cat. Sotheby Parke-Bernet (New York) February 17, 1978, p. 4,
no. 16, p. 5, ill.

102. *Neck-amphora*

Height, 28.7 cm.
Chalcidian, about 550–540 B.C.
Attributed to the Painter of the Cambridge Hydria
 Cavalcade

The class of vases to which this neck-amphora belongs is known as "Chalcidian," since those that are inscribed employ the distinct Chalcidian alphabet. Surprisingly enough, excavations on the island of Euboea (of which Chalcis is the

102

most important city) have not yielded a single sherd that can be attributed to what we call Chalcidian vases. On the other hand, Chalcidians founded colonies both in the north (especially on the Thracian coast) and in the west (Cumae, in the Bay of Naples; Zankle and Rhegion in the Straits of Messina; and in Sicily). It therefore is not unlikely that Chalcid-

ian immigrants in the West produced pottery at Rhegion, where vast numbers of Chalcidian vases and fragments have been found. Chalcis enjoyed excellent trade relations with Corinth, and the earliest Chalcidian vases betray a strong Corinthian stylistic influence. After the middle of the sixth century B.C., when Corinthian pottery went into decline, the Chalcidian painters fell under the spell of Attic pottery, which, at that time, had edged out Corinthian vases as a profitable export to Etruria.

Seven galloping riders race around the vase. It is not difficult to determine who is meant to be in the lead, for the painter singled out one, toward whom two eagles converge. The decoration on this vase—three "sunflower-rosettes" on each side of the black neck; festoons of palmettes and lotuses on the shoulders; and a band of twelve large rosettes below the figure zone, with three smaller ones serving as filling ornaments in the background behind the riders—owes much to Corinthian conventions.

Some missing fragments have been restored in plaster and repainted—notably, in the area of the right wrist of the rider who looks back, in part of the hind legs of the horse ridden by the jockey behind him, and in the knee, left hand, and groin of the horse of the jockey's companion, situated between the eagles. The biggest loss has occurred in the rider in the middle, on the other side (the one with a rosette above his left elbow and another below his mount): His legs and much of his horse's neck and chest are restored.

D.V.B.

103. *Alabastron*

Height, 23.4 cm.; diameter, 11.5 cm.
Middle Corinthian, about 595–570 B.C.
Attributed to the Erlenmeyer Painter

A Boread

The Corinthian alabastron (a perfume vase), unlike the Attic examples, does not derive from Egyptian models but from Near Eastern prototypes (D. A. Amyx, *Corinthian Vase-painting of the Archaic Period*, Berkeley, 1988, p. 438). In contrast to the primarily spheroid aryballos, the body of an alabastron is pear shaped and elongated; a perforated lug connected to the lip and neck of the vase permitted easy carrying by means of a cord. The narrow opening (as on

The Boread's left foot is flat on the ground, and his right knee touches it. Although the tips of the wings almost reach around to the back, and a dozen rosettes are scattered over the background, there remained a considerable area under the left arm of the Boread and to the right of his lower left leg to be filled. For this the painter devised a helmeted head as a suitable although incongruous space filler, influenced perhaps by a Middle Corinthian composition showing a Boread between two helmeted heads, as on the Turin aryballos (*CVA* Turin I, III c, pl. 3, 5–6, p. 5), which Lo Porto (*CVA* Turin I, loc. cit.) compared with the Boread on the aryballos in the Louvre (A 467; *CVA* Louvre fasc. 8, III Ca, pl. 17, pp. 21–25).

D.v.B.

104. *Neck-amphora of Panathenaic shape*
Height, 30.5 cm.
About 540 B.C.
Attributed to a Painter of Louvre F 6

Footrace

At the great Panathenaic festivals, celebrated like the Olympic games every four years, the prizes in the gymnic and hippic competitions were jars of olive oil from the sacred groves of Attica. These Panathenaic amphorae were uniform in liquid content, holding one *metretes* (about 39 liters), and bore the inscription, applied before firing, "one of the prizes from Athens." On the obverse, the cult statue of a striding Athena brandishing her spear would be shown between two columns, surmounted by cocks, along with the inscription, while the reverse portrayed the competition for which the prize was awarded. In addition to these large standard "prize" vases, the potters and painters of ancient Athens also produced smaller neck-amphorae of the same Panathenaic shape whose decorative schemes resembled those of the "prize" vases save for the official inscription, which occurs on them only exceptionally. Another variant, like the present amphora, is Panathenaic only in the subject of the competition depicted; it does not show the statue of Athena or the columns.

On each side three men are shown in the sprint, a footrace for the length of a stadion that corresponds to the modern 200-yard dash. On one side the front-runner lacks a beard and may hence qualify as a youth or boy, but I suspect that

103

aryballoi) prevented spilling, and the flat mouth allowed the contents to be spread before application. The shape does not change much during the alabastron's long popularity in Corinthian pottery.

The single handle at the back of the vase gave a sense of direction to the painter, who used the entire body for his decoration; this generally consisted of animals and winged figures or monsters. Here, the winged man flying with his knees bent has been dubbed "Boread," on the analogy of Zetes and Kalais, the sons of Boreas, whose names are inscribed on a Chalcidian vase, the Phineus cup, in Würzburg (see H. Payne, *Necrocorinthia*, Oxford, England, 1931, p. 78). The spread wings also allowed the painter to cover more of the surface with decoration. An attribution to the Erlenmeyer Painter (D. A. Amyx, op. cit., pp. 160–62) is borne out by the prominent eye, the ear, and the ornamentation.

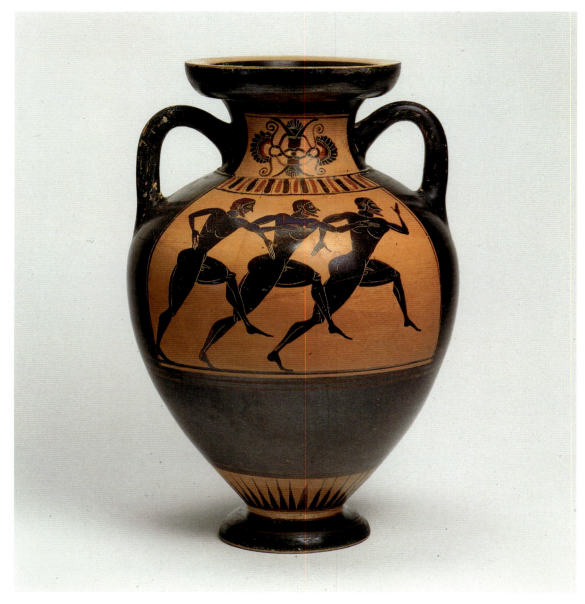

104

the painter merely neglected to apply added red and incisions to the jaw. Normally, boys or youths did not compete with men in the same event.

The two races are obviously close, and, since the finish is not shown, we may conclude that each of the runners has a chance at winning. However, by depicting the figure in the middle with a fillet over his shoulders and across his chest, the painter may have wished to mark him as the eventual winner.

The graffito, lambda upsilon, incised retrograde, occurs on the neck-amphora designated Würzburg 169 (A. W. Johnston, *Trademarks on Greek Vases*, 1979, p. 75, type 15 A, no. 5), assigned by A. D. Trendall to the Lydan circle, of which the Painter of Louvre F 6 is a member.

D.v.B.

BIBLIOGRAPHY
Cat. Sotheby's (London) 17 July 1985, no. 313.

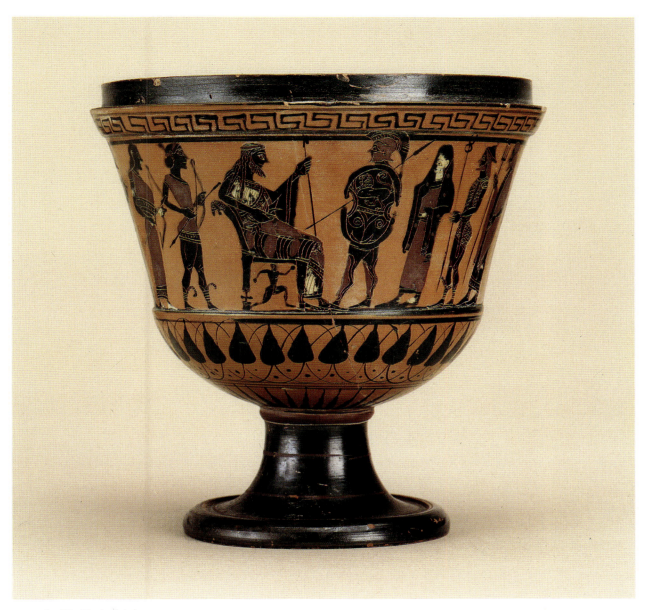

105: *A, The Birth of Athena*

105. *Pyxis of Nicosthenic shape*

Height, 13.5 cm.
About 540 B.C.
Attributed to the Painter of the Nicosia Olpe

A, The Birth of Athena

B, Theseus Killing the Minotaur

This pyxis of a special shape, equipped with a stem and foot and a domed lid surmounted by a cone-shaped knob, is named after the prolific potter Nikosthenes, whose workshop began in the days of the painter Lydos (see *ABV*, p. 109, no. 28, p. 113, no. 80) and lasted well into the period of Archaic red-figure, the late sixth century B.C. He may have been the first to establish this type of pyxis, for his

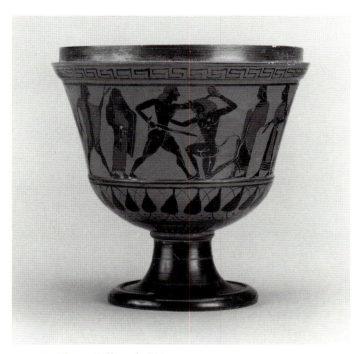

105: *B, Theseus Killing the Minotaur*

is the only signature that appears on one example (Florence 76931; *ABV*, p. 229, VII); on another pyxis he is praised as handsome (Vienna 318; *ABV*, p. 671). There is much variety in patterning and profile: Some, like the present pyxis—published here for the first time—have concave walls, so that the vase proper resembles a calyx-krater, while others, especially the later examples, have convex walls. The foot and stem are like those of contemporary drinking cups, as are the rays above the foot encountered here. The rim of the vase is recessed to accommodate a lid (now missing) that slipped over the inner edge, much like the lids of certain psykters.

The figures on these pyxides are relatively small, and as the vases have no handles, the decoration is continuous. The chief scene here is the birth of Athena. Expectant Zeus sits somewhat impatiently on an elaborate throne, holding a scepter in his left hand and a thunderbolt in his right. The little boy in running stance under the seat is a decorative touch that first appears about the middle of the sixth century B.C. as part of the fanciful throne. The deities facing Zeus—Ares, Aphrodite, Hermes, Poseidon, and Amphitrite—are ready for the big event but will be of no help. That comes from the group to his rear: Apollo,

Artemis, and Hephaistos, flanked by a youth holding a spear, like many an onlooker best known from the vases by the Amasis Painter. It is Hephaistos, with his double ax, who will presently split the pate of Zeus so that Athena, fully armed, can be born.

The figures on the other side show the most important exploit of Theseus. He had volunteered to join the annual tribute of fourteen youths and maidens exacted by King Minos from the King of Athens—victims intended to be fed to the Minotaur—and found his way into the maze of the labyrinth, where he slew the monster. A boy and a girl on each side of the struggle await the outcome apprehensively, although the boy at the extreme left, watching the blood squirt from two wounds already inflicted on the collapsing Minotaur by Theseus, does not contain his excitement.

Between 1956, when the *Attic Black-figure Vase-painters* was published, and 1971, when the *Paralipomena* appeared, J. D. Beazley discovered that the artist he had identified as the Painter of Louvre F 28 and the Painter of the Nicosia Olpe were not merely related but were, in fact, the same painter (see *Paralipomena*, 1971, p. 196).

D. v. B.

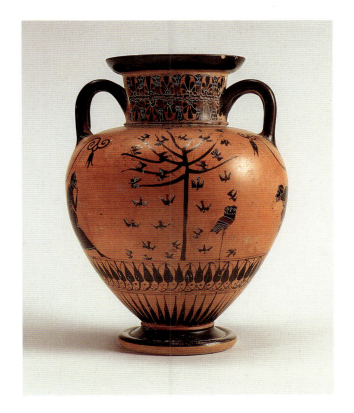

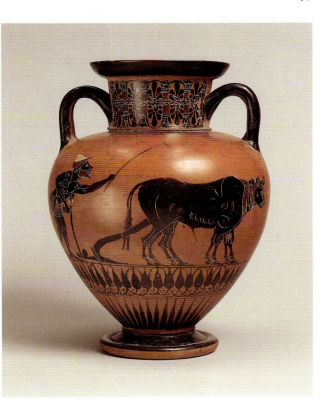

106. *Neck-amphora*

Height, 30.85 cm.
About 540–530 B.C.
Attributed to the Bucci Painter [J. Robert Guy]

Spring Plowing: Fowling

As on the neck-amphora with Dionysos and Ariadne (cat.
no. 107), the scenes on each side of this vase are connected,
although the standard ornament under the handles has been
suppressed. On the principal side a plowman drives a yoke
of two oxen. He steers the plow with his right hand and
raises his whip with his left. His attire is that of a man
working in the fields: a short chiton, an animal skin (proba-
bly that of a deer), and a brimmed hat of the type often worn
by Hermes and by travelers. The man is bent over in his
labors but his gaze is fixed on the scene ahead, which
unfolds on the other side of the amphora. A leafless tree has
been coated with glue to trap birds that have been attracted
by the prospect of freshly sown seeds and do not seem

deterred by the presence of an owl that fulfills the functions
of a scarecrow. Under each handle a crouching man clad in a
himation is about to pounce on the birds that have become
attached to the branches. Of the thirty-one birds depicted,
twelve have already been lime-twigged, and some of the
others seen descending may no longer be capable of sus-
tained flight, but those on the ground are merrily going
about their destructive business of picking the newly sown
seeds.

The hostility of owls to small birds was familiar to
Aristotle, Aelian, and other writers. Lime-twigging with
an owl as a decoy is also known from fragmentary red-
figured skyphoi in Newcastle upon Tyne (*Archaeological
Reports*, 1969/70, p. 60, figs. 14–15) and in Brussels
(*ARV²*, p. 984, no. 2), on which the owl is in the tree and
there is no connection with plowing. A non-Attic black-
figured amphora in Taranto (114326; *Bollettino d'Arte* 48,
1963, pp. 18 ff., figs. 1–3; K. Schauenburg, *Jagddar-
stellungen auf griechischen Vasen*, Hamburg, 1964, plates

22–23) is closest to the Bucci Painter's depiction of the birds and the owl on the present neck-amphora. Unlike the owls on the skyphoi in Brussels and in Newcastle upon Tyne, which, like the birds, sit on the branches of the tree, the Taranto owl is perched on a stake to which it is presumably tied.

The potting of this neck-amphora is somewhat unusual, especially that of the foot. Unlike most neck-amphorae of this period, the neck is glazed only to a depth of two centimeters.

The Bucci Painter is named after the Italian antiquarian Donato Bucci, who owned the amphora now in New Orleans (*ABV*, p. 315, no. 3). Bucci befriended Stendhal while the latter was French Consul in Civitavecchia.

D. V. B.

BIBLIOGRAPHY
Cat. Sotheby's (London) 9 December 1985, no. 132 (the lid sold with the amphora is alien).

107. *Neck-amphora*

Height, 31 cm.
About 520 B.C.
Attributed to a Painter of the Medea Group

Dionysos and Ariadne Feasting

Unlike panel-amphorae, which demanded strict observation of the separate panels of obverse and reverse, neck-amphorae gave the painter the opportunity of allowing the scene to extend around the vase. The subject of Dionysos and a female companion (often only half dressed) at a banquet, reclining on a couch, can be traced back to the time of Lydos. On a neck-amphora now in Florence (*ABV*, p. 110, no. 32), he shows the divine couple entertained by mortals rather than by the satyrs and maenads of their habitual entourage. On the Florence vase, Dionysos's partner, Ariadne, has bared her right shoulder; on a contemporary vase in New York (J. D. Beazley, *Paralipomena*, p. 31, center; *Beazley Addenda*², p. 23), her right breast is bared. The chief painter of the Medea Group went one step farther on a neck-amphora at Amherst College (*ABV*, p. 321, no. 1), published by Diana Buitron (*Attic Vase-painting in New England Collections*, Cambridge, Massachusetts, 1972, pp. 50–51), where Ariadne has let her himation fall to her waist. The couple feasts in the presence of a youth playing

the flutes and two naked men who dance. The amorous tone is continued on the other side by three men and their female friends.

The scene on the neck-amphora published here for the first time shows somewhat greater abandon. Ariadne's right shoulder is being caressed by Dionysos, and she has bared her right leg (the painter, however, has given her the toes of a left foot). She looks at the first naked man, who proffers a wreath, and at his companion, lugging a heavy wineskin, who glances back at another man squatting beneath the handle to vomit. The cortege continues with a girl playing the flutes, another man bringing a second wineskin, a fifth carrying a heavy volute-krater—like the satyr in the scene of the return of Hephaistos on a neck-amphora by the same painter in Madison, Wisconsin (W. Moon, *Greek Vase-painting in Midwestern Collections*, Chicago, 1979, pp. 96–97)—and yet another figure also with a wineskin. Behind Dionysos a dancing man approaches, his sick companion once again discreetly shown under the other handle. With so much wine being brought to the banquet it is odd that no drinking cups are in evidence. The food on the table

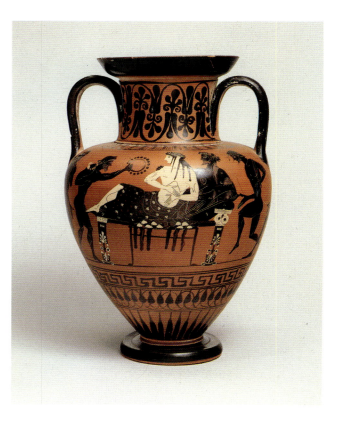

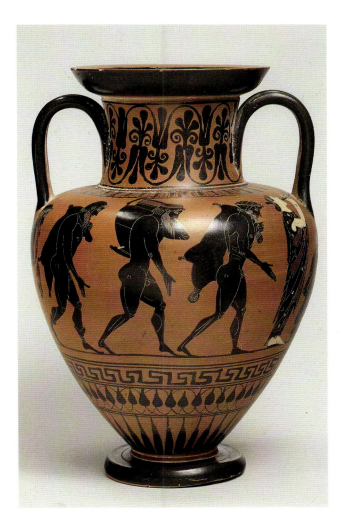

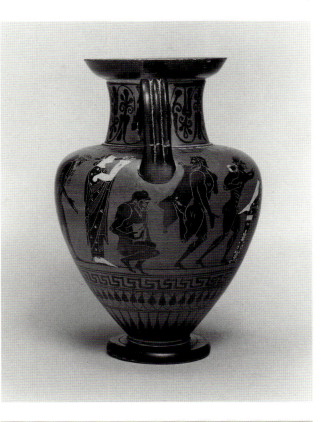

next to the couch is as yet untouched: The feast is just beginning, and we can readily imagine that more worshipers of Dionysos will soon appear bearing pitchers and cups.

The ornament on the neck is a special variant of the palmette-lotus festoon. The painter uses it again for the obverse of a neck-amphora in London (*ABV*, p. 321, no. 4); it links the Medea Group with a neck-amphora in Munich (1490; *ABV*, p. 321; *Paralipomena*, p. 141; *Beazley Addenda*², p. 87).

The retrograde graffito alpha, theta, iota, under the foot, is A. W. Johnston's type 1 D (*Trademarks on Greek Vases*, 1979, p. 115); it occurs almost exclusively on neck-amphorae and hydriai.

D. v. B.

108. *Neck-amphora*

Height, 40.9 cm.
About 520 B.C.
Attributed to the Antimenes Painter

The Mask of Dionysos

Frontal views of faces can be somewhat startling, and the heads of Dionysos on this amphora, staring at us from between—and behind—the two enormous eyes, are no exception. Like the terrifying head of Medusa on many black-figured vases, they are drawn in an outline technique practiced in Attic black-figure intermittently from the late seventh century B.C. The ears, nose, eyebrows, and lips appear in outline, while the eyes of Dionysos, his hair, and his beard are in standard black-figure, with incisions for the details of the beard and hair, as well as for the olive wreath (on the obverse) and the ivy (on the reverse). The huge white eyes that partly overlap the face of Dionysos are more at home on the outside of drinking cups—of which the earliest and finest Attic example is that signed by Exekias, in Munich (*ABV*, p. 146, no. 21)—but the conceit quickly spread to other shapes: column-kraters, hydriai, oinochoai, and lekythoi. On neck-amphorae, such eyes are employed either on the shoulder in oblong panels (*ABV*, p. 276, nos. 1–9, p. 691; J. D. Beazley, *Paralipomena*, p. 121) that are long enough to allow narrative subjects to be accommodated between the eyes, or on the body, as on this neck-amphora. The Antimenes Painter (*ABV*, ch. XVIII, pp. 266 ff.), the "brother" of Psiax, as Beazley calls him (*ABV*, p. 266), seems to have invented this decorative scheme for neck-amphorae, and while he was followed or imitated by other vase painters, notably Psiax (*ABV*, p. 293, no. 6), this neck-amphora agrees so closely with London B 266—which Beazley attributed to the Antimenes Painter himself (*ABV*, p. 273, no. 118)—that it must be by the same hand.

The graffito under the foot, one of many variants of A. W. Johnston's type 21 E (*Trademarks on Greek Vases*, 1979, pp. 145–47), is well attested from the vases by the Antimenes Painter.

D.v.B.

109. *Hydria*

Height, 58.5 cm.
About 510 B.C.
Attributed to the Priam Painter

Chariot Race (on the shoulder)

Chorus of Nine Goddesses [the Muses ?], between Dionysos and Hermes (on the body)

This hydria is of the canonical black-figured shape, with three handles: The vertical one in the back, rising above the mouth, is used for tilting, while the two horizontal handles are for lifting the vase when it is filled with water. Figural decoration is limited to the front, where the two scenes are set in panels; the scene on the shoulder is separated from the chief subject on the body by a key pattern. The shoulder panel exceeds in width the panel on the body, which is framed on the sides by the traditional ivy vines. There is no predella.

On the body of the vase nine maidens are shown in profile, side by side. The first and last wear himatia over their peploi, while the other seven are dressed in peploi

only. Each wears a red diadem and a necklace with a small black pendant. Their hands are either clenched or open; some are raised, others are lowered. Oddly enough, there are twenty-two hands instead of eighteen: The painter became carried away as he added the white arms, apparently unable to keep track of them. He seems to have given up on the feet, which are not separated by incisions and form an undulating mass with toes and instep contoured only for the one on the extreme right. We look in vain for individual attributes. Only the first maiden next to Hermes holds a flower in her left hand. Hermes, dressed in a short chiton and chlamys, boots, and a brimmed hat, is accompanied by a dog. He faces right as he looks around, as in many representations of him conducting the three goddesses to Mount Ida to be judged by Paris. Dionysos, who follows the procession behind the nine maidens, holds a long vine that trails in the background and stretches all the way to the right end of the scene, where it reemerges between Hermes and the nine women. Are they the nine Muses? Hermes is not the leader of the Muses, the *mousagetes*; this is the epithet of Apollo, and later—as we learn from an inscription found on Naxos (*BCH* 2, 1878, p. 587, no. 3)—also of Dionysos. The first work of art on which all nine Muses first appear is the François vase in Florence (*ABV*, p. 76, no. 1) on which the visit of the gods to Peleus and Thetis is depicted, and each Muse is named. The name "Urania" is inscribed on a fragment perhaps from a hydria found on the north slope of the Acropolis in Athens (*ABV*, p. 77, no. 8, p. 682).

On the signed dinos by Sophilos, in London, with the same subject of the gods visiting Peleus and Thetis (J. D. Beazley, *Paralipomena*, p. 19, no. 16 bis; *Beazley Addenda²*, pp. 10–11)—now published by D. Williams (*Greek Vases, J. Paul Getty Museum* 1, 1983, pp. 13–34)—only eight maidens are shown: Next to the chariot of Aphrodite and Ares is a cluster of five, inscribed "Muses," sharing one cloak, with the central maiden, in frontal view, seen playing the syrinx, as well as a trio of figures, again identified by an inscription as Muses, walking alongside the chariot of Apollo, conducted by Hermes. Sophilos's rendering of five Muses sharing the same cloak brings to mind the outer decoration on a black-figured cup in Berlin (F 3993; A. Furtwängler, *La Collection Sabouroff*, Berlin, 1883–87, pl. 51), in which there are nine women on one side, in right profile and seen amidst youths, who appear to be forerunners of the ennead on this hydria; in the decoration on the other side, the number of figures is reduced to seven. Viewed in this light, perhaps the wedding procession on the Corinthian column-krater by the Cavalcade Painter (D. A. Amyx, *Corinthian Vase-painting of the Archaic Period*, Berke-

ley, 1988, p. 198, no. 8), with its group of three maidens under one cloak, next to a bridal couple in a chariot, specifically alludes to the wedding of Peleus and Thetis honored by the presence of the nine Muses.

The chariot race on the shoulder occurs often on black-figured hydriai, being eminently suited to an oblong panel. Here, the quadriga on the right is in the lead by one length, and its charioteer is more relaxed than his rival, who is hunched over. The inscriptions are hard to read (TVᴧIOꟻ WꟻIOꟻ MINON+ꟻ MIKONNIOꟻ) and may be garbled; in another similarly tantalizing inscription on an amphora in Oxford by this painter (*ABV*, p. 331, no. 5) a certain Mynnichos is praised.

The graffito ⊢V is very common on vases by the Priam Painter (see A. W. Johnston, *Trademarks on Greek Vases*, 1979, type 13 E, nos. 5–12, 18–21).

D. v. B.

110. *Amphora (type B)*

Height, 51.8 cm.
About 510–500 B.C.
Attributed to the Leagros Group

A, The Departure of Memnon

B, Dionysos amidst Satyrs and Maenads

Memnon, the son of Tithonos and Eos, was the grandson of Laomedon, King of Troy, and the nephew of Priam, to whose aid he came after the deaths of Hector and of Penthesilea, Queen of the Amazons. Memnon became king of the Ethiopians. In Homeric times, the Ethiopians were thought to live at the ends of the world, on the shores of Okeanos, but later they were localized on the eastern frontier of Persia and in the West, in Africa. In Greek art they were represented, as on this vase, as blacks. Memnon's armor, like the second armor of Achilles, was the work of Hephaistos: Memnon was sent to Troy by his father, Tithonos, who was bribed to do so by Priam with the gift of a golden grapevine, originally a present from Zeus to Laomedon after the latter had abducted Ganymede. The fatal duel between Achilles and Memnon was decided by the gods, after pleas by their divine mothers, Thetis and Eos, through a weighing of the souls (psychostasia).

110: *A, The Departure of Memnon*

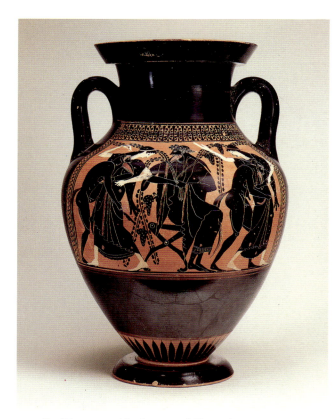

110: *B, Dionysos amidst Satyrs and Maenads*

The depiction of Memnon setting out for battle at Troy accompanied by Ethiopian troops first occurs in Attic art on a neck-amphora by Exekias, in London (B 209; *ABV*, p. 144, no. 8); on another neck-amphora near Exekias, in New York (98.8.13; *ABV*, p. 149, V); and on a third example by the Swing Painter, in Brussels, who replaced Memnon with an Ethiopian, and his squires with Amazons—survivors of the fatal encounter of Achilles and Penthesilea—perhaps under the influence of the neck-amphora by Exekias, who had shown the death of Penthesilea on the obverse of the neck-amphora now in London. In the Leagros Group, to which the panel-amphora published here belongs, the composition of Exekias is retained, but dogs are added.

Memnon appears here in left profile, as on the neck-amphora near Exekias, in New York, and his two black squires—armed and equipped with bows, clubs, quivers, and sheathed swords—strike the same poses as their counterparts on the New York neck-amphora, although the

sheathed swords are lacking and bronze cuirasses are clearly indicated. On the Levy panel-amphora, however, the upper bodies are treated as if they were bare, so that the short chitons look like kilts. The more imposing figure of Memnon, in the center, wears his Corinthian helmet raised up, and his enormous spear, which extends almost the full length of the panel, is brandished rather than shown resting at an angle on the ground, as on the neck-amphora. For additional protection he also wears a mantle. The white of the large round shield was applied *after* the shield-device, a raven, had been painted in the center with black glaze. The same composition with only minor variations occurs on both sides of a neck-amphora in Munich, likewise attributed to the Leagros Group (*ABV*, p. 375, no. 207; *CVA* Munich 9, plates 1,3; 4; 6,3); Beazley remarked that "it recalls the Acheloos Painter, and in general character the Nikoxenos Painter." This narrowing of an attribution also applies to the reverse of the panel-amphora discussed here.

Dionysos is shown seated on a campstool. He holds grapevines in both hands as he watches two satyrs attempting to carry off maenads. This exercise is depicted with even greater vigor on three amphorae by the Acheloos Painter: on his pelike in London (*ABV*, p. 384, no. 20); on a neck-amphora last sold in London in 1968 (*ABV*, p. 383, no. 10), on which it is performed with equal gusto by a group of komasts; and on a panel-amphora in the Metropolitan Museum (26.60.29; *ABV*, p. 384, no. 17), where it is initiated by a satyr. As to specific characteristics linking the amphora to the "general character" of "the Nikoxenos Painter," the campstool of Dionysos on the obverse and his himation, as well as the mantle of Memnon, are sufficiently close stylistically to the Nikoxenos Painter to bear out Beazley's assessment.

The white shield with black device carried by Memnon on three of the four vases that show him in the company of Ethiopian squires is too conspicuous a feature to be merely fortuitous. Since the earliest literary sources of the story— the *Aethiopis* by the epic poet Arktinos and the dithyramb by Simonides—are lost, there is no detailed account of Hephaistos supplying the armor of Memnon. I suspect that the white shield reflects a literary tradition, just as the very long spear on this amphora denotes it as different from common arms.

The graffito on the underside of the foot is the well-known ligature of lambda and eta, to which four other letters have been added. The ligature is extremely common on vases attributed to the Leagros Group.

D. V. B.

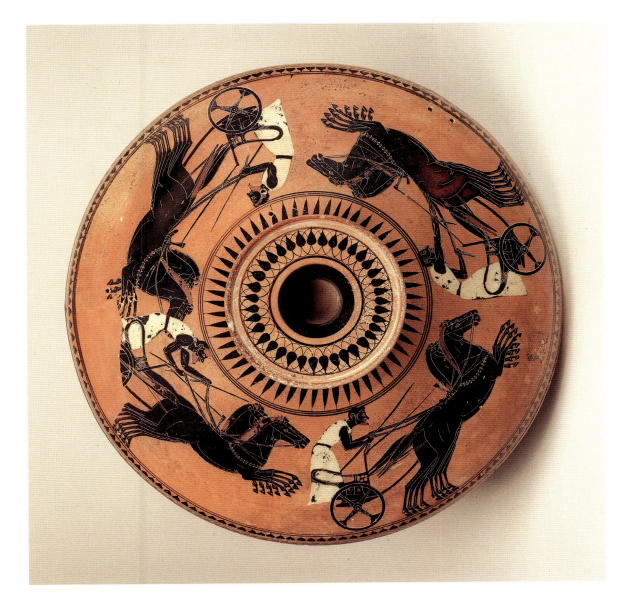

111. *Lid of a lekanis*

Height, 12.69 cm.; diameter, 40.64 cm.
About 520–510 B.C.

Chariot Race

Attic lekanides are low-footed dishes with two handles and are equipped with a cover (presumably to keep food warm). Lekanides in early black-figure, by the Nettos Painter

(*ABV*, p. 5, nos. 6–9, p. 19, nos. 5–7, p. 24, nos. 1–6, p. 41, nos. 28–31), are without lids, and the figural decoration appears in the tondo of the dish proper and on the outside. Once lids were introduced, at about 590 B.C. (*ABV*, pp. 24–25, nos. 7–10), they became almost ideal for extensive compositions, such as the Sack of Troy (*ABV*, p. 58, no. 119, by the C Painter), and painting was limited to their broad, nearly flat surfaces. Sometimes painted

decoration was applied to both lid and receptacle (*ABV*, pp. 114–15, no. 2 [in the manner of Lydos], p. 118, nos. 41–47 [animals]). After those by Lydos, his companions, and his followers, painted lekanides went into a long eclipse, only to reappear in the Leagros Period (J. D. Beazley, *Paralipomena*, pp. 162–63, nos. 294 bis, ter) and a little beyond (C. H. E. Haspels, *ABL*, pp. 218–19, nos. 57–62 [Edinburgh Painter]).

Here, four chariots race around the lid at top speed. The first and third charioteers use their goads to make their teams run faster, while the second and fourth are more relaxed. Since the large flat knob of the lid, decorated on top with a recessed ring of hanging lotuses, obscured part of the picture by its considerable overhang, the painter framed the picture zone above with a pattern of rays. The nearly vertical rim of the lid is decorated with an ivy wreath.

Not many lekanides of this period have been found, and only one large fragment (from Lentini) with the same subject and decorative scheme is known to me (*Bollettino d'Arte* 48, 1963, p. 344, fig. 5). On the present lid and the fragment, the racing chariots are arranged so that the heads of the charioteers line up with the four cardinal points of the compass. The Lentini fragment may be by the same hand as the lid shown here.

The two black-figured lids in the Louvre with three racing chariots on each (F 317: *CVA* III He, pl. 5,4; F 318: *CVA* II He, pl. 8,4) belong to *red-figured* amphorae of type A (Louvre G 46 and G 45, respectively; *Paralipomena*, pp. 346 [Nikoxenos Painter, no. 3], 324 [Dikaios Painter, no. 4]), and two red-figured amphorae by the Kleophrades Painter (*ARV²*, p. 181, no. 1, p. 182, no. 4) also have black-figured lids showing chariot races. Perhaps the painter of the lekanides with the same subject took his inspiration from the lids of amphorae.

The present lid was broken and repaired in antiquity, as indicated by the three pairs of drilled holes to accommodate bronze rivets or staples.

D.V.B.

for strings for carrying, nor a lid. At banquets, the psykter, filled with wine, would be set in a calyx-krater containing a coolant—most of the time, cold water—in which it could be spun around, providing a kinetic spectacle for the reclining banqueters.

Four of the mounted horsemen approach from the left toward a fifth, who is leading his horse, followed by a sixth rider. The two groups thus converge, forming a pleasing symmetry with the rider on foot in the center. The latter walks toward the right but looks back at the group on the

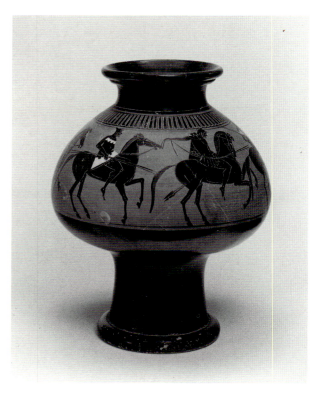

112. *Psykter*

Height, 33.3 cm.; diameter, 25.8 cm.
About 510–500 B.C.

The Departure of a Troop of Cavalry

Of the two psykters in the Levy collection, this is the earlier one; it is an example of the type that has neither attachments

left as he spreads the fingers of his right hand in one of those difficult-to-interpret gestures often shown on vases. All six cavalrymen wear short, belted chitons, a short cloak over their shoulders, and wide-brimmed petasoi, or Oriental caps; two of these are clearly the fox-skin caps associated with Thrace, just as of the six mantles four bear the distinc-

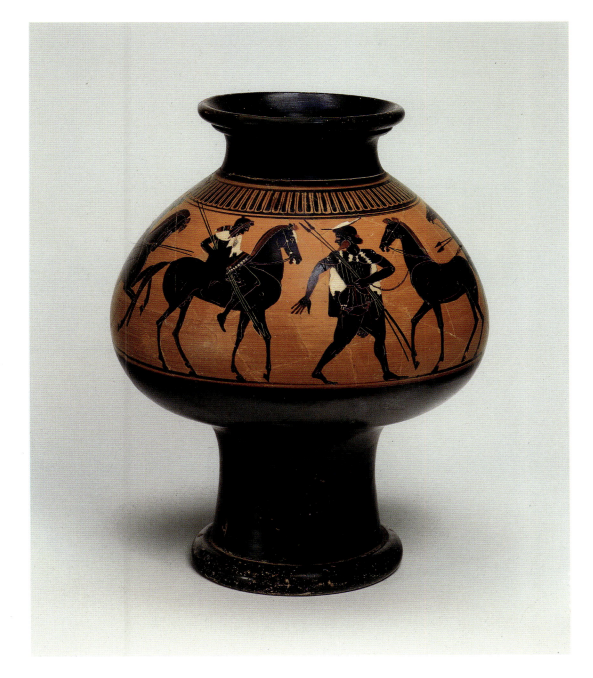

tive patterning of Thracian cloaks. All the men carry two spears. There is much variety in the gaits of the horses, two of which are shown at a gallop: Presently the troop will form and ride off to battle, as on a contemporary unpublished red-figured psykter by Smikros in the Spears collection, on loan to The Metropolitan Museum of Art (L. 1980. 104).

Although the psykter has been broken and repaired, there are only minor losses. The largest of these, measuring four by two centimeters, affects the right arm and buttocks of the rider to the left of the man on foot, and the rump of his horse.

D. v. B.

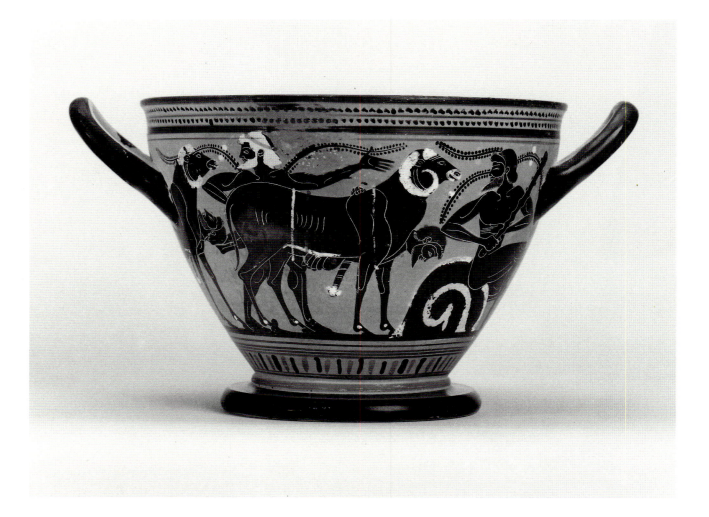

113. *Skyphos*

Height, 16.8 cm.; width, 30.5 cm.; diameter, 22.4 cm.
About 490 B.C.
Attributed to the Theseus Painter

The Escape of Odysseus from the Cave of Polyphemos

The narrative extends around the vase, and although both sides repeat the same subject, an illusion of a greater escape is created by the repetition. The Cyclops, blinded in his only eye, sits on a rock, while behind him two rams or sheep, each with a sailor strapped to its belly and chest, move in single file out of a cave; a third Greek, not under a ram, supervises the departure. This figure has a white beard and white hair, in which, like that of the other Greeks, there is a red fillet. The painter may well have represented him as Odysseus, who guided his companions out of the cave of Polyphemos and, like a good captain, left last (as related by Homer in the *Odyssey* 9, lines 415 ff.). The straps binding

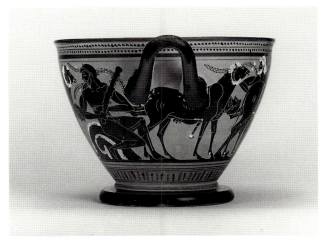

113

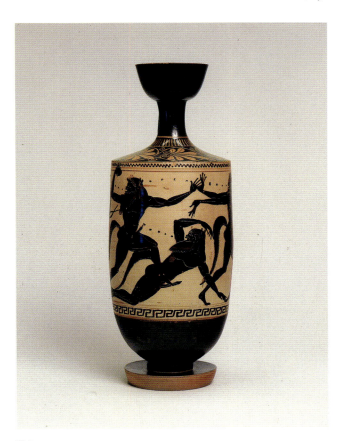

114

the men—one of whom looks up and the other down—are red and white.

The "supervisor," not attached to a ram, appears also on a white-ground lekythos by the Theseus Painter, in Oxford (C.H.E. Haspels, *ABL*, p. 252, no. 116; O. Touchefeu-Meynier, *Thèmes odysséens dans l'art antique*, Paris, 1968, pp. 48–49, no. 16, pl. 10,2–4), which shows two companions emerging from the cave, while the standing figure carries two spears. The earliest Attic representation of the escape of Odysseus appears on a fragment of a volute-krater in the collection of Herbert A. Cahn that belongs to the same vase as the Moscow fragment by Kleitias (*ABV*, p. 77, no. 2; *Antike Kunst* 24, 1981, pp. 66–67, pl. 10).

The repetition of a subject on the reverse of a skyphos is common on those painted by the Theseus Painter and on those in the White Heron Class to which these belong.

D.V.B.

114. *Lekythos*

Height, 30.7 cm.
About 480 B.C.
Attributed to the Athena Painter

Hermes, the inventor of many games, is shown here in the guise of a coach or trainer with five excited satyrs, one of

whom has been tripped and is falling. The ball, made of leather and stitched, is carried by the last satyr. Moving rapidly to the right, he is about to pass the ball, possibly to the satyr at the extreme right whose hands, palms up, are in the position of a catcher. The painter has telescoped the action, which would take place on a playing field, into a tightly knit group. Hermes wears his winged hat and boots, a short chiton, and a chlamys over his left shoulder. Instead of the caduceus he holds the forked wand of athletic coaches or judges in his right hand, while his left hand is raised in the time-honored gesture that can be interpreted as friendly greeting and as stern admonition.

The inscriptions in the field are, alas, without meaning; they issue from the open mouths of three of the satyrs and may have been intended to represent the shouts of the different players. The mouth of Hermes, by contrast, is closed. The satyrs wear red bracelets and anklets on one wrist and ankle, and are wreathed. Hermes has a red fillet in his hair, and added red is also used for the top of his hat and the borders of the mantle, as well as for the stripes that

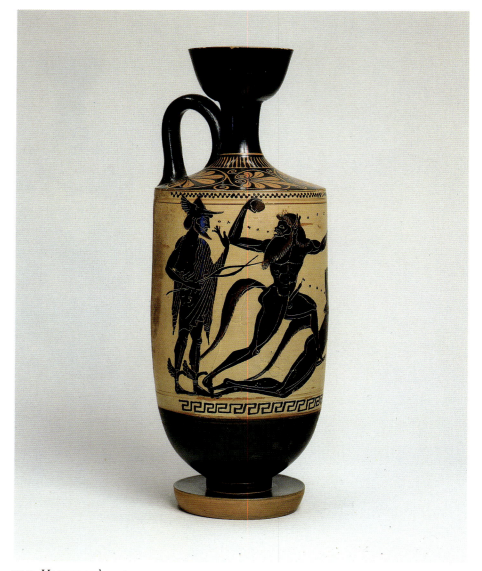

114: Hermes and a satyr

appear near the edges of all beards and tails. The red area below the pectoral of the falling satyr may be an accidental smear, not another ball, as it lacks the precise contour of the half-red, half-black ball in the right hand of the satyr next to Hermes. The neat row of red dots bisecting the black-and-red ball indicates stitching.

The ornaments on the shoulder of the lekythos (four linked palmettes and a lotus) are painted in red-figure; the main scene is black-figure on a white ground, bordered above by a net pattern and below by a key pattern. The use of red-figure for the ornament on the shoulder is rare but not

surprising since by about 480 B.C. the cylinder lekythos had become fully established and its shape was shared by artists of red-figure as well. Other lekythoi with red-figured palmettes on the shoulder and black-figured decoration on the body are cited by Beazley (*ABV*, p. 524; *ARV²*, pp. 694 [foot], 1666); the Peyrefitte lekythos (J. D. Beazley, *Paralipomena*, p. 264; D. C. Kurtz, *Athenian White Lekythoi*, pl. 13,1) was sold in Paris at the Peyrefitte auction May 26, 1977 (no. 38).

D. V. B.

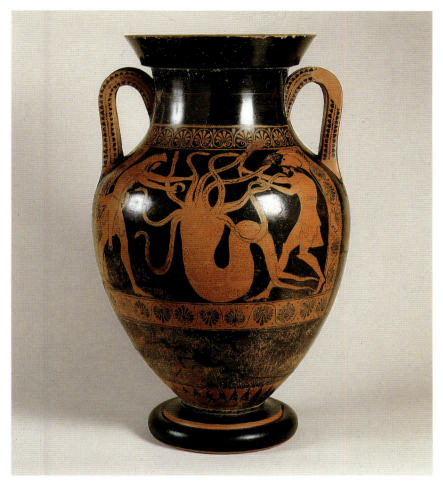

115: *A, Herakles and Iolaos Killing the Hydra*

115. *Amphora (type A)*
Height as preserved, 58 cm.
Said to be from Veji, about 510–500 B.C.

A, Herakles and Iolaos Killing the Hydra
B, Peleus Wrestling with Thetis

The second labor of Herakles, the killing of the nine-headed Hydra, took place at Lerna and posed an unusual problem in that every head that Herakles cut off grew back, until Iolaos came to his aid with flaming torches and cauterized each severed stump. The myth enjoyed great popularity in art from the seventh century B.C. on. In the panel on the obverse of this vase the monster, all nine "tentacles" fully deployed, is center stage. Herakles, at the left, steadies

one of the wiggling extremities with his left hand in order to cut it off with the *harpe*, a sickle-shaped tool with a serrated edge that Perseus before him had successfully used to behead the gorgon Medusa. Iolaos, in the armor of a hoplite (cuirass, Corinthian helmet, and greaves), approaches from the right with two firebrands. The names of Herakles and Iolaos are inscribed.

On the reverse, Peleus is about to seize the Nereid Thetis, whom he had surprised while the Nereids were dancing. Two of Thetis's companions run off to bring the news to their father, Nereus. The abduction of Thetis was not easy, as the divine bride possessed the gift of changing into a lion, a snake, fire, and water, but Peleus followed Chiron's counsel and kept his hold on Thetis through all her meta-

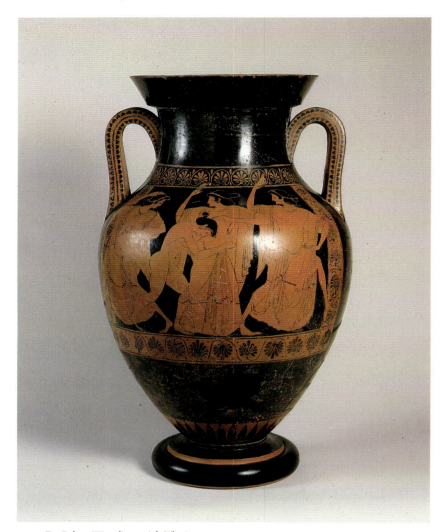

115: *B, Peleus Wrestling with Thetis*

morphoses until she regained her original form. (The in-
scriptions on this panel are meaningless.)

J.-L. Zimmermann, who published this vase in 1975,
attributed it to the Kleophrades Painter, which has been
supported by J. Robert Guy, but several characteristics of
the drawing make this attribution not entirely persuasive.
The decorative scheme derives from Euthymides, the ac-
knowledged teacher of the Kleophrades Painter, but Euthy-
mides had many pupils, companions, and imitators.
Among these, the Dikaios Painter seems closest to the
painter of this amphora—a proximity that extends to the
physiognomies, the many anatomical details, and the orna-
ments that frame the panels, as well as to the palmettes
under the handles, in contrast to the style of the
Kleophrades Painter, whose depiction of Hydra, for in-

stance, on the volute-krater now in Malibu (J. Paul Getty
Museum, 77.AE.11; *ARV*², p. 186, no. 51), is of a differ-
ent breed.

The foot of the amphora was broken off in antiquity and
the fillet above it was filed down to serve as a base. The vase
was broken and repaired, but some losses remain—notably,
in the head of Herakles and in the lower part of Iolaos's face
in scenes A and B, and in part of the middle section of the
left Nereid. The brow and forehead of Thetis are restored.

D.V.B.

BIBLIOGRAPHY
J.-L. Zimmermann, in *Art antique: Collections privées de Suisse
Romande*, J. Dörig, ed., Geneva, 1975, no. 204.

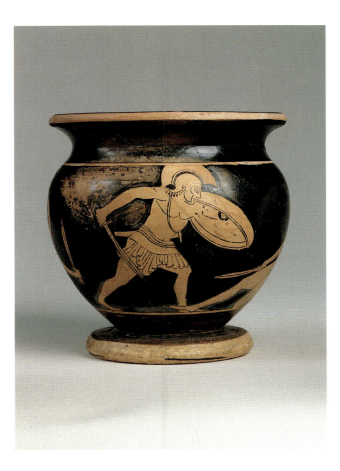
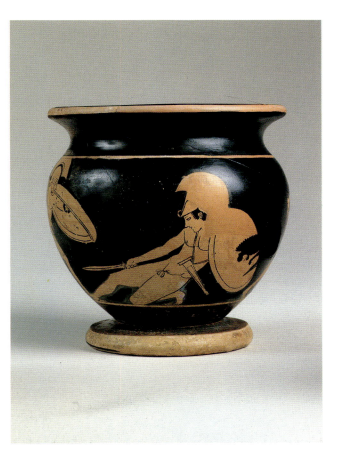

116. *Drinking cup (footed mastoid ?)*

Height, 11.23 cm.; diameter, 10.88 cm.
About 500 B.C.
Attributed to Epiktetos

Combat

Two duels of hoplites are shown, one beside the other; as is often the case in Greek art, the victors are the warriors who advance toward the right. Both are similarly armed with a drawn sword, the scabbard of which is suspended from a baldric over the right shoulder. Their round shields are shown in three-quarter view. The head and shoulders of one of the warriors are missing, but his comrade, who is unbearded, wears a low-crested Chalcidian helmet. Their

opponents have fallen on the ground. One, with a lion as a shield device and a Corinthian helmet pushed back on his head, is dying, as is shown by his eye; the other, whose shield is emblazoned with a plane leaf, has turned right as if fleeing, his sword held in an upright, defensive position. As he has fallen on his right knee, he is at the mercy of his attacker. The falling warriors, unbearded like the victors, are naked, in contrast to their foes, who wear a short garment tied around the hips.

The attribution to Epiktetos is borne out by a comparison with a cup by him in Munich (2619; ARV^2, p. 74, no. 40) and with the fragments in Malibu (ex-Bareiss; ARV^2, p. 1624, no. 24 bis).

D.V.B.

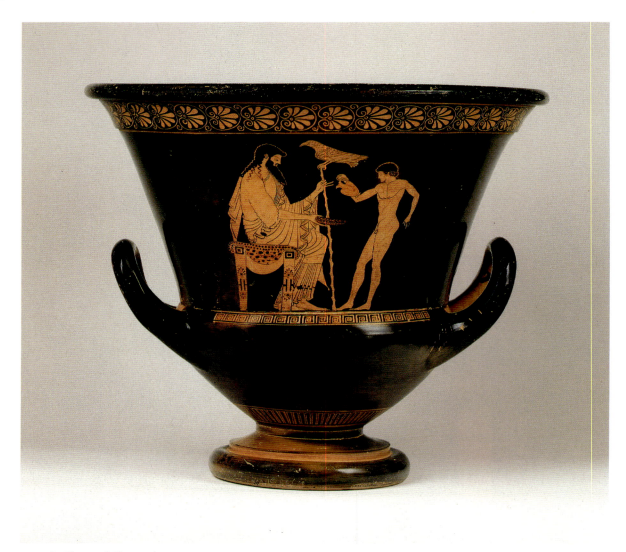

117: *A, Zeus and Ganymede*

117. *Calyx-krater*
Height, 39.7 cm.
About 490–480 B.C.
Attributed to the Eucharides Painter

A, Zeus and Ganymede
B, Herakles and Iolaos Arming

On the obverse of the krater Zeus is enthroned on an elaborately carved wooden stool covered with a leopard skin. With his left hand he holds onto a walking stick on which a large eagle perches rather precariously, as he signals with two fingers to his cupbearer, Ganymede, while the latter pours wine from an oinochoe into Zeus's libation bowl, or phiale, which is ornamented with a laurel wreath. Both the phiale and the oinochoe are tinted with dilute glaze that is strongly suggestive of gleaming metal, no doubt of gold. The names of Zeus and Ganymede are inscribed.

Herakles and his nephew Iolaos are shown on the reverse, about to set out for battle. Iolaos, already fully armed, wears a bronze helmet with movable cheekpieces, a leather corselet with lappets (the so-called *pteryges*) reinforced with bronze scales on the upper part, and bronze greaves. A

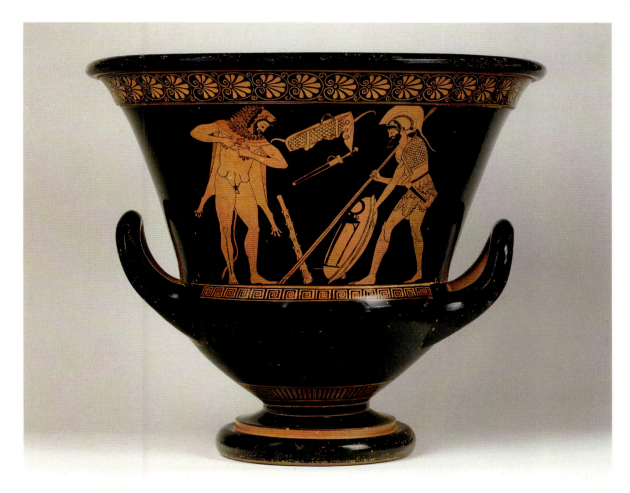

117: *B, Herakles and Iolaos Arming*

sheathed sword, suspended from a red baldric over his right shoulder, hangs at his side. He bends forward to pick up a round shield emblazoned with a tripod with his left hand as he firmly grips his two spears in his right hand. Herakles has tied the forelegs of his lion skin into a tight knot across his shoulders. He gazes at his club, which seems to float; his quiver, with bow attached, and his sheathed sword appear to hang on an imaginary wall. The names of the two heroes are inscribed.

The calyx-krater came into use at the time of Exekias, and was developed in red-figure chiefly by the Pioneers who, like Euphronios, kept much of the rich floral decoration above the handles and on the cul. The early calyx-kraters have a squatter appearance; in the new style of the Kleophrades Painter and the Berlin Painter the ornaments become somewhat subdued, and the cul of the vase is, in a later phase of the development, left blank except for a low band of black tongues directly above the fillet connecting the vase with the foot. This helps to highlight the figures in the picture zone. The Eucharides Painter, to whom this krater has been attributed, illustrates this progression from ripe Archaic luxury to Late Archaic austerity that emphasizes single figures most tellingly.

For a similar grouping of Zeus and Ganymede by the Eucharides Painter compare the fragmentary neck-amphora of Panathenaic shape in the collection of Herbert A. Cahn in Basel (no. 638).

The inside of the krater fired a brilliant red, which, however, was not intentional but accidental.

For the graffito (AT V⁄) on the underside of the foot, probably Etruscan, see A. W. Johnston, *Trademarks on Greek Vases*, 1979, p. 110, type 14 C (AT⧺).

D. v. B.

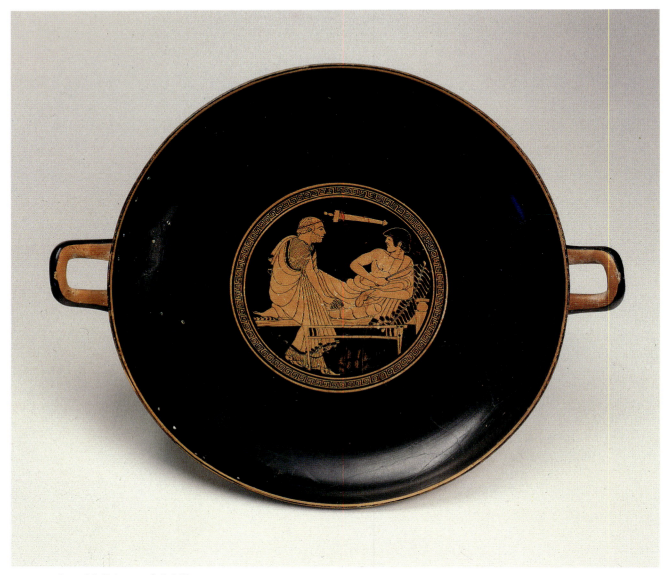

118: tondo, with Priam and Achilles

118. *Kylix*

Height, 11.9 cm.; width across handles, 39.3 cm.;
 diameter of bowl, 31.4 cm.
About 490–480 B.C.
Attributed to the Painter of the Fourteenth Brygos

The Ransom of Hector

The moving encounter of Priam and Achilles, which con-
cludes Homer's *Iliad*, is not represented in Greek art until
the sixth century B.C. It is known in Attic vase painting
from the second quarter of the sixth century on, but,
judging from the preserved representations—numbering
not more than a score—it never became a very popular
subject.

Both the inside and the entire outside of this cup are
devoted to the story. The scene in the tondo concentrates on
the aged Priam, both arms extended in a gesture of plead-
ing, as he approaches the young Achilles on his couch, busy

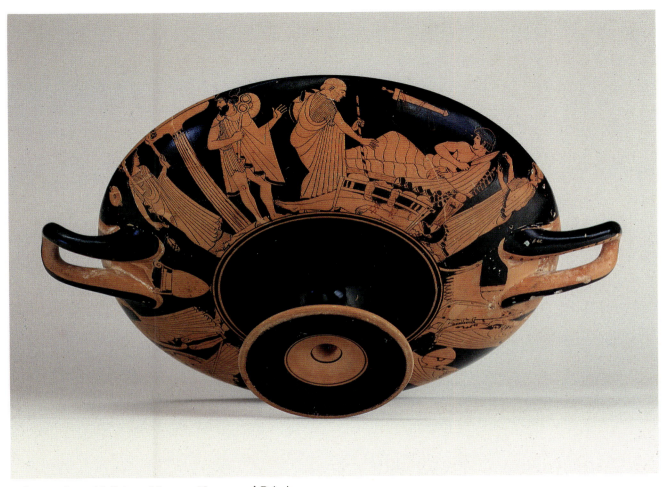

118: exterior, with Priam, Hermes, Hector, and Briseis

cutting up meat. Their eyes meet. The body of Hector is not shown in this excerpt from the story, just as on a similar tondo by Makron (*ARV²*, p. 460, no. 14) Achilles is represented on his couch, with the body of Hector below, but without Priam. On the outside of the Levy cup, however, the artist has gone to great lengths to depict the visit of Priam. The setting is the tent of Achilles, indicated by two columns and a door, in the kind of architectural shorthand favored by Attic vase painters from the François vase on. The architectural elements are disposed to suggest that part of the unfolding scene is inside, while Priam's large retinue is on the outside of the vase.

The exterior of the Levy kylix must be read counterclockwise: first the foursome of Priam, Achilles on his couch, Hector below it, and Briseis, only recently restored to Achilles, behind him. Next to Priam is Hermes, who conducted the entourage safely through the Greek camp. He turns back toward the first tribute bearer, a girl carrying a stool on her head and a glass alabastron in her right hand. A volute-krater under the handle behind her may also be part of the ransom; it serves as the transition to a group of three Trojan youths bearing a set of armor: helmet and greaves, shield and spear, leather cuirass, and a wrap. A girl balancing three stacked phialai in each hand, another girl with a pointed amphora resting on her left shoulder and a hydria in her right hand, and, finally, a Trojan, with a dinos atop his left shoulder, who carries a footbath by its handle in his right hand, bring up the rear. The door and an empty klismos with a leather seat cover conclude the scene under and around the other handle, which bears the signature of

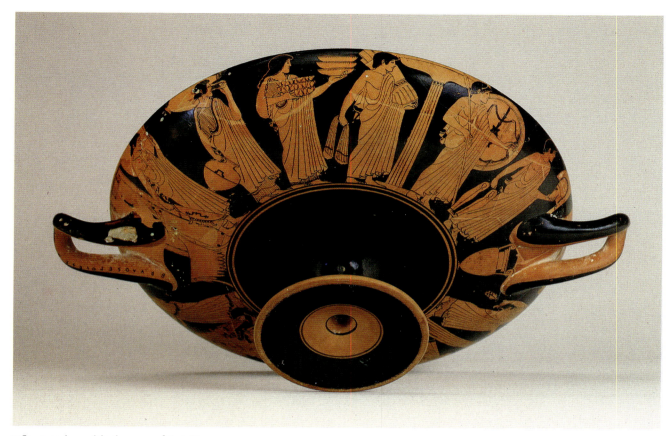

118: exterior, with the tent of Achilles

Brygos as potter. When the kylix was suspended by one of its handles, with the inside to the wall, this handle was on top.

Of the vases on the cup being brought as ransom, the dinos, pointed amphora, hydria, and the six phialai are made of metal (possibly silver and gold), but the alabastron is clearly of glass—the earliest representation of a sand-core glass, a technique that originated in Egypt. More astonishing, perhaps, is that Priam is bringing a complete panoply to Achilles. This armor cannot be the first armor of Achilles, lent to Patroklos when he set out to fight the Trojans, for that armor was worn by Hector after he killed Patroklos, and was recovered by Achilles when he, in turn, defeated Hector. On an early vase by the Painter of London B 76, in a Swiss private collection, with a depiction of the ransom of Hector's body (*ABV*, p. 85, no. 1 bis; J. D. Beazley, *Paralipomena*, p. 32), we see two helmets, two greaves, and two shields in the tent of Achilles; a slightly later amphora of Group E, in Kassel (*Paralipomena*, p. 56), treats the same

subject, and two shields are also shown. The armor brought by Priam should therefore be the old armor of Hector, either as part of the ransom or as a worthy gift to the valiant Greek who had defeated the strongest and bravest of the Trojans. Nor is this the only vase on which Priam includes armor in his mission to Achilles: An earlier fragmentary calyx-krater by the Kleophrades Painter, in the Ceramicus in Athens (*ARV²*, p. 186, no. 45; *Beazley Addenda²*, p. 187), has, on the reverse, a similar youth carrying a cuirass on his left shoulder (misinterpreted by U. Knigge, *AM* 85, 1970, p. 8, pl. 4, as parts of a box carried on the head), followed by a youth bringing a hydria. A stamnos by the Pan Painter, in the Louvre (Cp 10822; *ARV²*, p. 552, no. 22: a large fragment in a private collection in Geneva, as E. Knauer has seen, augments the Louvre stamnos considerably), also includes armor brought to Achilles, of which a spear and a pair of greaves are preserved.

While the cup is signed by Brygos as potter, it is not painted by the anonymous artist called the Brygos Painter.

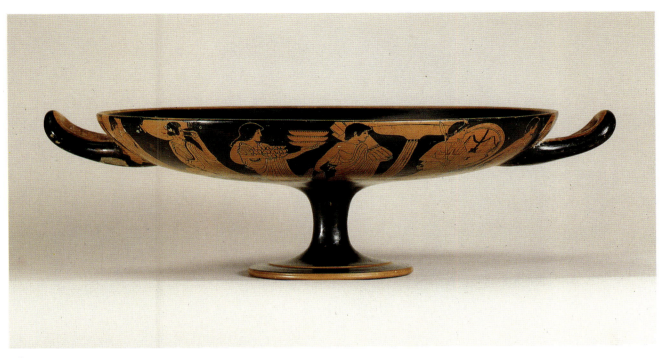

118

It was, however, painted by an artist belonging to his circle whom Beazley (after the fourteenth signature of the potter Brygos known to him at that time) named the Painter of the Fourteenth Brygos (*ARV²*, p. 1650; *Paralipomena*, p. 369; *Beazley Addenda²*, p. 230). Beazley remarked that the design of the cup may have been by the Brygos Painter himself (*ARV²*, p. 1650), whose skyphos in Vienna (*ARV²*, p. 380, no. 171) contains another splendid portrayal of Hector's ransom. Yet, the composition of the Vienna skyphos differs in many essential details from the kylix in New York; perhaps the painter was copying a cup by the Brygos Painter that has not been preserved.

D.V.B.

BIBLIOGRAPHY

ARV², pp. 399, 1650; J. D. Beazley, *Paralipomena*, p. 369; J.-L. Zimmermann, in J. Dörig, ed., *Art antique: Collections privées de Suisse Romande*, Geneva, 1975, no. 209, figs. a–d; A. Kossatz-Deissmann, in *LIMC* I, 1, 1981, p. 150, no. 661, plates 124–125; D. Williams, in *Proceedings of the International Vase Symposium, Amsterdam 1984*, pp. 275–76, fig. 3; D. F. Grose, *The Toledo Museum of Art, Early Ancient Glass*, New York, 1989, p. 111, fig. 59.

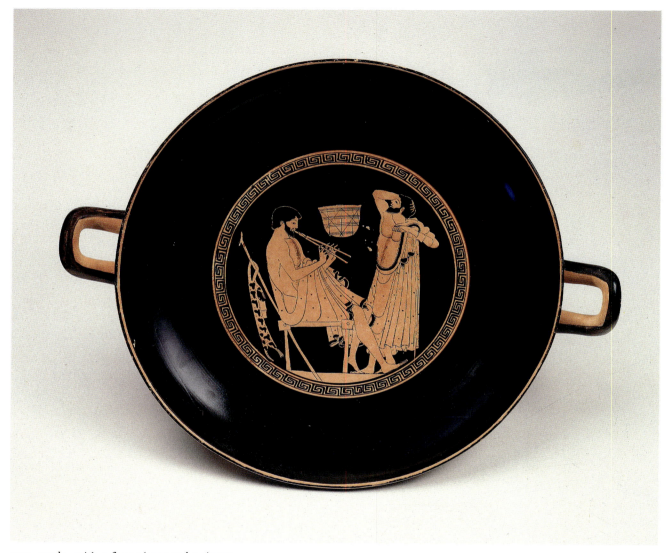

119: tondo, with a flute player and a singer

119. *Kylix*

Height, 14.25 cm.; diameter, 33 cm.; width across
 handles, 42.33 cm.
About 490–480 B.C.
Attributed to the Foundry Painter

Revelers

The more subdued interior of the cup shows a seated flute
player facing a singing man who throws back his head, on
which he has placed his right hand, in a gesture recalling
that of Thoudemos on the earlier calyx-krater by Eu-
phronios, in Munich (*ARV²*, pp. 1619, 1705, no. 3 bis;
J. D. Beazley, *Paralipomena*, p. 322; *Beazley Addenda²*,
p. 152). The singer leans on the walking stick wedged
under his left arm. His himation is worn over his left
shoulder, and in his hair he has an apicate fillet. The flute
player, likewise wreathed, has let his himation fall over his
left arm and then has pulled it up to his middle, baring both
legs up to the knees. His cheeks are puffed. He has slung his
sybene (flute case) around the walking stick propped up
behind him. A picnic basket suspended between the two
men indicates that this is not a formal concert.

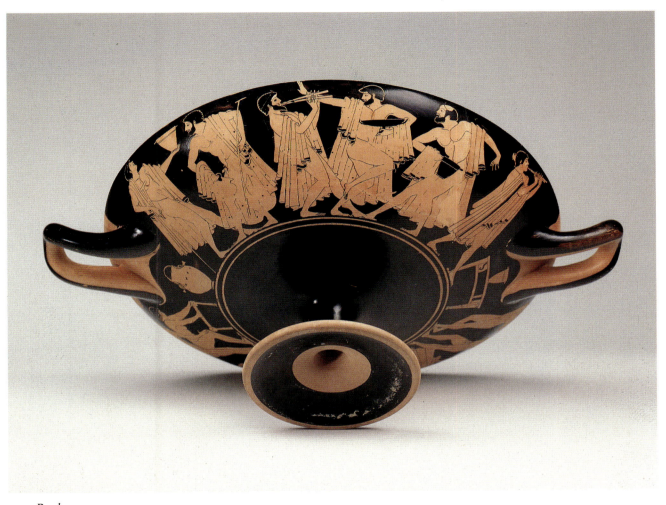

119: *Revelers*

Flute music continues on the exterior, where a bearded flute player and a youth follow other revelers, three of whom (a youth and two men) are equipped with drinking cups—two skyphoi and a kylix. One man relieves himself in an oinochoe. The man holding a kylix attempts to dance. All except the flute players are singing. The party continues on a different level on the other side, where three of the four revelers have taken off their clothes and are enjoying the company of four naked girls, some more actively than others. At the extreme left, a girl looks apprehensively at her companion, who brandishes a sandal in his left hand, as she protects her breasts with both arms; both look toward the trio in the center, which includes a girl bending over in

the presence of two men and steadying herself with both arms on a low stool. Next comes a naked girl playing the flutes who observes the fourth man occupied with his girl in much the same fashion as one man in the center. In the field, suspended from an imaginary wall, are a flute case and a picnic basket.

As is often the case on cups by the Brygos Painter and his circle—as well as on contemporary cups by other artists—the painter of the present kylix has utilized the space under the handles for low objects: On one side is a pail used for drawing water from a well; under the opposite handle is a table on which there is a skyphos.

In a lecture at the Accademia Nazionale dei Lincei,

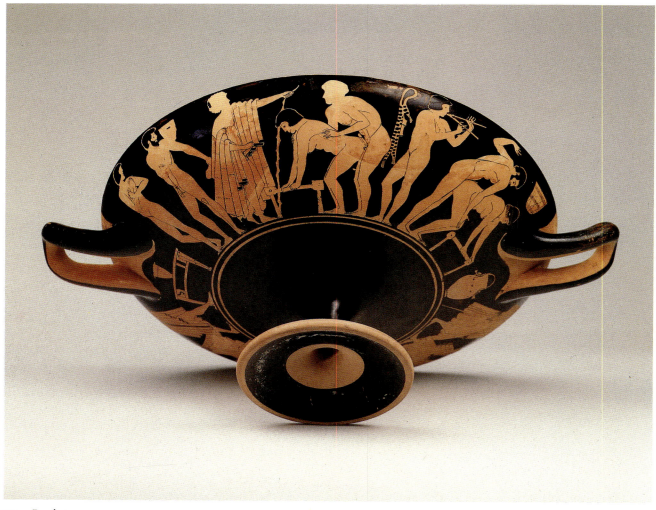

119: *Revelers*

Rome, delivered in Italian on November 13, 1965 (now translated into English and republished in *Greek Vases, Lectures by J. D. Beazley*, Oxford, England, 1989, pp. 78–81), Beazley characterized the Foundry Painter as a Greek realist. Although there are not many cups by this painter depicting revels or banquets, and none is quite so licentious as the cup in this collection, many of its details can be matched on other known cups by this painter. A cup at Corpus Christi College, Cambridge (*ARV²*, p. 402, no. 12), exhibits counterparts to the naked girl playing the flutes, the balding man, and the singer placing his hand on the back of his head; in addition, flute players have the same puffed cheeks on both cups. While the Foundry Painter's loving couples do not have quite the variety offered by those

on the Brygos Painter's cup in Florence (*ARV²*, p. 372, no. 31), a cup by this artist in London (*Paralipomena*, p. 370, no. 14 bis) and one in Malibu (ex-Bareiss 231; *Paralipomena*, p. 370, no. 33 bis) are further illustrations of the poses favored on the cup in New York. The man relieving himself in an oinochoe recalls the komast on the inside of Berlin 3198 (*ARV²*, p. 402, no. 13).

Euphronios, rather than Brygos, was the potter, as is true of most of the cups by the Foundry Painter and of many painted by the Brygos Painter (see H. Bloesch, *Formen attischer Schalen von Exekias bis zum Ende des strengen Stils*, 1940, pp. 70–74).

D.V.B.

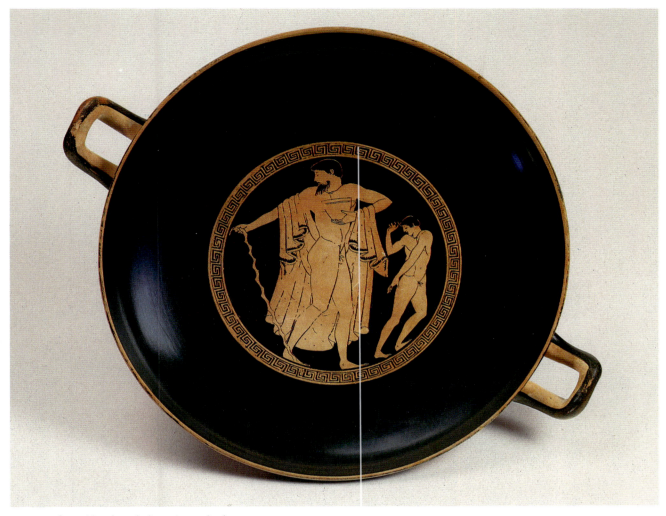

120: tondo, with a bearded reveler and a boy

120. *Kylix*

Height, 12.6 cm.; width across handles, 39.9 cm.;
 diameter of bowl, 31.3–31.7 cm.
About 480 B.C.
Attributed to the Painter of the Paris Gigantomachy

A Komos (or Revel) with a Man, a Boy, and Ten Youths

The depiction, inside the cup, of a bearded reveler, his himation draped over his arms and back, in the company of a smaller, naked boy, is closely linked to the scene of ten youths capering and dancing on its two outer surfaces. The man and boy are advancing toward the right but look back at the spectacle presented by five naked dancing youths, whose arms and legs assume a variety of positions that are imitated by those of the other five youths with short mantles draped over their arms. Two figures in the latter group, who are separated by the handle (from which the cup was suspended when not in use), in addition carry walking sticks in their right hands; the youth to the right of the handle holds a deep drinking cup in his left hand, as does the bearded man on the inside, whom he thus resembles more closely than his companions. Four of the five naked youths are

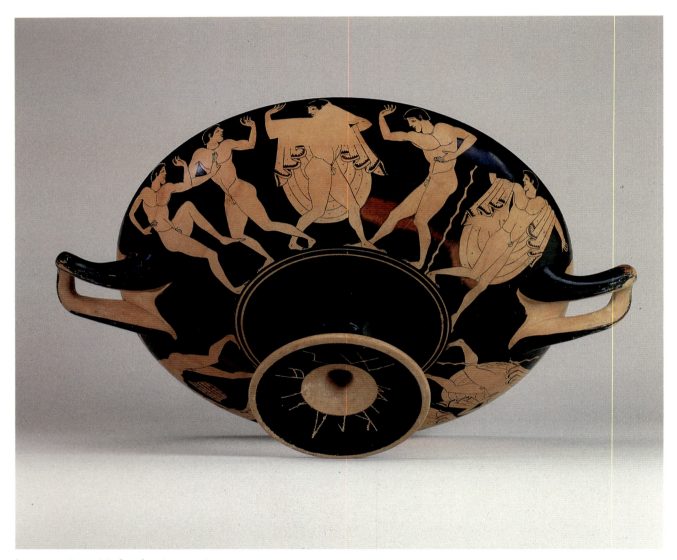

120: exterior, with five dancing youths

grouped around the opposite handle; a suspended picnic basket appears in the background between the figures to the handle's left.

All of the garments are ornamented with single dots, and three of their borders contain solid black stripes, although these are less elaborate than the border of the himation of the man on the inside, which is further decorated by a row of

dots, like the shorter mantles of the two youths on the other side. Note that there are no flutes and lyres and that the komos thus lacks musical accompaniment.

There is much repetition in the style of the Painter of the Paris Gigantomachy who, as Beazley noted (*ARV²*, p. 400), "has vigour, but no subtlety." The Painter of the Paris Gigantomachy is one of the artists in the circle of the Brygos

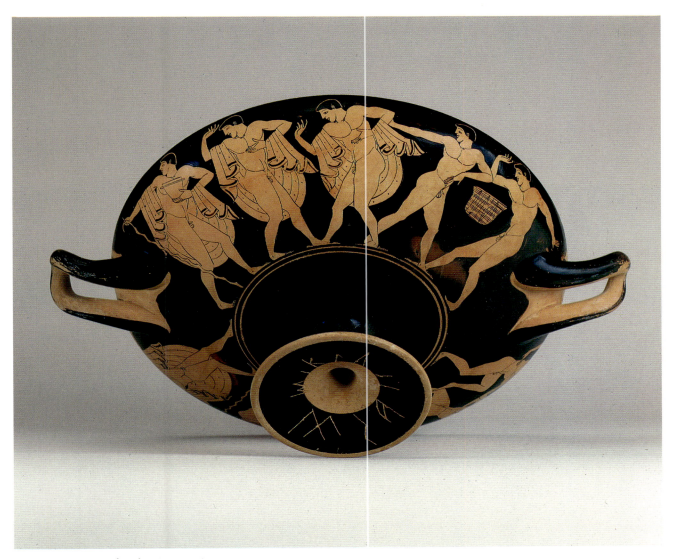

120: exterior, with five dancing youths

Painter, some of whom are closer to the master than others; according to Beazley (*ARV²*, p. 400), he "stands nearer to the Foundry Painter than to the Brygos Painter himself." This observation has led Dyfri Williams to reattribute the komos cup in Philadelphia (*ARV²*, p. 420, no. 60) to the Foundry Painter, prompted in part by Marinette Lefavre's independent attribution to that painter of Amsterdam 52 a—a fragment that Williams had joined with the Philadelphia cup (see *CVA*, Amsterdam, pl. 31, 1).

The long graffito under the foot may include the word "kylix" in one form or another (see A. W. Johnston, *Trademarks on Greek Vases*, 1979, p. 224, type 5 F), but the exact context cannot be readily interpreted.

D. v. B.

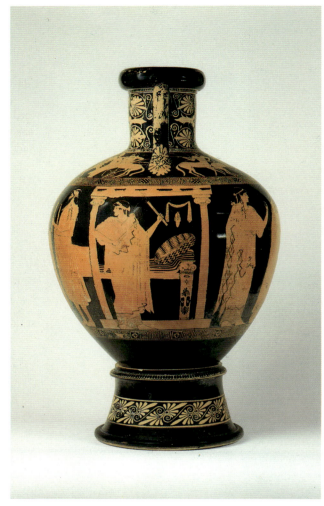 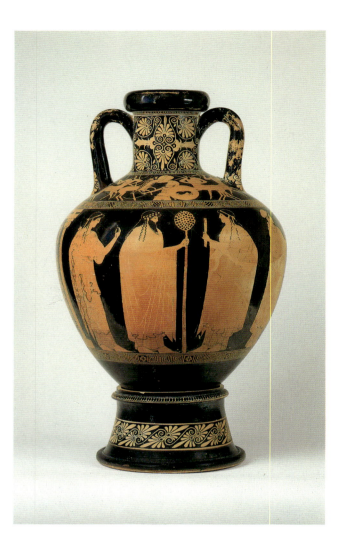

121: *The Wedding of Peleus and Thetis*

121. *Pointed neck-amphora, with stand*

Height: amphora and stand, 64.115 cm., amphora alone,
 59.25 cm.

About 470 B.C.

Attributed to the Copenhagen Painter [J. Robert Guy,
 in a lecture delivered in Copenhagen, September 2,
 1987]

The Wedding of Peleus and Thetis

Centauromachy (on the shoulder)

The procession extends all around the body of the vase, the
bridal chamber marking its beginning and end. The cor-
tege takes place at night. Philyra, the mother of the good
centaur Chiron, is awaiting the couple in front of the house,
which she illuminates with two torches. The structure is
indicated in typical architectural shorthand: two Ionic col-
umns, an abbreviated entablature, and a stylobate, allow-
ing us a glimpse into the chamber proper with its neatly
made bed on which there is a mattress and cushion. Chiron,
who lived with his mother, Philyra, on Mount Pelion,
appears to the left of the building, which obscures his
equine hindquarters. He, too, holds two torches to welcome
Peleus, who leads his bride, Thetis, by the hand. The
couple is followed by Artemis, who has lit the way with her

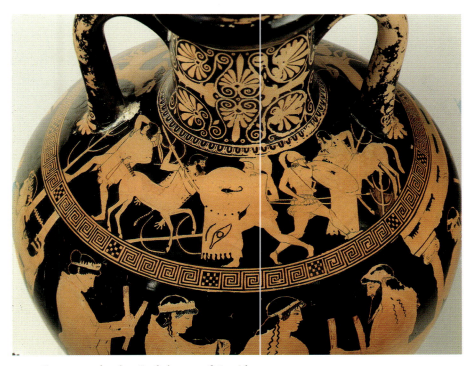

121: *Centauromachy,* detail of obverse of shoulder

two torches, and by her brother Apollo, who holds his kithara and looks back at their mother, Leto. This Delian triad has come to rest, as has the next trio of Semele, her son Dionysos, and a divinity whose name, spelled "Hopla," is not attested. Semele, torch in hand, has turned her back on Leto and seems to be conversing with her son, who holds a thyrsos. His companion, shown next to him, like Leto, holds a flower in her left hand. All the participants are richly dressed and wreathed: The bride wears a special broad and decorated diadem; Dionysos, an ivy wreath; and Apollo is crowned with laurel. Fillets are worn by the companion of Dionysos and by Semele and Philyra; Artemis, in contrast, is diademed, and the groom wears a special headband decorated above and below with beads. The headgear of Chiron is much abraded; Leto alone of all the participants has her hair hidden in a saccos.

This peaceful procession stands in marked contrast to the battle of the centaurs and Lapiths, supported by Theseus and Perithous, that rages on the shoulder of the vase, divided into four separate engagements by the handles. The six centaurs outnumber the four Greeks: They attack with

pine trees that have been uprooted and employ huge boulders to ram Kaineus into the ground, as the latter was invulnerable. Theseus and Perithous are equipped as hoplites with cuirasses, helmets, and round shields. Lapithas is shown as a lightly armed youth: He fights with a saber and is bareheaded (his petasos is pushed back onto his neck and shoulders). Two of the round shields of Theseus and Perithous are equipped with leather shield-aprons as extra protection; one of these is decorated with a large apotropaic eye. The devices on the shields are an attacking lion (for Kaineus) and, on the obverse, a scorpion for Theseus.

There can be little doubt as to the outcome of the battle: One of the centaurs is already wounded by the sword of Kaineus. He, like two of the centaurs on the other side, wears a splendid leopard skin over his shoulders. The main scene is framed above and below by a band of maeanders facing right, interrupted by checkered squares; an elaborate configuration of six palmettes and two lotuses fills the neck on each side of the vase, and another palmette appears below the root of each handle. The stand on which the pointed neck-amphora rests bears a tongue pattern on its everted lip

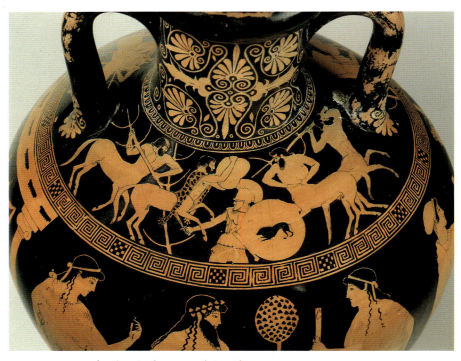

121: *Centauromachy,* detail of reverse of shoulder

121: without cylindrical support

and a broad band of addorsed, slanted palmettes midway between its mouth and base.

All the names, except those of the centaurs on the shoulder, are inscribed (Lapithas may be a variant of Lapithes, the mythical eponymous ancestor of the Lapiths; Hopla, the companion of Dionysos in the main scene, may be connected with the Lapith, Hoplon, on the François vase). To my knowledge this is the only representation of Philyra, the mother of Chiron, who helped Chiron bring up the young Achilles, only child of Peleus and Thetis, when the latter abandoned her newborn son and her husband.

The shape is rare but not unparalleled. In black-figure it appears in the Leagros period (Florence, 3871, and Toledo, 1958.69, both by the Acheloos Painter; *ABV*, p. 383, no. 2; J. D. Beazley, *Paralipomena*, pp. 168–69, no. 2 bis; *Beazley Addenda²*, p. 101), at which time, however, it still has a small foot with a resting surface, as has the earliest red-figured pointed amphora by the Kleophrades Painter, in Munich (*ARV²*, p. 182, no. 6). The Syleus Painter's pointed amphora in Brussels (*ARV²*, p. 249, no. 6) has a rounded knob in lieu of a rudimentary foot, but the neck is short and the body is more spheroid, as are two amphorae by the Copenhagen Painter and the same potter: one in London (*ARV²*, p. 256, no. 2) and another, in a German private

collection, recently published by Herbert A. Cahn (*Proceedings of the Copenhagen Congress*, 1987, pp. 107–15). The Levy pointed neck-amphora, published here for the first time, is slimmer and the neck is longer: It is halfway between the squatter versions in Brussels and London and the two more elegant pointed amphorae by the Oreithyia Painter, in Berlin and Munich (*ARV²*, p. 496, nos. 1–2). However, a third pointed amphora by the Oreithyia Painter, in Zurich (*ARV²*, p. 1656, no. 2 bis; *Beazley Addenda²*, p. 250), is of the squatter type. Later, the slender type prevails, such as the pointed amphora by the Achilles Painter, in the Cabinet des Médailles, Paris (*ARV²*, p. 987, no. 2). Some of the pointed amphorae have been found with a cylindrical support (Toledo, 1958.69; this vase; and Cabinet des Médailles, 357), but it is not always the one made for the vase; supports were replaced or switched, like many an amphora lid. The support that came with this pointed amphora, judging by clay, glaze, and ornamentation, may well be the original one.

Another splendid Centauromachy by the Copenhagen Painter occurs on the shoulder of the pointed neck-amphora in a German private collection, cited above; here, too, Theseus and Perithous are named.

D.V.B.

122. *Oinochoe (shape 3: chous)*

Height, 22.8 cm.; diameter, 18.3 cm.
About 470–460 B.C.
Attributed to the Altamura Painter [J. Robert Guy]

Apollo Citharoedus

The youthful citharode, judging by his long hair, splendid attire, and his position close to an altar, should be Apollo himself rather than an Athenian youth performing at a festival, if only on the analogy of two other oinochoai by the same painter (Boston, 97.370, and Louvre, CA 154; *ARV²*, p. 594, nos. 62, 63) that show Apollo and Artemis at an altar or with another goddess.

The somewhat squat shape of this oinochoe, with its trefoil mouth, is called "chous" in Greek, a term that originally denoted a liquid measure. The festival of choes was part of the Dionysiac celebrations in the spring, when the new wine was tasted. Small children participated in this festival and were given miniature choes; these have been found in great quantities.

D.V.B.

123: *A, Concert*

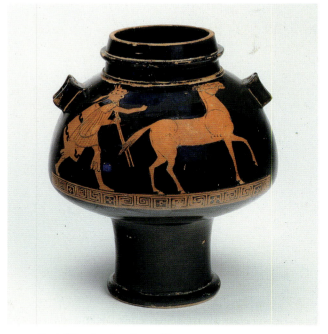

123: *B, A Thracian Leading a Horse*

123. *Psykter*

Height, 18.9 cm.
About 470 B.C.
Attributed to the Painter of the Yale Oinochoe

A, Concert

B, A Thracian Leading a Horse

Psykters came into fashion in the last quarter of the sixth
century B.C., replacing an earlier, more complicated series
of double-walled amphorae, each with a spout and a spigot,
in which the coolant (cold water) was poured into the hollow
between the two walls surrounding the inner receptacle that
held the wine to be cooled.

Attic potters made two varieties of psykters, one without
lid and handles, and another—of which this small psykter
is a good example—usually equipped with a lid, that has
two pairs of small connected tubes, one pair on each side of
the shoulder, through which a string or cord was passed for
lifting and easy carrying. The decoration was limited to the
shoulder, since the psykter, when it was filled with wine,
floated in the cold water of a krater, its cylindrical lower
extension acting as a keel.

A bearded citharode in festive garb accompanies his song
on his seven-stringed instrument in the presence of a seated

male holding a wand and a walking stick. The citharode
faces another man who leans on the walking stick propped
under his left armpit. The man, whose rather sketchy beard
is rendered in dilute glaze, holds a flower in his raised left
hand. The listener on the left may be a judge or trainer. As
most of his head is restored, we cannot tell whether he was a
youth. His right leg is pulled back, with the foot slightly
raised (most of his left leg is a restoration).

The reverse shows a young Thracian rider shouldering
two spears and leading his horse. His attire—the fox-skin
cap (*alopeke*); a short Thracian mantle (the *zeira*), with its
distinctive woven pattern, over a short chiton; and fur
boots—is reminiscent of that of the similarly dressed young
horsemen on an unattributed psykter in the Louvre (G 59)
by one of the Pioneers (*CVA* III I c, pl. 58, 1–4), and on the
kalpis in Madrid (11125; *CVA* III I c, pl. 11, 2, and pl. 14,
top), which Beazley, as late as 1942, attributed to the Berlin
Painter (*ARV*[1], p. 140, no. 136) but has since omitted from
his lists of attributed vases (see D. C. Kurtz, *The Berlin
Painter*, 1983, p. 111).

Parts of the psykter, which were once in the collection of
Herbert A. Cahn in Basel, are discussed by Stella Drougou
(*Der attische Psykter*, Würzburg, 1975, p. 20, no. B 11, pp.
53, 97–98).

D.V.B.

124. *Loutrophoros*

Height, 84.9–85.9 cm.; width, 37.5 cm.; diameter,
 29.5 cm.
About 340 B.C.
Attributed to the Darius Painter, an early work
 [A. D. Trendall]

The Death of Hippolytos

This very tall vase, like the hydria (cat. no. 125) by the same painter, was made expressly for a tomb, as indicated by the absence of a bottom. Since its neck is quite narrow, the potter was obliged to make two vent holes on the shoulder, each piercing the strap handle at its lower attachment, lest the expansion of trapped air caused the vase to explode in the firing. The decoration is very ornate but disciplined, with figures included in several registers. On the sloping shoulder, female heads emerge from the calyx of a flower amidst a profusion of tendrils. The head on the obverse is in three-quarter view and is painted white, and the tendrils are rendered in a perspective that suggests a third dimension, while the profile head on the other side has no white added, and the scrollwork is flat and less naturalistic.

The figures in the scene in the lower register, which extends around the body of the vase, are depicted as conventional mourners at a tomb—a white stele, drawn in perspective, surmounted by a shallow-footed dish with vertical handles (as on the hydria, cat. no. 125). The mourners—seven figures in all—bring various offerings, including boxes with open lids, mirrors, fans, wreaths, and a tambourine. Four more figures occupy the reverse of the upper zone. One woman leans on a pillar; two others are seated on Ionic capitals. Of the three youths (one above and two below), two are seated on the ground and the third, next to the stele, who stands atop an elevation, is tying a long fillet to the tomb monument.

Loutrophoroi, originally vases for the nuptial bath, as such became symbols of marriage. Beginning in the fourth century B.C., they came to serve as tomb monuments or as offerings at the tombs of those who died young and were unmarried. In this connection, the mythological scene in the upper register on the obverse takes on a special meaning since it portrays the tragic death of Hippolytos, which was brought on by the bull emerging from the sea and frightening his horses. The fearful aspect of the narrative is further heightened by the Fury who threatens Hippolytos with a flaming torch and a wand, helped in her task by the two snakes that are coiled in her hair. Hippolytos is startled and

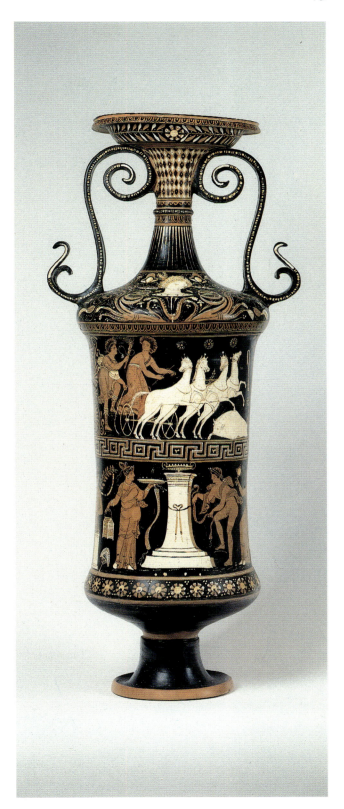

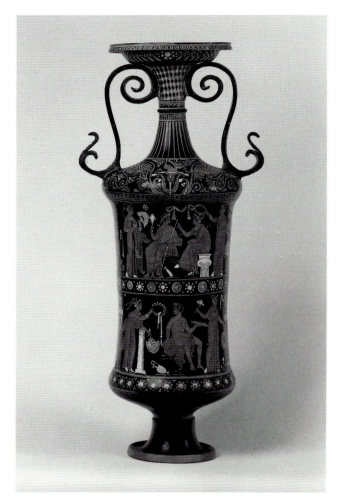

124: reverse

turns around; his eyes and furrowed brow express mortal fear. Of the four horses that rear at the apparition from the sea, the left trace horse throws up its head in panic. Disaster will strike in a moment.

Hippolytos was the son of Theseus and the Amazon; his neglect of Aphrodite brought him into conflict with his stepmother, Phaidra (the sister of Ariadne), as recounted in the tragedy by Euripides. The Darius Painter has left us a similar representation in the lower register of a volute-krater in London (F 279; A. D. Trendall, *RVA*, p. 487, no. 17, pl. 173, 1), where the Fury, in front of the chariot, seizes the left trace horse by its topknot and brandishes her torch while the paedagogue of Hippolytos helplessly rushes toward them from the left. The white bull sent by Poseidon in answer to Theseus's prayer is less menacing than the one

on the loutrophoros, and Hippolytos himself looks less apprehensive. Still weaker is a volute-krater by the Underworld Painter, in a Naples private collection (A. D. Trendall, *RVA*, suppl. I, p. 86, no. 293 a, pl. 17,4). The terror brought on by the monstrous bull was conveyed by Euripides (*Hippolytos*, lines 1198 ff.) and by the messenger in the tragedy by Seneca (*Hippolytus*, lines 1025 ff.). Following in the tradition of Euripides and Seneca, the description of the apparition from the sea in Racine's *Phèdre* is equally forceful, culminating in the memorable line, "Le flot qui l'apporta recule épouvanté."

<div align="right">D. V. B.</div>

BIBLIOGRAPHY
A. D. Trendall, *RVA*, suppl. I, p. 73, no. 20 a, pl. 11,1–2; Galerie Nefer, Zurich, 1982, p. 4.

125. *Hydria*

Height, 63.6 cm.; width, 44.6 cm.; diameter, 36.6 cm.
About 330 B.C.
Attributed to the Darius Painter, in his more mature
 period {A. D. Trendall}

The Story of Io

This hydria, which has no bottom, was obviously made for a tomb; a funerary subject is shown on the body, below the ornamental handle zone. Two youths and four women are seated or stand next to a white stele, which is surmounted by a fluted shallow dish with upright handles. These worshipers hold or carry the usual offerings—a phiale, mirror and xylophone, aryballos, open casket, fan, wreath, cylindrical box (of basketry ?), and a bird. Terrain lines are indicated, and the stele is shown in three-quarter view.

The chief subject on the shoulder—below a band on the neck in which the bust of a woman is depicted in a floral setting—tells the story of Io's deliverance from her bovine transformation and from the watchful Argos. Zeus and Io, at last reunited, occupy the center of the scene. Both are seated on the ground. Zeus has placed his thunderbolt by his side but holds his scepter in his right hand, while, with his left, he touches the shoulder of Io. The bovine horns on her head are all that remain of her former metamorphosis. Eros hovers above, proffering a coronet, and Aphrodite, next to Zeus, plays a love oracle on an Iynx wheel.

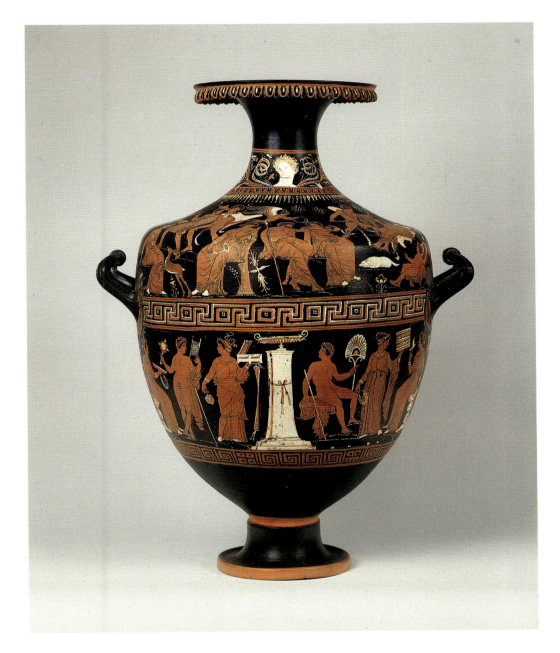

The death of "all-seeing Argos" (as he was called by the Greeks because of the many eyes all over his body) is shown on the right. The ideal watchman was commissioned by Hera to guard Io after Zeus—in love with Io, the priestess of Hera, and challenged by his wife—changed Io into a heifer (or, according to some scholars and many of the vases, a bull). Hera, suspecting her husband of a ruse, asked that Io be brought to her in her new disguise, and had her watched day and night. Zeus, in turn, sent Hermes to free Io, and this Hermes accomplished with the aid of Hypnos, the god of sleep. Here, with a magic wand, Hypnos has put Argos to sleep and now uses his power on Argos's dog.

The figures at the left are more enigmatic. Two hunters are about to depart. The younger, clad only in an animal

skin, looks suspiciously like Argos, asleep on just such a pelt at the extreme right, while the other man, dressed in a short chiton, a petasos, and a somewhat smaller animal skin, resembles Hermes. The older hunter at the left, however, does not carry a caduceus but a shepherd's crook. The remaining figures at the far left are a young Pan, leaning on a laver, who holds a syrinx and a branch, and Artemis, recognizable by a fawn, to whom Pan is talking. A. D. Trendall suggested (in a letter) that Hermes (in the disguise of a herdsman) first beguiled Argos with his tales, before putting him to sleep, which would account for the combination in one picture of the different events in the story.

The significance of the ivy wreath worn by Aphrodite (to Zeus's right) poses a problem, but it may be borrowed from an earlier iconography. On an Attic red-figured oinochoe in Berlin (F 2651; *AA*, 1985, p. 279, fig. 63), Io is shown with such an ivy wreath in her hair.

Hermes' disguise is recounted in Ovid's version of the trials of Io (*Metamorphoses* I, lines 668 ff.). Upon his arrival on earth, Hermes put down his wings and magic cap, but kept his sleep-inducing wand (the *virga somnifera* referred to by Ovid). Like a herdsman, he drove a flock of goats collected on the way, playing on his syrinx until he met Argos. First he tried to put Argos to sleep with the music of his pipes, but did not succeed until Argos asked Hermes how the syrinx got its name. The lengthy response (Ovid, op. cit., lines 689–714) finally produced the desired results, and Argos was slain.

Io's troubles, however, were far from over, for she was still a heifer, and Hera sent a gadfly to torment her. Io was maddened and roamed the earth until she reached Egypt, when Zeus intervened a second time. In a touching reconciliation (still, according to Ovid) Hera relented, and Io once again became a nymph. Part of this story derives from the account known to us from Aeschylus. In a dialogue (*Suppliants*, lines 274 ff.), the Danaids elicit the true story of Io from Pelasgus, King of Argos, and thus establish their claim to be of Argive descent through Epaphos, issue of the union of Zeus and Io—not, however, in the customary way but merely through laying on of hands (op. cit., line 315). Epaphos means caress, and seen in this light the gentle gesture of Zeus laying his left hand on the shoulder of Io is more than just a caress. We also learn from Aeschylus (*Prometheus Bound*, lines 560 ff.), who prophesied the future of Io, that she would be delivered by Zeus at Canobus, in the Nile delta, through the mere touch and caress of his hand "that need not be feared," and would then bring forth Epaphos (op. cit., lines 846 ff.).

Many of the mythological subjects painted on Apulian vases were taken from Greek plays performed in southern Italy. Thus, it is possible to learn about the contents of lost plays by the great tragedians by analyzing the scenes on these vases.

D. V. B.

BIBLIOGRAPHY
A. D. Trendall and A. Cambitoglou, *First Supplement to the Red-figured Vases of Apulia* [University of London, Institute of Classical Studies, *Bulletin Supplement*, 42], 1983, pp. 76, 78, no. 63 d.

126. *Volute-krater*

Height: to top of handle, 81.5 cm.; to top of rim, 71.8 cm.
About 340 B.C.
Attributed to the De Schulthess Painter [A. D. Trendall]

The Battle of Gods and Giants

Like its companion vase (cat. no. 127), on which the arming of Achilles is depicted, this volute-krater has a bottom. The funerary subject is subordinated to the obverse, where a mythological scene is featured. The two sides of each vase are separated by the same heavy palmettes and lotuses, and the subsidiary ornaments and adjuncts—the white heads of Io in the volutes, and the white swan finials—are identical. The two vases are not only contemporary, but clearly are by the same painter, and may well have been found together.

As in the krater with the arming of Achilles, the main subject unfolds on two levels. In the upper register Nike drives the chariot of Zeus, who has hurled his thunderbolt at one of the giants at the right. Apollo, on slightly lower ground, releases an arrow, which is about to strike the giant to his right who has fallen on one knee. The giant has wrapped an animal skin around his left hand and arm, and prepares to defend himself against Apollo with a rock that he has picked up from the ground. He is accompanied by another giant with a cloak and more conventional armor: a white shield, a sheathed sword suspended by a baldric from his right shoulder, and a spear. Both figures are seen from the back, but the artist, in applying the inner markings,

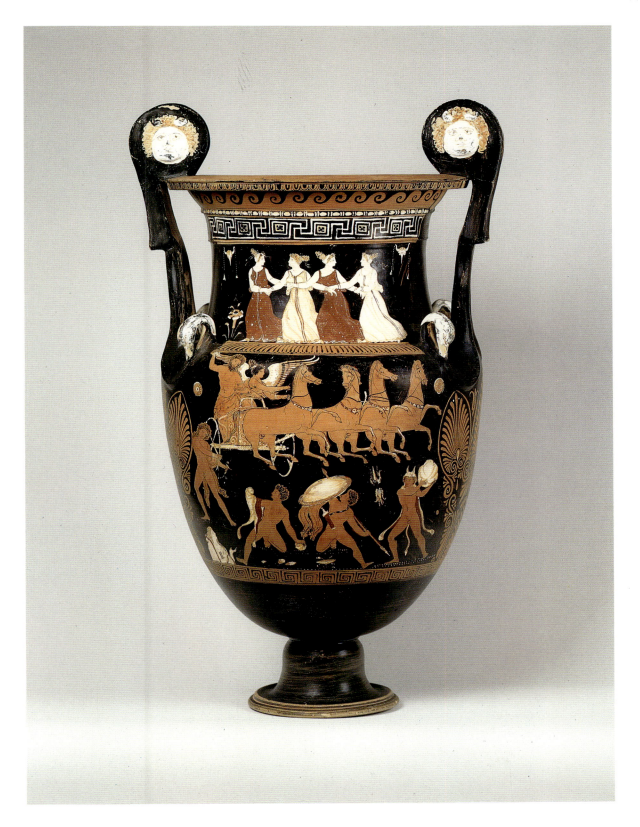

126: reverse

depicts the legs in frontal view. To the giants' left, Ge, the mother of the giants, emerges from the ground, while Herakles, clad in his lion skin, joins in the battle at the right, lifting a colossal boulder without much effort. The giants are clearly outnumbered, and the inevitable victory of the gods is symbolized by the charioteer of Zeus.

The tomb scene on the other side differs from that on the companion vase only in the offerings of the youths and women: Above, the grapes and the wreath have been interchanged, and the box has been replaced by a tympanon; below, grapes have been substituted for the wreath held by the woman, which, here, is in the right hand of the youth. More radical, however, is the novel treatment on the obverse of the neck. Four maidens, in alternating red and white garments, are shown in a dance, their hands interlocked. This dance takes place in a sanctuary out of doors, as indicated by the flower on the left and two bucrania suspended above, one on the left, the other on the right.

D. V. B.

BIBLIOGRAPHY
A. D. Trendall, *RFVSIC*, 1989, p. 88, fig. 199.

127. *Volute-krater*

Height: to top of handles, 83.5 cm., to top of rim,
 72.8 cm.; diameter of body, 43.2 cm.
About 340 B.C.
Attributed to the De Schulthess Painter [A. D. Trendall]

The Rearming of Achilles

The obverse and reverse of this vase may be clearly differentiated by the greater attention to detail, the more lavish use of added color, and an imaginative treatment of the subject on one side, in contrast to the more summary rendering of the standard funerary subject on the other. The separation is reinforced by the massive barrier of palmettes under the handles, which prevents any overlapping or intrusion of scenes.

In the second arming of Achilles, he received the new arms made by Hephaistos at the request of his mother, Thetis, following the death of Patroklos at the hands of Hector. When the new set was ready, Thetis and the other Nereids carried the arms across the sea to the Greek encampment at Troy. In Homer's account (*Iliad* XVIII, lines 468 ff.), Hephaistos made an elaborately decorated shield, cuirass, helmet, and greaves, and the painter has concentrated his efforts on these essentials.

Achilles stands in front of Thetis in the center of the scene on the obverse, putting the greave on his left leg; the greave for the right leg is being brought by a Nereid below, swimming with a dolphin, a parasol in her left hand. Next to her is the hippocamp from which the goddess Thetis has alighted. In her right hand she holds a Corinthian helmet, with its leather liner and "golden crest" (Homer, loc. cit., line 612), while with her left hand she steadies a corselet and a spear against her shoulder. A shield with a fierce gorgoneion in the center leans against her right leg. Another Nereid swims next to a *ketos* in the water below, holding up a sheathed sword in her left hand. Above, a Myrmidon leads a white horse; the elderly Phoinix, leaning on his staff, stands behind Achilles and gives advice; and a seated woman holds a shield and spear and carries a sword suspended from a baldric. In the background the painter has included the wheels of a chariot, a helmet of distinct south Italian type, three libation bowls, and a third shield to indicate that the setting is the inside of the tent of Achilles. The shore is clearly marked by dotted lines below the feet of Phoinix, Achilles, Thetis, and the Myrmidon, and the sea in which the dolphin, hippocamp, and *ketos* swim is sketched in with a wavy line.

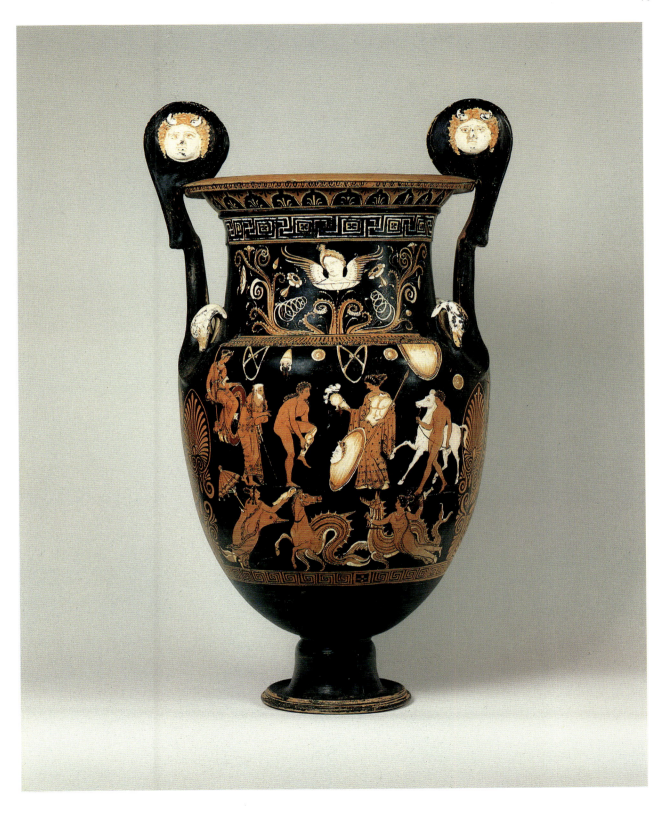

127: reverse

white palmettes is separated by a black band from the labyrinth maenader below, while, on the reverse, a wave pattern is followed by a band of astragals and a laurel wreath. Like the palmette configuration on the neck it lacks added white and thus is rather flat in appearance.

D.V.B.

BIBLIOGRAPHY
A. D. Trendall, *RFVSIC*, 1989, p. 88, fig. 198.

On the neck of the obverse a winged woman emerges from a flower flanked on either side by tendrils and by more flowers and buds; the spiral tendrils in added white are drawn in perspective, lending a third dimension to the exuberant foliage.

The scene on the reverse is more subdued. Four mourners are arranged symmetrically on two levels, beside a tall stele on a massive socle. The two above, a youth and a woman, are seated; their counterparts on the ground level approach the tomb rapidly. The offerings comprise grapes, platters with other fruit, two wreaths, a box, and a branch.

The heads and necks of the swans that serve as the finials of the arch supporting the volutes of the handles are painted white, as are the mascaroons of Io in the central medallion of each volute. The decoration on the rim of the vase differs on each side: on the obverse, below the egg pattern, a black Lesbian kymation outlined in white and enhanced with

128. *Dinos*

Height, 27.8 cm.; diameter, 33.5 cm.
About 335–320 B.C.
Attributed to the Painter of Louvre MNB 1148

The dinos is equipped with a ring base, and thus is not in need of a special support, although for convenience at a banquet it may well have been put on a stand. As there are no handles, the scene extends around the vase. The banqueters occupy a continuous circular mattress that rests on an equally imaginative frame without legs or posts, instead of reclining on individual couches. Eleven youths are engaged in a serious drinking bout, entertained by two flute-playing girls who stand in front of them, clad in long-sleeved undergarments and long tunics. Both young women also wear boots and are wreathed. Above their heads and those of the banqueters is a vine wreath with white grapes, which encircles the body of the vase; it is a fitting pendant to the ivy wreath with berries on the neck. There are two bronze *kottabos* stands in front of the banqueters, and platters of fruit or cakes are on the ground.

Although the mattress is continuous, the protocol of symposia that would prevail if there were separate couches is preserved: The youths are in pairs, except that one has climbed up between two couples to have his skyphos filled. On the other side is a second unorthodox figure—the youth who sits upright, facing front, skyphos in hand.

In addition to skyphoi, kantharoi, oinochoai, and a stemless cup are included in the scene, all painted white with touches of dilute-glaze shading to render them more realistically. A long curtain appears below the bedstead, which is draped with valances.

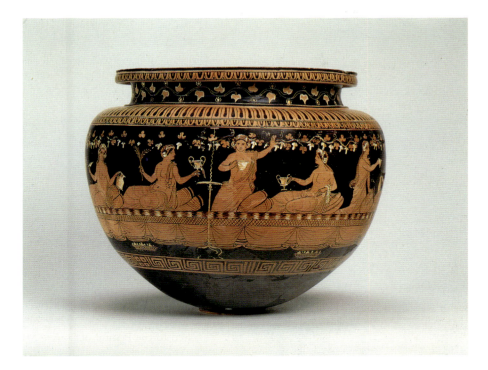

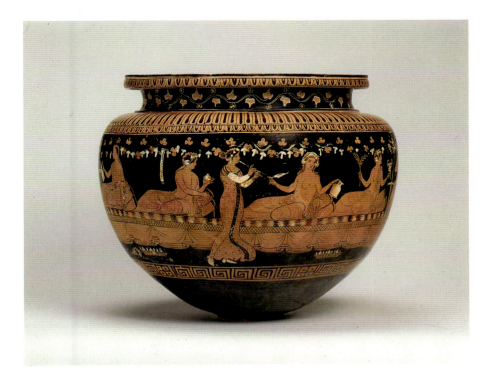

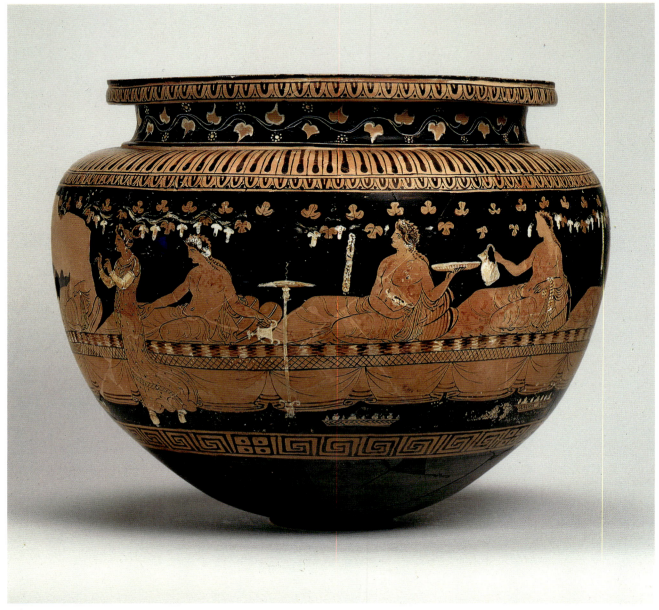

128

The Painter of Louvre MNB 1148, a follower of the Varrese Painter, has been praised by A. D. Trendall for his originality (*First Supplement to the Red-figured Vases of Apulia* [University of London, Institute of Classical Studies, *Bulletin Supplement*, 42], 1983, p. 99), and this dinos bears out Trendall's observation.

The vase has been broken into many fragments and repaired, and some losses remain, notably in the shoulders, head, and right arm of the banqueter to the left of the flute-playing girl who faces left, and in the right forearm of the kneeling boy farther to the left, who is shown in profile.

D. v. B.

129. *Guttus*

Height: to top of handle, 8.78 cm., to top of mouth,
 6 cm.; diameter, 11.78 cm.
About 330 B.C.
Attributed to the BM Centaur Group [A. D. Trendall]

The guttus has a ring handle, a spout in the shape of a ram's
head (with a hole in its muzzle), and a built-in strainer on
top with sixteen holes in its opening. The strainer kept out
any lees or dregs as the vessel was being filled. On the side
opposite the spout an Eros flies toward a seated woman who
holds a phiale in her left hand. To the left of the handle is a
reclining youth also holding a phiale.

This strainer is an Apulian adaptation of an Attic type
that came into fashion in the late fifth century B.C. Beazley
(*AJA* 25, 1921, p. 326, n. 3 [8]) cites three examples with
lion heads—a list that has since been increased considera-
bly. The ram's head on this Apulian guttus finds its closest
parallel on a guttus in the British Museum (F 413, from
Ruvo; *RM* 83, 1976, p. 266, n. 36, pl. 86,2; A. D.
Trendall, *RVA* II, 1982, pp. 627–28, no. 241) that is a
trifle bigger (diameter, 5¼ inches) but has the same wave
pattern around the rims, and shares the composition of a
flying Eros between a woman and a youth.

<div align="right">D. v. B.</div>

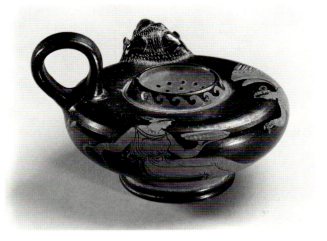

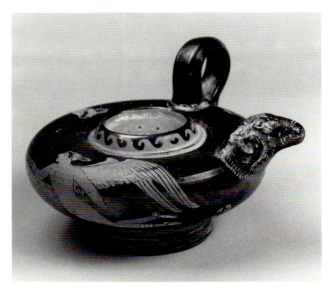

130. *Rhyton in the form of a ram's head*

Height, 20.45 cm.; width, 12.57 cm.; diameter,
 11.93 cm.
About 330–320 B.C.
Associated with the Paidagogos Group [A. D. Trendall]

The conceit of a rhyton, or drinking horn, in the form of an animal's head entered the realm of Greek art from the East, and Apulian red-figured rhyta, in turn, are intimately linked to Attic red-figured prototypes.

The composition on the bowl presents a scene often portrayed by Apulian vase painters: Eros, holding a platter in his left hand and a sash or fillet in his right, approaches a woman who is seated on a stylized rock. In her hands she holds a ball and a cluster of grapes. Eros is flanked by two upright laurel branches, a characteristic of the kantharoi in Trendall's Paidagogos Group (*RVA* 2, 1982, pp. 610–11), with which this rhyton can be associated.

The ram's head is all black except for the eyes, which are reserved and bear a black dot for the pupil. The plastic part is closest to the rams' heads in H. Hoffmann's "Main Group" (*Tarentine Rhyta*, Mainz, 1966, pp. 32–33).

D.V.B.

131. *Fish-plate*

Height, 5.5 cm.; diameter: of plate, 24.7 cm., of foot,
 11.53 cm.
Mid-fourth century B.C.
Attributed to the Cuttlefish Painter [A. D. Trendall]

The abundance of fish in the Mediterranean, which prevailed until fairly recently, made fish a staple food in the region, and the inventive genius of Attic potters in the late sixth century B.C. introduced a specific type of plate admirably adapted for serving fish. Instead of being perfectly flat and level on top, a fish-plate slopes gently toward a central depression. It is equipped with a foot and a long stem, and has an overhanging rim. In the fourth century B.C., Attic painters began to decorate these special plates with fish, abandoning the earlier fashion of depicting maritime mythological subjects, and the true fish-plate was born. By the middle of the fourth century the shape entered the repertory of south Italian potters and painters, and by far the largest number of fish-plates that have come down to us were made in Sicily, Campania, Paestum, and Apulia.

This fish-plate—one of several in this collection—is exceptional in that the fish are drawn with their bellies

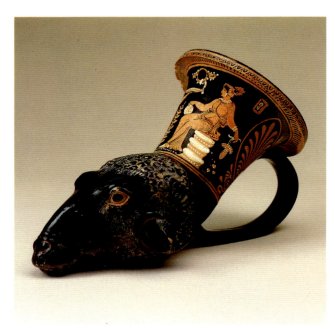

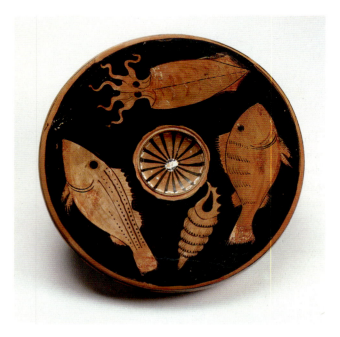

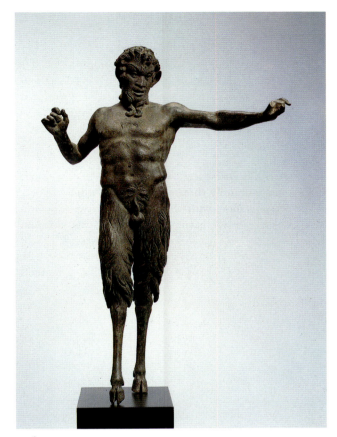

136 : *a*

136 : *b*

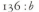

visual. Detailed measurements taken at a number of key points vary markedly from one figure to the other, and the surface analyses indicate that the alloys from which they are cast are dissimilar in their compositions, the bronze of one of the figures (*b*) having a noticeably higher lead content (I thank Arthur Beale of the Museum of Fine Arts for this unpublished information, communicated in a letter on January 12, 1990).

Such significant compositional differences suggest that the pieces were not cast at the same time, after the same original model, as I proposed when they were originally published. Rather, according to Beale's observations, one statuette most likely was modeled in direct and intentional imitation of the other, at a slightly later time in antiquity, perhaps by another artist. The greater anatomical accuracy and the generally finer execution of the details of figure *a* may identify it as the original, as may the lower lead content of its alloy. Patina and condition suggest that the two figures were ultimately buried together.

The unusual occurrence of two figures that are so closely related in appearance, scale, and patina can be explained by the original having been replicated to become part of a group composition. The loss of the horns on both images, in spite of their otherwise generally excellent state of preservation, and the presence of a third hole in the head of figure *b* suggests one possibility in this context: The two statues may have served as supports, accommodating an article of furniture on their heads, similar in function to the bronze satyrs that form the legs of a Late Hellenistic tripod from Herculaneum (E. Pernice, *Gefässe und Geräte aus Bronze* [*Die Hellenistische Kunst in Pompeji* IV], Berlin, 1925, p. 37, pl. X).

While the tradition of manufacturing furniture and vessel ornaments in numerous replicas goes back to the earliest periods of bronze casting (see C. Mattusch, *Greek Bronze Statuary*, Ithaca, New York, 1988, p. 36), duplicates were not made for attachment purposes only. Freestanding pairs of decorative bronze statuettes have long been known, as

well. (See, for example, the Genii in Anatolian costume, now divided between the collections of The Metropolitan Museum of Art [49.11.3] and the Walters Art Gallery [54.1330], most recently published by J. J. Herrmann in *The Gods Delight* . . . , Cleveland, 1988, pp. 288–95, nos. 51, 52; and the pair of slaves with shoulder-carriers, in the Kunsthistorisches Museum, Vienna [VI 337, VI 339], published by K. Gschwantler, *Guss und Form, Bronzen aus der Antikensammlung*, Vienna, 1986, pp. 134–35, nos. 205–206.) Although not furniture in the strict sense, these pairs of ornamental figures often served some practical function, such as holding torches or supporting suspended lamps or other implements.

Without the lost attachments and attributes, the original purpose or purposes for which these figures were made can never be known for certain. As twin replicas of an otherwise unknown figure type, however, they contribute a new and noble image to the iconographic repertoire of the Arcadian goat-god. No sedentary flutist or comic attendant, Pan, in these images, recalls again the free spirit of meadows and forests. This god has never ceased to represent the bucolic pleasures of paganism, nor lost his appeal to civilized society's nostalgia for simpler times.

M. T.

BIBLIOGRAPHY

M. True, in *The Gods Delight: The Human Figure in Classical Bronze*, A. Kozloff and D. G. Mitten, eds., Cleveland, 1988, pp. 142–47, no. 23.

137. *Silver-gilt rhyton*

Height, 26.7 cm.; diameter of mouth, 12.7 cm.
Second century B.C.

This splendid rhyton, with the protome of a leaping horse, said to have been found in Iran along with the bowl in the following entry (cat. no. 138), is of the type of drinking horn terminating in an animal protome that originated in the Near East and flourished primarily in Achaemenid and Hellenistic times—the second half of the first millennium B.C. The repertory of animal protomai includes lions, lion-griffins, eagle-griffins, bulls, goats, and stags. Near Eastern rhyta reached the Greek world as early as the fifth century B.C., when Greek silversmiths adapted the Eastern models according to their own specific preferences. Lions and lion-griffins gave way to horses, which were especially favored by Greek patrons and workshops in Thrace and along the shores of the Black Sea and were even incorporated in reliefs decorating Late Hellenistic Etruscan cinerary urns (see F. H. Pairault-Massa, *MEFRA* 87, 1975, pp. 255–72, figs. 14, 20, 22). Although horse-rhyta are rare in the East, they are not entirely unknown, for a rhyton with a typically Achaemenid mane and a ram's head has been found in Borovo, Bulgaria (*Gold der Thraker*, Mainz, 1979, p. 146, no. 288). This rhyton is certainly of Greek workmanship and may be a modification of a rare Near Eastern model not otherwise known to us. Even after the fall of the Persian Empire under Alexander the Great and the spread of Hellenism to the East, when new rhyton types were introduced into the Seleucid and Parthian repertory—as we learn from the ivory rhyta found at Nisa (M. E. Masson and G. A.

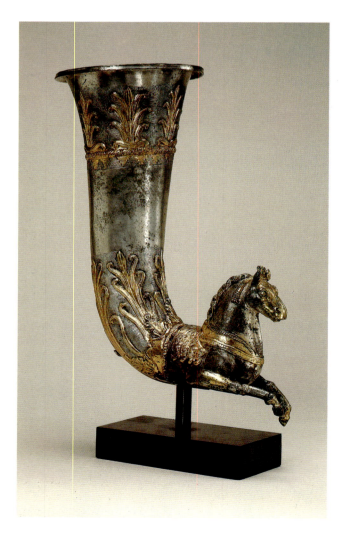

Pugacenkova, *The Parthian Rhytons of Nisa*, Florence, 1982, passim)—the horse-rhyton remains conspicuously absent in the East.

While singular among Eastern rhyta, the Levy rhyton cannot be considered a Greek import, for it belongs to the so-called calyx class of rhyta—a group that did not make its appearance until about 200 B.C., and is known almost exclusively from Near Eastern finds. Even the kind of horse, the so-called ram's-head type, already popular in Achaemenid times, remains virtually unknown in Greece. In addition, the topknot of the gilded mane between the horse's ears and the careful rendering of its curls—which are almost like a hairdo—are in keeping with Eastern tradition, as is the gilding of the muscles on the upper parts of the legs. An Eastern influence also extends to the ornamentation: the pattern of battlements that adorns not only the breastband of the horse but, together with the guilloche, forms the groundline for the frieze of slender palmettes along the rim of the vessel. For the other decorative details the best parallels are Greek. These comprise the placement of the slender palmettes below the rim (see the rhyton in Malibu, 86.AM.753; *J. Paul Getty Museum Journal* 15, 1987, p. 165, no. 22); the indication of fur as the saddle, best known from the Alexander mosaic (B. Andreae, *Das Alexandermosaik aus Pompeji*, Recklinghausen, 1977, pl. 5); the heavy breastband; and even the fringed fillet of the topknot.

The trappings of the horse's head, however, once again signal the East. The *prometopidion* (chamfron, or frontlet) is attached by cross straps—a nomadic feature unknown on Greek bridles but which occurs on a small golden horse from the Oxus treasure that had been buried in the first half of the second century B.C. and was found on the Central Asian frontier of the Hellenized East (O. M. Dalton, *The Treasure of the Oxus*[3], London, 1964, pp. 4–5, no. 8, pl. 13). The frontlet itself is lenticular and, especially because of its spine, resembles the Italic shield, the *scutum*, which was introduced throughout the Hellenistic world by Celtic tribes and mercenaries. In the last decades of the third century B.C. the Hellenistic armies adopted this originally Italic shield and its distinctive shape was subsequently also adapted to jewelry. Its occurrence on the frontlet helps us to date the rhyton, for it would not have been employed before the *scutum* had become a standard shield of the Hellenistic armies. This detail, coupled with the type of this calyx-rhyton, allows us to propose a date for it in the second century, or possibly as late as the first century B.C. Taken together, all the different criteria favor an Iranian workshop rather than one in Asia Minor, as had been proposed, even if some questions remain. In this connection the conspicuous knot on the left side of the breastband takes on a special

significance. It is a square knot, also known as the knot of Herakles since it was with this knot that the famous Greek hero tied the front legs of the lion skin over his chest. The knot thus acquired talismanic qualities that persisted well into Roman times and became particularly important in Macedonia: Not only did Alexander the Great claim Zeus as his father and, hence, Herakles as his brother, but the entire Macedonian royal house traced its descent from Herakles. The Herakles knot appeared in Greek jewelry of the Hellenistic age, and became a symbol of Macedonia. Therefore, a rider tying the breastband of his horse in this fashion identifies himself with the Macedonian tradition.

At the time that the Levy rhyton was made, the Macedonian sway over Iran and the Near East had been widely replaced by that of the Arsacids (or Parthians)—nomadic tribes from Central Asia who invaded Iran in the late third century B.C. By the middle of the second century they already controlled a realm stretching from Central Asia to Mesopotamia. In true nomadic tradition their military power was based on their cavalry of mounted archers. Parthian horse trappings included a special type of decoration—the disks called phalerae, which are attached to the horse's sides in front and sometimes also behind the saddle. The silversmith of the Levy rhyton ignored these phalerae. In depicting the bridle he faithfully followed the Central Asian model, while for the saddle, the breastband with its Herakles knot, and even the topknot of the mane he adhered to a Greek (Macedonian) or Near Eastern tradition. This would seem to deny that the owner of the rhyton was a Parthian, and suggests, instead, that he was either a member of one of the old Iranian families who, even under Parthian rule, continued to predominate, or else was a descendant of the Greek settlers who adopted some Near Eastern practices but did not entirely renounce all Greek traditions. In any event, the Levy rhyton reflects the coexistence of a dual Iranian cultural heritage in the days of Parthian political domination—a strong Greek strain, which was not suppressed by the invasion of the non-Greek Arsacids, whose coinage, incidentally, proclaimed them as friends of the Greeks. Seen in this historic and political context, it is not surprising that the overall appearance of the rhyton is almost entirely Greek, clearly illustrating that even after the collapse of the Graeco-Macedonian world in the Near East and Central Asia, Greek culture continued to prevail in the artistic workshops of the Hellenized East.

M. P.

BIBLIOGRAPHY

B. Barr-Sharrar, in M. Leeb Hadzi, *Transformations in Hellenistic Art* (exhib. cat.), Mount Holyoke College Art Museum, South Hadley, Massachusetts, 1983, pp. 26–28, no. 9.

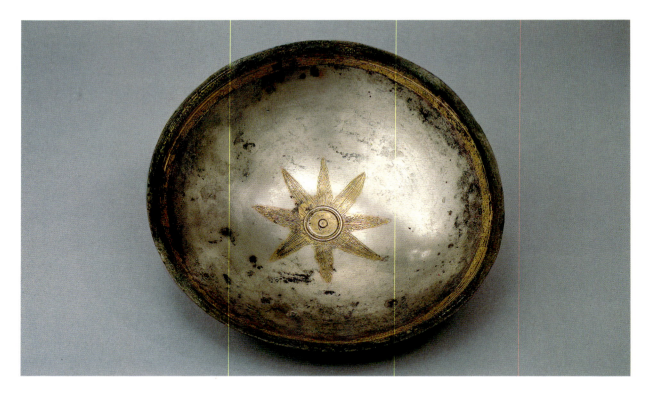

138. *Shallow silver-gilt bowl*

Height, 6.4–7 cm.; diameter, 22.8–23.2 cm.
Second century B.C.

This bowl, said to have been found in Iran with the silver-gilt rhyton also in the collection (cat. no. 137), was not raised from a disk but cast and later finished on a lathe. The decoration is limited to the inside: Below the rim is a guilloche above a narrow battlement frieze. In the center of the bowl, around a tondo of raised concentric circles, is an engraved calyx of eight alternating serrated acanthus and straight-edged plain leaves. The ornamental decoration is gilded.

As on the rhyton (cat. no. 137), the stepped-battlement design suggests the East. The central calyx recurs on a Parthian bowl in the J. Paul Getty Museum, Malibu (81.AM.8416; M. Pfrommer, *Catalogue of Silver from the Hellenized East*, in press). The serrated acanthus leaves, carefully arranged in groups of two or three, are also a feature on Corinthian capitals of the second century B.C. from Ai Khanoum in northern Afghanistan (O. Guillaume, *Les Propylées de la rue principale, Fouilles d'Ai Khanoum* 2, Paris, 1983, pl. 26B-E) and again point to the East.

The differences between the eastern extremity of the Hellenistic *koine* and its western creations can be most tellingly demonstrated by comparing the Levy bowl with a silver bowl from Magna Graecia, in The Metropolitan Museum of Art (D. von Bothmer, MMA *Bulletin* 42, 1948, p. 55, no. 94); the bowl from Magna Graecia in general is deeper, and its calyx is cast separately: It ranks among the finest ever acquired by a modern museum. While there is an overall conformity in the repertory and shape of the bowls, the differences in detail and workmanship help to distinguish regional styles that developed in diverse parts of the Hellenistic *koine*.

The date and execution of the bowl corroborate the report that, like the rhyton (cat. no. 137), it was found in Iran, thus proving the dominant influence there of Greek forms, which persisted long after the decline of Graeco-Macedonian rule in Central Asia.

M.P.

EXHIBITIONS
The Metropolitan Museum of Art, New York, from April 1985.

BIBLIOGRAPHY
B. Barr-Sharrar, in M. Leeb Hadzi, *Transformations in Hellenistic Art* (exhib. cat.), Mount Holyoke College Art Museum, South Hadley, Massachusetts, 1983, pp. 56–57, no. 24.

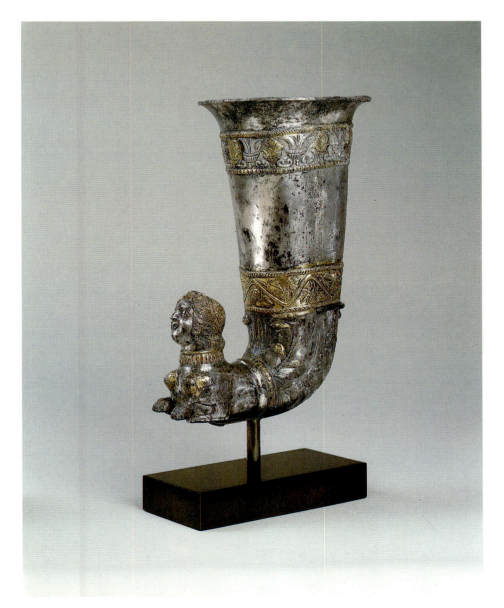

139. *Silver-gilt rhyton*

Height, 22.5 cm.; diameter of mouth, 12.53 cm.
Second to early first century B.C.

This rhyton is raised in two parts and joined at the juncture of the horn and the sphinx protome. Gilding is used somewhat sparingly but is visible on the protome and in some details of the ornamentation. The spout of the rhyton is between the legs of the sphinx. As explained in the discussion of the horse-rhyton (see cat. no. 137), Graeco-Macedonian influences dominated Near Eastern silver ware in the Hellenistic Age. Although the two Levy rhyta are not a pair, and must be attributed to different hands and workshops, both, however, belong to the class of calyx-rhyta that owes its name to the ornamental calyx decoration behind the protome—a group that first appeared in the Hellenized Near East late in the third or early in the second century B.C.

That the protome is in the form of a female sphinx is clear

from the ample breasts, the feminine hairdo, and the parure of necklace and earrings. Although represented without wings, the legs and the lion's paws mark the creature as a sphinx rather than as another hybrid. Unlike the Egyptian sphinx, Greek sphinxes are almost exclusively female, while Achaemenid sphinxes can be both bearded (like the Egyptian sphinx) or without a beard. Sphinxes with female breasts, however, are virtually unknown in pre-Hellenic Iran. This rhyton is the first sphinx-rhyton known from Iran, although maenads occur on several ivory calyx-rhyta from Nisa, the Central Asian capital of the Parthian Kingdom (M. E. Masson and G. A. Pugacenkova, *The Parthian Rhytons of Nisa*, Florence, 1982, p. 54, no. 11, plates 116, 117, p. 70, no. 32, plates 116, 117, p. 78, no. 59, pl. 118, p. 81, no. 73, pl. 118). Closer to the Levy rhyton are the spectacular Greek rhyton from Borovo, Bulgaria (now in Rousse, II-358; *Gold der Thraker*, Mainz, 1979, p. 146, no. 289), and the similar rhyton represented on the silver vase from the same treasure (Rousse, II-361; op. cit., p. 146, no. 292); the treasure is dated to the first half of the fourth century B.C. The rhyton shown on the vase cannot be considered a direct prototype of the Levy rhyton, since the huge calyx behind the protome on the latter does not appear on rhyta before the second century B.C. The sphinx-rhyton may well have entered the repertory of the Hellenized workshops of what was once the Achaemenid Empire in the late fourth or early third century B.C., so that the Levy rhyton is a later, somewhat provincial descendant.

The ornamentation—especially the exuberant foliage behind the protome—also reveals a Greek heritage. Four acanthus leaves with alternately bent tips are grouped with four smaller lanceolate leaves, the central veins and outer contours of which are beaded. The calyx composition can be traced back to early Hellenistic prototypes (see M. Pfrommer, in *JdI* 97, 1982, p. 131, fig. 3 d), but was not adapted to pottery and metal vases until the third century B.C.; the period of its greatest popularity occurred in the second century B.C. (M. Pfrommer, *Studien zu alexandrinischer und grossgriechischer Toreutik* [*Archaeologische Forschungen*], Berlin, 1987, pp. 111–15). In the Hellenized East, similar ornamentation occurs as late as the first century B.C., but the analogies with the Levy rhyton argue for a date for the latter in the second or early first century A.D. The type of acanthus—the leaves have rounded serrations—and its careful grouping in sets of three or four, is frequent on Near Eastern silver ware, and thus supports an Iranian provenance for this rhyton. The frieze of tendrils, grape leaves, and grapes (above the calyx) is very common in Late Classic

and Early Hellenistic gold and silver plate (see D. Strong, *Greek and Roman Gold and Silver Plate*, London, 1966, p. 101, pl. 25 B) and is also known in a somewhat different version from the ivory rhyta found at Parthian Nisa (M. E. Masson and G. A. Pugacenkova, op. cit., pp. 50, 82, nos. 8, 76, plates 45, 108). Even more telling with regard to a provenance in the East is the frieze of small palmettes and lotuses below the rim. The fan-like flowers and even the scroll-like elements between the stems clearly represent an Ancient Near Eastern tradition (see M. Pfrommer, op. cit., p. 33, pl. 5 a), while the clustered flowers are derived from the Graeco-Macedonian repertory (M. Pfrommer, in *JdI* 97, 1982, p. 126). All other details of the upper frieze—the rope-like border above it, the beaded band below it, and even the guilloche—are in keeping with the decorative systems employed in the Hellenistic Near East, and need no elaboration.

Thus, while the frieze of flowers below the rim conforms to pre-Hellenistic Near Eastern traditions, the fact that all other details strongly reflect the Greek artistic domination of the Hellenized East would imply that both the craftsman and his patron belonged to a Hellenized class that all but ignored its native Near Eastern heritage. The somewhat provincial character of the workmanship of the rhyton favors the attribution to an indigenous artist, who had become Hellenized.

The proposed date agrees with an attribution to the Parthian or Arsacid period, which followed the collapse of the Seleucid Kingdom. Whether the patron was a descendant of Greek settlers, a Hellenized Iranian, or even a member of the new Parthian upper class (which, as we know, valued Greek culture) remains—in the absence of an inscription—difficult to determine.

M.P.

140. *Silver-gilt roundel*
Diameter, 6.84 cm.
Hellenistic-Roman, second century B.C.–second
　century A.D.

This is one of several roundels that was found along with silver-gilt spear tips, the silver-gilt rim of a shield, a nondescript ornamented flange, and other miscellaneous frag-

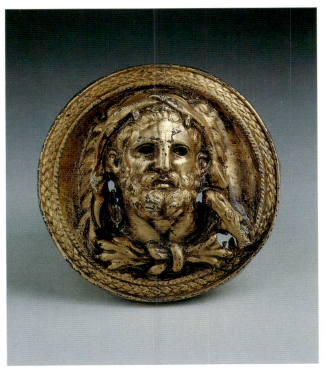

140

141. *Gold treasure*

Third century B.C.

a. Gold coiled snake armbands
 Height as mounted, 8.89 cm.
b. Pair of gold and enamel earrings with swans
 Height of each, 3.64 cm.; wingspread of each,
 1.44 cm.; diameter of each roundel, 1.6 cm.
c. Gold and carnelian necklace with African-head finials
 Diameter as mounted, 13.4 cm.
d. Gold ring with carnelian intaglio
 Height of bezel, 2.09 cm.; diameter, 2.26 cm.
e. Fragment of a gold wreath of leaves
 Length as preserved, 19.5 cm.
f. Gold diadem with inset stones
 Diameter as mounted, 18 cm.

a. Both armbands are in the form of a snake. Each of the S-shaped ends is naturalistically modeled to resemble a serpent's head and a section of its scaly body. The head and tail of each snake is flattened on the underside (the tail of one is missing); toward the center, the coil changes into an abstract spiraling form. Arm bracelets of this type were favored in the Early Hellenistic period; a pair from Thessaly shares much of the detail of the Levy armbands.

141 *a*

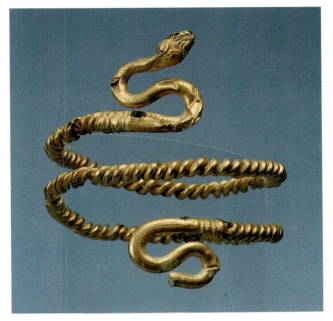

ments. The bust of Herakles appears in the medallion. He is shown wearing a lion skin over his head, with the animal's front legs tied across his chest. By his side is his club. The scene is framed by a laurel wreath. A roundel in the Museum of Fine Arts, Boston (1985.333; *109th Annual Report 1984/85*, p. 26), part of the same find, contains an image of Apollo, associated by Cornelius Vermeule with Euphranor's statue of Apollo Patroös. The exact function of these roundels is not certain, but it is possible that they served as phalerae.

Four similar roundels found at Krumovgrad, Bulgaria, and now in Sofia (Archaeological museum, 3748–3749; MMA *Bulletin* 35, 1977/78, p. 54, pl. 16,2), were dated by the excavators to the second century A.D. The other plaques from that find depict a bust of Athena and a man with unkempt hair, either a giant or a river-god.

D. v. B.

BIBLIOGRAPHY
Form and Ornament: The Arts of Gold, Silver and Bronze in Ancient Greece, New York, Michael Ward, Inc., 1989, no. 32, ill.

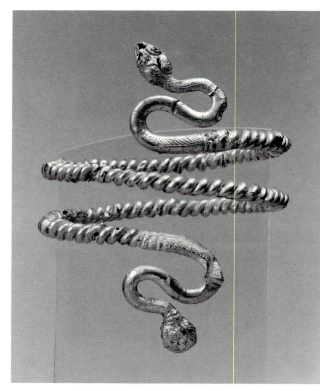

141 *a*

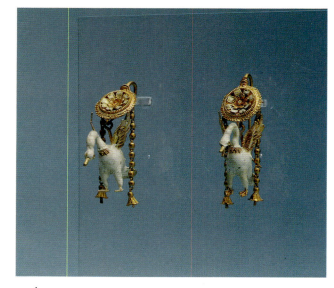

141 *b*

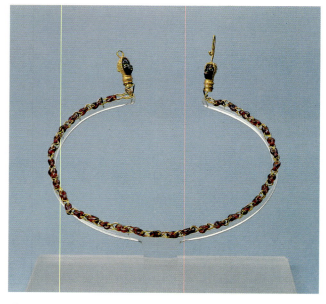

141 *c*

b. Each of the earrings has a disk inset with an eight-petaled rosette in enamel; a smaller, pure-gold rosette is set within this larger one. Around each outer rosette is fine beading surrounded by a leaf pattern. Two glass-paste swans hang from the disks, as do two chains ending in bell-shaped terminals. A very similar pair of earrings from Taranto (E. M. De Juliis, *Gli ori di Taranto* [exhib. cat.], Milan, 1984, pp. 168–69, no. 84) has a small altar-shaped base below each swan, which may have been true of the Levy pair, as well, although no traces of a solder or fixative exist.

c. The necklace is in the form of a chain of gold links alternating with hollowed stones of carnelian; hook-and-ring finials on the terminals, which are in the form of a pair of African heads, make up the clasp. A closely comparable necklace is in the Museum of Fine Arts, Houston.

The Hellenistic fascination with exotic peoples is widely attested in the art of the period: An unprecedented cultural internationalism resulted from the consolidation of empires under Alexander the Great, and continued unabated after the disintegration of central authority following his death in 323 B.C.

d. The gold ring contains a carnelian intaglio depicting a woman leaning on a column. She holds a sheaf of wheat in her lowered right hand and her left hip is swathed in drapery. Her hair is rendered in the *Melonenfrisur* style, with

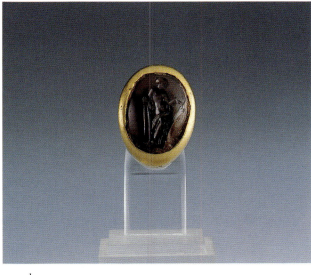

141 *d*

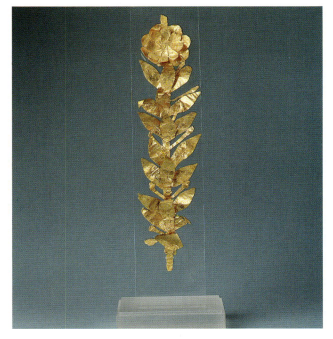

141 *e*

melon-shaped braids and a bun at the back of the head. Her pose is familiar from representations of goddesses dating to the fourth century B.C. and copied thereafter. From the sheaf of wheat, we may identify the figure as Demeter or Persephone, goddesses of agriculture and the underworld.

e. Although only a fragment of the gold-leaf wreath is preserved, it consists of a central band with leaves emanating from both sides, pairs of shoots growing out of the central band below each pair of leaves, as well as the center of the wreath—a small seven-petaled rosette mounted on a larger one.

f. The necklace is composed of a profusion of leaves, berries, flowers, and buds, almost all of which are inlaid with enamel. A diadem from Canosa, of the third century B.C., presents a close parallel for the leaves and the settings. The delicacy of the workmanship argues for its manufacture by an important workshop in southern Italy—perhaps from Canosa itself, where a variety of elaborate polychrome vases were also produced during this period.

<div align="right">M.L.A.</div>

BIBLIOGRAPHY
G. Becatti, *Oreficerie antiche dalle Minoiche alle Barbariche*, Rome, 1960, pl. 88, no. 353 [diadem], pl. 108, no. 407 [armbands]; B. Deppert-Lippitz, *Griechischer Goldschmuck* [Kulturgeschichte der antiken Welt, 27], Mainz, 1985, p. 221, no. 157 [necklace].

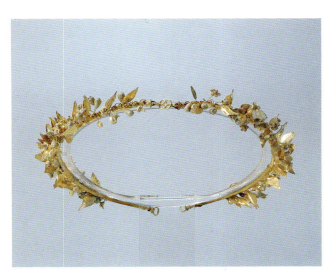

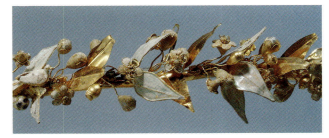

141 *f* and detail

Roman

142. *Section from a fresco*

Height as preserved, 86.2 cm.; width, 86.5 cm.
Second Style, about 50–30 B.C.

This section of fresco is part of the upper zone of a wall from a Second Style house. Various details, including the ornate Corinthian capitals with inlaid stones, the distinctive mask on the lintel, and the shields on the shelf to the left, suggest that it was completed by a workshop in the environs of Pompeii during the third quarter of the first century B.C. The villa of Oplontis in Torre Annunziata provides a close parallel for the rich decorative elements, which include a metal kylix on the same lintel as the mask, the ornate column shaft at the left, and a frieze of Erotes at the lower edge of the section, as preserved.

M.L.A.

143. *Section from a fresco*

Height as preserved, 29 cm.; width, 72 cm.
Third Style, about A.D. 25–50

This fragment from a fresco shows a reclining female, looking to her left and slightly upward. Her legs are stretched out toward the viewer's left, and she raises her right hand while resting her left elbow on a pillow. She is nude to the hips, and a transparent garment is draped over her legs.

Although the attribute in her right hand is missing it may have been a drinking cup, which would establish this fragment as part of a Dionysiac scene; she may be a maenad. The section is perhaps from just above the socle of the wall, and thus at the bottom of the median zone. The black background behind the figure would have continued throughout the remainder of the median zone, just as the red background below her probably characterized the whole socle. We may presume that a series of Bacchic figures disported themselves along the groundline separating the bottom sections of the wall. The color scheme, predella-like character of the fragment, and free brushwork argue for a date in the second quarter of the first century A.D., with the villa in which the fresco served as a wall decoration conceivably situated in the area of Castellammare di Stabia.

M.L.A.

deep-set eyes with a knitted brow, and wavy hair combed up into an *anastole* over the forehead and bound by a broad fillet, which has the vestigial remains of three pendant leaves on each side. The fillet continues over the clavicles and down on each side of the chest. The bust is flat in back.

The sitter's mouth is open and the upper teeth are described. On his right side is a small hole that may have been drilled to affix the herm to its base with a clamp. The underside is flat. The bust is weathered throughout. A rectangular hole in the top of the head, which is iron stained, is too large to have been intended to repair the break in the back of the head, but must, instead, have resulted from the loss of a dowel that was perhaps used to secure an attachment.

This likeness is evidently in the tradition of late Greek portraits of men of letters. The sitter's open mouth has led to the suggestion that he is not a philosopher but a poet singing one of his works. Portrait busts of lyric poets like Anakreon, who is commemorated in about ten Roman copies, were popular in the Roman world and served as emblems of their owners' erudition. The original portrait would have been a retrospective work of the Classical or Hellenistic period that approximated the appearance of the poet on the basis of his surviving writings.

To judge from its sketchy drill work and technique, the herm bust should be a Roman copy, of the first century A.D. It would have been displayed in a Roman villa along with other images of philosophers and thinkers of the Greek past. Such portraits have been found in private homes in the vicinity of Pompeii, and the best known are from the so-called Villa dei Papiri at Herculaneum, dating from the mid-first century B.C.

M.L.A.

144. *Bust of a man*

Height, 37.8 cm.; width, 22.5 cm.; depth, 21.8 cm.
Roman copy of a Hellenistic original, first century A.D.

The head of this elderly man, who has a thick, curly beard and a moustache, is turned slightly to his right. He has

BIBLIOGRAPHY
Catalogue des objets antiques et du Moyen Âge: Collection Canessa, Cat. Hôtel Drouot (Paris) *19–21 mai 1910,* no. 50, pl. VII; Münzen und Medaillen AG, Basel, *Auktion 16, 30 juni 1956,* p. 8, no. 12, pl. 5; *Cat. Sotheby Parke-Bernet (New York) November 20–21, 1975,* no. 676.

145. *Head of a man*

Height, 33.1 cm.; width, 19.6 cm.; depth, 21.8 cm.
Late Republican, about 40–20 B.C.

This sober portrait of an older man shows the sitter turning his head to the right. His hair is close cropped and combed forward in comma-like locks, and his M-shaped hairline is high on the forehead, which has four pronounced furrows. The eyebrows are knit, there are deep crows' feet at the corners of the eyes, and the lower lids are fully defined. The nose is intact—sharp and hook shaped. The nasal-labial lines are long and uninterrupted, and the mouth is wide, with thin lips. The chin is set off by a deep, curving groove. There are lines in the neck, and the underside of the sculpture is carved for insertion into a herm.

The portrait has suffered discoloration on the proper left side of the face, most likely from extended burial. The chin and left ear are chipped and there are slight abrasions on the face.

Hellenistic portraits of rulers and literati were joined by a new genre in the second and first centuries B.C.: the psychological portrait, which reached its apogee in the late Roman Republic and early Empire. It was born of a combination of native Italic traditions and imported examples from the Hellenistic world.

This sitter's rugged features are underscored by the sculptor, who used the fine-grained marble to advantage in emphasizing details of age, such as the wrinkles in the forehead, cheeks, and around the mouth. To judge from the emphasis on such features, which is achieved without the mannered exaggeration of many Julio-Claudian imitations of Republican style, this should be an original Republican portrait of the second quarter of the first century B.C. Close in character is the bust cradled in the right arm of the "Togatus Barberini," in the Museo Capitolino, Rome (G. Lahusen, *Römische Mitteilungen* 92, 1985, pp. 281 ff.).

The back of the neck is worked almost as a flat surface, which leads one to conclude that the head was inserted into a herm. Similar portrait herms were dedicated to athletes— as was a later pair with colored marble shafts in the collection of the Museo Nazionale Romano, Rome. This middle-aged subject, however, is clearly not an athlete. His distinctive hooknose, broad face, and severe countenance have given rise to the appealing suggestion that he depicts an actor. Such a herm could have been displayed outside a theater, as an honorary commemoration.

M.L.A.

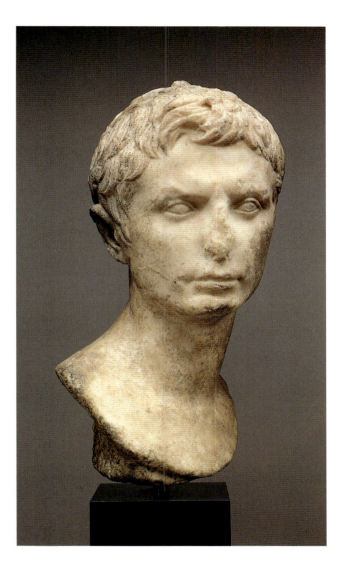

146. *Bust of Octavian*

Height, 41.6 cm.; width across shoulders, 22.8 cm.;
 depth, 23.6 cm.
Late Augustan, about A.D. 5–15

This portrait bust is an image of the triumvir Octavian,
later the first emperor of Rome, Caesar Augustus. The
sculpture shows Octavian turning his head to the right. His
hair is parted in the conventional manner, with three locks
combed to the right toward the center of the forehead and
the other bangs on the forehead combed away from the
center. This hairstyle was adopted by Octavian in imitation
of the windswept hairstyles of Hellenistic monarchs, as is

the case with the Levy statue of a ruler (cat. no. 173). The
triumvir, who held power with Mark Antony and Lepidus
before the Battle of Actium in 31 B.C., consciously chose a
portrait type that would underscore his prowess as a decisive
military leader and man of action. Upon consolidating his
power and being declared emperor in 27 B.C., Augustus
would shed this guise in favor of a more reflective, benefi-
cent countenance. In sculpture, this is known as the Prima
Porta type, named after the findspot of its most famous
example.

The pronounced twist of the neck renders the portrait a
very active one. The broad brow and small chin are also
features typical of the triumvir's first portrait type, best
exemplified by a bust in the Museo Capitolino, Rome
(Stanza degli Imperatori 2; 413). The Levy Octavian de-
parts from other images by having small eyes that are not so
deeply set. The breaks in the nose and on the tip of the chin
do not alter the overall effect of the portrait, which artfully
conveys the dynamic image sought by this nephew and
adoptive grandson of Julius Caesar in his quest for power.

Although the portrait is one of a score known of Octa-
vian's initial portrait type, its workmanship suggests that it
dates to after the type's invention (before 37 B.C.). The hair
of the Levy bust is tamer, and the features more smooth and
classicizing than on other examples, leading to a probable
date in the Late Augustan period.

Octavian's portrait type was replaced with the Prima
Porta type sometime after 27 B.C., raising the question of
the function of the Levy sculpture. It was worked for
insertion into a herm: The underside is roughly tooled and
terminates in a rectangular socle preserved in back and
visible along the front. The work thus might have been
displayed as one of a group of portrait herms or busts. The
group could have included images of the Prima Porta por-
trait type as well as of other members of the Imperial family,
in a hall intended for the celebration of the rulers of Rome in
the Early Imperial period.

M.L.A.

BIBLIOGRAPHY
On Octavian portraits, see K. Fittschen and P. Zanker, *Katalog
der römischen Porträts in den Capitolinischen Museen . . .* I, Mainz,
1985, pp. 1–3, nos. 1, 2. See also P. Zanker, *Studien zu den
Augustus-Porträts I. Der Actium-Typus*, Göttingen, 1973;
R. M. Gais, *AJA* 87, 1980, pp. 341–44; A. Stavridis, *AJA*
87, 1980, pp. 345–47; U. Hausmann, *Aufstieg und Niedergang
der römischen Welt* II, 12,2, Berlin and New York, 1981, pp.
535 ff.; H. Jucker, *JdI* 96, 1981, p. 292, n. 146; A.-K.
Massner, *Bildnisangleichung, Das römische Herrscherbild* 4, Ber-
lin, 1982, pp. 32 ff.; U. Grimm, *Römische Mitteilungen*, 1989.

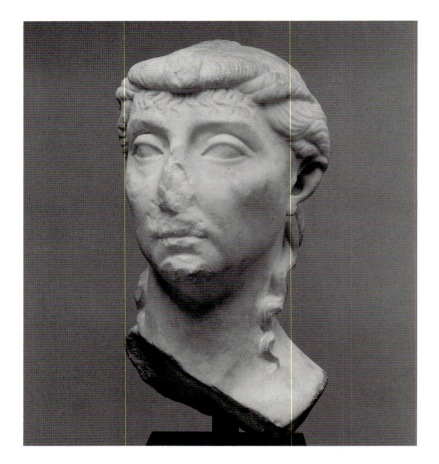

147. *Bust of a woman*

Height, 25.7 cm.; width across hair, 18.5 cm.; depth,
23.5 cm.
Early Augustan, late first century B.C.

This bust-length portrait of a woman shows the sitter's hair
pulled back into three braids, which are centered on the top
of the head and over the temples. A fringe of hair extends
across the forehead. There are two shoulder-length locks
and a bun at the back. The head is weathered, and the front
is rather planar. The oval-shaped face has high cheekbones.

The sitter's hairstyle relates this portrait to a fashion
adopted toward the end of the first century B.C. by the
empress Livia Drusilla (58 B.C.–A.D. 29), the powerful
second wife of the emperor Augustus (r. 27 B.C.–A.D. 14).
The coiffure of this likeness shares the *nodus*, or puffed-up
roll of hair above the forehead, the fringe of bangs on the
forehead, a braid running the length of the top of the head, a
bun in back, and shoulder-length locks on the sides of the
neck.

Although the hairstyle is Livia's, the sitter's facial charac-
teristics are dissimilar from those of the empress: Her jaw is
longer and her eyes more almond shaped than those of Livia.
This would appear to be a lady of rank who is emulating the
style of the Imperial house. Beginning in the first century
B.C., the adoption of the official hairstyle became common-
place for both women and men.

M.L.A.

EXHIBITIONS
The Metropolitan Museum of Art, New York, November 2,
1984–June 2, 1986.

BIBLIOGRAPHY
See W. H. Gross, *Iulia Augusta*, Göttingen, 1962; H. B.
Bartels, *Studien zum Frauenporträt der augusteischen Zeit*, 1962;
V. Poulsen, *Les Portraits romains*, Copenhagen, 1962, p. 65 ff.;
H. von Heintze, rev. of W. H. Gross, in *AJA* 68, 1964, pp.
318–20; E. Alföldi-Rosenbaum, *Eikones. Studien zum grie-
chischen und römischen Bildnis*, Bern, 1980, pp. 31–33;
B. Freyer-Schauenburg, in *Bonner Jahrbücher* 182, 1982, pp.
209–24.

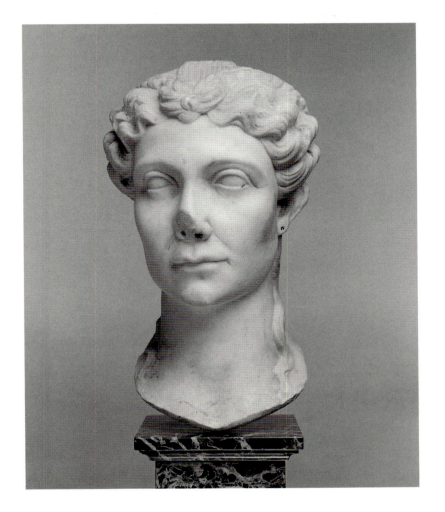

148. *Head of a woman*

Height, 31 cm.; width, 17.1 cm.; depth, 17.8 cm.
Late Augustan, about A.D. 1–14

The hair of this severe lady is parted in the center and combed to the sides of the head in front. The center of the hair is gathered into a topknot, and twin braids are pulled to the sides behind the hair combed back on the head. In addition, a separate plait is gathered at the top of the head and pulled straight back. Two locks descend down the back of the neck and are visible across each shoulder. A bun at the back, which was made with a separate piece of marble attached with a pin, is missing. The ears were drilled for the insertion of earrings.

Although the carving of the eyes and mouth are anomalous, the sitter's elaborate coiffure, like that of the portrait described in catalogue number 147, recalls the official hairstyles of the Augustan house. It is distinct from that of the previous example in that instead of a fringe of hair it has a curved plait over the forehead, called in German a *Zopfschlaufe*. This feature may be significant, in that such shapes are sometimes used for the knot or diadem of a priestess. It may, of course, also depict an elaborate hair band with no cultic implications.

The long, narrow face is not known to us from extant likenesses of the Imperial family, suggesting that the sitter was a private individual. The carving of the underside suggests that the portrait was inserted in a bust, which seems more likely than a statue because the head is slightly under life-size.

M.L.A.

BIBLIOGRAPHY
For comparable portraits, see K. Fittschen and P. Zanker, *Katalog der römischen Porträts in den Capitolinischen Museen . . .* III, Mainz, 1985, p. 5, pl. 4, no. 4, p. 43, pl. 64, no. 50.

149. *Bust of an older man*

Height, 37.6 cm.; width, 18 cm.; depth, 21.9 cm.
Claudian, A.D. 41–54

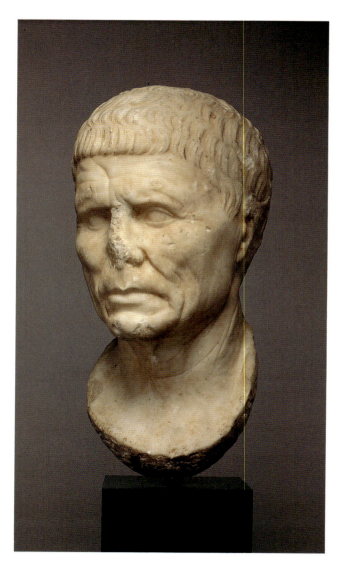

The sitter turns his head to his right. His hair is trimmed in five rows of short bangs combed downward from the crown in alternating directions, with the neat bangs across the forehead not separated from each other. The forehead has numerous creases, and the brow is strongly knit. There are pronounced nasal-labial lines as well as several additional wrinkles in the face. The nose is broken, and it appears that a punch was used to prepare its surface for the addition of a repair at some point in antiquity. There are chips in the chin and the cheek.

This powerful portrait of an older man adopts the conventions of Republican portraiture for a retrospective likeness. The modeling of the facial features, unlike that of the Republican herm portrait described in catalogue number 145, is extremely accentuated. The abundance of wrinkles in the neck, particularly behind and below the ears, demonstrates the Julio-Claudian tendency to exaggerate the signs of the sitter's age in male portraiture of a conservative style, ordinarily, as here, in combination with the depiction of neatly arranged hair.

The bottom of the portrait is roughly tooled for insertion into a supporting element. On the proper left side are the remains of a fold of drapery, which makes it clear that the portrait was inserted into a bust or statue of a toga-clad man. The large mass of marble below the neck renders the sculpture very heavy, so that it seems more plausible that it was set onto a statue rather than a bust.

With regard to the sitter's identity, the high quality of the portrait need not exclude the possibility that he is a freedman. A representation of a toga-clad Roman of the mid-first century A.D. is just as likely to have been a servant as a patrician. The statue might have figured in a funerary monument or a public display. The excellence of the carving and the subtle modeling of the surfaces point to an accomplished artist working in the period of the emperor Claudius. The probable place of manufacture would have been the environs of Rome or Naples.

M.L.A.

150. *Head of a woman*

Height, 26 cm.; width, 18.2 cm.; depth, 21.6 cm.
Flavian or Trajanic, A.D. 80–100

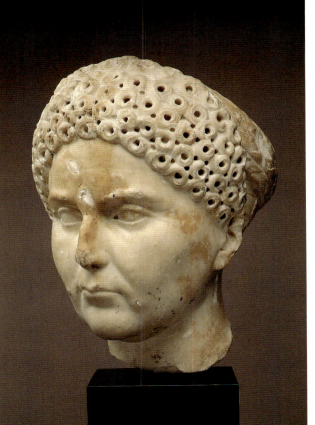

The sitter wears a toupet of curls over the forehead and close to the skull. The hair is braided and coiled in back into a turban-like arrangement. Her face is round and full, and she has a stern expression, with a knitted brow.

Unlike portraits of women from the Augustan and Julio-Claudian periods, those from the end of the first century A.D. often avoid flattering the sitter. In the case of this portrait, the accomplished artist has gone so far as to include the subject's warts: one on each cheek and another just below the chin on the left side. This trend away from the idealized likenesses of women dating from earlier in the century was not long-lived; it began at the time of the emperor Vespasian (A.D. 69–79), portraits of whom eschew the bland idealism characterizing many preceding portrait types in favor of a more forthright style, in keeping with his humble origins.

Women of the Flavian and Trajanic periods (from the end of the first century A.D. and the beginning of the second) often favored hairstyles with a high toupet of curls across the front of the head. This example is relatively restrained but is typical of works from that period in the contrast of the smooth finish of the face and the somewhat rougher surface of the hair, which facilitated the adherence of paint. The relative sobriety of the hairstyle—the toupet of curls in front, which does not rise high above the forehead—points to a date for the work in the Late Flavian or Early Trajanic period, about A.D. 80–100.

The clean break at the neck may imply that the head was originally part of a statue. Late Flavian and Early Trajanic portraits of this type often show ladies of rank in the guise of a goddess, a possibility that cannot be excluded here.

M. L. A.

BIBLIOGRAPHY
L. Gorelick and A. J. Gwinnet, "The Coiffures of Flavian Women: Functional Analysis Using Scanning Electron Microscopy," in *Archeomaterials* 2, 1, Fall 1987.

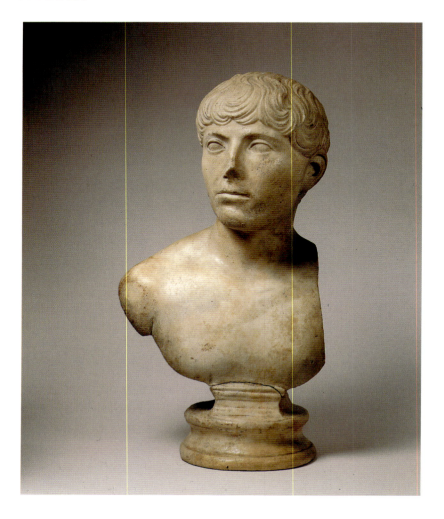

151. *Bust of a young man*

Height, 54.1 cm.; width across hair, 18.1 cm.; depth, 21.5 cm.

Late first—early second century A.D.

This young man turns his head toward his right and looks up slightly. He has longish hair that is combed forward in bangs that appear unruly at first but actually form a regular wavy pattern across the forehead. The head and bust are small in relation to the socle, and the upper part of the arm is indicated sculpturally.

The bust is in a fine state, except for the left shoulder and part of the chest, which are missing. It appears that the shoulder was broken in antiquity, and that the edge was smoothed and then prepared for the addition of a piece of marble. Three iron pins were inserted in the bust for the new attachment, and the uppermost one still survives. The bust broke off the socle at some point and was reattached. While the surface of the bust is in good condition, the face and hair have been cleaned vigorously, with a resulting loss of detail; there is pitting in the face as a consequence. Traces of what may be lacquer fill the interstices of the hair.

In format this bust of a young man is typical of those of the Flavian and Early Trajanic periods, as is the large socle of the base. The sitter's nudity distances him from the toga-clad participants in matters of the Roman state, identifying him instead with the athletic and heroic genres of Classical Greek sculpture. The light beard suggests a date in the Late Trajanic period. In all likelihood, the bust was a private commission.

M.L.A.

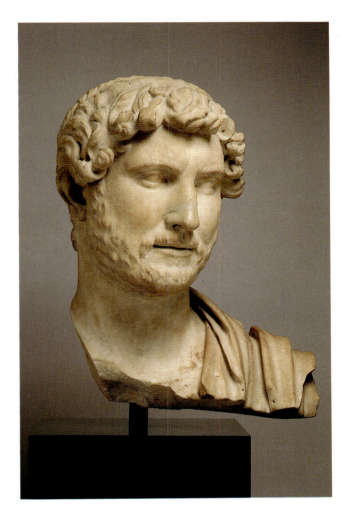

proper right side. The remaining drapery is so close to that on the example in the Museo Chiaramonti, Vatican City, that the bust may be restored according to that formula.

The hair is full and long, combed forward into a cap-like arrangement and curled at the ends. The hairstyle is that of the so-called Vatican Chiaramonti 392 type, in Max Wegner's classification. The bust should date from early in Hadrian's reign. The closest parallel is a bust in London (British Museum, 1896), although over twenty versions of this type survive.

While sculptural articulation of the pupils and irises becomes commonplace in portraiture during the Hadrianic period, older portraits of the emperor lack articulation in the eyes. The earlier portraits also have softer features, and few worry lines. The beard that Hadrian introduced into fashion is not as full as it will become later in his rule. This beard was the most graphic evidence of Hadrian's Philhellene outlook—his embrace of Greek culture and traditions.

The bust was broken in antiquity on the proper right side, and in a diagonal extending down toward the left shoulder. A repair was made by smoothing the surfaces of the break and drilling two holes for the attachment of a new section of drapery, which is now lost. The rounded face is smooth, as is the surface of the well-trimmed beard. A lock of hair is missing from above the right eye, and seems to have been repaired in antiquity with a small metal pin. The surface is evenly weathered.

The bust was formerly in the collections of Thomas Mansel-Talbot and his descendants; E. G. Spencer-Churchill.

<div style="text-align: right">M.L.A.</div>

152. *Bust of the emperor Hadrian*

Height, 47.8 cm.; width across hair, 23.8 cm.; depth of head, 28 cm.

Early Hadrianic, about A.D. 118–20

This superb portrait bust of the emperor Hadrian (r. A.D. 117–38) was found at the emperor's villa in Tivoli, and thus has pride of place among surviving imperial likenesses. As a work from early in his reign it would likely have been seen by Hadrian himself, and was probably displayed beside busts of other members of his family, including those of his wife, Sabina, and his sister-in-law Vibia Matidia. Hadrian is shown with a garment draped over his left shoulder, and he looks to his left. From the fall of the drapery, it is clear that when the bust was intact, it would have represented a military cloak, or paludamentum, which was clasped on the

EXHIBITIONS

André Emmerich Gallery, New York, "The Emperor Hadrian and His Time," November 16, 1978–January 3, 1979.

BIBLIOGRAPHY

F. Poulsen, *Greek and Roman Portraits in English Country Houses*, Oxford, England, 1923, p. 75, no. 58; *Cat. Christie's (London) 29 October 1941*, no. 437; M. Wegner, *Hadrian* [Das römische Herrscherbild], Berlin, 1956, pp. 102–3; C. C. Vermeule, *AJA* 59, 1955, p. 143; *idem, AJA* 63, 1959, p. 339, plate 80, 30; *Northwick Park Collection: Antiquities, Cat. Christie's (London) 21–23 June 1965*, p. 86, no. 371, pl. 32; K. Fittschen, *MM* 25, 1984, p. 205, n. 58, plates 66 c, 67 c–d; J. Raeder, *Die statuarische Ausstattung der Villa Hadriani bei Tivoli*, Frankfurt am Main and Bern, 1983, pp. 55 ff., no. I 36; K. Fittschen and P. Zanker, *Katalog der römischen Porträts in den Capitolinischen Museen . . .*, Mainz, 1985, pp. 46–47, no. 4 (listed as on loan to the J. Paul Getty Museum), Suppl. 29 c.

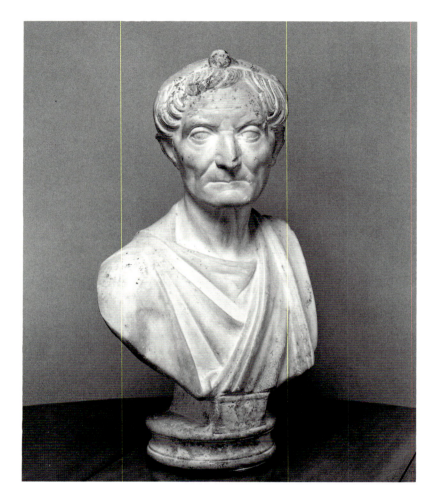

153. *Bust of a priest*

Height, 62.5 cm.; width, 41 cm.; depth, 23.8 cm.
Hadrianic, about A.D. 125

This elderly man turns his head to his right. His hair is cut longer over the temples and shorter above the forehead, where the bangs curve inward. Deep creases and wrinkles accentuate the sitter's evident sunken cheeks, and the neck is also wrinkled. The lips are improbably thin. The sitter wears a toga drawn from the left shoulder over his chest to the right.

To judge from the diadem worn by the sitter, he must have been a member of a priesthood, perhaps of the Egyptian god Sarapis. The distinctive hooknose and severe countenance are features typical of the genre of priestly portraiture, which endured through the late second century A.D., particularly in North Africa and the Near East. Comparable but later busts are in the collections of the J. Paul Getty Museum, Malibu (C. Vermeule and N. Neuerburg, *Catalogue of the Ancient Art in the J. Paul Getty Museum*, 1973, pp. 34–35, no. 75), and Berlin's Antikenmuseum (Sk 1810; G. Zimmer, in W.-D. Heilmeyer, *Antikenmuseum Berlin*, 1988, p. 244, no. 5).

The rolled fillet worn by the sitter would have had a seven-pointed star painted on the center of the diadem.

The bust was formerly in the collection of Joseph E. Levine.

M. L. A.

BIBLIOGRAPHY
Cat. Sotheby's (London) 18 June 1968, no. 147; see M. Bergmann, *Studien zum römischen Porträt*, 1977, p. 172.

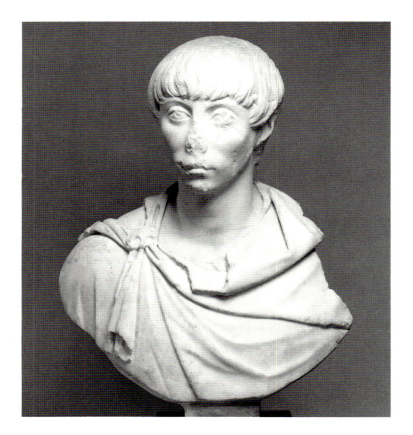

154. *Bust of a young man*

Height, 56.1 cm.; width across hair, 19.5 cm.; depth,
25.7 cm.
Late Hadrianic or Early Antonine, about A.D. 130–45

This bust of a young man is mounted on a socle, the base of
which is missing. His head is inclined slightly to the left. A
paludamentum is wrapped tightly around the sitter's shoul-
ders and chest and covers an undergarment.

A technically accomplished work, the bust may be by a
skilled artist in the western provinces. Certain features of
the portrait—especially the sitter's full head of hair, wide-
open eyes, and lightly incised pupils—suggest a date to-
ward the middle of the second century. While the subject
bears no close resemblance to any identifiable public figure
of the time, his costume makes apparent the desire to be
seen in the guise of an emperor, as distinct from the athletic,
heroic, or mythological pretensions of the sitters repre-
sented in other portrait busts in the collection.

Especially noteworthy on the Levy bust is the device on
the paludamentum clasp: A fragmentary pelta of Italic type
appears in high relief. The portraits of a pair of young men,
in Berlin (R 64, R 65; C. Bluemel, *Staatliche Museen Berlin.
Katalog der Sammlung Antiken Skulpturen* [*Römische Bildnisse*,
6], 1933, pl. 40) provide parallels for the hair and pupils, as
does the statue of a youth, in Kansas City (*Bulletin* 3, 1960,
no. 2, p. 7, fig. 5). By virtue of the mop of long, undrilled
hair and the light incising of the pupils, the portrait falls
within a class of private likenesses that are related to depic-
tions by Polydeukes. There are close to thirty examples of
these (E. Gazda, Michigan *Bulletin* 3, 1980, p. 1, no. 3),
among them, one in Sir John Soane's Museum, London (F.
Poulsen, *Greek and Roman Portraits in English Country Houses*,
Oxford, England, 1923, p. 94, no. 81), in Kassel (M.
Bieber, *Skulpturen*, Marburg, 1915, pp. 38 ff., no. 56, fig.
5), and in Berlin (C. Bluemel, op. cit., R 72; *AJA* 46,
1931, pp. 360 ff.).

M.L.A.

155. *Bust of a man*

Height, 70.2 cm.; width: of bust, 56.8 cm., across hair,
 27.7 cm.; depth, 36.1 cm.
Antonine, about A.D. 160–70

This exceptionally fine portrait bust seems to be of Greek manufacture to judge from its close resemblance to such works as the portrait of Antinous in the Nelson-Atkins Museum of Art, Kansas City (C. C. Vermeule, *Greek and Roman Sculpture in America*, Berkeley and Los Angeles, 1981, no. 269). It probably dates from shortly after the mid-second century A.D.

The bold characterization of the young man, who has a faint beard, and the expressionistic freedom of the drill work in the hair mark this as the product of a master sculptor of the Antonine age. The curly hair on the sitter's head is full and richly carved, but the facial hair is only lightly incised. The young man's chest is bare and a military cloak is draped over his shoulder, while what may be a baldric is suspended from his right shoulder. To judge from his cloak and baldric, the sitter was a ranking officer, and by his costume and scant beard, he identifies himself with heroes from Greek mythology, such as Diomedes.

The work is a splendid example of psychological portraiture. We sense the swaggering self-confidence of the sitter, whose light beard and full head of hair distinguish him from the subjects of more restrained contemporary portrait commissions in Rome. The sharp turn of the head makes him appear caught in motion and evokes a masculine ideal in the medium of Roman military portrait sculpture.

M.L.A.

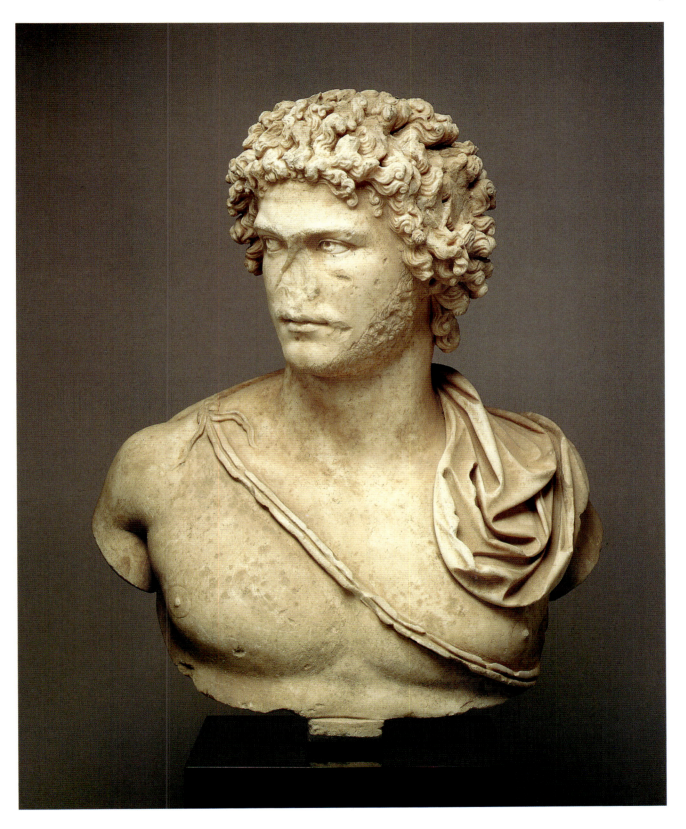

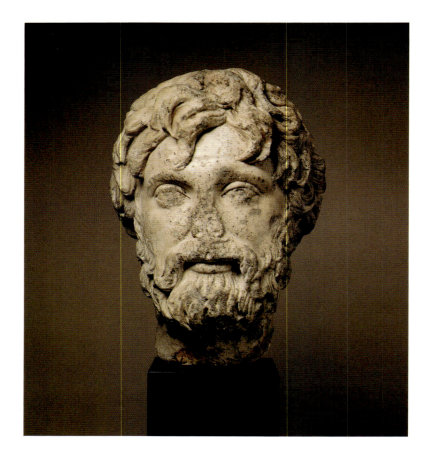

156. *Head of a man*

Height, 35.9 cm.; width, 25.7 cm.; depth, 25.1 cm.
Antonine, about A.D. 150–60

The top of the head is cursorily finished, as if the work were intended to be seen from below. Three large locks of hair overhang the forehead, and the thick beard is deeply worked. The whitish gray marble has traces of blue veining, and may be Proconnesian.

Because of the sketchy workmanship on the back of the head, among other features, this likeness may have been made in Asia Minor. The hairstyle and beard identify the sitter as a provincial represented as a philosopher. Unruly locks are routinely found in portraiture of this epoch, but such disheveled hair leads one to compare this bust with portraits of Cynic philosophers in the tradition of Antisthenes, such as one example in Athens (346; see E. Lattanzi, *I Ritratti dei Cosmati nel Museo Nazionale di Atene*, Rome,

1968, pp. 43–44, no. 10, pl. 10 a–b). Details of an Antonine portrait in the Bergama museum share much in their workmanship with that of the beard and hair here (J. Inan and E. Rosenbaum, *Roman and Early Byzantine Portrait Sculpture in Asia Minor*, London, 1966, p. 114, no. 120, pl. LXXII, figs. 1–2). Another contemporary portrait in the museum in Antakya, in Turkey, displays a similar treatment of the long hair, full beard, overhanging moustache, and roughly tooled top and back of the head (J. Inan and E. Alföldi-Rosenbaum, *Römische und frühbyzantinische Porträtplastik aus der Türkei*, Mainz, 1979, pp. 277–78, pl. 191, no. 267). Such works may be contemporary portraits of men in the guise of thinkers rather than of practicing philosophers; they are made in the venerable tradition of portraits of thinkers, as was catalogue number 144.

M.L.A.

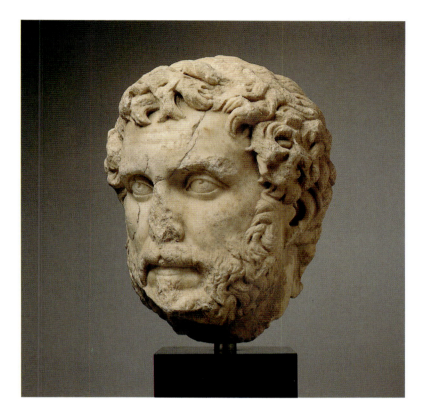

157. *Head of the emperor Antoninus Pius*

Height, 33 cm.; width, 21.2 cm.; depth, 26.9 cm.
Mid-Antonine, about A.D. 160–70

The fashion of wearing a beard was maintained by Hadrian's successor, the first member of the Antonine dynasty that was to rule the Roman Empire for over half a century.

This larger than life-size portrait of the emperor Antoninus Pius (r. A.D. 138–61) is roughly worked in back. The remains of a support suggest that the head was carved in Asia Minor. The portrait exemplifies Max Wegner's Formia type, the primary examples of which are in the Museo Nazionale Romano, Rome (*Terme*; 627); the Glyptothek, Munich (a bust, 337); and the Museo Archeologico Nazionale, Naples (6031; see K. Fittschen and P. Zanker, *Katalog der römischen Porträts in den Capitolinischen Museen* . . . , Mainz, 1985, pp. 63–67, nos. 39–44). This sculpture was the earliest and primary version, or *Haupttypus*, of the Antoninus Pius portrait typology.

The size of the portrait suggests that it would have been suitable for public display, perhaps together with statues of other members of the Imperial family; in all likelihood, it would have surmounted a togaed statue of the emperor. There are some eighteen other examples of the Formia type known, and the one here may be posthumous. A version in the Schloss Fasanerie, Adolphseck, is similar in dimensions and in the roughly rendered locks of hair on the back of the neck and in the beard, as well (see K. Fittschen and P. Zanker, op. cit., Appendix 44 a–d).

M. L. A.

BIBLIOGRAPHY
K. Fittschen and P. Zanker, *Katalog der römischen Porträts in den Capitolinischen Museen* . . . , Mainz, 1985, pp. 63–67, refs. and ills.; M. Wegner, *Herrscherbildnisse* II, 4, Berlin, 1939.

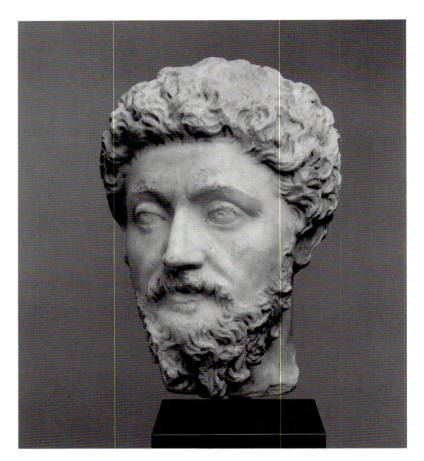

158. *Head of the emperor Marcus Aurelius*

Height, 39.5 cm.; width across hair, 27.3 cm.; depth,
27.4 cm.

Late Antonine, A.D. 170–80

The emperor Marcus Aurelius is depicted in a fine likeness
that dates to the second half of his reign (A.D. 161–80). The
head appears to have broken off a bust or statue, and is in
good condition.

The work is an example of the emperor's fourth portrait
type. Close parallels may be found in Rome (Museo Cap-
itolino, Stanza degli Filosofi 79, 524; Stanza degli Imper-
atori 38, 448) and in Paris (Louvre, MA 1179). The second
version in Rome is so close as to warrant consideration of a
shared workshop (K. Fittschen and P. Zanker, *Katalog der
römischen Porträts in den Capitolinischen Museen . . .* , Mainz,
1985, pp. 76–77, no. 69). Particularly similar are the
description of the beard, its long locks emerging in high

relief from the surface of the marble; flat areas in front of the
ears; and the hair, which is drilled more deeply in front than
toward the top of the head.

Some forty three-dimensional portraits in this version are
known to exist. It appears that the type was introduced
following the death of the emperor's co-regent Lucius Verus
(see cat. no. 174). The upswept hairstyle and timeless gaze
seem to have been adopted with the intention of recalling
images of heroes and gods—perhaps of Jupiter himself,
according to M. Bergmann (*Marc Aurel* [*Liebieghaus Monog-
raphie 2*], 1978: type IV, variant B). The propensity to link
the emperor to the gods began with Augustus, but is
thereafter rarely apparent in portraits made during the
imperator's lifetime. Once revived, the impulse to divinize
emperors endured through the succeeding Severan dynasty
and is again evident under the emperor Constantine.

M.L.A.

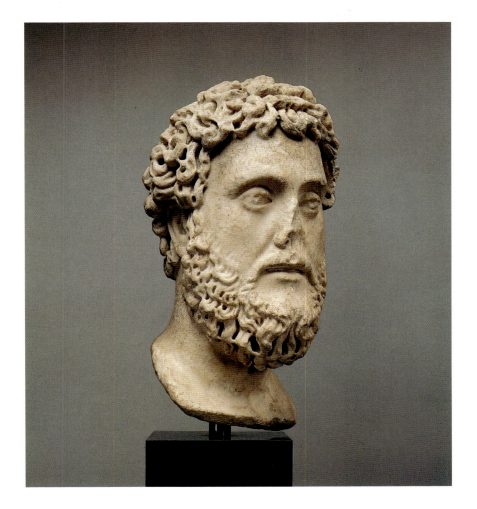

159. *Head of the emperor Commodus*

Height, 41.5 cm.; width across hair, 21.8 cm.; depth, 24 cm.

Late Antonine, A.D. 180–92

The emperor Commodus is shown in a revealing, if weathered portrait from his lifetime (r. A.D. 180–92). His long face and the extensive drill work establish this as a variant of the fourth portrait type of the emperor. The closest parallel in appearance and technique is a work in Munich (Glyptothek, 385) that has at times been considered modern. Both portraits are surely expressionistic evocations of the type invented in the 180s (for replicas, see K. Fittschen and P. Zanker, *Katalog der römischen Porträts in den Capitolinischen Museen . . .* , Mainz, 1985, pp. 83–85).

The open drill work, which leaves abundant bridges of marble in the hair and beard, is characteristic of all forms of marble sculpture from the period of the generation following the accession of Commodus, including ideal sculpture, historical reliefs, and sarcophagi. On the back of the head, however, the curls are not drilled but carved. A chiaroscuro effect must have been heightened when the hair and beard were gilded or painted.

From the unsympathetic accounts of Roman historians, Commodus is known to us as a madman who wreaked havoc with the order of Roman society, capriciously commanding change for no apparent reason. The heavily lidded eyes of the sitter convey some of his unsettling character.

M.L.A.

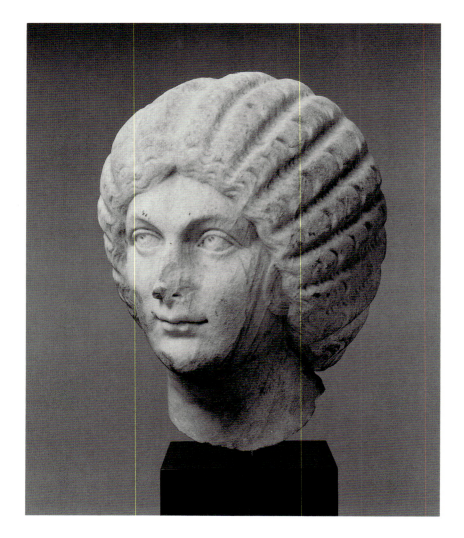

160. *Head of the empress Julia Domna*

Height, 38.2 cm.; width across hair, 27.8 cm.; depth, 28.2 cm.

Early Severan, about A.D. 193–210

The Syrian empress Julia Domna, wife of the Libyan-born Septimius Severus, was born between 165 and 170, and died in 217. The wig-like coiffure that she introduced in the beginning of her husband's reign was initially imitated but later changed by the empresses who followed her. This portrait, also identified as the Gabii type (see K. Fittschen and P. Zanker, *Katalog der römischen Porträts in den Capitolinischen Museen . . .* , III, Mainz, 1985, pp. 27–30, esp.

no. 28), is of the earliest version of some forty examples known in three-dimensional sculpture. The work may be posthumous, judging from the fact that it is larger than life-size. Although weathering and prolonged burial have resulted in an erosion of its surface, based upon the workmanship and the coarse marble the portrait may be a provincial commemoration of this cultivated empress.

M. L. A.

EXHIBITIONS
The Metropolitan Museum of Art, New York, November 2, 1984–June 2, 1986.

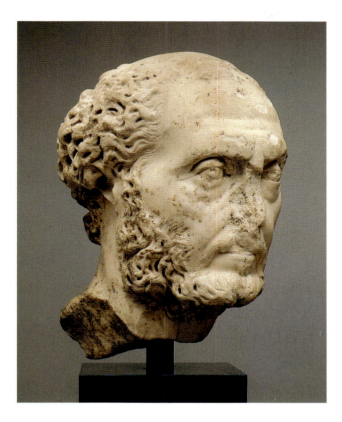

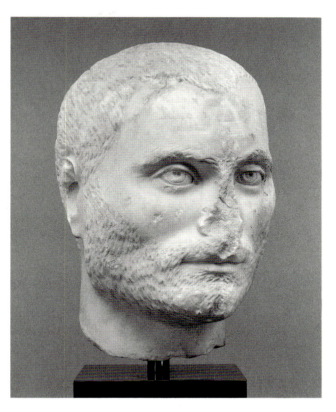

161. *Head of a man*

Height, 30 cm.; width across hair, 21.8 cm.; depth,
 25.6 cm.
Early Severan, about A.D. 190–210

A pensive sitter is depicted in this fine portrait, which is
broken from a bust or statue. Traces of drapery remain on
the back of the neck. The drill work in the hair and beard
mark it as a work of the Early Severan period, and the
willingness to show the subject as balding indicates that it is
a likeness of a private individual, since public figures were
loath to commemorate that condition in their portraits.
Puffy eyelids and a downturned gaze are unusual features as
well. The work accordingly is outside the mainstream of
likenesses from its time, although there exists a concentra-
tion of particularly sensitive portraits from the Antonine
and Severan periods.

M.L.A.

162. *Head of a man*

Height, 27.5 cm.; width, 17.3 cm.; depth, 21.2 cm.
About A.D. 222–51

This extremely subtle portrait of a man is notable for the
sitter's evident lack of anguish or concern, which had be-
come commonplace in male portraiture by the second quar-
ter of the third century A.D. The work must date to between
the reigns of the emperors Alexander Severus (A.D. 222–25)
and Decius (A.D. 249–51), as the subject displays an aware-
ness of the fashion of that time by his closely cropped hair.
The smooth contours of the face contrast with the staccato
rhythm of the hatched cap of hair. Sculptors from the time
of the so-called soldier emperors (about A.D. 217–80) rou-
tinely made use of this expressive technique, which exem-
plifies a persistent phenomenon in Roman art: the coexis-
tence of apparently incompatible styles in a single work or
monument.

A rectangular hole on the back of the head may be the
remains of an ancient repair. M.L.A.

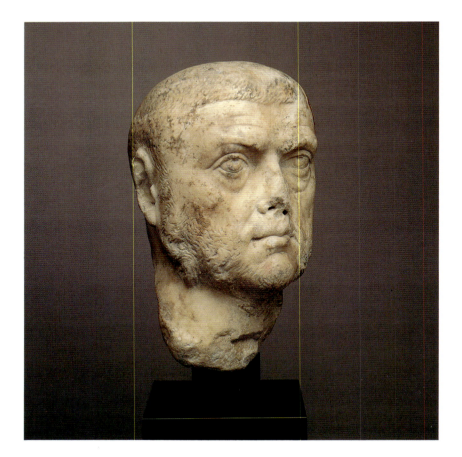

163. *Head of a man*

Height, 31.5 cm.; width, 19.2 cm.; depth, 19.5 cm.
About A.D. 250–80

This striking portrait of a man betrays evidence of extensive recutting, particularly in the flattened ears, small jaw, and traces of a once fuller beard. The original curls of the beard have been flattened, and the surfaces of these undulating planes given hatched details. It thus seems that the portrait originally was carved in the second half of the second century A.D. and reused in the mid-third century. Scholars have recently begun to assert that a high percentage of portraits from the third century are recut from earlier works. The decline in the marble trade at this time, occasioned by the disruption of Rome's international economy, necessitated such frugality.

It is in the nature of recut portraits that the sculptor compartmentalizes the features of the new sitter, modifying the physiognomic landscape as the original volumes permit. The result in this instance is disjointed but expressive. Deeply sunken eyes and pronounced bags below them argue for a late date, perhaps from the time of the emperor Decius (A.D. 249–51) or later (see a portrait of Decius in the Museo Capitolino, Rome; K. Fittschen and P. Zanker, *Katalog der römischen Porträts in den Capitolinischen Museen* . . . I, Mainz, 1985, pp. 130–33, no. 110, plates 135–137).

The bust was formerly in the collection of Martin Stansfeld.

M.L.A.

BIBLIOGRAPHY
Cat. Sotheby's (New York) November 21, 1985, no. 107; *The Stansfeld Collection of Ancient Art, Cat. Sotheby's (New York) December 2, 1988*, no. 58.

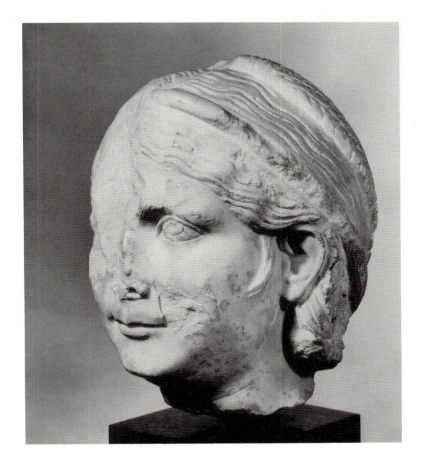

164. *Head of a woman*

Height, 28.4 cm.; width, 17.6 cm.; depth, 15.2 cm.
Late Severan, about A.D. 225–40, or Tetrarchic, A.D.
 284–305

Despite the damage it has suffered, this portrait of a woman ably conveys the cheerful disposition of the sitter. A plait of hair is gathered at the back and brought up toward the top of the head. The distinctive hairstyle may relate the portrait to images from the time of the empress Julia Mamaea—the A.D. 220s—or it may be a revival of that style near the end of the century. Such portraits of women befuddle scholars seeking to assign them to a specific period.

The diadem worn by the sitter may suggest that she was part of the Imperial circle, although a majority of portraits of empresses shows them without diadems. As in so many sculptures of the third century, the face is highly polished. The surviving left eye is somewhat cursorily worked, as is

the hatched eyebrow; the mouth is more sensitively rendered. Such uneven treatment becomes more common during the turbulent epoch of the soldier emperors (about A.D. 217–80), when the medium of portraiture was even more of a luxury.

The full face of the sitter and the lightly incised "Venus ring" on her neck speak of a healthy appetite; this became especially common among men, following the reign of the emperor Balbinus (A.D. 238), but is less often evident in female portraiture. We are left with a distinctive sense of the sitter's unpretentious and vivacious character.

M.L.A.

BIBLIOGRAPHY

J. Inan and E. Rosenbaum, *Roman and Early Byzantine Portrait Sculpture in Asia Minor*, London, 1966, pl. XCIX, figs. 1–4.

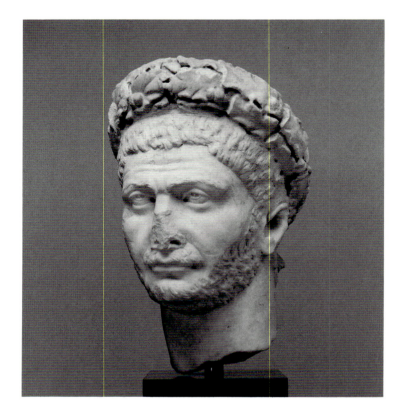

165. *Head of a man, perhaps an emperor*

Height, 40.7 cm.; width, 27.6 cm.; depth, 22.5 cm.
Tetrarchic, about A.D. 280–90

The subject wears a crown of oak leaves and acorns. His hieratic gaze suggests a date for the work toward the end of the third century A.D. The portrait may well have been recut from an earlier likeness—perhaps from one originally depicting Domitian (r. A.D. 81–96), as E. La Rocca has convincingly proposed—to judge from the scale of the crown and its relatively naturalistic character. The Flavian crown of oak leaves could have been retained even for a non-Imperial sitter, presumptuous as that would have been.

The incremental abstraction of third-century portraiture takes a penultimate step with this imposing likeness. The eyes do not betray the sitter's psychology, but, instead, stare upward vacantly. Naturalism is no longer the primary goal of the sculptor: The roughly tooled hair, uneven surface of the face, and planar volumes combine to make this a schematic depiction of a public individual, rather than a subtle characterization of the sitter's mood or disposition. A hard-won insistence on realism, which had defined Greek and Roman art since the fifth century B.C., dissipated in the climate of the day, and art became primarily symbolic and secondarily representational. The official embrace of Christianity under the emperor Constantine (r. A.D. 306–37) accelerated the process. The extraordinary possibilities of naturalistic portraiture would not be explored again on a large scale until the Italian Renaissance, almost a thousand years later. M.L.A.

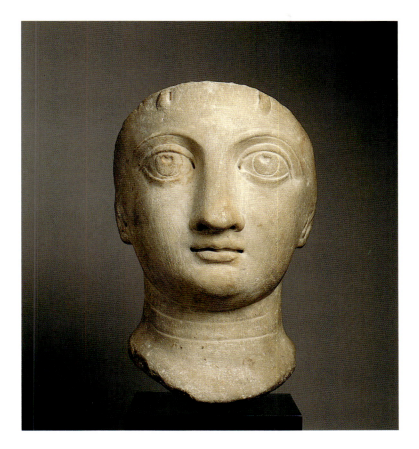

166. *Head of a woman*

Height, 27 cm.; width, 17.6 cm.; depth, 14.8 cm.
Fifth–sixth century A.D.

The highly schematic rendering of the subject, with her disproportionately large eyes and nose, small ears, and artlessly incised "Venus rings" on the neck, is characteristic of portraiture from the end of the fifth or the beginning of the sixth century A.D.

Originally, a headdress was added separately to the work: Raised points of marble above the eyebrows seem to be the vestiges of pearls hanging from an independently worked crown, which is now lost. The crown would establish the sculpture as an extremely formalized likeness of an empress, although an identification is hampered by the dearth of comparable images. A head of Ariadne, in Paris, wears the type of headdress that might have been represented in this work (K. Weitzmann, ed., *Age of Spirituality*, New York, The Metropolitan Museum of Art, 1979, pp. 30–31, no. 24), while the depiction of the eyes is close to those of Theodora, in a portrait head in Milan (ibid., p. 33, no. 27).

M.L.A.

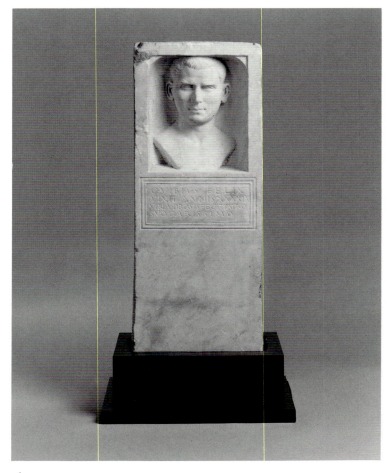

167 *a*

167. *Marble group: Funerary sculptures of the family of Vibia Drosis*

a. Stele of Gaius Vibius Felix
 Height, 83.1 cm.
 Early Flavian, about A.D. 69–80
 Inscribed (on the front): To Gaius Vibius Felix [who]
 lived 49 years, made by Vibia Drosis [for] her
 dearest father; (on the left side): QVIS/QVIS/HVIC/
 MONI[*sic*]/MENTO/CONTI/MELIA/NONFEC/ERIT/
 DOLORI/NVIVMEX/PERICA/TVR [in a less careful
 cursive script, as the spelling errors confirm, than
 the inscription on the front].

b. Stele of Vibia Drosis
 Height, 91.8 cm.
 Early Flavian, about A.D. 69–80
 Inscribed (on the front): Vibia Drosis made this for
 herself and her descendants; (on the right side):
 HIC/AMOR/FIDES/PIETAS/EST.

c. Stele of Gaius Vibius Severus
 Height, 74 cm.
 Early Flavian, about A.D. 69–80
 Inscribed (on the front): To Gaius Vibius Severus,

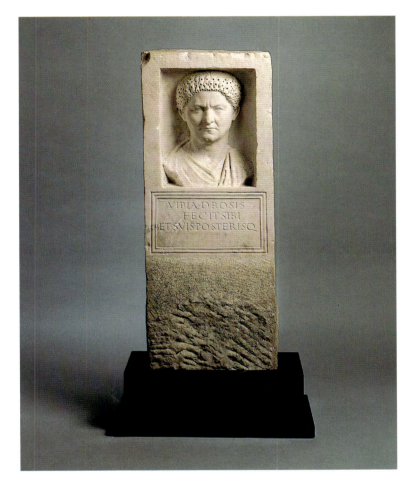

167 *b*

who lived [for] 23 years; made by Vibia Drosis for her dearest son.

d. Cinerary urn of Gaius Vibius Herostratus
Height, 32.8 cm.
Flavian, about A.D. 85–95
Inscribed (on the front): C. VIBIVS/HEROSTRATVS/
VIBIA/·C·/L/HAERESIS; the sides bear incised circles.

The three stelai in this group of funerary sculptures of the family of Vibia Drosis are linked by the shared format of a rectangular shaft, a carved portrait bust in a niche in the upper half, and an inscribed loculus. The three inscriptions make it clear that the group was carved for a single family, notwithstanding the divergent styles of each stele. The inscriptions relate that Vibia Drosis commissioned the portrait of her son, Gaius Vibius Severus (*c*)—shown with a light beard—at some point after his untimely death at the age of twenty-three. To judge from his hairstyle and whiskers, he probably died during the Neronian period (A.D. 54–68). His mother, Vibia, obviously outlived him; her portrait represents her as a lady of the Flavian period (about A.D. 69–80), wearing a chiton and a palla (*b*).

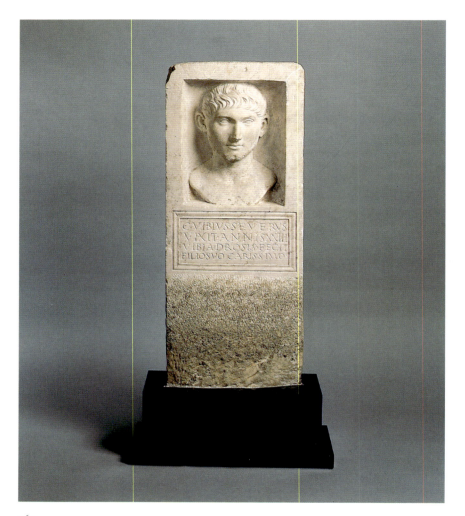

167 *c*

In addition to ordering a portrait of her son, Vibia commissioned a retrospective likeness of her father, Gaius Vibius Felix, who died at the age of forty-nine during the Julio-Claudian period. The last-mentioned portrait (*a*) thus was carved in the tradition of the *imagines maiorum*—or images of the accomplished ancestors of a Roman gens (clan). The hairstyle and features of Gaius Vibius Felix are those of a man from the Augustan period. Like the other two stelai (*b*, *c*), that of Gaius Vibius Felix has a portrait bust of the deceased set in a framed niche above an incised loculus plaque, with identifying inscription. However, the stele is distinct from the other two in three significant respects: First, the portrait bust is set farther back in the niche; secondly, the inner corners at the top of the niche are

recessed slightly and rounded off so that the niche appears semicircular at the top rather than rectangular; and, lastly, the lower half of this stele is smoothly finished, rather than roughly tooled like the other two. Gaius Vibius Felix is unbearded, his hair falls in short bangs over the forehead, and he has a wide M-shaped hairline and thick eyebrows. His face is modeled to show such signs of age as deep nasal-labial creases and a wrinkled brow. The portrait type is characteristic of conservative Julio-Claudian likenesses that recall the *gravitas* of Republican portraiture but smooth over the features of the sitter. The semicircular top of the stele is in keeping with the niche form favored in Roman burials of the late first century B.C. and the Julio-Claudian period. By the later first century A.D. through the mid-second century

MARBLE FUNERARY SCULPTURES 229

167 *d*

A.D., the customary preference was for fully rectangular niches in the columbaria, or underground crematoria; the niches of the other two stelai thus are appropriate to the periods typified by the hairstyles of their subjects.

According to this interpretation of the three stelai, Vibia Drosis would have been born about A.D. 20, and before the age of twenty (in A.D. 40) would have given birth to Gaius Vibius Severus. Vibia had all three works executed by the time she reached the age of about fifty, during the early Flavian period, as her pin-curl hairstyle reveals. The portrait of her father simply copies an image of Gaius Vibius Felix dating to the Augustan period—perhaps a life-size bust made about A.D. 15, when he was approximately thirty-five years old; his death occurred perhaps ten years

after Vibia's birth, or about A.D. 30. Her son was post-humously memorialized in a likeness that, conservatively, retained the Neronian hairstyle in vogue at the time of his death. The fourth family member in this group, Gaius Vibius Herostratus, is remembered in a simple rectangular cinerary urn (*d*) commissioned by Vibia, as well.

The stylistic and epigraphical evidence revealed by the succession of monuments of the family of Vibia Drosis presents a fascinating account of the historicizing taste of this Roman family. Vibia evidently chose to commemorate her beloved father and son in works that retained the traditions of portraiture from the time of their respective deaths.

M.L.A.

168. *Funerary altar*

Height, 124.5 cm.; width, 76.2 cm.; depth, 58.4 cm.
Julio-Claudian or Neronian, about A.D. 45–65

This imposing monument, which commemorates Publius Annius Eros and his wife, Ofillia, would have been placed in a cemetery. The cremated remains of Publius and his wife were deposited in the large rectangular cavity on the top of the altar, originally outfitted with a lid in the form of a pedimental roof.

Three sides of the altar are in excellent condition; the back is sketchily preserved, implying that it was either never completed or extensively weathered, or both. The center of the front of the monument shows an eagle with splayed wings; the inscription above him identifies the deceased and announces that the altar was commissioned by Publius's two freedmen, Trophimus and Stephanus. Rams' heads on the corners of the altar to the sides of the inscription support a heavy garland of fruit and leaves, symbolizing the afterlife hoped for by Publius and Ofillia. Below the rams' heads are candelabra resting on rostrums, or ships' prows. Although the inscription refers to two freedmen who might have lived into the Flavian period, according to R. Gergel (*J. Paul Getty Museum Journal*, 1988), the style of the altar accords best with the refined decorative sculpture typical of the Claudian and Neronian periods, in which case the inscription may have been added long after the altar was completed.

Below the garland of fruit and leaves on the front of the altar is a scene in which the Capitoline Wolf suckles the divine twins, Romulus and Remus. On each side of the altar, a hind suckles a single infant. The combination of scenes from mythology, like these, and such emblems as the ships' prows, cannot be explained as anything other than decorative.

M.L.A.

EXHIBITIONS
The Metropolitan Museum of Art, New York, November 8, 1984–November 19, 1986.

BIBLIOGRAPHY
P. Zanker, *The Power of Images in the Age of Augustus*, Ann Arbor, 1988, p. 280, fig. 221 a–b; *idem, Bilderzwang: Augustan Political Symbolism in the Private Sphere* (from *Image and Mystery in the Roman World, Three Papers Given in Memory of Jocelyn Toynbee, 1988*), pp. 8–13, plates 4–8.

169 *a*

169. *Fragmentary "Asiatic" sarcophagus in three sections*

Antonine, about A.D. 170–80

a. Achilles and Penthesilea
Height, 100 cm.; length, 142.7 cm.; thickness, 21.5 cm.

b. Menelaos and Patroklos
Height, 99 cm.; length, 133.4 cm.; thickness, 22 cm.

c. Theseus and the Minotaur
Height, 96 cm.; length, 135.8 cm.; thickness, 22.6 cm.

These three sections of a marble sarcophagus of Asiatic type show a series of nine mythological scenes. When intact, the original monument would have been quite long and deep, as is often the case with so-called Asiatic sarcophagi, which were produced in Asia Minor during the second and third centuries A.D.

The scenes are separated by Corinthian columns with spiral fluting, which support an elaborate entablature consisting of alternating pediments of rounded and triangular shape. Masks occupy the center of the lintel of each pediment. Perched on top of the niche between the pediments is a pair of mythological animals: a sphinx and a fish-tailed monster with a feline head.

The mythological scenes in the intercolumniations de-

169 b

pict heroes from Greek mythology. Section *b* shows, from left to right, a male figure to the right of a tree, which may represent Herakles and the apples of the Hesperides; a standing male figure with a horse behind him, probably intended to be one of the Dioscuri; and Menelaos with the fallen Patroklos in his arms. On fragment *a*, from left to right, are Achilles and Penthesilea; a standing male figure with an object resting against his left arm; and Herakles freeing Prometheus from the Caucasus. Relief *c* includes, from left to right, Theseus and the Minotaur; a young man, who may represent Meleager, resting on a lance held in his upraised left hand, with a chlamys draped around his neck and over his lowered right arm; and a part of a scene with a rocky landscape and three pairs of feet, which may illustrate the myth of Laocoön.

It is difficult to be certain about the original configura-tion of the three carved sections. Although one is tempted to imagine appropriate juxtapositions of the mythological sub-jects, the arrangement of the scenes was probably arrived at through compositional rather than narrative considerations. The organizational principle may have been based on the alternation of a central group scene with single figures and other group scenes. It is not clear that the sections are all from different sides of the rectangular monument, although the proportions suggest that there were five scenes on each long side and three on each end.

Fragment *b* may be from the left end of one of the long sides; two columns and the vestiges of the capital of a third column at the left are fully preserved. If the long sides were symmetrical, each would have had a total of six columns, five scenes, three pediments (a central rectangular type and two rounded types), and two niches. The short sides could

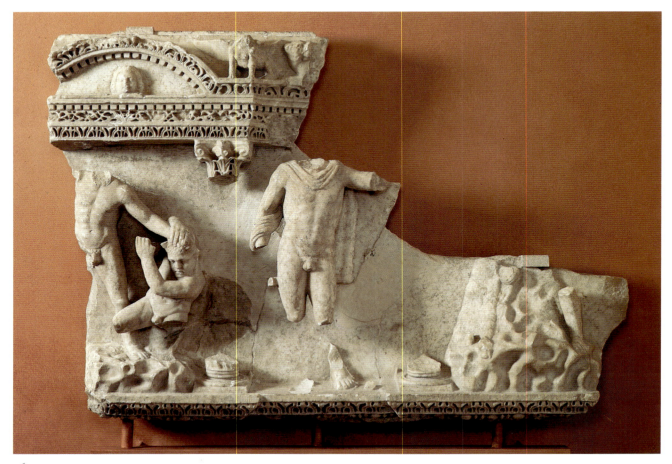

169 c

have had two rounded pediments with a central niche on each side.

A possible clue to the original arrangement may be provided by the niche in the center of the two best-preserved sections, which curves outward to abut the rounded pediment, but flattens out where it meets the triangular pediment. Again presuming that the sides were symmetrical, it would follow that a second niche was in mirror reverse on each side; this would make the panels with Menelaos and Patroklos (b) and Achilles and Penthesilea (a) from opposite sides of the sarcophagus—in each instance, from the right end. The section with Theseus and the Minotaur (c) would therefore be from one of the short ends.

Thus, the scene of Achilles and Penthesilea would occupy the central niche on one side, flanked on the left by the scene of the Dioscuri, with a group scene, in turn, to its left. The scene with Herakles and Prometheus would fall in the center of the other side, with another single standing figure to its left, and a third group scene to the far left.

Such sarcophagi for the most part were made in Pamphylia, and date to between the middle Antonine period and the mid-third century A.D. From the details of the entablature, this sarcophagus appears to date from the earlier phase of the genre, perhaps about A.D. 170–80. The mythological subjects all are connected with death or regeneration, and are particularly appropriate to the monument's funereal function. The high quality of the work, with its sensitive carving, places this example among the finest Asiatic sarcophagi known. (On columnar sarcophagi, see especially G. Koch and H. Sichtermann, *Römische Sarkophage*, Munich, 1982, pp. 76–80.)

There are losses in some of the figures, but the condition of the surfaces is generally excellent.

M.L.A.

BIBLIOGRAPHY
"Zur römischen Kunst," Staatliche Kunstsammlungen, Schloss Wilhelmshöhe, Antikensammlung, Kassel, leaflet 3.

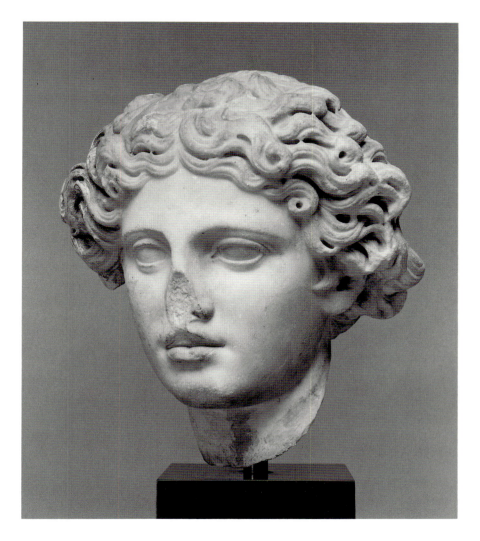

170. *Head of a woman*

Height, 26.5 cm.; width, 24.3 cm.; depth, 19.7 cm.
Early Antonine, about A.D. 138–60

The life-size head has long hair parted in the center, pulled to the sides, and bound in part by a narrow fillet, which has a Herakles knot. The fillet is wound around the back and the top of the head three more times, ending, apparently, in back with a bun, which is now lost, along with a piece of marble below. Several locks of hair missing from the proper right side of the head have been restored in plaster, and the lower part of the nose is missing, as well. The eyes are undrilled. The mouth is open and the upper lip broken. A smooth area beneath the missing upper lip at first seems intended to represent the teeth of the upper jaw, but is more likely the exposed surface of a break.

To judge from the loosely arranged hair and elaborate fillet, which is distinct from the type usually worn by Apollo, the subject is female. The head gives no indication of being a portrait, but, rather, the arrangement of the hair suggests that it was part of a statue of Diana. The small bridges of marble left in the hair argue for a date for the head in the early Antonine period. Such works, often accompanied by a statue of Diana's brother, Apollo, would have been appropriate in a Roman villa of the mid-second century A.D.

M.L.A.

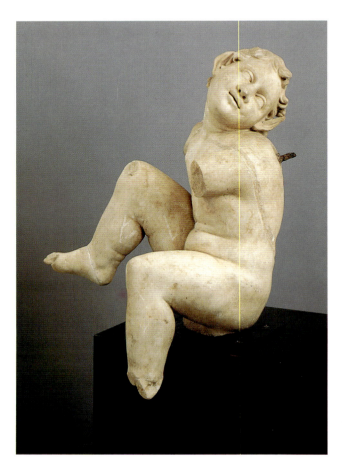

171. *Statue of a satyriskos*

Height, 51.5 cm.
Late first century A.D.

This under-life-size statue of a seated infant satyr is a Roman copy of an early Hellenistic statue type. The right leg is raised and bent, with the knee almost touching the chest. The left leg is bent but lowered. There are remains of the original circular base of the seated figure below his buttocks, implying that he was seated on a columnar pedes-tal, thereby freeing his legs from acting as supports. The arms are missing, but enough survives to show that the right arm was raised toward the right and the left arm was lowered and extended frontally. The head is turned to the left and bent back as far as possible. The ears are pointed, and the hair is tousled in front. There is a small drill hole in the top of the head.

Two large iron pins emanate from the shoulder blades. Around the base of each pin, the surface of the marble is roughed out in tall oval shapes. These areas, together with the pins, leave no doubt that the statue had wings, in all likelihood added in the Renaissance, since the satyr's ears are original.

The elevated right knee originally had a protrusion of some kind; the marble is raised just to the left of the kneecap. There is also a slightly heightened section of marble at the level of the right clavicle. The position of the right arm would not have permitted it to relate to either of these higher portions, whereas the left arm could have been bent and crossed, and supported by the right knee. The object held in the left hand might have been braced by a strut rising from the area of the left clavicle. The right forearm may have extended down toward whatever was in the left hand—possibly a wine cup or other Dionysiac object. Crudely incised around the left shoulder of the figure is a shallow channel, which continues down his left side and over his buttocks, ending below the right hip. This was very probably for the later addition of a metal quiver case and strap to complement the new wings and the statue's altered identity as Cupid.

The original figure may have been part of a group that included Dionysos and other satyrs. Its three dimen-sionality is typical of early Hellenistic sculpture. The low-ered foot might well have been dangled in the water of a fountain pool, with the raised foot placed on the edge. Roman sculptors were often challenged to incorporate figu-ral scenes with the architecture of pools and fountains—as in the remarkable sculptural groups from the Imperial grotto at Sperlonga (B. Andreae, *Laokoon und die Gründung Roms*, Mainz, 1988).

M. L. A.

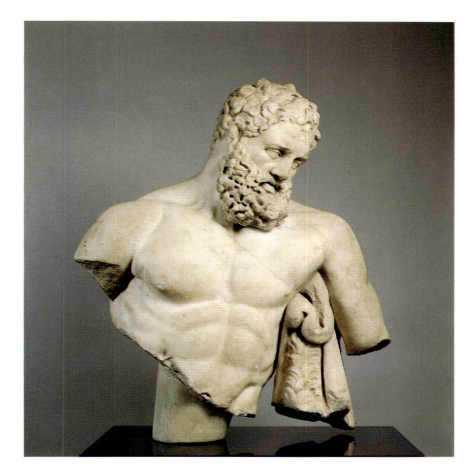

172. *Statue of Herakles resting, perhaps contemplating Telephos*

Height as preserved, .67 m.

Marble (from the Aegean Islands or western Asia Minor)

Greek Imperial period, Late Antonine, about A.D.
170–92

Jointly owned by the Museum of Fine Arts, Boston
(1981.783; Gift of the Jerome Levy Foundation), and
Leon Levy

The original version of this statue, which derives from the *Weary Herakles* identified with Lysippos of Sikyon, of about 330 B.C., was created at Pergamon in northwest Asia Minor at the height of that kingdom's artistic prestige, in the years 175 to 130 B.C. The unruly strands of the hair and beard are bunched in masses of curls; the brow is knotted; the eyes are sunken above protruding cheekbones; and the expression of strain is heightened by the depth of the mouth—all, characteristics of the so-called Pergamene baroque style of Greek sculpture.

In the Greek cities of Asia Minor, from Pergamon itself to the Pamphylian coast (Side) and Cyprus (Salamis), the dramatic aspect of such statues was admired in the Antonine and Severan periods of the Roman Empire, A.D. 160 to 230. The statues were copied widely in sculptural workshops along the Ionian coast, at Aphrodisias in Caria, around the

quarries of Phrygia, on the Greek islands, and in Attica. The Pergamene restyling of the *Weary Herakles* after Lysippos was one of the most popular Greek Imperial statues. Severan coins suggest that this Late Antonine example could have been part of a group: Herakles contemplating his infant son, Telephos, being nursed by a hind in the mountains of Arcadia. Telephos was to grow up to become the legendary founder of Pergamon—a career paralleling that of Romulus in Italy.

Another important aspect of this Pergamene Imperial statue is its aesthetic position as a document of transition to the elongated Herculaean figures of the Late Antique. The great couch-sarcophagus from Yunuslar (Pappa-Tiberiopolis) in Lycaonia, in the Archaeological Museum in Konya (Iconium), shows how Byzantine distortions overtook the figures of Herakles in action and in repose about the year 250 (E. Akurgal, *Griechische und Römische Kunst in der Türkei*, Munich, 1987, figs. 248, 249). Dating to some time between the Levy Herakles and the giant sarcophagus, with its wraparound scenes of the Labors of Herakles (and Herakles resting), is the similar, small statue from Aidin (Tralles), near Aphrodisias, in the Maeander valley, in the R. H. Lowie Museum of Anthropology, University of California, Berkeley (*AJA* 79, 1975, pp. 327–28, pl. 54, figs. 8 a, b). Here, the canon of distortion from the Pergamene version is halfway toward the figures on the sides and ends of the Lycaonian sarcophagus, therefore confirming the Levy statue as Late Antonine and the icon from Tralles as a version of about A.D. 230, the end of the Severan dynasty.

The Levy statue (or group, if Telephos and the hind were present) might have stood in a small public building, such as an urban bouleuterion, or a gymnasium-bath complex like that at Salamis on Cyprus (which had a Lysippic Herakles of fourth-century-B.C. type). In any event, the sculptor of the Levy Herakles made a significant contribution to the perpetuation of Greek monumental sculpture in the later Roman Imperial world.

<div align="right">C.C.V. III</div>

BIBLIOGRAPHY

C. Vermeule, *Divinities and Mythological Scenes in Greek Imperial Art*, London, 1983, p. 39, pl. 49; *idem*, in *Studien zur Mythologie und Vasenmalerei: Konrad Schauenburg Zum 65. Geburtstag am 16 April 1986*, E. Böhr and W. Martini, eds., Mainz, 1986, pp. 134–35, pl. 23, fig. 2; D. Krull, *Der Herakles vom Typ Farnese: Kopienkritische Untersuchung einer Schöpfung des Lysipp*, Frankfurt, 1985, p. 422; M. B. Comstock, C. C. Vermeule, A. Herrmann, J. J. Herrmann, E. T. Vermeule, and F. Z. Wolsky, *Sculpture in Stone and Bronze in the Museum of Fine Arts, Boston*, Boston, 1988, pp. 34–36, no. 22.

173. *Statue of a man*

Height, 221 cm.; from chin to hairline, 19.5 cm.
First century B.C.

This statue of a man is approximately one-and-a-half times life-size. The hair is tousled and there are no traces of a beard. The right arm is upraised, evidently to hold a spear or scepter, while the left arm is akimbo, with the hand resting on the hip. The right leg is engaged, and the left one bent, with the foot pulled back. Although the right index finger, as restored, is bent, it need not have been originally: A modern fiber glass restoration of the center joint may exaggerate the angle. When a pole is placed in the upraised right hand, it touches the ground far in front of the statue. If the figure originally held a spear, it may have been made in two parts, with one above the hand, and another below, thereby permitting it to rest on the base closer to the statue in its conventional orientation. Less likely is that the figure had a different object in his right hand.

The statue is reconstructed from numerous fragments. A modern steel armature is surrounded by a fiber glass core over which the extant parts are assembled, with many sections restored. The head is intact and its pertinence to the neck certain, as is the orientation of the right arm. The genitals are in large part fiber glass, but, as elsewhere, the reconstruction appears faithful—with the possible exception of the right index finger. The right ankle and foot and the front of the left foot are missing.

Despite the misalignment of various elements, including the index finger and the body as a whole—which, today, stands slightly off axis—the statue clearly depends upon the iconography of nude Hellenistic ruler portraits. This tradition began with a famous statue of Alexander the Great holding a spear, from the end of the fourth century B.C., and seems to have varied little during the course of the second and first centuries B.C.

Of primary importance in determining the identity of the man, which has been the focus of much speculation, would be any attributes worn or held by him, but these are now missing. There are no traces of a diadem, which could establish the work as a portrait statue of a ruler, yet the pose is unlikely for an athlete, since the figure apparently rested his weight on a spear or scepter in his upraised right hand. Furthermore, athletes were probably not commemorated in larger than life-size statues, and the pronounced musculature would be anomalous as well, since in classical antiquity athletes were more commonly depicted in an ideal figural form.

With regard to the identity of the Levy sculpture, nu-

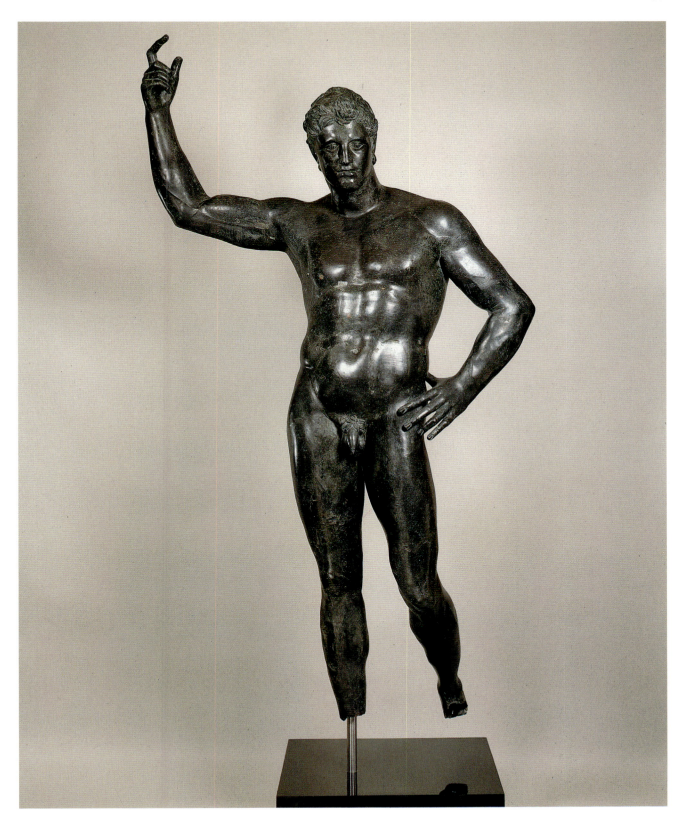

merous hypotheses have been advanced; these have included a Republican general such as Lucullus, and, most recently, as suggested by C. C. Vermeule, Alexander I Balas (r. 150–145 B.C.), the ill-fated Syrian usurper, or Attalos II of Pergamon (220–138 B.C.), as proposed by H. Meyer. The absence of a royal diadem argues for a Roman general who vanquished a Hellenistic *diadoch*, but too few original statues survive to be certain.

The windswept hair and explicit musculature point to a fourth-century-B.C. sculptural type as the inspiration for this work, as does the disproportionately small head—a characteristic associated with statues by Lysippos. Yet, the pose of the figure and the sharply rendered facial features reveal an incipient Classicism during the first century B.C., which would lead the emperor Augustus later in the century to resort to models from the oeuvre of Polyclitus. The absence of Imperial details, such as a Julio-Claudian hair-style, makes it clear that the work can date to no later than the last quarter of the first century B.C.

M.L.A.

EXHIBITIONS
Historisches Museum, Bern, November 6, 1982–February 6, 1983; San Antonio Museum of Art, July–December 1988.

BIBLIOGRAPHY
H. Jucker, *Gesichter*, 2nd ed., 1982, pp. 312–13, no. 184; *Art and Auction*, September 1987, p. 116; R. R. R. Smith, *Hellenistic Royal Portraits*, Oxford, England, 1988, p. 164, no. 45.

174. *Statue of the emperor Lucius Verus*

Height, 188 cm.
Late Antonine or Early Severan, late second–early third
century A.D.

This larger than life-size statue of the emperor would have been part of a group of statues of members of the Imperial family. J. Inan and C. C. Vermeule have speculated about the original appearance of this group. It has been proposed that a series of statues stood in a *sebasteion*, or hall of the emperors, at Bubon, a site in Turkey.

The version on which the head is based appears to be of the fourth type of portraits of Lucius Verus—the most commonly reproduced throughout the Empire. The long face, small chin, and pronounced nose are features of this type, of which more than ninety examples survive; the

174: Detail of head

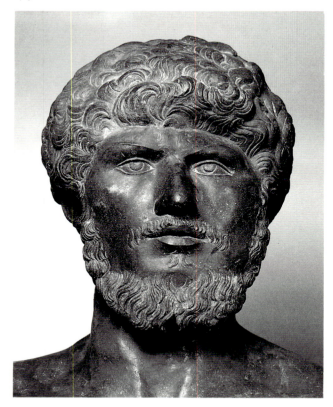

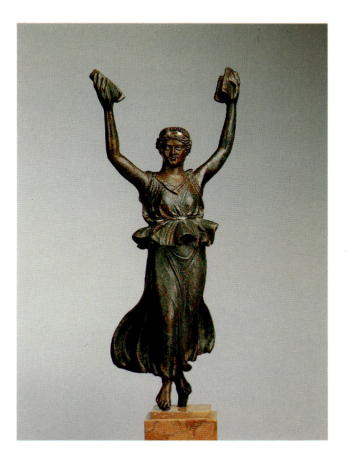

178. *Statuette of a woman*

Height, 32.4 cm.
Late first century A.D.

This intriguing bronze figurine of a woman with arms aloft, holding what have been identified by some as musical clappers, has silver-inlaid eyes. The figure's right foot is advanced, and she wears a short, girded peplos over a fluttering chiton. Her pose is derived from a traditional type of Nike, or Victory, the original version of which was associated with an image of Zeus holding the diminutive goddess in an outstretched hand. The pose of the lower body of the Levy figurine is echoed by a statuette of Nike, in Boston, whose feet are balanced on an orb (M. Comstock and C. Vermeule, *Greek, Etruscan & Roman Bronzes in the Museum of Fine Arts, Boston*, 1971, p. 71, no. 74). Despite the absence of traces of wings, the Levy bronze must be a Roman adaptation of the Nike type to a different figure. The objects held in the woman's hands may be receptacles for torches or, as has been argued, clappers in the shape of roof tiles. The statuette could have served as part of a thymiaterion (incense burner) or a candelabrum.

The statuette was formerly in the collection of Baron de Bernard, who acquired it in Egypt.

M.L.A.

BIBLIOGRAPHY

J. J. Herrmann, in *The Gods Delight: The Human Figure in Classical Bronze*, A. Kozloff and D. G. Mitten, eds., Cleveland, 1988, pp. 349–52, no. 69, ill. (Marion True has called attention to a similar dancer with tile-shaped clappers, in the museum in Alexandria.)

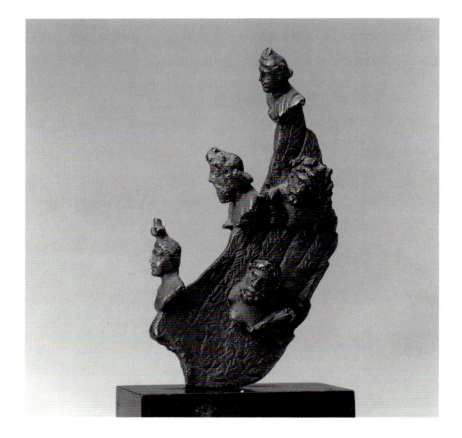

179. *Wing of a statuette*

Height, 10.2 cm.
Gallo-Roman, late second or early third century A.D.

This detailed appliqué in the shape of a left wing, with five miniature busts, would have been attached to a statuette of a goddess. The three busts on the top of the wing appear to represent (from top to bottom) a crowned female wearing her hair in the manner of the early third century, Neptune holding a trident, and a male priest crowned by a small boat-shaped headdress. The busts on the side of the wing facing the front of the statuette (from top to bottom) are of Jupiter and Hercules.

E. Knauer has called attention to a close parallel for a wing decorated in this manner on a Gallic bronze statuette, of the late third century A.D. discovered in Mâcon, France (Saône-et-Loire), and now in the British Museum (height, 11 cm.; see *Archaeologia* 245, April 1989, pp. 34–35;

Archeo 57, November 1989, p. 19). The figurine depicts Fortuna making an offering with a patera in her lowered right hand. In addition to the figures on her wings, miniature busts adorn cornucopias and are mounted above the wings, as well. The divinities shown include Apollo, Diana, the Dioscuri, Saturn, Sol, Luna, Mars, Mercury, Jupiter, and Venus. On the basis of this comparison, it is likely that a similar variety of divinities was represented on the figurine to which the Levy wing originally belonged.

To judge from the hairstyle of the woman crowning this work, it should date from the Late Antonine or the Severan period.

M.L.A.

BIBLIOGRAPHY
Cat. Sotheby Parke-Bernet (New York) February 17, 1978, no. 122.

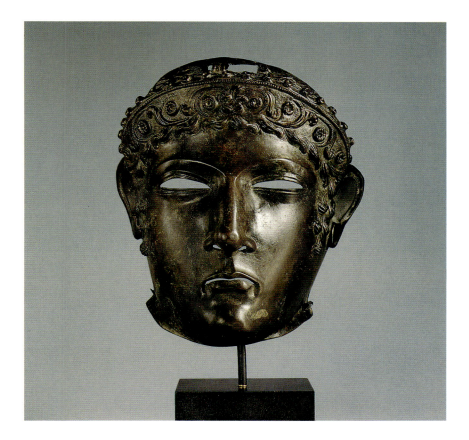

180. *Cavalry sports mask*

Height, 21.6 cm.; width, 20 cm.; depth, .11 cm.
Second century A.D.

This mask from a bronze parade helmet is in exquisite condition. The narrow slits for the eyes and mouth contribute to the cool demeanor of the subject. The mask originally would have been attached to a helmet by means of a hinge at the top. The decoration, other than the features of a man's face with light sideburns, consists of an elaborate diadem that covers the locks of hair along the forehead—a device that serves to render the hinge at the top less noticeable.

Helmets of this type from the first and second centuries A.D. were common in northern Europe under Roman rule. Rather than having a function in combat, they would have served as part of a cavalry officer's parade armor.

M.L.A.

BIBLIOGRAPHY
J. Garbsch, *Römische Paraderüstungen*, Munich, 1978, pl. 22, fig. 3: Hirchova 027, with a rosette in the center of the headdress; MMA *Bulletin* 35, 1977/78, p. 66, fig. 49 (D. von Bothmer compares the helmet in Stara Zagora, Bulgaria, II C-1116).

181. *Bone reliefs*

First century A.D.

a. Frontal sphinx
 Height, 9.55 cm.; width, 3.6 cm.; depth, 1.71 cm.
b. Sphinx in profile
 Height, 4.54 cm.; length, 6.47 cm.; depth, .36 cm.
c. Bust of Eros facing right
 Height, 5.77 cm.; width, 5.91 cm.; depth, .89 cm.
d. Bust of Eros facing right
 Height, 5.77 cm.; width, 5.71 cm.; depth,
 1.72 cm.
e. Bust of Eros facing left
 Height, 6.21 cm.; width, 5.6 cm.; depth, 1.1 cm.

These five bone carvings most likely were part of a couch,
on the analogy of the couch in the Fitzwilliam Museum,
Cambridge, that R. V. Nicholls has patiently recon-
structed from hundreds of carved bones, and that appeared
on the London art market in 1974 (*Archaeologia* 106, 1979,
pp. 1–32). Nicholls's fundamental monograph on decorated
couches enables the location of these five elements to be
identified: Cupids *c–e* come from the sides of the rounded
lower parts of the two fulcra that were movable armrests,

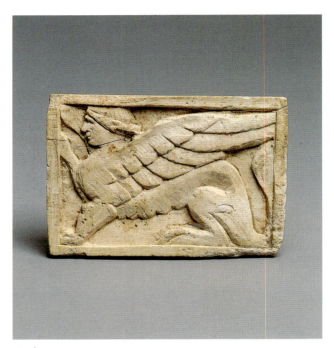

181 *b*

181 *a*

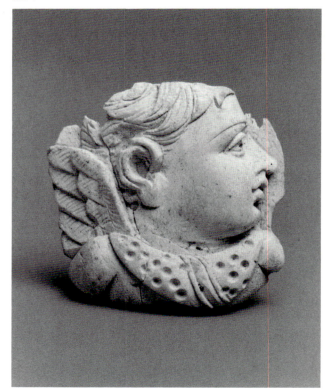

181 *c*

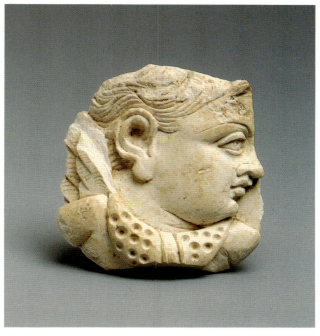

181 *d*

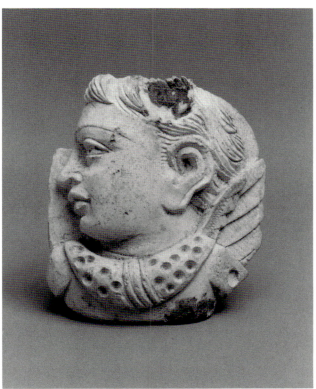

181 *e*

footrests, or headboards; the frontal sphinx would have been on the upper part of one of the four legs, which were made of iron; and the oblong framed relief of a sphinx, less easily placed, perhaps belonged to the wooden bed frame, which may have had a veneer of bone plaques. The busts of the cupids were obviously carved by the same master who created the fulcra on the Cambridge couch (R. V. Nicholls, op. cit., pl. 8). These Erotes have large ears, wavy hair, and full features, and wear garlands around their necks. The eyes are drilled and must have been inlaid with glass, which is now missing. In shape, the cupid plaques would have been circular, and presumably were pieced together from other fragments of carved bone to complete the tops of the heads and the circle on the sides and below.

The Erotes in Nicholls's reconstruction (op. cit., p. 6, fig. 3) face the elevated part of the fulcrum. Since, in this group, there are three heads, two facing right and one facing left, of which *c* and *e* form a pair (one on each side of the fulcrum), the other cupid facing right, *d*, must be from a second fulcrum. This argues for a provenance from Italy, as Roman beds found in Italy invariably have two fulcra, one for the head and the other for the feet, differing in this respect from Greek and Hellenistic couches, which only had headrests. Nicholls observed (op. cit., p. 8) that footrests are usually a little smaller than headrests; therefore we can assume that *d* is from a footrest.

Most of the couches with bone veneer that have been assembled by Nicholls (op. cit., pp. 21–24) originated in the Etruscan hinterland, especially the Abruzzi. The present bone carvings, which agree stylistically with Nicholls's numbers 4, 7, 8, 10, and 11, and with the couch in Cambridge, may be ascribed to the same area. In due time the approximate dates of these couches may be narrowed down more precisely, but for the moment we are safe in dating them to the second half of the first century B.C. and the first half of the first century A.D.

For a clearer idea of the appearance of a couch with bone veneer, see the example from Boscoreale in The Metropolitan Museum of Art. Originally restored as a love seat and sold as such to the collector J. P. Morgan, it was lengthened into a proper couch in 1946.

D. v. B.

BIBLIOGRAPHY
[R. V. Nicholls kindly supplied the following references to couches with bone carvings]: C. Letta, "Due letti funerari in osso dal centro italico-romano della Valle d'Ampetro (Abruzzo)," in *Mon. Ant.* 52 (Ser. Misc. III, 3), 1984, pp. 67–114; E. Talamo, "Un letto funerario da una tomba dell'Esquillino," in *Bullettino della Commissione Archeologico Comunale di Roma* 92, 1987–1988, pp. 28ff.

182. *Knife handle*

Height, 8.35 cm.
Third century A.D.

A gladiator is shown armed with a helmet, lion-headed crest, face guard, greaves, and arm padding, standing on a finial in the form of a leafy capital. He holds a shield in his left arm inscribed SENIII, and carries a short sword in his right hand. The iron shaft of the knife would extend up the back of the figure. The knife was evidently the possession of a gladiator, and the abbreviated inscription probably a reference to his rank.

M.L.A.

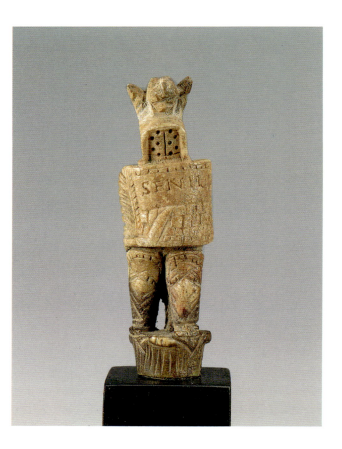

183. *Relief plaque*

Height, 5.71 cm.; width, 10.48 cm.; depth, .37 cm.
Third—fourth century A.D.

A woman is shown reclining in the scene on this small plaque. She extends her legs to the left and looks back toward the viewer's right, as she lifts the billowing drapery in the background to reveal her nude form. Although crudely incised, the plaque has a vigorous appeal. It may represent a maenad or other mythological female. The pose is often seen on Egyptian bone carvings of the Roman period, in depictions of Dionysiac revelry, marine deities, or figures in association with Aphrodite. The plaque may have served as an inlay for furniture or for a box, like one in the Benaki Museum, Athens (10314), which shares much in detail (L. Marangou, *Benaki Museum Athens, Bone Carvings from Egypt* I, Tübingen, 1976, p. 117, no. 169).

M.L.A.

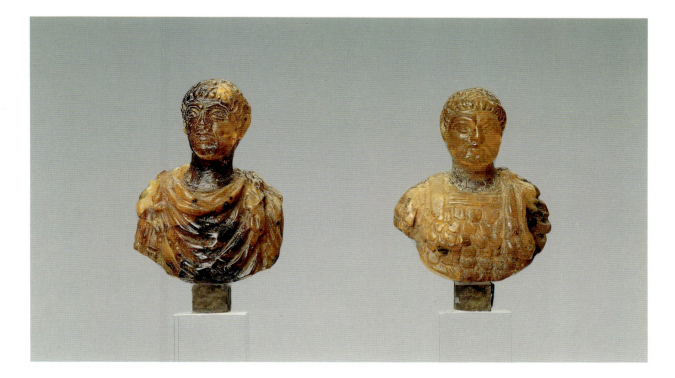

184. *Amber miniature busts*
Height, 4.45 cm. and 4.16 cm.
Third century A.D., or post-Classical

These small busts may have been part of a set of emperor portraits. The bearded figure wears a cuirass and a paludamentum over his left shoulder, while the unbearded man's paludamentum is clasped over the left shoulder but open.

The unbearded figure is either a young ruler, of the third century; an emperor from before the Hadrianic period, such as Trajan; or possibly Severus Alexander or a young Gordian. The bearded man shares some features with mid-third-century emperors such as Philip the Arabian, of whom the J. Paul Getty Museum, Malibu, has a comparable miniature bust, in bronze.

The date of the busts is also uncertain, for although miniature portraits in ivory are known throughout the Hellenistic and Roman periods, amber busts are highly unusual. Furthermore, images of Roman emperors were extremely popular, from the Renaissance onward. Nevertheless, there are plausible grounds to consider these busts antiquities, including the shape of the support on the back of each.

M.L.A.

185. *Rock crystal head*

Height, 5.7 cm.
First century A.D.

This miniature portrait is a fine example of the manipulation of rock crystal into sculpture. Few examples survive in the medium. A comparably sized portrait identified by some as the emperor Vitellius (r. A.D. 69) is in the Israel Museum, Jerusalem (*Treasures of the Holy Land: Ancient Art from the Israel Museum,* New York, The Metropolitan Museum of Art, 1986, no. 101, p. 204). Such works may have been carved in Alexandria during the first century A.D., or in other centers in the Near East and in Rome. The miniature was evidently suspended by means of the two rings attached to the ears.

The distinctive receding hairline of the subject and his furrowed brow, intense expression, and long beard argue for an identification as a Papposilenus, or elderly follower of Dionysos.

M.L.A.

186. *Silver ring with a carnelian portrait*

Height of bezel, 2.42 cm.; diameter, 2.81 cm.
Julio-Claudian, mid-first century A.D.

The silver ring has a large carnelian bezel with a portrait of a long-necked male facing left. The sitter wears a laurel wreath tied at the back of the head. The two ends of the fillet descend to the base of the neck. From the high forehead, distinctive curving lips, small chin, and long hair combed forward on the back of the neck, it is almost certain that the gem depicts the emperor Gaius Caesar, called Caligula (r. A.D. 37–41).

The ring is oxidized and the surface slightly corroded, but the gem is in excellent condition, apart from very minor abrasions.

M.L.A.

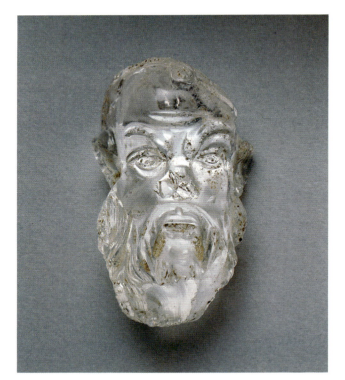

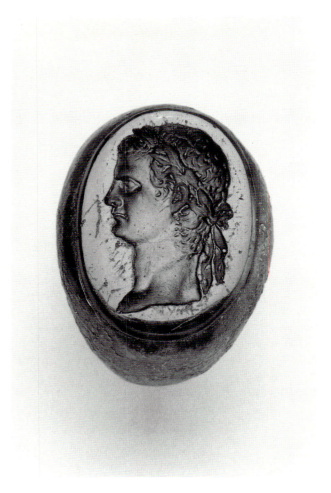

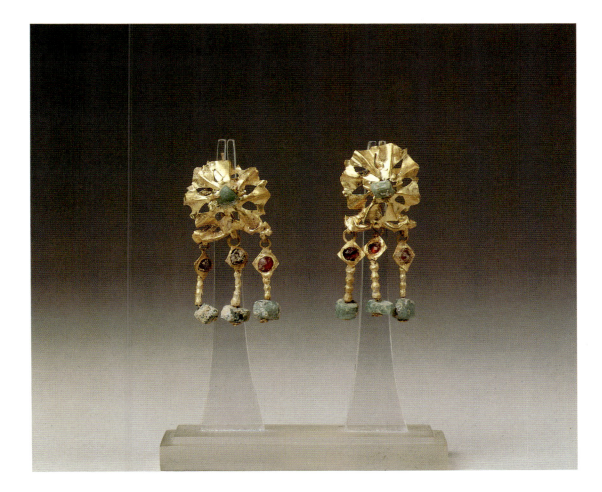

187. *Pair of gold earrings with inlaid stones*

Height of each earring, 3.39 cm.; diameter of each
 earring, 1.62 cm.
Second–third century A.D.

Roman jewelry of the second and third century A.D. is generally less refined than that of preceding and succeeding periods, although it does not lack interest. With the enlargement of the Empire under the emperor Trajan, a vari- ety of styles and influences made themselves apparent in Roman art. The somewhat rustic character of much Roman jewelry of this epoch is well illustrated by this pair of gold earrings; each is composed of a gold-leaf rosette with a central stone, from which are suspended three small inlaid pendants.

M. L. A.

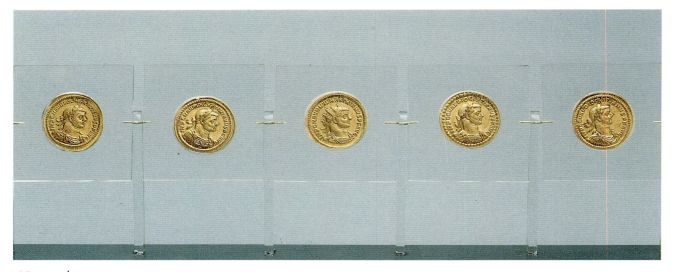

188 *a–e*: obverses

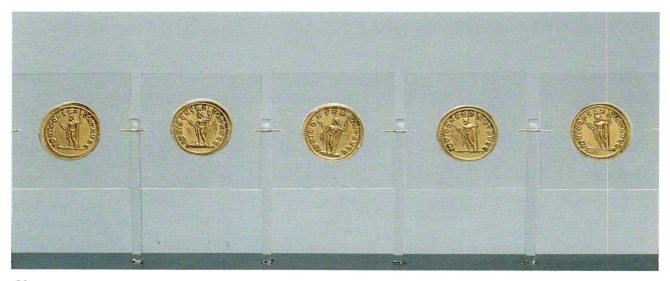

188 *a–e*: reverses

188. *Gold treasure: Five coins and a fibula*
Late third–early fourth century A.D.

a. Aureus of Diocletian
 About A.D. 290
 Rome Mint
b. Aureus of Diocletian
 About A.D. 290
 Rome Mint
c. Aureus of Maximianus
 About A.D. 290
 Rome Mint
d. Aureus of Maximianus
 About A.D. 290
 Rome Mint
e. Aureus of Maximianus
 About A.D. 290
 Rome Mint
f. Gold and bronze crossbow fibula, with onion-shaped
 finials and beaded collars
 Height, 3.23 cm.; width, 5.75 cm.; length, 7.04 cm.

a. On the obverse is a bust of Diocletian in right profile. He is clad in a paludamentum and wears a wreath. The inscription reads IMP CC VAL DIOCLETIANVS PF AVG. On the reverse is a standing figure of Jupiter, resting on a staff clasped in his left hand and eyeing a thunderbolt held in his upraised right hand. The thunderbolt has opposed corn-like finials. The inscription reads IOVI CONSERVAT AVGG.

b. The obverse shows a bust of Diocletian in right profile, clad in a paludamentum and wearing a wreath. The inscription reads IMP CC VAL DIOCLETIANVS PF AVG. The reverse shows the standing figure of Jupiter resting on a staff and eyeing a thunderbolt with opposed corn-like finials. The inscription reads IOVI CONSERVAT AVGG.

c. On the obverse is a bust of Maximianus in right profile. He wears a paludamentum and a five-pointed crown. The inscription reads IMP C M AVR VAL MAXIMIANVS PF AVG. The reverse has the same standing figure of Jupiter with a staff, thunderbolt, and the inscription IOVI CONSERVAT AVGG.

d. The obverse shows a bust of Maximianus in right profile, wearing a paludamentum and a wreath. The inscription

reads IMP C M AVR VAL MAXIMIANVS PF AVG. The reverse shows the same standing figure of Jupiter with staff, thunderbolt, and the inscription IOVI CONSERVAT AVGG that is found on all these coins.

e. On the obverse are a bust of Maximianus in right profile, wearing a paludamentum and a wreath, and the inscription IMP C M AVR VAL MAXIMIANVS PF AVG. The reverse bears the same standing figure of Jupiter with staff, thunderbolt, and the inscription IOVI CONSERVAT AVGG as on coins *a–d.*

f. The gold portion of the fibula is in pristine condition, apart from a few nicks on the surface. The bronze pin of the clasp is missing, except for a heavily encrusted portion in the base of the pin and at the intersection of the crossbow. The bronze inlays in the onion-shaped terminals are also corroded.

 M.L.A.

188 *f*

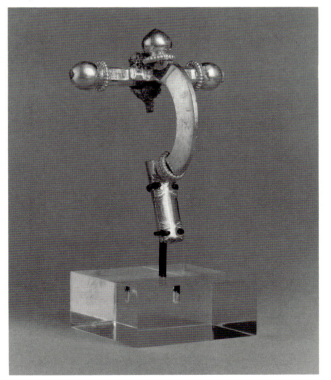

189. *Bronze crossbow fibula*

Height, 2.4 cm.; length, 5.96 cm.; width, 4.355 cm.
Late third or early fourth century A.D.

This bronze fibula has onion-shaped finials with beaded collars, and terminals separately inlaid in bronze. It was formerly in the collection of Thomas F. Flannery.

M.L.A.

BIBLIOGRAPHY
Cat. Sotheby's (London) 12–13 December 1983, p. 30, no. 117, ill. p. 33.

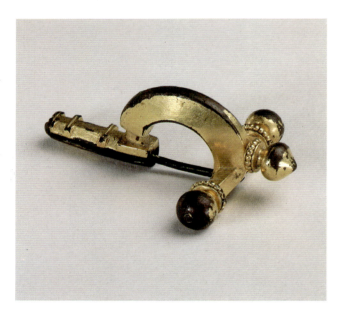

190. *Gold and enamel crossbow fibula*

Height, 2.45 cm.; length, 5.55 cm.; width, 4.65 cm.
Fourth century A.D.

This crossbow fibula has onion-shaped finials with beaded collars. The central part of the body of the fibula is inlaid with blue enamel, which, in turn, is itself inlaid with a miniature gold pattern consisting of diamond shapes separated by narrow twin horizontal lines. The most elaborate of the fibulae in the collection, this example bears comparison with the finest cloisonné work of the period. Fibulae of this type are among the last expressions of pagan craftsmanship in the Roman world, and represent a link with the emergence of barbarian jewelry in the Early Medieval period and the new amalgam of decorative traditions in a Christian Europe.

M.L.A.

BIBLIOGRAPHY
Cat. Christie's (London) 12 December 1984, p. 13, no. 35.

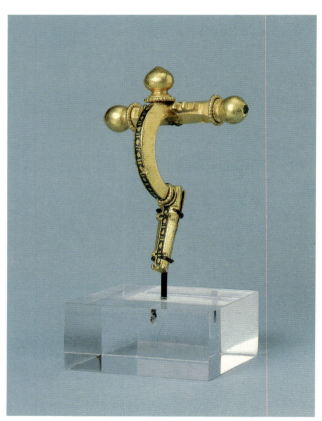

Late Antique

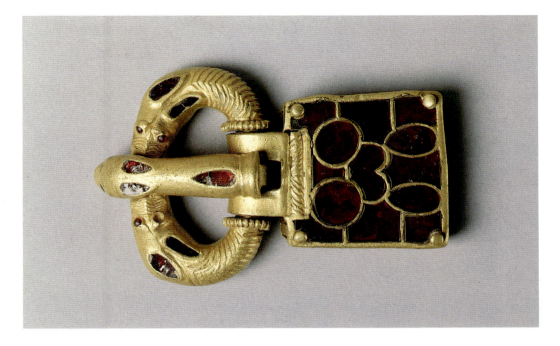

191. *Massive gold buckle with garnets*

Length, 7.6 cm.; width: of buckle plate, 4.4 cm., of
 loop, 4.7 cm.

Gothic, first half of the fifth century A.D.

 (found in Hungary)

Confronted, stylized animal heads, like those on the con-
temporary armlet from Bakodpuszta, Hungary (H. Roth,
Kunst der Völkerwanderungszeit [*Propyläen Kunstgeschichte*,
suppl. vol. IV], 1979, no. 31 b), form the terminals of the
loop that supports yet a third such head, which serves as the
end of the tongue of this buckle. The third head has bared
gold teeth (as do the heads on the armlet), as well as ears and
eyes set with garnets. (The garnet once in the right eye of the
right animal head that forms the loop is now missing.) The
partially open mouths are also inlaid with garnets. At the
base of the tongue is another inlaid garnet that, like those of
the ears, is in the shape of a teardrop; this shape, formerly
attributed to Hunnish goldsmiths' work, recently has been
associated with the Goths, Gepids, and Huns of the Danube
basin (W. Menghin, ed., *Germanen, Hunnen und Awaren,
Schätze der Völkerwanderungszeit* (exhib. cat.), Nuremberg,
Germanisches Nationalmuseum, 1987–88, pl. 19, p. 222,
V, 9 b). The squared-off snouts and muzzles indicated by
cast (and sometimes incised) parallel lines, such as those on
the heads of this buckle and on the heads of the Bakodpuszta
armlet, and those forming the digits of the exceptionally

large Gepidic silver-gilt fibulae from Gava, Hungary (W.
Menghin, op. cit., pl. 19, 9 b), are other features shared by
jewelry of this period from the Danube basin.

Although some of the settings have been replaced, in-
cluding those of the plate, this does not detract from the
design of the buckle, which is comparable to that of the
buckle from Nagydorog, Hungary (H. Roth, op. cit., no.
33 a). On the other hand, one detail may be an inaccurate
restoration: the pair of twisted wires at the juncture of the
loop and the flange of the buckle plate. Whereas this
element is virtually unknown on buckles, it is common on
contemporary fibulae, the pair from Untersiebenbrunn,
Austria, providing a case in point (H. Roth, op. cit., no. 32
b).

The buckle was formerly in the collections of Geza von
Kárász; Tyszkiewicz; Béarn; Béhague; Ganay.

K.R.B.

BIBLIOGRAPHY
*Collection Geza von Kárász, Vente Hôtel Drouot (Paris) 11 avril
1890,* no. 11, pl. 2,4; W. Froehner, *Collection d'Antiquités du
Comte Michel Tyszkiewicz, Vente . . . Hôtel Drouot (Paris) 8–10
juin 1898,* p. 69, no. 192, pl. 21; *idem, Collection de la Comtesse
R. de Béarn,* I, 1905, pp. 14–15, pl. 3,2; É. Coche de la Ferté,
Bijoux du Haut Moyen Âge, Lausanne, 1961, no. XIX; *Anti-
quités et objets d'art, Collection Martine, Comtesse de Béhague . . . ,
Cat. Sotheby's (Monaco) 5 December 1987,* no. 52.

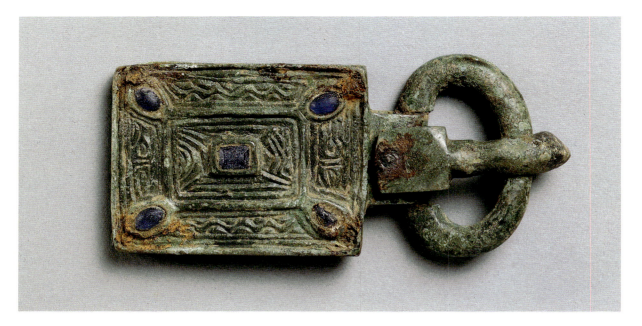

192. *Bronze and glass buckle*

Length: of plate, 10.8 cm., of tongue, 4.8 cm.;
 width of loop, 4.9 cm.
Visigothic, sixth century A.D.

This bronze Visigothic buckle, with its cast "Kerbschnitt" (chip carving) decoration, obliquely positioned pieces of glass in each of the four corners, and central rectangular stone is based on silver-gilt Ostrogothic prototypes found in Italy and dated to the fifth century, but known earlier in south Russia and in Hungary (A. Götze, *Gotische Schnallen*, Berlin, pp. 2, 3). While the loop may be original, most comparable excavated examples have some form of cast "Kerbschnitt" decoration (H. Zeiss, *Die Grabfunde aus dem Spanischen Westgoten Reich* [*Germanische Denkmäler der Völkerwanderungszeit*, II], Berlin and Leipzig, 1934, pl. 9, no. 8, p. 157; E. James, *The Merovingian Archaeology of South-West Gaul*, part I [BAR Supplementary Series 25], Oxford, England, 1977, pl. 67, p. 249). The tongue is probably not original to the piece.

The Goths had migrated from Scandinavia to the northern shores of the Black Sea in the second and third centuries A.D., and by peaceful agreement with the Romans, the Visigoths, or "Western Goths," had taken over the province of trans-Danubian Dacia (between the Carpathian Mountains and the Danube River) by about A.D. 275. The Ostrogoths, or "Eastern Goths," were situated to their east.

When, in 374, the Huns, probably coming from the steppes of Central Asia, invaded the southern plains of what is now modern Russia, some of the Ostrogoths remained under Hunnish domination and others fled westward to Italy. By the end of the fifth century (491–526) Theodoric the Great reigned in Ravenna. Some Ostrogoths continued to move north and west into Frankish territory—by this time comprising the area today shared by France, Belgium, Luxembourg, parts of the Netherlands, Germany, and Switzerland—where some of them were employed by the Frankish court. When the Huns reached the Danube in 376, the Visigoths fled into the territories of the Roman Empire, where they lived as auxiliary troops until 385. At that time their king, Alaric, had a dispute with the Roman emperor, which culminated in the famous Sack of Rome in 410 by the Visigoths and their ensuing migration into southern France and Spain in 418. Even after 507, when the Visigothic capital moved from Toulouse to Toledo, some Visigoths continued to live in southern France.

As a type, this buckle plate is interesting because it demonstrates—as do the well-known cloisonné eagle-shaped fibulae—the continued close artistic relationship between the Ostrogoths and the Visigoths even after they went their separate ways.

K.R.B.

193. *Buckle*

Length, 13.3 cm.; width: of plate, 7.5 cm., of loop,
 7 cm.
Bronze and glass, with a single turquoise that may be a
 modern addition
Visigothic, sixth century A.D.

The cast, grid-like pattern of this buckle and plate, set with
round and square glass-paste cabochons, is comparable to
allover patterns from the Near East, particularly Egypt and
Syria, which came via the Mediterranean and became par-
ticularly popular in the sixth-century barbarian art of
southwestern France and Spain. The oval-shaped loop is
attached to the plate by a narrow strip of metal bent around
the thin part of the loop and soldered to the plaque. The
trilobed base of the tongue is inlaid with glass, and the
tongue terminates in the traditional animal head.

As is true of the majority of Visigothic buckles, this one
probably came from a woman's tomb. It was originally
fastened to a leather strap by means of the four small pins
that are still visible in the plate. The loop and tongue were
attached to the other end of the strap. The tongue would
have pierced the leather after the strap had been passed
around the loop and knotted on itself. It is thought that
women wore such belts around their tunics rather than their
mantles.

Although the Visigothic capital was moved from Tou-
louse to Toledo in 507, many Visigoths continued to live in
southwestern France. It is known that a very similar buckle,
now in the Musée de Cluny, came from there (J.-P. Caillet,
*L'Antiquité classique, le haut Moyen Âge et Byzance au Museé de
Cluny*, Paris, 1985, p. 195, no. 121). Thus, this buckle,
too, may have originated in southwestern France.

K.R.B.

194. *Bronze, glass, and mother-of-pearl*
 buckle

Greatest length, 13.4 cm., length of tongue, 4.5 cm.;
 width: of loop, 6 cm., of plate, 7 cm.
Visigothic, sixth century A.D.

Although most of the glass appears to be original, fill material has been added between the glass and the cloisons, and colored paste has been added under the glass, making it impossible to ascertain the original color of the surface. The design, however, which is formed by the pattern of the cells, remains, and is characteristic of Spanish Visigothic cloisonné buckles. It consists of a circle within a circle, the inner one of which can be read as two crosses radiating from the center. The four mother-of-pearl settings in, or, as on this piece, near the corners, are typical of Visigothic buckles in Spain and France. Most of these white inlays appear to be of mother-of-pearl, although in some examples, such as the recent acquisition by the Metropolitan Museum's Department of Medieval Art (1988.305 a,b), the substance has been identified as cuttlefish bone. A comparable buckle is in the Museo Arqueológico, Barcelona (*Memorias de Los Museos Arqueológicos Provinciales*, vol. VIII, 1947, pl. XX, no. 37, p. 69).

K.R.B.

195. *Twisted silver torque*

Diameter, 22.9 cm.
Frankish, fifth century A.D.

This heavy silver torque of square section, twisted and fastened by means of a hooked end passed through a loop, was found at Rognac (Charente) in southwestern France, along with the Frankish bow fibula discussed in catalogue number 194, according to the dealer from whom it was purchased; both objects were said to have been in the collection of Anatole France.

Michael Ward has noted that the torque provides evidence that this ancient form of jewelry, which originated among prehistoric tribesmen, survived into Merovingian times. Another, similar twisted silver torque of the fifth century A.D. corroborates this observation. Called a nomadic rider torque, it was found in the Crimea (W. Menghin, ed., *Germanen, Hunnen und Awaren, Schätze der Völkerwanderungszeit* [exhib. cat.], Nuremberg, Germanisches Nationalmuseum, 1987–88, I, no. 15 a [South Russia], p. 109).

However, most barbarian torques are gold and are round in section, like the well-known example from Pouan (Aube), France (P. Périn and L.-C. Feffer, *À la Conquête de la Gaule* [*Les Francs*, I], pp. 116–17). A similar gold torque in

The Metropolitan Museum of Art (27.122.16), from Kerch, has recently been called East German and dated to the fifth century (W. Menghin, ed., op. cit., p. 114), as has another one found in Austria (W. Menghin, ed., op. cit., VII, no. 33 d). A Hunnish torque, discovered in Hungary, has also been dated to the first half of the fifth century (W. Menghin, ed., op. cit., III, no. 50 a, pl. 10, p. 181). The Pouan torque is now considered to have been made in the West; it is of the type usually associated with Germanic princes, and, as proposed by Périn, should be regarded as a symbol of the status of its owner. Both traditions—that of preserving the prehistoric form of the torque, and the association of gold torques with status symbols and with Germanic princes—are upheld by a gold twisted torque from the third century A.D., which is square in section like the two fifth-century silver examples (W. A. von Jenny and W. F. Volbach, *Germanischer Schmuck des frühen Mittelalters*, Berlin, 1933, pl. XIV).

K.R.B.

BIBLIOGRAPHY

M. Ward and J. Rosasco, *Origins of Design: Bronze Age and Celtic Masterpieces*, New York [n.d.], no. 74.

196. *Silver-gilt bow fibula*

Height, 8.9 cm.
Frankish, sixth century A.D.

A common type of Frankish bow fibula has a semicircular head with five digital projections, each ornamented with a circular piece of almandine, and a rectangular foot connected to the head by an arched bow. The borders of the foot and bow and the entire surface of the head are decorated in a technique known as chip carving because of its resemblance to wood carving. Zigzag borders are characteristic of the type. Such fibulae were actually cast in clay molds and were conceived in pairs. Although all scholars are not in agreement, it is thought that the Franks wore them horizontally, on the diagonal, to close a mantle.

What distinguishes this example from most others are the crosshatched gold foil placed under the garnets (one setting is missing) and the maeander design in niello, which emphasizes the median point. Examples of the mae-ander are found on similar fibulae in the Diergardt collection (J. Werner, *Katalog der Sammlung Diergardt, Römisch-Germanisches Museum, Köln*, Berlin, 1961, nos. 4 b, 13 a). A more traditional emphasis of the median is by a row of incised dots, as on the similar fibula in the Walters Art Gallery (K. R. Brown, *Frankish Art in American Collections*, New York, The Metropolitan Museum of Art, 1984, p. 15, fig. 5). Both the accent on the median and the predilection for placing gold foil under the garnets came to the Frankish artisans from the Ostrogoths.

According to the dealer from whom the fibula was purchased, it is said to have been found at Rognac (Charente), in southwestern France, along with a large, heavy, twisted torque of square section, from the fifth century A.D. (cat. no. 195). Both objects were previously in the collection of Anatole France.

K. R. B.

197. *Bronze cruciform brooch*

Height, 12.7 cm.; width, 7.5 cm.
Anglo-Saxon (probably from Norfolk, Suffolk, or
 Cambridge), mid-sixth century A.D.

Toward the end of the third century A.D., Roman Britain became the object of more or less consistent attacks by Germanic pirates—notably, Jutes, Angles, and Saxons. During the course of the fifth century, three principal zones of Germanic colonization emerged: Northumbria, Mercia, and East Anglia, which were inhabited by the Angles; Essex, Sussex, and Wessex, which were occupied by the Saxons; and the area extending from Kent to the Isle of Wight, where the Jutes settled. Many Romano-Britons fled during the invasions. The conversion to Christianity of these islanders did not begin until the mission of Saint Augustine in 596 and the ensuing baptism of King Ethelbert.

In all regions of early pagan Anglo-Saxon England, the predominant mode of female dress was a tunic pinned at each shoulder with matching brooches, often with a swag of beads hanging between them. Regional variations in the types of brooches worn were marked, with cruciform bow brooches characteristic of the Angles.

The long or cruciform brooch was invented or adopted by the Goths while they were still in south Russia. A stream of influence can be traced about A.D. 200 from south Russia to East Prussia, and via the Baltic Coast, to Denmark, Sweden, and Norway. In Kerch, on the north shore of the Black Sea, a type was found with a narrow arched bow and a returned foot. The spring was of a La Tène type, with a series of bilateral coils, but passed around a short crossbar that terminated in knobs; another knob was attached to the extremity of the bow called the head. This prototype has a foot almost as long as the bow. In the Roman period, before the brooch type reached England, an animal-head terminal was developed on the foot. This ornament was of north

German origin and may best be described as a horse's head seen from the front. During the fifth century in England, details of casting these brooches indicated connections with Denmark rather than with Norway or Sweden (O. M. Dalton, *A Guide to the Anglo-Saxon and Foreign Teutonic Antiquities in the Department of British and Medieval Antiquities, British Museum*, 1923, pp. 23–26). At the close of the fifth century and into the mid-sixth century the connections between England and Denmark were interrupted and relations were established with the western coast of Norway, affecting a change toward a broader, flat crossbar cast in one piece, with the brooch and the raised panel in the center of the head plate surviving merely as an ornamental feature, as on Norwegian specimens. In the mid-sixth century, cruciform brooches were no longer made in Norway, and England was left to continue their development. An increase in the width of the head plate, bow, and nostrils of the horsehead terminal became characteristic (O. M. Dalton, op. cit., pp. 26–27).

The patina of this particular brooch consists of a brownish-green coating of copper carbonates. As noted by Suzanne Fredericks (in the appendix of an unpublished paper), on the lowest part of the animal head one can see a distinct alteration in the patination on the reverse, as well as very crude carving of the nostrils executed with a larger tool than was used for the finishing of the rest of the piece. The bottom edge has been filed, leaving an abrupt, irregular outline. X-ray photography has revealed a high porosity in this area—often an indication of a weaker section in the bronze casting. The brooch was probably damaged and then repaired and it is possible that the nose actually extended vertically below the nostrils (S. Fredericks). Although Fredericks has placed this brooch in the first half of the sixth century or in Åberg's group IV (N. Åberg, *The Anglo-Saxons in England*, Uppsala, 1926, pp. 42–49), the addition of wings to the foot, just below the bow, seems to be a later development, which would place the brooch more specifically in the period around 550.

K.R.B.

Contributors to the Catalogue

M.L.A. Maxwell L. Anderson
E.B. Erika Bleibtreu
D.v.B. Dietrich von Bothmer
K.R.B. Katharine R. Brown
E.C.B. Emma C. Bunker
D.C. David Cahn
F.C. Faya Causey
P.G.-P. Pat Getz-Preziosi
P.O.H. Prudence O. Harper
T.S.K. Trudy S. Kawami
J.R.M. Joan R. Mertens
E.J.M. Elizabeth J. Milleker
M.P. Michael Pfrommer
H.P. Holly Pittman
E.P. Edith Porada
K.R. Karen Rubinson
D.S. Deborah Schorsch
N.S.-W. Nicholas Sims-Williams
M.T. Marion True
C.C.V. Cornelius C. Vermeule III
J.-L.Z. Jean-Louis Zimmermann

Bibliographical Abbreviations

ABV: J. D. Beazley, *Attic Black-figure Vase-painters*, Oxford, England, 1956.

ACC: J. Thimme, ed., *Art and Culture of the Cyclades in the Third Millennium B.C.*, Chicago, 1977.

AJA: *American Journal of Archaeology*.

AM: *Athenische Mitteilungen*.

Arch. Delt.: *Arkhaiologikon Deltion*.

Arch. Eph.: *Arkhaiologike Ephemeris*.

ARV²: J. D. Beazley, *Attic Red-figure Vase-painters²*, Oxford, England, 1963.

Beazley Addenda²: T. H. Carpenter, *Beazley Addenda. Additional References to ABV, ARV², & Paralipomena*, 2nd ed., Oxford, England, 1989.

BSA: *Annual of the British School at Athens*.

CAH: *Cambridge Ancient History*.

CVA: *Corpus Vasorum Antiquorum*.

ECS: P. Getz-Preziosi, *Early Cycladic Sculpture: An Introduction*, Malibu, 1985.

Goulandris 1983: C. Doumas, *Cycladic Art: Ancient Sculpture and Pottery from the N. P. Goulandris Collection*, London, British Museum, 1983.

C. H. E. Haspels, *ABL*: *Attic Black-figured Lekythoi*, Paris, 1936.

JdI: *Jahrbuch des Deutschen Archäologischen Instituts*.

D. C. Kurtz, *Athenian White Lekythoi*: *Athenian White Lekythoi, Patterns and Painters*, Oxford, England, 1975.

LIMC: *Lexicon Iconographicum Mythologiae Classicae*, Zurich, 1981– .

MEFRA: *Mélanges de l'École Française de Rome, Antiquité*.

MM: *Madrider Mitteilungen*.

MMA *Bulletin*: The Metropolitan Museum of Art *Bulletin*.

MMA *Journal* (or ***MMJ***): The Metropolitan Museum of Art *Journal*.

Mon. Ant.: *Monumenti antichi pubblicati per cura della Reale Accademia dei Lincei*.

Mon. Piot: Fondation E. Piot, *Monuments et Mémoires publiés par l'Académie des Inscriptions et Belles-Lettres*.

M. L. Morricone, "Eleona e Langada": "Eleona e Langada, sepolcreti della tarda Età del Bronzo a Coo," in *Annuario della scuola archeologica di Atene*, 1965–66.

NAC: P. Getz-Preziosi, *Early Cycladic Art in North American Collections*, Richmond, Virginia Museum of Fine Arts, 1987.

Paralipomena: J. D. Beazley, *Paralipomena. Additions to Attic Black-figure Vase-painters and to Attic Red-figure Vase-painters*, 2nd ed., Oxford, England, 1971.

RA: *Revue Archéologique*.

Safani: *The Art of the Cyclades. An Exhibition of Sculpture and Artifacts of the Early Cycladic Period*, New York, Safani Gallery, 1983.

Sculptors: P. Getz-Preziosi, *Sculptors of the Cyclades: Individual and Tradition in the Third Millennium B.C.*, Ann Arbor, 1987.

A. D. Trendall, *RVA:* (and A. Cambitoglo), *The Red-figured Vases of Apulia*, vol. I, Oxford, England, 1978; vol. II, Oxford, 1982; First supplement, London, 1983.

A. D. Trendall, *RFVSIC*: *Red-Figure Vases of South Italy and Sicily*, London, 1989.

Glossary

ALABASTRON: a perfume vessel, named after alabaster, a material much favored for this shape; also made of terracotta, marble, or glass

ANASTOLE: hair brushed up and back

ANTONINE: the period of the Roman emperor Antoninus Pius and his dynasty

APICATE FILLET: a fillet equipped with a point or apex above the forehead

BOREAD: a son of the wind-god Boreas

BUCRANIUM: the skull of a bull, often suspended near an altar in a sanctuary; later, a common architectural ornament

CALYX-KRATER: a mixing bowl for wine and water, the shape resembling the calyx of a flower

CENTAUROMACHY: a battle of Greeks and Centaurs

CHITON: an undergarment

CHLAMYS: a short mantle

CITHARODE: a musician singing to his own accompaniment

CYCLOPS: a member of a tribe of one-eyed savages, of whom Polyphemos is the best known

DIADOCH: one of the successors of Alexander the Great

DINOS: a mixing bowl without handles or foot; normally placed on a stand

DIOSCURI: the twin brothers Castor and Pollux

GORGONEION: the head of the decapitated gorgon Medusa

GUTTUS: a small container for liquids, which were poured through its narrow spout

HERM: a rectangular shaft surmounted by a head or bust, often a portrait

HIMATION: an outer garment, worn over the chiton

HYDRA: the many-headed water serpent killed by Herakles at Lerna

HYDRIA: a water jug, usually with three handles

IYNX-WHEEL: a wheel held horizontally by strings in one hand and rotated in a love oracle; named after Iynx in Greek mythology, who was changed into a bird (the wryneck)

KANTHAROS: a deep drinking cup with two upright handles, much favored by Dionysos

KETOS: a sea monster with the head of a wolf

KITHARA: a seven-stringed musical instrument with a large sound box made of wood

KLISMOS: a chair with curving back and legs

KOINE: something commonly shared, such as a language or culture; a commonwealth or confederation

KOMAST: a reveler participating in a *komos* (revel or procession)

KOTTABOS: a bronze stand used at banquets in an elaborate game in which the last drops of wine in a drinking cup were aimed at a mobile disk, which, when hit, clattered to the bottom of the shaft

KRATERISKOS: a small krater

KYLIX: a wide, shallow drinking cup equipped with two horizontal handles and a foot

KYMATION: an architectural curvilinear ornament resembling waves

LEKANIS: a shallow, footed dish with two horizontal handles, and usually equipped with a lid; used for food

LEKYTHOS: a one-handled container for oil or perfume

LOCULUS SLAB: a small plaque placed in a compartment or a pigeonhole

LOUTROPHOROS: a long-necked amphora or hydria used for a bride's ritual bath

MAGNA GRAECIA: the area of southern Italy and Sicily that was extensively colonized by the Greeks

MASTOID: a drinking cup with or without handles, somewhat resembling the breast (*mastos*) of a woman; also a vase shape

MELONENFRISUR: a female hairdo resembling the surface of a melon

NECK-AMPHORA: a two-handled storage jar for wine, oil, or other liquids; similar in shape to the amphora, except that the neck of the vase is clearly set off from the shoulders

NODUS: a roll of hair tied into a knot

OINOCHOE: a one-handled jug for pouring wine

PALUDAMENTUM: a military cloak worn by high-ranking officers and fastened on one shoulder with a brooch

PANATHENAICS: the chief religious festival in Athens, held on the birthday of the goddess Athena. The Great Panathenaics were celebrated every four years and included hippic, athletic, and musical contests. The prizes for the first were Panathenaic amphorae filled with olive oil from the sacred groves of Attica.

PEPLOS: the Doric chiton, with an overfold; usually worn by women

PETASOS: a wide-brimmed hat worn by Hermes and also by travelers, hunters, riders, and lightly armed soldiers

PHALERA: a metal disk or boss (often ornamented) worn by horses on their trappings or by soldiers as military decorations

PHIALE: a shallow libation bowl, usually without handles, with a navel in the center of the inside. It is held in the right hand, with the thumb resting against the rim and the tip of the middle finger in the hollow of the navel.

POLOS: the cylindrical headgear of some goddesses, notably Demeter and Artemis

PROTOME: the forepart of an animal or monster

PSYKTER: a wine cooler; filled with wine it was floated in a krater containing cold water or snow

PYXIS: a small, round box, usually lidded, named after the boxwood from which such containers were originally made

RHYTON: a drinking cup in the shape of an animal's head or protome, or a horn. A small hole at the tip allows wine to be aerated as it is poured into a cup.

SACCOS: a headdress worn by women

SATYRISKOS: a small satyr

SEVERAN: the period of the Roman emperor Septimius Severus and his dynasty

SKYPHOS: a deep drinking cup with two horizontal handles

SYRINX: the panpipes or shepherd's pipe; made of reeds of differing lengths

TETRARCHIC: the period of rule by four tetrarchs, two Augusti and two Caesars, introduced in the Roman Empire by the emperor Diocletian in A.D. 285

VOLUTE-KRATER: a mixing bowl with handles that terminate in volutes

ZOPFSCHLEIFE: the loop of a braid

Index

Items in boldface are titles of catalogue entries. Titles in italics are of scenes depicted on works of art that are the subjects of catalogue entries. Italicized numbers refer to pages with illustrations.